The Sage and the Second Sex

The Sage
and the
Second Sex

Confucianism, Ethics, and Gender

Edited by Chenyang Li

With a Foreword by Patricia Ebrey

Open Court
Chicago and La Salle, Illinois

To order books from Open Court, call toll free 1-800-815-2280.

Open Court Publishing Company is a division of Carus Publishing Company.

Library of Congress Cataloging-in-Publication Data

The sage and the second sex : Confucianism, ethics, and gender / Edited by Chenyang Li ; with a foreword by Patricia Ebrey
 p. cm.
 Includes bibliographical references and index.
 ISBN 0–8126–9418–X (alk. paper) — ISBN 0–8126–9419–8 (pbk. : alk. paper)
 1. Women in Confucianism—China. 2. Feminism—Moral and ethical aspects—China. 3. Confucianism. I. Li, Chenyang, 1956–

HQ1676 .S24 2000
305.42′0951—dc21 00–029672

For
Dr. Hong Xiao

Contents

Foreword

Confucianism has meant many things over the centuries in China. Feminism, in its much shorter history, has also taken many forms, made many claims, and lent support to many different social policies. Not surprisingly, therefore, the encounters between these two complex sets of ideas have been complicated. Scholars and activists, in China and the West, have drawn on one to challenge the other in several distinct ways.

Early in the twentieth century, Chinese reformers, influenced at least indirectly by Western feminism, decried the deleterious effects of Confucianism on women. The "New Culture" reading of Confucianism was that it sacrificed individuals for the sake of families and fell particularly hard on women. Chen Duxiu, for instance, wrote in *New Youth* in 1916 that women would not be able to take their proper place in society so long as they were bound by Confucian teachings such as "To be a woman is to submit," or "Men and women do not sit on the same mat," or "Never disobey or be lazy in carrying out the orders of parents or parents-in-law."[1]

In the decades that followed, Chinese Marxists, even when adhering to a materialist interpretation of history, rarely challenged the view that Confucianism was bad for women, and Chinese government organs commonly blamed the persistence of "feudal remnants" for part of what held women back. In 1985 one author explained that the "physical and mental gap" that persisted between the attainments of men and women could be explained in terms of the long history of denigrating and repressing women, mentioning in particular "feudal morality and ethics" with its "three obediences and four virtues" and its ideas that "men are superior and women are inferior" and that "the absence of talent in a woman is a virtue."[2]

Those who have blamed Confucianism for holding back Chinese women have usually used the term loosely to cover the whole gamut of orthodox, normative behavior related to the family in late imperial times. Confucian authors over the centuries celebrated the patrilineal, patriarchal, patrilocal family system, and urged men and women alike to be filial, loyal to their families, and serious in their obligations to their ancestors and kin. The ideas that underlay the daily practice of the Chinese family system can thus with some justice be labeled "Confucian." Tracts for women's education and exemplary biographies

of virtuous women, easily labeled Confucian in this general sense, certainly promoted an inequality of the sexes, arguing for the moral rightness of separate spheres for men and women and women's subordination to the male heads of their households.

Those who have defended Confucianism against charges of abetting the oppression of women, not surprisingly, have defined Confucianism differently. Confucianism, as they use it, is not the conventional morality of the Confucian elite of late imperial times, or even the ideas to be found in the inspirational literature written by later Confucians, but the core ideas of the founders and leading thinkers of Confucianism, who may have been guilty of ignoring women or taking their status for granted, but who never set out to denigrate or oppress them. They see no reason to blame Confucius, Mencius, Cheng Yi, or Zhu Xi for taking for granted basic features of the social order in which they lived, since philosophers and religious teachers the world over have usually accepted much about the social systems around them.

Today Confucianism is not the same target as it was at the beginning of the twentieth century. Although it still certainly has associations with the past, it is no longer the ideology of those in power, and it is important to keep in mind that its ideas have become detached from particular social forms. None of those who identify themselves as Confucians argue that the separation of the sexes should be reinstated, that parents should have control over their children's marriages, that wives or children should endure mistreatment out of devotion to fidelity or filiality, or that widows should renounce remarriage. Confucians today, in Asia and in the West, want Confucianism to evolve in a way that accommodates all the changes that have occurred in the family system as well as ideas about the equality of males and females introduced by feminism.

Writing at the beginning of the twenty-first century, the authors of this volume bring a wide range of expertise to this ongoing engagement of feminism and Confucianism. In his introduction, Chenyang Li frames the project of this book as one of revitalizing Confucianism, of finding within it the conceptual flexibility to embrace notions of male–female equality. He finds validation of some key elements in Confucianism in their parallels to some contemporary feminist theories. Readers whose interests are primarily in the future of Confucianism or comparative philosophy will find much to think about in his overview of the issues.

As an historian, I can more usefully highlight some of what this book has to offer other readers, particularly those interested in Chinese history in general or Chinese women's history in particular. The authors whose work is presented here challenge the New Culture reading of the links between Chinese women and Confucianism in three principal ways: they suggest that women's situations were not as bad as supposed; that core Confucian teachings had little to do with anything bad about their situations; and that Confucianism offers an ethical vision compatible with feminism.

This volume is particularly strong in its coverage of early Chinese history through the Han dynasty, whereas the bulk of previous work has been on later periods. Taking earlier work and this volume together, we now have specialists in virtually every period of Chinese history who grant in a general way that Chinese society was sexist but who find for the period or class they know best evidence of the opposite—gender-neutral philosophies, women who had enough leeway to create productive and meaningful lives, and so on. Readers will want to think about how this all adds up. Clearly it is time to discard the exaggerated stereotypes generated by the rhetoric of the New Culture Movement. But what do we put in their place? The notion of Chinese women's oppression has been central not only to Western views of China but also to modern Chinese views of the progress they have made over the course of the twentieth century. Dislodging it will require more than proof that many women did well. The work presented in the book can be read as a challenge for historians or theorists to offer a new model of the gender system that accounts for both women's achievements and the obstacles they faced.

Assuming that such a new understanding can be attained, we still have the issue of the connection between the gender system and Confucianism. Historians have generally held that Confucianism provided the intellectual underpinnings of Chinese social and political life, and that an understanding of how it developed over time is essential to any understanding of Chinese society. Yet several authors in this book grant that there was something wrong with women's situations in late imperial China, but then show that the key elements of Confucian philosophy had little if anything to do with it. Does it then follow that Confucianism did little to shape everyday behavior or attitudes in later periods of Chinese history? On what grounds could one hold both that Confucianism provided the intellectual underpinnings of Chinese social and political life throughout the imperial period and that it had little if anything to do with people's ideas or practices with regard to something as fundamental as gender? One way out would be to distinguish between original Confucianism and later Confucianism, which obviously undermines the claim that Confucianism underlay Chinese society. Another would be to abandon that claim and view Confucianism as a critical discourse that was always at odds with ordinary ways of thinking and acting. If that is the case, the critics of Confucianism may have put the blame in the wrong place, but those who want to understand the mental, moral, and emotional basis of China's gender system still have their work cut out for them. They will now have to find ways to study the common assumptions and habits of thought that persisted without support by the major religions and philosophies.

East–West comparisons are central to several papers in this volume, and these raise difficult issues of their own. By the nineteenth century, Western observers were in general agreement that women in the East did not fare as well as in Western, Christian lands. In the time it has taken historians of Chinese

women to chip away at the empirical basis of the feminist critique of Confucianism, feminist theorists have also critiqued the assumptions of Western superiority that were built into much Western writing on Asian women. Within Western feminism today, activists and scholars alike struggle with how to take up the cause of women in other countries without being guilty of cultural imperialism. Consequently, Western feminists today generally are more comfortable applauding and supporting the efforts of feminists abroad than voicing their own criticisms of other people's societies. To some the need to be sensitive may seem a lamentable limitation on the pursuit of truth. Others find in it appropriate recognition that the readership of our work has changed: we can no longer assume that those we write about are not also part of our audience.

In this volume, the difficulty of drawing comparisons that will be satisfactory to all sides comes out in a very different way. Several authors examine the parallels between Confucianism and certain strands of feminist ethics, particularly Carol Gilligan's care ethics. Dominant Western ethical systems, with their emphasis on rights and justice, are seen as rooted in a competitive adversarial male sense of self as separate; by contrast, women's ways of ethical thinking are seen as originating in conflicting responsibilities rather than competing rights and as requiring a contextual rather than a formal and abstract mode of thinking. To me, this formulation unfortunately resonates with the pervasive Western imperialist construction of the West as masculine—rational, assertive, dominating—and the non-West as its feminine counterpart. I can understand how Western feminists would be pleased to discover ammunition in Chinese philosophy to use against Western assumptions of the superiority of male modes of thought. But it is just as easy to imagine that Chinese would resent the implication that Chinese think like women. There are, after all, still plenty of Western men (and not a few Western women) who disparage women's ways of thinking and would be more likely to find in this convergence a reason to dismiss Chinese thought as prerational than a reason to reevaluate their own ethical principles. China scholars naturally love to have their evidence drawn upon by scholars and theorists or other fields, but there are plenty of cases where it has been used to make points no one knowledgable about China would want to make. For instance, historians of Chinese women tend to be uncomfortable with the fascination of some Western feminists with footbinding as the ultimate form of women's self–subjugation. The problem, of course, is that scholars can never predict all the uses that might be made of their work.

Finally, let me note that the evolution of feminism is not occurring solely in the West. Chinese feminist circles are also rethinking many of the issues concerning the connections between basic features of Chinese culture and society and women's status. Some find Western feminism unsuited to China, given that it is an outgrowth of Western bourgeois liberalism with its notion of individual rights and the pursuit of individual happiness, and therefore un-

suited to a socialist country like China. Others are trying to develop a truly Chinese feminism through extension of Chinese social and ethical principles.

The engagement between feminism and Confucianism, in other words, will continue for some time to come. The authors of this volume deserve our thanks for bringing so many of the issues to our attention.

PATRICIA EBREY

Notes

1. Quoted in Elisabeth Joan Croll, *Feminism and Socialism in China* (Boston: Routledge & K. Paul, 1978), 82–83.

2. Zhang Xiping. "Cultivation of New Women," *Chinese Sociology and Anthropology* 20, no. 1 (1987):47–48.

Acknowledgments

This book is a product of collective effort. I would like to thank Roger T. Ames, Paul R. Goldin, Philip J. Ivanhoe, Joel J. Kupperman, Shu-Hsien Liu, Michael Nylan, Lisa Raphals, and Sandra Wawrytko for their encouragement, advice, and assistance in various ways. Kerri Mommer, Acquisition Editor of Open Court, has gone out of her way to help me make this volume a reality; in particular, I thank her for suggesting the title of this book. A 1999 NEH Summer Seminar fellowship at Columbia University in New York City helped me with the research while I wrote the introduction. Last, but not the least, I would like to take this opportunity to thank Diana T. Meyers for being the first to introduce me to feminist philosophy. All errors that may exist in the volume are, of course, my sole responsibility.

"Sexism, With Chinese Characteristics," by David L. Hall and Roger T. Ames, is adapted from *Thinking from the Han: Self, Truth, and Transcendence in Chinese and Western Culture* by David L. Hall and Roger T. Ames, by permission of the authors and the State University of New York Press. ©1998, State University of New York Press. All rights reserved.

"The Confucian Concept of *Jen* and the Feminist Ethics of Care: A Comparative Study," by Chenyang Li, was previously published in *Hypatia: A Journal of Feminist Philosophy*, vol. 9, no. 1 (Winter 1994): 70–89. ©1994, Indiana University. All rights reserved. Reprinted here with minor revisions by author.

Introduction: Can Confucianism Come to Terms with Feminism?

Chenyang Li

1

Confucianism has a reputation for its degrading and repressive attitude toward women and for its history of women-oppressive practice. If Confucianism is to remain a world philosophy and religion, it has to deal with this problem. A philosophic-religious tradition cannot have a future if it is hostile to half of the human population. Most curiously, however, leading contemporary Confucian scholars have been practically silent on this matter. Early contemporary Confucians in the twentieth century, such as Xiong Shili, Mou Zongsan, and Liang Shuming, had virtually nothing to say on this subject. In the 1990s, although most contemporary Confucians are for equal rights for women, there is little scholarship on this subject. At conferences where Confucianism is discussed, one often hears questions from the audience, usually from female scholars, asking about Confucian attitudes toward women. Answers given on these occasions have been typically unsatisfactory. The problem is, first of all, a lack of scholarship on this subject. Some Confucian scholars today may still feel that discussing feminist concerns is an "unmanly" thing to do and choose to stay away from it. Whether this lack is due to inadequate sensitivity or short-sightedness, it is extremely detrimental to the cause of Confucianism, which is going though the process of transforming itself and moving into a new millennium.

Feminism has so many forms that it defies a single definition. In this volume feminism is understood broadly as a movement that strives for sex equality between men and women. This general characterization of feminism would include in this category a large number of people who otherwise would not claim to be feminist because of its radical affiliation.[1] Quite understandably, feminists have been critical of Confucianism. But as Terry Woo points out, the affair between Confucianism and feminism in the last one and a half centuries has been one-sided, namely feminists criticizing Confucianism.[2] The question

for feminists now, however, is how to form a relationship with Confucianism. A radical feminist may not want to have anything to do with Confucianism. After all, Confucianism has played a role in victimizing women. Nevertheless, as Woo suggests, such a strategy may be ill-advised for the feminist causes. She argues for the need for feminists, particularly Chinese feminists, to come to terms with Confucianism. Moderate feminists may agree with Woo that a more constructive path is preferable in dealing with Confucianism. It may prove fruitful if both Confucianism and feminism take a step forward in building a new relationship. The question is: How can it be done?

2

Even though the term "Confucianism" has been commonly used to refer to a philosophic-religious tradition that is traced back to Confucius (551–479 B.C.E.), there is no consensus on its exact definition. Some people have used it to refer to a state–sponsored systematic philosophy established during the Han time and continued through the Song, Ming, and Qing dynasties, which Ambrose Y.C. King has called "institutional Confucianism."[3] By this definition, there was no Confucianism before the Han Dynasty (206 B.C.E.–220 C.E.), even though Confucius and Mencius developed their core ideas several hundred years earlier. Others have used the term broadly to include not only the doctrines of certain scholars of the Han and later times, but also that of Confucius, Mencius, and Xun Zi. According to this usage, Confucianism existed both prior to and after the Han Dynasty. It should be noted that there is no exact Chinese counterpart of the English term "Confucianism." The Chinese term often used in similar contexts is "*Rujia* 儒家," literally the "family of the literati" or the "school of the literati." "*Rujia*," as compared to "*Daojia* 道家" or the "family of the Tao" and "*Mojia* 墨家" or the "family of Mo," was originally the name for the school of thought by Confucius, Mencius, and Xun Zi during the Spring-Autumn and Warring States period before the Han. The term has also been used to include its later developments. Scholars sometimes divide this tradition into several periods, such as classic *Rujia* 原始儒家, Han *Ru* 漢儒, and Song-Ming *Ru* 宋明儒 (宋明理學). If one uses "Confucianism" to refer to "*Rujia*," it certainly existed prior to the Han time. In this introduction, I use "Confucianism" as a rough English expression of "*Rujia*."

Gender segregation in the Confucian tradition started early in its long history. It is, however, not obvious that its founders, Confucius and Mencius, had an oppressive attitude toward women. Like their contemporaries, Confucius and Mencius were evidently not advocates for gender equality. When the *Analects* and *Mencius* mention women, it is often in the role of the mother. Under the idea of filial morality, both Confucius and Mencius give the mother equal status with the father in relation to children. But their attitude toward

women in general is mixed at best. In the *Analects*, Confucius comments on King Wu's ten able ministers:

> [The sage King] Shun had five ministers and society was well managed. King Wu said, "I had ten able people as ministers." Confucius said, "Is it true that it is difficult to find talent? The Tang [Yao]-Yu [Shun] period was a high time for talented people. [Among King Wu's ministers] there was a woman; so there were only nine people. [King Wu of Zhou] controlled two thirds of the country, but he still treated the Yin as the king. Zhou had the highest morals possible! (8.20)

Confucius says that, because one of the ten people was a woman, King Wu only had nine people as able ministers. Confucius apparently considers home, not politics, women's proper place. It appears that, for him, women do not count in politics.[4]

Yet another passage of the *Analects* tells a different story:

> Confucius went to visit Nanzi. Zilu was unhappy. Confucius swore: "If my behavior was inappropriate, then Heaven will abandon me! Heaven will abandon me! (6.26)

Nanzi was the notorious wife of Duke Ling of Wei. The passage does not indicate the purpose of this visit. But it was clearly a controversial act that even his top disciple Zilu expressed displeasure about it. Given Confucius's political ambition, it is likely that the visit was politically motivated in order to influence Duke Ling. If so, then Confucius must have thought women have some role in politics. Otherwise he would not have risked his reputation to visit her in the first place.

The most controversial passage on women in the *Analects* is probably this one:

> Only nüzi 女子 and petty people are hard to rear. If you are close to them, they behave inappropriately; if you keep a distance from them, they become resentful. (17.25)

Clearly here Confucius claims that certain people are difficult to deal with. The key question, however, is what "nüzi 女子" means. Some people have interpreted it to mean "women." If so, then Confucius here is degrading women: Why are women, not men, hard to rear? However, it is arguable that "nüzi 女子" was used in ancient time to mean "young girls" instead of women in general. For example, the eminent ancient Chinese language scholar Wang Li 王力 maintains that, in ancient times "zi" refers to "child" or "children," the "nü" before "zi" is an attributive, and "nüzi" means "female children."[5] Based on

this interpretation of "nüzi 女子," some scholars have argued that Confucius here is referring to servants (petty men) and maids, not women in general. After all, at other places in the *Analects* the word Confucius uses for women is "fu 婦" not "nüzi 女子." However, it is also a fact that "nüzi 女子" has been used in ancient times to refer to women in general.[6] Perhaps it is fair to say that Confucius's intention in that passage is unclear. What is clear is that this passage has been used in later days to degrade women.

Mencius advocated the Five Relationships:

> Love between father and son, duty between ruler and subjects, distinction between husband and wife, precedence of the old over the young, and trust between friends. (*Mencius*, 3A.4)

However, he did not make it explicit what the husband–wife distinction should be. Scholars have generally believed that it is the idea that the husband's function is "external" whereas the wife's is "internal." This idea of distinction between the husband and wife is not particularly Confucian or Mencian, however, because it can also be found in such non-Confucian texts as *Mo Zi* 墨子 and *Guan Zi* 管子.[7] In another passage, Mencius says:

> The father teaches sons the way of good men; the mother teaches daughters about marriage. [When the mother] sends her daughter to the wedding, she would say "After getting married, you must be respectful and diligent, and do not go against your husband's will. Women's way is to obey." (3B.2)

This passage is probably the most "sexist" one in the entire book of the *Mencius*. Yet, it is more of a description of the then common practice than an invented doctrine. As Terry Woo suggests, Confucius and Mencius may be more properly judged as accomplices to the continued cultural minimalization of women, rather than inventors or calculated advocates of this practice.[8] If Confucius and Mencius did not change the social attitudes of their time toward women, their doctrines at least did not make the situation worse for women.

It is arguable that sexism became characteristic of Confucianism sometime after Confucius and Mencius died. The Han Confucian master Dong Zhongshu 董仲舒 (179–104 B.C.E.) maintains that, between the two principles that govern the universe, the *yang* and *yin*, *yang* is superior and *yin* is inferior. He said that "the husband is *yang* even if he is from a humble family, and the wife is *yin* even if she is from a noble family" (*Chun Qiu Fan Lu* 春秋繁露 Bk. 11, section 43).[9] Therefore, between the husband and wife, the husband is superior and the wife inferior. The degrading attitude toward women became extreme during the period of Song-Ming neo-Confucianism.[10] The neo-Confucian Zhu Xi 朱熹 (1130–1200) advocated the "Three Bonds," which emerged first not in Confucian classics, but in *Han Fei Zi*. The doctrine asserts the ruler's authority

over the minister, the father's over the son, and the husband's over the wife. Commenting on whether poor widows could get remarried, another neo-Confucian, Cheng Yi 程頤 (1033–1107), said that it is a small matter to starve to death, but a large matter to lose integrity, implying that widows getting remarried are immoral, while it is all right for widowers to remarry (*Yi Shu*, Chap. 22). This degrading and oppressive attitude toward women translated into oppressive practice in reality. Under the doctrine of the Three Bonds, the abusive husband could easily turn the wife into a virtual house slave. During the Ming Dynasty the doctrine of "chaste widowhood" became an official institution. Women who kept their widowhood were officially honored and their families were exempt from official labor service. Thus, tremendous pressure was put on young widows not to remarry. The notorious practice of women's footbinding was also institutionalized during this period and lasted till the early twentieth century. If we use the term "Confucian China" as shorthand to refer to periods of Chinese history after the Han Dynasty when Confucianism played an influential role in society, it is justified to say that women have been oppressed and victimized in Confucian China.[11]

<div align="center">3</div>

In the wake of the awareness of the history of Chinese women's oppression, a model emerged in the literature according to which Chinese women have been forever universally oppressed by men. The best image of this model is "Xiang Lin's Wife" under the pen of the eminent Chinese writer Lu Xun 魯迅. This poor woman, who does not even have her own name, suffers all kinds of hardships and bitterness and is victimized by all kinds of injustice. At the end, even her most miserable life-stories can no longer solicit sympathy from anyone.[12] It is questionable, however, if this "forever victimized Chinese women by men" model reveals the whole picture of gender relations in Chinese history, and if this model is too overly simplified to explain Chinese women's long-time apparent compliance with Confucians' demands on women. Some scholars argue that this model conceals the fact that Chinese women contributed a great deal to Chinese civilization; portraying them as mere passive victims and identifying them with backwardness and dependency distort the status of Chinese women in history. Others seem to defend Confucianism's record of its treatment of women and argue that Confucianism simply has not treated women as badly as has been portrayed. Thus, even though most scholars agree that Confucianism has oppressed women, they do not agree as to what extent women as a whole have been oppressed in Confucian China.

The degradation of women seems to have correlated with a long-held Chinese belief that there should be distinction between men and women. Zhu Xi advocates that the husband's right position is outside the home while the wife's position is inside the home (*Yu Lei*, chap. 68). To many, this distinction is a

matter of division of labor; it does not necessarily imply that one is superior and the other inferior. In his book *My Country and My People,* Lin Yutang maintains that

> Confucianism saw that this sexual differentiation was necessary for social har-
> mony, and perhaps Confucianism was quite near the truth. Then Confucianism
> also gave the wife an "equal" position with the husband, somewhat below the
> husband, but still an equal helpmate, like the two fish in the Taoist symbol of *yin*
> and *yang*, necessarily complementing each other. It also gave the mother an hon-
> ored position in the home. In the best spirit of Confucianism, this differentiation
> was interpreted, not as a subjection but as a harmony of relationships. [13]

According to Lin, these gender roles had been maintained because "women who could rule their husbands knew that dependence on this sexual arrange-ment was their best and most effective weapon for power, and women who could not were too dull to raise feminist problems."[14] He suggests that there are two sides of the issue of whether Chinese women were suppressed. On the one hand, men have been undoubtedly unfair to women (as Song–Ming neo–Confucianism evidences);[15] on the other hand, Lin claims, the deprivation of women's rights outside the home is "unimportant" compared with their posi-tion in the home:

> In the home the woman rules. No modern man can still believe with Shakespeare
> that "Frailty, thy name is woman.". . . Close observation of Chinese life seems to
> disprove the prevalent notion of women's dependence. The Chinese Empress
> Dowager rules the nation, whether Emperor Hsienfeng [Xianfeng] was living or
> not. There are many Empress Dowagers in China still, politically or in common
> households. The home is the throne from which she makes appointments for mayors
> or decides the professions of her grandsons.[16]

Lin argues that in real life Chinese women have not been really oppressed by men, though they have been oppressed by other women, namely mothers-in-law. Therefore, he concludes that "the so-called suppression of women is an Occidental criticism that somehow is not borne out by a closer knowledge of Chinese life."[17]

Lin is not alone in his opinion. For instance, Thomas Taylor Meadows, an interpreter in the British civil service stationed in China before and during the Taiping Rebellion (1850–1864), wrote that, even though woman was still more of a slave of man among the Chinese than among Anglo-Saxons, the quality of her slavery was much tempered by the great veneration which Confucian prin-ciples require sons to pay both parents. Meadows noted that the government did not dare to refuse leave if an official, as the only son, required it in order to tend his widowed mother during her declining years; when a Chinese man

introduced his friend to his mother, the friend would perform the kow-tow ritual to the woman: he would kneel before her and touch the ground repeatedly with his forehead. The son would return the salute by kneeling and kowtowing to his friend:

> Thus, two men, and often, of course, grey beard men of high stations, will in China be found knocking their heads against the floor in honour of a woman of their own class in society. Add to this that if a mother accuses her son before the magistrate, the latter will punish him as a black slave is punished in an American flogging-house, i.e., without inquiry into the specific offence. The reader will conclude that this great social and legal authority of mothers in China must operate to raise the position of females generally; and this it does in fact: though in the contraction of their own marriages each is but a passive instrument.[18]

There is truth to this observation. Richard Guisso, who is critical of the Confucian *Five Classics* for their accepting and enshrining the earlier stereotypes of women in a patriarchal society, writes,

> If the *Five Classics* fostered the subordination of woman to man, they fostered even more the subordination of youth to age. Thus, in every age of Chinese history where Confucianism was exalted, the woman who survived, the woman who had age and the wisdom and experience which accompanied it, was revered, obeyed, and respected . . . even if her son were an emperor. It is perhaps this fact, more than any other, which enabled the woman of traditional China to accept for so long the status imposed upon her.[19]

Observations of this kind render support to Lin Yutang's claim that Chinese women have not been "really" oppressed. But they fall far short of justifying Lin's claim. Lin's account of Chinese women as a whole does not do enough justice to the historic facts of women's oppression by men. It is true, as suggested by Lin, Meadows, Guisso, and many others, that the mother had significant power in Confucian societies, but she had power as parent, not as woman. The issue of sex equality is about whether women as women are equal to men. And they were not. In a patriarchal society like Confucian China, women's oppression by men is undeniable. It is true that women had power inside the home, either as wife or mother. But this power is not nearly comparable to (ruling class) men's power in the society. Sex equality is about equality between men qua men and women qua women, which Chinese women simply did not acquire in Confucian China.

It should be noted that Lin Yutang was not a male chauvinist who blindly defended the Confucian patriarchal tradition. To the contrary, Lin may be well labeled an early Chinese feminist thinker, who fought against the tradition for women's equality.[20] Lin's remarks point out another side of the issue, indicat-

ing that the matter is not as simple as many have believed. One may argue that Chinese women were not as powerless as has been portrayed. This does not only mean that women, mainly mothers-in-law, had power inside the home; the fact that such females as Lü Hou 呂后 (241–180 B.C.E.), Wu Zetian 武則天 (624–705), and Ci Xi 慈禧 (1835–1908) ruled China with an iron hand indicates that Chinese gender relations could not have been merely a matter of men oppressing women.[21] The question, then, is how to give a holistic account of gender politics in Confucian China.

4

Confucianism must recognize not only the necessity but also the justice of sex equality. Instead of ignoring challenging questions raised by feminist thinkers, it must take them seriously and answer these questions adequately. The answer to the question of whether Confucianism and feminism can come to terms may be found in answers to the following questions: Is it accurate that the Confucian attitude toward women has been solely degrading and repressive? Is Confucian oppression of women a necessary implication of its general philosophy? Are there enough common grounds between Confucianism and feminism so that they may render support to each other in pursuing their causes? If historical studies show that, contrary to the common perception, women in Confucian China have been able to participate in social and moral functions in society to a certain extent that may be by no means satisfactory but can be greatly expanded, and if philosophical studies show that Confucianism and feminist thinking are in principle not incompatible, then it will not be a problem for Confucianism to come to terms with feminist thought.

The long time "one-sided affair" between feminism and Confucianism, as dubbed by Terry Woo, means that scholarship on women's status in Confucian China has not been a balanced one. Under the "forever victimized Chinese women by men" model, many writers seem to have felt that, in order to reveal the "evil" of Confucianism and the need for reform, one has to portray women in Confucian China as nothing more than pitiful victims. Nevertheless, prior to the rising of a more balanced scholarship on Chinese women in Confucian China by historians in the 1990s, there were a few works done in that direction. In a 1931 article, "Women's Place in Chinese History," the eminent historian-philosopher and foremost critic of the Confucian tradition, Hu Shi, argued that, despite traditional oppression, Chinese women have been able to establish themselves a fairly exalted position:

> Against all shackles and fetters, the Chinese woman has exerted herself and achieved for herself a place in the family, in society, and in history. She has managed men and governed empires; she has contributed abundantly to literature and the fine

arts; and above all she has taught and molded her sons to be what they have been. If she has not contributed more, it was probably because China, which certainly has treated her ill, has not deserved more of her.[22]

Accordingly, Chinese women should not be characterized as mere pitiful victims who contributed nothing in history. Priscilla Ching Chung's study (1981) of power and prestige of palace women in the Northern Song period revealed how these women both fulfilled the Confucian role for women and enjoyed a level of power and prestige similar to that of their male counterparts. Commenting on the Confucian requirements for women, she writes,

> The obedient daughter, the faithful wife, the sacrificing mother, characteristics of the Confucian woman, are qualities any man would find ideal. Similarly, the woman would find ideal the obedient son, the faithful husband, and the sacrificing father. Therefore, the characteristics of the Confucian woman, rather being the average or the norm, are probably better thought of as the ideal.[23]

These studies have been primarily on elite women. Due to lack of available records, we know little about the real lives of women in the commoner's home. Nevertheless, these studies at least show that some aspects of Chinese women's lives may not fit well into their "nothing but oppressed victim" image.

A new trend of Chinese women scholarship started to take shape in the 1990s. In a 1992 article "Historical Roots of Changes in Women's Status in Modern China," historian Li Yu-ning writes, "Confucian philosophy itself was not exclusively antiwomen. It has its favorable as well as its unfavorable consequences with regard to the position of women."[24] She argues that some Confucian ideas have actually helped improve women's position. For instance, Confucianism did not attach importance to birth or social background, and Confucians believed that everybody could improve through education and self-cultivation. Because they also believed that the rules of *li* (禮 propriety) should be adjusted to changing times and circumstances, the respective roles of men and women were subject to change as conditions changed. Thus, according to Li Yu-ning, modern changes of Chinese women's status have their roots in the Chinese tradition, particularly the Confucian tradition.

In her pathbreaking work *Teachers of the Inner Chambers: Women and Culture in Seventeenth-Century China* (1994), Dorothy Ko shows that literate gentry women in seventeenth-century Jiangnan were far from oppressed or silenced. Even though men had legal rights over family property and fathers maintained authority over women and children, the housewife as mother and educator of children was the de facto household manager, and thus had ample opportunities to influence family affairs. Thus, Confucianism's relationship with educated women was rather complex and ambivalent. Ko maintains,

The power of the Confucian ideological and cultural tradition is at once a constraint and an opportunity for the privileged women. The constraints of the rigid gender-based parameters were most keenly felt by the women themselves. . . . Yet to speak of oppression and restrictions is to assume women to be extraneous to the Confucian tradition. Although this is true to some extent, it is more valid to recognize them as intrinsic to that tradition.[25]

Ko indicates that some of these women actively embraced Confucian values and took it as their own duty to resuscitate the Confucian way and to transmit it to the next generation. Their affirmation of the Confucian tradition, however, should not be interpreted as merely serving the interest of the patriarch. Borrowing from Foucault's notion of "power without the king" and Pierre Bourdieu's notion of "dominated power," Ko suggests that even thoroughly patriarchal Chinese kinship systems and family relationships may not have been the workings of men alone, though the nature and degree of women's power depended on such factors as social positions, type of task, personal skills, and one's position in the life cycle.[26] She argues that the identification of Chinese women with backwardness and dependency has been associated with China's modernization movements; this image of Chinese women as victims was intensified during and by the May Fourth New Culture movement, re-enforced by the Chinese Communist Party's need to claim credit for the "liberation" of women, and readily accepted [and one may add, stereotyped] among Western readers. Ko concludes, "In short, the invention of an ahistorical 'Chinese tradition' that is feudal, patriarchal, and oppressive was the result of a rare confluence of three divergent ideological and political traditions—the May Fourth New Culture movement, the Communist revolution, and Western feminist scholarship."[27]

Susan Mann's study (1997) of educated Chinese women in the High Qing era (1683–1839) indicates that these women as writers enjoyed "remarkable satisfaction and gratification."[28] They used writing as means to preserve their values, to celebrate their admiration, and to lament their loss. These findings in part explain why elite women did not heed the calls for social change in the Confucian society of the High Qing era. Thus, by placing women at the center of High Qing history, Mann challenges

a century and a half of scholarship (1843–1993) in which both Chinese radicals and Western missionaries saw Chinese women as oppressed victims of a "traditional culture" who were liberated only by education and values imported from the West. This assumption has locked the study of Chinese women in a response-to-the-West paradigm that most scholars in the China field thought they had since cast aside. Worse, it has forced an Orientalist view of gender relations on students of Chinese history for which Western scholarship is largely to blame.[29]

In *Sharing the Light: Representations of Women and Virtue in Early China* (1998), Lisa Raphals finds that women in early China were often represented as intellectually adroit, politically astute, and ethically virtuous, directly countering the familiar image of Chinese women as eternally oppressed, powerless, passive, and silent. She suggests that serious attention to gender as a social construct calls for a reexamination of the tacit assumptions about philosophical activity in ancient China, which are often based on transhistorical generalizations, essentialized normative concepts, "Confucian" or otherwise. Raphals questions,

> Can we assume, for example, that the readers, writers and audience of Chinese philosophical works (however defined), at all times, were for men? Can we assume that references to "people" (*ren* 人), including a range of "sages" and "developed individuals" inevitably referred to men?[30]

Her study presents a negative answer to these questions.

These studies serve as a strong corrective to the common image of Chinese women as universally victimized in Confucian China. Following these studies, one has to think that ancient China, which is largely under the influence of Confucianism, while having been by no means fair to women, must have left some room for women's moral cultivation and social participation. Such room, however limited, may be expanded in the future as time changes.

5

If historical study shows how much room has been left for women in ancient China, philosophical analyses of Confucianism and feminism may reveal how much room Confucianism can extend for women. In order to see this, we must examine the philosophical aspect of Confucianism, finding out whether conceptually Confucianism is capable of accommodating women's equality.

In the 1990s, some authors started to note philosophical similarities between Confucianism and feminism. In his essay "The Confucian Concept of *Jen* and the Feminist Ethics of Care: A Comparative Study" (1994),[31] which is included in this volume, Chenyang Li points out that Confucianism and feminism, though dissimilar in many aspects, do share similar ways of thinking in ethics. He outlines several parallels between Confucian ethics and care-oriented feminist ethics. First, as moral ideals, *jen* and care share an important similarity. Through an analysis of the Confucian concept of *jen*, Li argues that this concept carries a strong care orientation; both *jen* and care focus on the tender aspect of human relatedness. Second, in contrast to Kantian and rights-based moral theories, both Confucians and feminists advocate the human person as socially connected, not as disinterested, separate individuals. Third, both ethics

emphasize situational, personal judgment, character-building, instead of rule-following. Wary of rigid general rules, they both allow flexibility in moral practice and regard the ability to make moral decisions under particular circumstances an important aspect of a person's moral maturity. Finally, Confucian ethics advocates "love with gradations." Because the self is socially constructed and defined, a person has more obligations toward related or more connected ones than unrelated or less connected ones. Specifically, one's obligations toward parents and family members are greater than obligations toward others. Some feminists think along the same line. They argue that caring starts with people around the person, and then expends to people further away. Both agree that, without gradations, one would fail one's obligations toward people around oneself.

Li should not be interpreted as endorsing the argument that philosophical thinking or virtue should be gendered. He simply takes it as an indisputable fact that there are different ways of philosophical thinking and argues that some philosophies share similar ways of thinking. Indeed, that the hitherto male-dominated Confucianism shares with Western feminism similar ways of philosophical thinking shows that these ways of thinking are not sex- or gender-based. Therefore, Li is not advocating a theory of gendered virtue.

If the Confucian *jen* ethics has a care orientation, how could it have oppressed women? Li suggests that there are two ways to explain the apparent discrepancies between Confucianism's care-orientation and its women-oppressive history. One account is that Confucius and Mencius were not as degrading to women as later ones such as the Han Confucian Dong Zhongshu and Song-Ming neo-Confucians were. The women-oppressiveness of Confucianism may be largely an add-on by later Confucians to the core doctrines outlined by Confucius and Mencius. Another account points to the restrictive application domain of *jen* in the Confucian tradition. Li suggests that, just like sexist interpretations of democratic principles in ancient Athens denied women political rights and racist interpretations of Christianity denied blacks brotherhood and sisterhood, sexist interpretations of *jen* and other core values of Confucianism may have been responsible for excluding women from fully participating in the Confucian project. It does not, however, necessarily imply that the concept of *jen* is sexist. Li concludes that, given these philosophical similarities between Confucianism and feminism, the two may render support to each other while pursuing their causes.

In his essay "Classical Confucian and Contemporary Feminist Perspectives on the Self: Some Parallels and Their Implications" (1997), Henry Rosemont, Jr. notes some parallels between classical Confucianism and contemporary feminism similar to those outlined in Chenyang Li's 1994 article. Rosemont emphasizes that the difference between the philosophical style of Confucians and that of their European counterparts does not imply that Confucians are inferior; indeed, not much can be inferred from the fact that Confucians are not

masculine Westerners; to the contrary, that in Confucianism the ethical is not consistently distinct from the sociopolitical and the economic is a strength rather than a weakness.

While readily acknowledging that Confucius and his followers were sexist, Rosemont maintains that the thrust of this tradition was not competitive individualism, which is associated in the West with the masculine, but rather other-directed nurturing, which is associated throughout Western history with the feminine. He writes

> If sexism revealed in classical Confucian writings was characteristic only of gender structure (patterns of social organization), not of gender symbolism or gender identity, then it is at least possible that Confucian philosophy can be reconstructed to be relevant today, in ways that a great many feminist thinkers might endorse. [32]

Accordingly, the feminist demand for gender equality may well be brought into Confucianism without doing violence to its basic insights and precepts. Confucianism may be modified to accord with contemporary feminist moral sensibilities.

In her article on Confucianism and feminism (1998), Terry Woo suggests that Confucius was more an uncritical adherent of the traditional norms of sexual segregation and male authority than a misogynist and primary oppressor of women. [34] She takes the common thread of feminism to be, as Karen Offen puts it, "the impetus to critique and improve the disadvantaged status of women relative to men within a particular cultural situation." [34] But unlike Chenyang Li and Henry Rosemont, Woo seems to hold a more liberal interpretation of feminism, viewing it primarily as a force to fight for rights and individual choices. Because Confucianism emphasizes duty and self-cultivation, Woo maintains that Confucianism in its core values is at odds with feminism. [35] Nevertheless, like Lin Yu-ning, Woo sees two principles in Confucianism, namely an equal opportunity to learning and an attitude of openness and flexibility, which do not contradict feminism; in fact, these are where the two philosophies converge and are most able to reinforce each other. She concludes,

> After a hundred and fifty years of a relatively one-sided affair, and at this time when the issue of race or charge of racism is threatening the integrity of feminism, an appropriation of *jen* and a better understanding of the history of Confucianism might offer a sense of cultural recovery for Chinese feminists and a better understanding and inspiration for non-Chinese feminists. [36]

It is encouraging that the prominent contemporary Confucian scholar Tu Wei-ming has also started addressing this issue. This may be an indication that the contemporary Confucian movement has finally started to take feminist concerns seriously and has finally realized the need of engaging in a meaning-

ful dialogue with feminism. In his essay "Probing the 'Three Bonds' and 'Five Relationships'" (1998), Tu differentiates the "Five Relationships" in Confucian Humanism and the "Three Bonds" in the politicized Confucianism.[37] The Five Relationships, first advocated by Mencius, are love between father and son, duty between ruler and subject, distinction between husband and wife, precedence of the old over the young, and trust between friends (*Mencius*, 3A.4). These are important elements of the Confucian Humanism. The Three Bonds, namely, the authority of the ruler over the minister, the father over the son, and the husband over the wife, emerged in Confucian literature almost four centuries after Mencius's Five Relationships. Tu maintains that the psychocultural dynamics of the Confucian family lies in the complex interaction of these two ideals. Tu argues that the idea of the Three Bonds is a deviation from the spirit of Mencius's Five Relationships and therefore should not be confused with the latter. Unlike the conception of the husband–wife relationship in the Three Bonds, Mencius's idea of the distinction of the husband and wife is based on the principle of mutuality; the underlying spirit is not dominance but division of labor. According to Tu,

> It is not true that the Confucian wife is "owned" by the husband like a piece of property. The wife's status is not only determined by her husband's position but also by her own family's prominence. By implication, her ultimate fate is inevitably intertwined with the economic and political conditions of her children, both sons and daughters. While in the domestic arena, the husband's influence may also prevail, especially in extraordinary situations when vital decisions, such as the selection of tutors for sons' education, the wife usually wields actual power on a daily basis. . . . The Confucian wife is known for her forbearance, but her patient restraint is often a demonstration of inner strength. While her purposefulness may appear to be overtly and subtly manipulative, she has both power and legitimacy to ensure that her vision of the proper way to maintain the well-being of the family prevails; for the wife is not subservient to the husband, but is his equal.[38]

Nevertheless, Tu suggests that it may be simple-minded to completely separate the Three Bonds and the Five Relationships. He holds that the Five Relationships served as an ideological background for the Three Bonds and a sophisticated understanding of the Three Bonds must involve adequate appreciation of the Mencian conception of the Five Relationships.

Unlike Chenyang Li and Henry Rosemont, Tu does not directly address the key questions of whether such women-oppressive elements as the Three Bonds are necessary components of Confucianism, and whether Confucianism can move forward without this long-held baggage. A more focused study to this matter is needed. So far these philosophical studies are still preliminary But they have opened doors to further investigations that may help Confucianism come to terms with feminism.

6

In this volume ten articles by eleven authors are devoted to questions discussed in the two preceding sections. These authors are scholars in various fields: history, literature, philosophy, religious studies, Asian studies, and interdisciplinary studies. They present different views on the issue from different perspectives.

In the first chapter, Chenyang Li puts the issue straightforwardly in front of the reader by comparing Confucian ethics and feminist ethics. Li focuses on some important common grounds between Confucian *jen* ethics and care-oriented feminist ethics. He shows that both ethics have a similar understanding of self as socially constructed, both emphasize situational moral judgment instead of principle-oriented judgment, and both advocate differential treatment of care in moral practice; in terms of ways of thinking in ethical evaluation, *jen* and care share a common mode. A "feminist" turn of Confucianism, in the sense of striving for sex equality, may consist in recovering a Confucianism as Confucius and Mencius had it and in expanding its application domain of *jen* to women and men alike.

Joel Kupperman maintains that the deepest questions of feminist ethical philosophy have to do both with the ways in which roles or the expectation of roles enter into the formation of self, and with the choices about it which can or should be open. He argues that there is convergence between Confucian ethical philosophy and feminist concerns about social roles, rituals, and the formation or revision of self. Both Confucianism and feminism take seriously the ethical importance of becoming a certain kind of person and this implies reflection on ways of shaping oneself and also of shaping others to come. Both also have an orientation that emphasizes responsibilities. But there is also a major difference between the two: Whereas Confucianism pretty much bases itself on tradition, feminism opts for reforming tradition. Nevertheless, such historical baggage of Confucianism as hierarchical roles and gender relations is largely or entirely disposable; the essential insights of Confucianism can be formulated without it. Therefore, a case can be made that feminists and Confucians are singing from the same page, even though what they are singing tends to be very different. To the extent that feminist ethics remains like Confucianism, it is a Confucianism radicalized in important ways.

Philip J. Ivanhoe compares contemporary feminist ethical theories with the ethical theories of two prominent classic Confucian philosophers, Mencius and Xun Zi. He identifies two general forms of contemporary feminist ethical theory. The gendered virtue view maintains that, by nature, women have greater resources for and tendencies to see and appreciate ethical situations in terms of their particularity and context and in terms of interpersonal relationships. By relying primarily on their feelings and intuitions as opposed to objective, rational rule-following, women purportedly are able to make more reliable ethical

judgments. The vocational virtue view maintains that the distinctive ethical tendencies demonstrated by women are the result of the particular social roles and norms that women have been allocated under the systematic oppression of patriarchy. Ivanhoe argues that Mencius's and Xun Zi's ethical theories of virtue ethics respectively resemble these two views. Drawing on these resemblance, he concludes that a meaningful dialogue between Confucianism and feminism is possible in constructing a more adequate and just philosophical position.

David Hall and Roger Ames present a correlative understanding of Chinese culture and Chinese sexism as opposed to the Western dualistic understanding. While fully acknowledging the sexist characteristics of traditional Chinese philosophy in general and traditional Confucian philosophy in particular, Hall and Ames argue for the importance of understanding these characteristics under the correlative model. In the correlative understanding, gender is fluid and lacks exclusivity; the sexist problem is one of degrees of disparity rather than strict inequality; males and females are created as a function of difference in emphasis rather than difference in kind. Correlativity more easily promotes the redefinition of roles and gender characteristics than does the dualistic model. Therefore, even though in practice the weight of tradition is a formidable obstacle to the instantiation of such redefinitions, it is still plausible to assume that, in the absence of transcendental commitments to the contrary, alterations in practice may be more easily made if there are concomitant changes in cultural attitudes and practices that reinforce sexual inequalities.

Ingrid Shafer highlights the tendency of "both–and" rather than "either–or" thinking in Chinese traditions in general and Confucian tradition in particular. She argues for the convergence of Confucianism and ecofeminism. In the absence of Western spirit–matter and soul–body dualism, Confucian philosophy considers human beings not primarily as rational but distinguished by a conjunction of heart and mind, affection and reason, compassion and cognition, love and intellect. Ecofeminism emphasizes the harmony rather than conflict between humanity and nature. Given that the dualistic spirit–matter and soul–body thinking has contributed to the degradation of nature and the deterioration of the environment, the "both–and" thinking is in accord with the ecofeminist philosophy of nature and the ecofeminist environmental program. She maintains that Confucius emphasizes relationality and interdependence, places *jen* at the center of his teachings, and insists that words are empty without action. These all indicate the confluence of Confucianism and ecofeminism. She concludes that these characteristics make Confucianism an ally as well as a philosophical resource for the feminist ecological movement in building an environmental partnership ethics.

Pauline Lee's chapter focuses on Li Zhi 李贄 (1527–1602), a Confucian philosopher of the Ming Dynasty, and compares his philosophy of sex equality with John Stuart Mill's. She argues that Li Zhi's view on husband–wife relation-

ship bears a striking resemblance to Mill's as presented in his work *The Subjection of Women*. Both philosophers developed ideals of equal and mutually respectful spousal friendship. Although neither author was without limitations in his view of sex equality, their ideas were remarkable achievements of their times and can contribute to contemporary debates in feminism and ethics. Lee maintains that Confucianism has its own distinctive expression of feminism which focuses on self-cultivation. While liberal feminists view legal reform as the most effective tool for overcoming gender inequality, and Marxist feminists conceive of the subversion of capitalist social structures as the prime method for overturning the subjugation of women, Li Zhi, a Confucian feminist, understands the process of self-cultivation to be the most effective strategy for addressing the problem of patriarchy.

Paul Goldin examines the view of women in such early Confucian texts as the *Book of Odes* 詩 經, *Guo Yu* 國 語, and *Zuo Zhuan* 左 傳. He finds that these sources both criticize vicious women and praise virtuous women, and they typically allow women to participate meaningfully in the Confucian project and reserve places in the pantheon of moral paragons for heroines as well as heroes. Women had not been considered inferior in the aretaic sense. Therefore it is misleading to bluntly say that Confucianism considers women inferior to men. Goldin presents three reasons why Confucianism has been repeatedly assailed as "sexist." First, the Confucian tradition only advocates the moral equality, not the social equality, of women. Second, the Confucianism of later stages has become more sexist and misogynic and has brought the bad name to Confucianism per se. Third, people often contrast Taoism, which apparently values the "female" principle, with Confucianism. They think that because Taoism values the "female" principle, it values feminine qualities, and hence values women, and that its opponent Confucianism values the "male" principle and therefore must degrade the "female" principle and hence degrade women. Goldin argues that this polarized interpretation of Taoism and Confucianism does not do justice to either.

Drawing on recent scholarship from China concerning the roles of women in ancient China, particularly Xia, Shang, and early Zhou, Sandra Wawrytko presents a perspective of women that is very different from later times. Her study of sexuality in early times reveals a picture of gender roles and relationships much more complicated than that of the stereotyped women in Confucian China. She suggests that during the early times in China, there was a Confucian–Taoist continuum rather than an opposition on the view of women. Her survey of sexuality throughout Chinese history shows that gynophobia, as a backlash to counter perceived female power, came later in history. This study sheds important light on the historical background of Confucianism and helps us understand early Confucians' attitude toward women.

In her article, Michael Nylan challenges prevailing stereotypes about elite women in early China, who are generally portrayed as untutored, weak or

vicious, the victims or the makers of unhappy fates. Because there are virtually no records of Han women in the common family, study of elite women gets us as close as we can to knowing Han women's status. Through a comparative study of ancient Greek and Han Chinese elite women, she points out the main problem in stereotyping ancient elite Chinese women: that limited prescriptions for women in classical Chinese (mainly Confucian) texts, prescriptions that were themselves the subject of considerable debate, have all too naively been read as accurate descriptions of women. She argues that the stereotypes of ancient China do not come from ancient historiographers but from relatively recent sources, namely the neo-Confucians and the May Fourth reformers, both of whom for different reasons preferred to assume the existence of rigid gender roles among cultured elites in antiquity, as well as the continuity of ultra-stable traditional Chinese culture. Her study shows that, just like Han elite men, Han elite women were lauded for their education, their physical courage, their loyalty to the family, and their attention to ritual.

Lisa Raphals's chapter is a combination of historic scholarship and philosophical analysis. It represents a voice that is somewhat different from the rest in this volume. She is critical of two approaches. One is a set of feminist attacks on Confucian patriarchy based on a kinship model, without reference to social structures outside of kinship. The other approach relies exclusively on a small set of "Confucian" canonical texts, with the premise that the statements in these texts transparently and authoritatively reflect Warring States and Han attitudes and social practice. Through an examination of the representations of women in classic literature during these times, Raphals shows that, while the historical Confucius's view on whether women can be educated or how they should be educated remains unclear, historical narratives from the Warring States and Han, such as *Gujin Renbiao* 古今人表 and *Lienü Zhuan* 烈女傳 represent women as possessing the same capacities for wisdom, practical intelligence, and moral reasoning as men do. She argues, however, this testimony cannot be extended to Confucianism. Although the authors of these narratives are Confucians, it does not mean that the stories they represent are Confucian. Specifically, she maintains, "Confucian ideologies and social practices from the Later Han through Song and Ming-Qing neo-Confucianism overwhelmed the earlier pattern of an ungendered approach to wisdom and the capacity for moral judgment." Based on her findings of ungendered moral representations of ancient Chinese women, Raphals criticizes the "feminist" theories of gendered virtue or gendered ethics and various attempts to interpret Confucianism based on similar views.

Let me say that the authors in this volume do not hold the same view on the issue of Confucianism and feminist concerns. What they share in common is a belief in the importance of this issue. Clearly, none of these authors denies that Confucianism has oppressed women, none regards this oppression as excusable, and none thinks it acceptable for Confucianism to continue this practice.

They may give different answers to the question of whether and how Confucianism and feminism can come to terms with each other. Some of these articles, however, show that, despite its oppression of women in general, Confucianism has left room, though very limited, for women's moral and personal growth in a mostly Confucian society, and that there is important convergence between Confucian ethical thinking and feminist ethical thinking. These observations can serve as a starting point for Confucianism to address feminist concerns, and for Confucianism to eventually come to terms with feminism. Some of these essays are provocative, for sure. The hope is that they will open to more engaging, more meaningful, and more fruitful discussions and dialogues among interested scholars.

Notes

1. See Christina Hoff Sommers, 1994.
2. Terry Woo, 1998.
3. Ambrose Y.C. King, 1993.
4. For a different reading of this passage, see Paul R. Goldin in this volume.
5. Wang Li, 1981.
6. I thank Paul R. Goldin for bringing these uses to my attention.
7. For a discussion of this distinction in *Mo Zi* and *Guan Zi*, see chapter 8, "*Nei-wai*: Distinction between Men and Women," Lisa Raphals, 1998.
8. Terry Woo, 1998.
9. Some scholars have questioned whether ancient texts such as *Chun Qiu Fan Lu* are authentic. For instance, Sarah Queen, 1996. Based on such questions, some may argue that there is no solid evidence that Dong Zhongshu actually degraded women.
10. Ch'en Heng-che has argued that this change toward oppression of women was a result of Buddhist influence from India. Even if this is true, it was still the neo-Confucians who incorporated the women-oppression element into the Confucian tradition. See Ch'en, 1992.
11. Of course, it does not mean that women fared better during the periods when Confucianism lost its prominent status to other schools.
12. Lu Xun, 1969, 87–101.
13. Lin Yutang, 1939, 139.
14. Ibid.
15. Lin criticized that the Song-Ming Neo-Confucians "had drifted a long way from the sane and healthy humanism of Confucius and turned it into a killjoy doctrine." See Lin, 1935, in Li Yu-ning, 1992, 34–58.
16. Lin Yutang, 1939, 145.
17. Ibid.

18. Quoted from Yang Lien-sheng, 1992, 17. This passage was originally taken from pp. 634–35 of Thomas Taylor Meadows's *The Chinese and Their Rebellions*, published in 1856. No location was given.

19. Richard Guisso, 1981, 60.

20. This is evident in his 1935 article "Feminist Thought in Ancient China."

21. See Yang Lien-sheng, 1992.

22. Hu Shi, 1931, 15.

23. Priscilla Ching Chung, 1981, 109.

24. Li Yu-ning, 1992, 102–122.

25. Dorothy Ko, 1994, 17.

26. Ibid., 11.

27. Ibid., 3.

28. Susan Mann, 1997, 225.

29. Ibid., 222–223.

30. Lisa Raphals, 1998, 3.

31. Chenyang Li, 1994.

32. Henry Rosemont, Jr., 1997, 63–82.

33. Terry Woo, 1998, 110–147.

34. Ibid., 111.

35. Ibid., 137.

36. Ibid., 138.

37. Tu Wei-ming, 1998, 121–136.

38. Ibid., 132–133.

References

Allen, Douglas, ed. 1997, *Culture and Self: Philosophical and Religious, East and West*, Boulder, Colorado: Westview Press.

Ch'en Heng-che. 1992. "Influences of Foreign Cultures in the Chinese Women." In Li Yu-ning, 1992.

Chung, Priscilla Ching. 1981. "Power and Prestige: Palace Women in the Northern Sung (960–1126)." In Richard W. Guisso and Stanley Johannesen, 1981.

Guisso, Richard. 1981. "Thunder Over the Lake: The Five Classics and the Perception of Woman in Early China." In Richard W. Guisso and Stanley Johannesen, 1981.

Guisso, Richard W., and Stanley Johannesen, eds. 1981, *Women in China: Current Directions in Historical Scholarship*, Youngstown, New York: Philo Press.

Hu Shi, 1931, "Women's Place in Chinese History." In Li Yu-ning, 1992.

King, Ambrose Y.C. 1993. *Chinese Society and Culture* 中國社會與文化. Hong Kong: Oxford University Press.

Ko, Dorothy. 1994. *Teachers of the Inner Chambers: Women and Culture in Seventeenth-Century China*. Stanford, CA: Stanford University Press, 1994.

Li, Chenyang. 1994. "The Confucian Concept of *Jen* and the Feminist Ethics of Care: A Comparative Study," *Hypatia: A Feminist Journal of Philosophy*, 9:1.

Li Yu-ning, ed. 1992. *Chinese Women Through Chinese Eyes*. Armonk, NY: M.E. Sharpe, Inc.

Lin Yutang. 1935. "Feminist Thought in Ancient China." In Li Yu-ning, 1992.

———. 1939. *My Country and My People*. New York: the John Day Company.

Lu Xun. 1969. "Zhu Fu 祝 福." In *Selected Works of Lun Xun* 魯 迅 選 集. Hong Kong: Wencai Publisher.

Mann, Susan. 1997. *Precious Records: Women in China's Long Eighteenth Century*. Stanford, CA: Stanford University Press.

Meadow, Thomas Taylor. 1856. *The Chinese and Their Rebellions*. Quote from Yang Lien-sheng, 1992.

Queen, Sarah. 1996. *From Chronicle to Canon: The Hermeneutics of the "Spring and Autumn" According to Tung Chung-shu*. New York: Cambridge University Press.

Raphals, Lisa, 1998, *Sharing the Light: Representations of Women and Virtue in Early China*, Albany, New York: The State University of New York Press.

Rosemont, Henry, Jr. 1997. "Classical Confucian and Contemporary Feminist Perspectives on the Self: Some Parallels and Their Implications." In Douglas Allen, 1997.

Sharma, Arvind, and Katherine K. Young, eds.. 1998. *Feminism and World Religions*. Albany, NY: The State University of New York Press.

Slote, Walter, and George A. De Vos, eds. 1998, *Confucianism and the Family*. Albany, NY: The State University of New York Press.

Sommers, Christina Hoff. 1994. *Who Stole Feminism?: How Women Have Betrayed Women*. New York: Simon & Schuster.

Tu, Wei-ming. 1998. "Probing the 'Three Bonds' and 'Five Relationships'." In Walter H. Slote and George A. De Vos, 1998.

Wang Li. 1981. *Ancient Chinese* 古 代 漢 語, Book 1, Beijing: China Books.

Woo, Terry. 1998. "Confucianism and Feminism." In Arvind Sharma and Katherine K. Young. 1998.

Yang Lien-sheng. 1992. "Female Rulers in Ancient China." In Li Yu-ning.

The Confucian Concept of *Jen* and the Feminist Ethics of Care: A Comparative Study

Chenyang Li

The purpose of this article is to compare two philosophies that have seldom been brought together, Confucianism and feminism. Specifically, I will compare the concept of *jen*, the central concept of Confucian ethics, and the concept of care, the central concept of feminist care ethics.[1] Originated from a feudal society, Confucianism has been typically patriarchal. It has a long history, and in some areas of the world it is so deeply involved in people's lives that it may properly be called a religion. Like most religions, Confucianism has given little recognition to women. The feminist care ethics is relatively new. As a philosophy, it is growing quickly and has become a force not to be ignored. One striking feature of this ethics is that it is anti-patriarchal. This means that it is against not only male dominance in the society but also against the "male/masculine" way of thinking in general. So one might suppose that Confucian ethics and feminist ethics are diametrically opposed to each other. This essay does not aim to show the differences between the two, which should be rather obvious, but the similarities, to which people normally do not pay attention. Do Confucian ethics and feminist care ethics have anything in common? If so, what are these common aspects? How important are they? While refraining from directly evaluating the validity of the two ethics, which goes beyond the domain of the present essay, I will show that they share common grounds far more important than have been realized and these important common grounds would make it possible for Confucianism and feminism to learn from and support each other.

1. *Jen* and Care as the Highest Moral Ideals

Morality concerns the code of acceptable behavior in a society. One's understanding of the nature of morality has much to do with one's understanding of the nature of the society. In investigating Confucian ethics and feminist care ethics, we should first note that both the Confucian society and the society advocated by the care perspective philosophers are non-contractual societies.

A major traditional Western social theory views individual persons as rational beings with self-interests and certain rights. They enter the society as if they had signed a social contract with each other for the purpose of mutual gains, and by this contract their individual rights are guaranteed. Thus the relation between members of a society is like a contractual relation. In contrast, the Confucian views the society as a large family in which the ruler's relation to the subjects is like that of a father to his children. For Confucius, just as there is no contract within the family, there is no contract in the society either. The philosophy of managing a good family and that of managing a good society are essentially the same. The Western division of "public sphere" and "private sphere" simply does not exist in Confucianism. Some feminists have a similar analogy between a family and a society. Virginia Held, for instance, attacks the assumption that human beings are independent, self-interested or mutually disinterested individuals. She believes that "relations between mothers and children should be thought of as primary, and the sort of human relation all other human relations should resemble or reflect."[2] The relation between mothers and children is to a large extent non-voluntary and hence non-contractual.

This way of understanding the nature of human societies is crucial for the unfolding of Confucian ethics as well as the feminist care ethics discussed here. For if the society is a contractual society, justice is served only if each participant's rights are guaranteed; and as long as these rights are not violated, morality is satisfied. Neither Confucian nor feminist care ethics bases its morality on individual rights. As Carol Gilligan observes, a woman's "construction of moral understanding is not based on the primacy and universality of individual rights, but rather on a 'very strong sense of being responsible to the world.'"[3] Within this construction, the moral dilemma is not "how to exercise one's rights without interfering with the rights of others," but how "to lead a moral life which includes obligations to myself and my family and people in general."[4] For Confucius, the concept of individual rights has no place in morality. Morality is a matter of fulfilling one's proper role in society, as a son or daughter, a brother or sister, a father or mother, and, further, as a ruler or a subject under the ruler. In this non-contractual society, for the Confucian, the key concept to guide human relations is *jen*, and for the feminist of this perspective, care.

Confucianism is also called "the philosophy of *jen*" (仁 學 "*jen xue*"). The concept of *jen* occupies a central place in the Confucian philosophy. In the *Analects* Confucius mentioned *jen* as many as 105 times, but he never formally defined it. In the English world, scholars have translated *jen* with many terms—benevolence, love, altruism, kindness, charity, compassion, magnanimity, human-heartedness, humaneness, humanity, perfect virtue, goodness, true manhood, manhood at its best, and so on.[5] These translations reflect the two senses in which Confucius used the word *jen*: "*jen* of affection" and "*jen* of virtue."[6] In the sense of "*jen* of affection," *jen* stands for the tender aspect of human

feelings and an altruistic concern for others.[7] Confucius said, "*jen* is to love others" (*Analects*, 12.22).[8] One can readily experience the sense of *jen* if willing to do so. Confucius said, "Is *jen* indeed so far away? If we really want *jen*, we should find that it is at our very side" (7.29). In Mencius, *jen* is treated almost exclusively in the sense of affection. Mencius made *jen* as affection the foundation of his ethics. He said, "No one is devoid of a heart sensitive to the suffering of others. . . . The heart of compassion is the germ of *jen*" (2A.6), and "for every person there are things one cannot bear. To extend this to what one can bear is *jen*" (7B.31). Sympathy naturally arises in one's heart when one sees other people suffer. One would not want to bear seeing sufferings. To extend this feeling to other things in the world and thus make it a general disposition is called *jen*. In this sense, *jen* is benevolence, love, altruism, tenderness, charity, compassion, human-heartedness, humaneness, and so on.

In the other sense, the sense of "*jen* of virtue," *jen* is a general virtue which has to be realized among other virtues. For example, Confucius said, "You are *jen* if everywhere under Heaven you can practice the five: courtesy, breadth, good faith, diligence and clemency" (17.6). In this sense, a person of *jen* is a morally perfect person, and *jen* may be translated as "perfect virtue," "goodness," "true [hu]manhood," and "[hu]manhood at its best."

Although the relation between "*jen* of affection" and "*jen* of virtue" is subject to different interpretations, one thing is certain: a person cannot have the latter without the former. A person who has *jen* as a general virtue cannot lack *jen* as affection. In order to understand Confucian ethics we must first of all understand the concept of *jen* as affection.

The word *jen* 仁 in Chinese consists of a simple ideogram of a human figure and two horizontal strokes suggesting human relations. What is this relation? What is the core of the concept of *jen* as affection? If benevolence, love, altruism, kindness, charity, compassion, human-heartedness, and humaneness all translate the concept of *jen*, what do all these terms have in common? I would suggest that, taken as a virtue of human relations, "caring" is the essence of every one of these terms. If a person does not care for others, he or she cannot be described in any of these terms. For example, benevolence is the kindly disposition to do good and promote the welfare of others. If one does not care for others, one cannot be benevolent. Confucius came closest to a definition of *jen* when he said, "*Jen* is to *ai* 愛 others" (17.22). Although "love" is the common translation of "*ai*," the English word expresses an emotion stronger than "*ai*." *Shou Wen Jie Zi*, a major lexicon of ancient Chinese, interprets *ai* as *hui* 惠, i.e., clemency. In Chinese, *ai* is often used in phrases such as *ai-hu* 愛護 ("take good care of") or *ai-xi* 愛惜 ("cherish"). In the phrases *ai-mo-neng-zhu* 愛莫能助 and *ai-wu-ji-wu* 愛屋及烏, *ai* is best understood as "caring for tenderly." They respectively mean "I care about it but cannot help" and "caring for the house along with the bird on its roof." "Caring" is more appropriate in expressing this tender feeling one has toward people and things.

In Mencius, *jen* as "caring" is more evident. If a child were to fall into a well, why should one care? Mencius believed that a person cares because he or she has compassion. A person has a natural tendency or disposition to be *jen*, to care, and therefore to act to save the child. One does not have to love the child to save her. In situations like this, a person who holds a "Who cares?" attitude is without a human heart. Although the heart of *jen* is natural, Mencius also said that a moral person needs to develop one's heart of *jen*, along with the heart of shame, of courtesy and modesty, and of right and wrong. "If one is able to develop all these germs that one possesses, it will be like a fire starting up or a spring coming through" (2A.6). Moral cultivation and development will make the natural instinctual heart of *jen* a mature moral virtue. Like Confucius, Mencius's ideal form of government is one of *jen*. He saw that princes of some states took the people away from their work during the busy farming seasons, making it impossible for them to till the land and minister to the needs of their parents. Thus parents suffered cold and hunger while brothers, wives, and children were separated and scattered. These princes did not care for their people. Mencius believed that in order to become a true king, one must care and practice the government of *jen* toward the people (1A.5). In other words, being caring, or *jen*, is the way to become a good ruler. Both Confucius and Mencius believed that if a government is really one of *jen*, one which takes good care of its people, there will be no crime or poverty. If the ruler cares for his people, he will make sure that they do not miss their farming seasons, and thus they will have good harvests in good years and be prepared for bad years. When people have enough food, they behave themselves well and do not steal or rob. It is not that we do not have enough punishment, nor is it that we do not have enough taxation. It is that we do not have enough care, and this sometimes makes life unbearable. What we really need is care.

Whether Confucius and Mencius are right in their opinions is open to discussion. What we can conclude from their teachings is that, in Confucian philosophy, to be a person of *jen* one must care for others. So, even if the entire concept of *jen* cannot be reduced to "caring," at least we can say that caring occupies a central place in this concept. As Lik Kuen Tong has properly concluded, Confucianism is a care-oriented humanism and the Confucian love (*ai*) is a caring, responsible love.[9] To understand the care orientation of Confucian ethics is the key for us to understand the concept of *jen* as Confucius's highest moral ideal.

At this point it may be useful to compare Confucius's conception of virtue with Plato's, which has been very influential in the West. For Confucius, the three cardinal virtues are wisdom, courage, and *jen*.[10] Plato's four cardinal virtues are wisdom, courage, temperance, and justice. Confucius believed that in order to become a person of *jen*, one needs to "conquer oneself and return to propriety" (20.1). Within this context, "to conquer oneself" means self-cultivation. It includes controlling one's desires in accordance with *li* 禮, i.e., Con-

fucian proper social behavior. Hence it can be said that the concept of *jen* implies temperance. Now we can see that where Plato placed justice, Confucius placed *jen*. In Plato justice is the highest moral ideal, which is achieved only when the other three virtues are duly practiced. But this ideal is missing in Confucius. Confucius, for whom *jen* is almost synonymous with morality, would find it unintelligible for a morality not to include some element of *jen*. This difference between the two major philosophers is not an accident. It reflects a major divergence between the two ethics. At this point Confucius would certainly find more common ground with feminist care ethics than Plato's justice ethics.

In the feminist care perspective, the highest ideal of morality is caring. In her book *In a Different Voice*, Carol Gilligan found that "morality, for these women, centers on care."[11] A moral person is one who cares for others, or as Nel Noddings puts it, "one-caring." Noddings writes, "It is this ethical ideal (caring), this realistic picture of ourselves as one-caring, that guides us as we strive to meet the other morally."[12] While Confucius believed that a person of *jen* is one who "wishing to sustain himself, sustains others; wishing to develop himself, cares for the development of others" (6.28), a female interviewee in Carol Gilligan's study equates morality with caring for others and considers responsibility to mean "that you care about that other person, that you are sensitive to that other person's needs and you consider them as a part of your needs."[13] Another interviewee believes that "if everyone on earth behaved in a way that showed care for others and courage, the world would be a much better place, you wouldn't have crime and you might not have poverty."[14] She would agree with Confucius and Mencius that a good government as well as a good person is one that cares, and promotes care, for the people. Gilligan writes, "The ideal of care is . . . an activity of relationship, of seeing and re-sponding to need, taking care of the world by sustaining the web of connec-tion so that no one is left alone."[15]

As the highest moral ideal, care serves as the guidance of one's moral be-havior. In our world, things are often complicated. People may get into moral dilemmas that have no easy solutions. In such cases, all we can ask people to do is to care about those who will be affected by their decisions. A really caring person is not one who merely sits there and says to oneself, "I care." One must make an effort to look into the situation and the effects of possible decisions. Afterwards, we may praise one for having been caring or blame one for having not been caring enough (therefore people may have been hurt). But it is un-reasonable to demand more than that. Things are not perfect. We cannot demand anyone to make things perfect. As long as one cares reasonably enough, morality is satisfied.

Then why should I care? For the care ethics, I am obliged to care because I place the utmost value on the relatedness of caring. As Noddings puts it, "This value itself arises as a product of actual caring and being cared-for and my

reflection on the goodness of these concrete caring situations."[16] In Confucian philosophy, we find a similar line of argument. Confucius never addressed the issue of the purpose of *jen*. *Jen* is the destiny of humankind and is good in itself. Asking "Why should I be *jen*?" would be like asking "Why should I be good?" which has no proper answer except that we value it. Confucius seemed to have taken it for granted that humans want to be good and to avoid evil. He said, "If you aim at *jen* then you can avoid evil" (4.4). When his disciple asked him whether a person of *jen* would ever complain about what might seem an undesirable situation because of being *jen*, Confucius said, "If you seek *jen* and get it, why should you complain?" (7.14; my translation). As Confucius values *jen* as a virtue with value in itself, Noddings similarly believes that "caring is important in itself."[17] Only with care can a person be a moral person. Only in the practice of caring can a person become a moral person. It is caring, not the consequences of it, which establishes moral values. At this point both Confucianism and the feminist care ethics differ widely from utilitarianism and consequentialism. *Jen* and care are not to be justified in terms of the consequences they bring about, though the consequences are generally desirable. As the highest moral ideals, *jen* and care are good in themselves.

2. *Jen* and Care: Ethics Without General Principles

In the *Analects*, Confucius talked many times about how to become a person of *jen*. But each time he came up with something different. He never gave a general guideline. This is by no means negligence. *Jen* cannot be achieved by following general principles.

In the last two thousand years a vast number of rules have been developed in the Confucian tradition. For instance, there were the rules that girls and boys older than seven should not sit at the same dining table, and a man would have to accept the bride picked by his parents, whether he liked her or not. But we must note the differences between Confucian rules and rules in other ethics, e.g., Kantian or utilitarian ethics. First, these rules are not an essential feature of Confucian morality. At the same time, different places often have different rules, even though they all are Confucian. And over the years these rules have changed, many have even disappeared. Yet Confucian ethics remains. Second, these rules are specific rules, not general principles. They are not like the utilitarian principle that one should always maximize total net utility or the Kantian principle that one should always treat people as ends. In Confucianism, these specific rules are guidelines for young people to learn *li*, i.e., proper social behavior. Rules of *li* are important, but learning *jen* is more important. Confucius indicated that, without *jen*, *li* is of no use (3.3). For him, being ethical is being *jen*; it is not merely a matter of following specific rules.

Where Confucius talked about reciprocity, he talked about things mostly like general rules. Confucius told his disciple Shen that his philosophy had one

thread that ran through it. When others asked Shen about it, Shen said "loyalty and reciprocity" (4.15). Loyalty here means loyalty to one's cause. If one is loyal to one's cause, one should exert all one's strength to the cause. Reciprocity means being considerate of others. But Confucius's notion of reciprocity goes beyond that of the rights and justice perspective. Proponents of the rights/justice perspective also believe in reciprocity. Their notion of reciprocity is the basis for the social contract: if you do not infringe upon my rights, I will not infringe upon yours. Confucius believed in the Golden Rule: "Never do unto others what you do not want others to do to you" (12.2). He also believed that a person of *jen* should sustain others if he wishes to sustain himself, and care for the development of others if he wishes to develop himself (6.28). That is, instead of leaving people alone, he should understand others' situations and care for them. Clearly, Confucius extended the notion of reciprocity beyond the limit of the "rights perspective" to the "care perspective." For Noddings, caring has the distinctive feature of motivational displacement. She writes that in caring, "when we see the other's reality as a possibility for me, we must act to eliminate the intolerable, to reduce the pain, to fill the need to actualize the dream," and in caring, there is "a total conveyance of the self to the other."[18] When one wants to do something, one should ask, "How would my action affect others?" "Would I want a person to do this if I were in their situation?" This way of thinking requires more than non-interference. This kind of reciprocity is different from rules in Kantian or utilitarian ethics. It demands that one should care for others.

To say "always care for others" is very different from saying "always follow such-and-such a general rule." Traditional Western ethical theories have principles or general rules for people to follow. Utilitarianism, for example, follows the rule to maximize total net or average utility. In addition to general rules there is also the thesis of universalizability. This is the idea that if one person is obliged to do x under certain conditions, then everyone under sufficiently similar conditions is obliged to do x, with no exceptions. While the care perspective does not entirely deny that we can receive some guidance from principles, there seem to be no general rules to determine whether a situation is sufficiently similar to another. More often than not general principles do not solve problems for us. We need to inquire into individual cases. Noddings said that her feminist care ethics "does not attempt to reduce the need for human judgment with a series of 'Thou Shalts' and 'Thou Shalt nots.' Rather, it recognizes and calls forth human judgment across a wide range of fact and feeling, and it allows for situations and conditions in which judgment may properly be put aside in favor of faith and commitments."[19] For example, there can be no general principles that will give a mother a definitive answer to whether she should send money to charity or spend it on her child's favorite meal. It really depends on individual situations, and individual situations vary from time to time and from place to place.

What makes Confucian ethics more like feminist care ethics than justice ethics is not that they have or do not have rules but that they both remain flexible with rules. When a rule fails to work, instead of trying to make up another rule, as justice ethics would do, they will readily accept flexibility with rules. Noddings writes: "The one-caring is wary of rules and principles. She formulates and holds loosely, tentatively, as economies of a sort, but she insists upon holding closely to the concrete."[20] In caring, a person may get into conflicts. Noddings gives us an example in which a professor receives a research proposal from graduate student B. In the proposal, B proposes to do research that requires deceiving the subjects involved in the research.[21] On the one hand, the professor does not want to hurt B by turning the proposal down. On the other hand, the professor is not sure whether the subjects would be hurt by the experiment. If they would not be hurt and B succeeds in the research, then everything would be fine. But what if they are hurt? In cases like this, there would be no general infallible rules or principles to follow. It is not to say there cannot be any rules. There are rules. But rules cannot give us infallible solutions in conflicting situations of caring.

Moreover, even though we can follow rules, rules do not have the overriding power in deciding our actions. Noddings thinks that although general principles call for support to socially oppressed people, a caring person would fight along with her father and brother against the oppressed if they are on the opposite side of the oppressed.[22] While this may sound extreme, it does make the point clear: general rules are not absolute. This is so because, as Joan C. Tronto put it, "The perspective of care requires that conflict be worked out without damage to the continuing relationships. Moral problems can be expressed in terms of accommodating the needs of the self and of others, of balancing competition and cooperation, and of maintaining the social web of relations in which one finds oneself."[23] Under certain circumstances, a caring person needs to break the rules in order to preserve social relations.

Confucius again would share the view of these feminists. He believed that, even though we normally consider theft to be wrong, a son should not expose it if his own father steals a sheep from his neighbor (13.18). He said, "In serving his father and mother a man may gently remonstrate with them. But if he sees that he has failed to change their opinion, he should resume an attitude of deference and not thwart them" (4.18). At first glance, this may sound immoral. But if *jen* and care are the highest moral ideals, it is only reasonable to follow Noddings's and Confucius's way, especially given the gradation of caring (which will be discussed later).

Often Confucianism leaves the impression that filial piety to one's parents is absolute. This is not so. In Confucianism, a person has many duties. Besides filial piety to parents, one also has the duty of loyalty (*zhong* 忠) to the ruler. The two duties may come into conflict. For instance, when the country is being invaded, a man has the duty to answer the ruler's call to fight at the frontline.

But what if his aging parents also need his daily assistance? Under situations like this one, Confucianism offers no general rules to solve the problem. It depends on individual circumstances, and, as long as one cares, one can be *jen* even though failing to perform one's duty.

Focusing on *jen* of affection, Mencius seemed even more flexible on general principles. He said, "All that is to be expected of a gentleman is *jen*. Why must he act exactly the same as other gentlemen?" (6B.6). For Mencius, "A gentleman need not keep his word nor does he necessarily see his action through to the end. He aims only at what is right (appropriate)" (4B.11).[24] This remark seems to suggest that a person of *jen* may not always live up to one's words as long as what one does is right or proper. Here the doctrine of living up to one's words, which would appear as a general principle, does not always determine what is appropriate. Unlike Kant, who believed that a person should never tell a lie, Mencius suggested that sometimes telling a lie is acceptable. He told a story about Zeng Zi. Mencius told that after his meal Zeng Zi's father Zeng Xi would ask Zeng Zi whether there was any food left for the family, and Zeng Zi always replied in the affirmative even when actually no food was left. In this way, Zeng Zi was able to give his father more gratification (4A.19). Though being honest is a virtue, whether we should tell the truth or a lie depends on individual circumstances. There are no general principles to follow. A person of *jen* is one with good judgment who knows what to do and when.

Noddings notes that even though not following general rules, a caring person is not capricious. Like Mencius, Noddings believes that moral life based on caring is coherent and one can be content if there has been no violation of caring.[25] No ethics can be entirely devoid of rules, general rules, or rules of thumb. One difference between Confucian ethics and feminist care ethics on the one hand, and Kantian ethics and utilitarian ethics on the other, is that the former are not as rule- or principle-oriented.[26] A person of *jen* or a caring person knows where and when not to depend on rules.

3. *Jen* and Caring with Gradations

As a person of *jen*, a person of caring, should I care for everyone equally? On this question feminist philosophers are divided. But with some feminist care philosophers the Confucian shares an important common ground.

Confucius distinguished between a person of *jen* and a sage. Once his disciple Zi Gong asked him, "If a person confers benefits on the people universally and is able to assist all, what would you say of him? Would you call him a person of *jen*?" Confucius said, "Why only a person of *jen*? He is without doubt a sage. Even (sage-emperors) Yao and Shun fell short of it" (6.28; my translation). Only sages are able to practice universal love. It is noble and admirable but far beyond ordinary people's moral horizon. For ordinary people, the highest moral ideal is *jen*, not being a sage.[27]

On the issue whether a person should care for everyone equally, Confucius and Mo Zi, the founder of Mohism, are diametrically opposed. Mo Zi, the major rival of Confucians of the time, also believed in *ai* or love. But he believed in universal love (兼愛 *jian-ai*) and urged everyone to "regard other people's countries as one's own. Regard other people's families as one's own. Regard other people's person as one's own."[28] Mencius condemned Mo Zi's universalism as an ethics with "no father" (3B.9). The difference here, however, is not whether one should love or care for other people universally. Mencius himself said, "A person of *jen* embraces all in his love" (7A.46). And Confucius also said one should "love all men comprehensively" (1.6). But Confucius and Mencius believed that a person practicing *jen* should start from one's parents and siblings and then extend to other people. This is called *"ai you cha deng* 愛 有差等*"* or "love with gradations." In other words, although one should love both one's father and a stranger, one should love one's father first and more than the stranger. Confucius believed that "the greatest application of *jen* is in being affectionate toward relatives,"[29] and "filial piety and brotherly respect are the root of *jen*" (1.2). A person of *jen* must love first his father and elder brothers and then, by extension, other people. Mencius said, "Treat with respect the elders in my family, and then by extension, also the elders in other families. Treat with tenderness the young in my own family, and then by extension, also the young of other families" (1A.7). He believed that a person of *jen* should be *jen* to all people but attached affectionately only to his parents (7A.45). This means that one's parents exert a greater pull on one. Thus, when both one's father and a stranger are in need, the doctrine of love with gradations justifies one's helping one's father before the stranger.

In this regard Confucius and Mo Zi had different perspectives. Mo Zi had a utilitarian approach. For him moral life is desirable because of the benefits it brings with it. He said, "What the man of humanity devotes himself to surely lies in the promotion of benefits for the world and the removal of harm from the world. This is what he devotes himself to."[30] Mo Zi argued that only by universal love is it possible to generate the most desirable outcome of utilities. For Confucius, moral life is desirable for its own sake. *Jen* demands that one love one's parents first and other people second. This is the ideal moral life one should devote oneself to. If a man treats his father as he treats a stranger and vice versa, then he is neglecting the affectionate tie between himself and his father and hence fails to be *jen*.

In her book *Caring*, Noddings follows a similar line of thought. She believes that morality requires two sentiments. The first sentiment is that of natural caring. Caring starts with a person's natural impulse to care. We naturally care for our own family and relatives and people close to us. The second sentiment "arises from our evaluation of the caring relation as good, as better than, superior to, other forms of relatedness."[31] This is the genuine moral sentiment. Because the most intimate situations of caring are natural, proximity is powerful

in caring.[32] Noddings notes that "my caring is always characterized by a move away from self . . . I care deeply for those in my inner circles and more lightly for those farther removed from my personal life. . . . The acts performed out of caring vary with both situational conditions and type of relationship."[33] In concurrence with the Confucian, Noddings concludes, "I shall reject the notion of universal love, finding it unattainable in any but the most abstract sense and thus a source of distraction."[34] For Noddings, this gradation of caring is justified by the fact that "my very individuality is defined in a set of relations."[35] This set of relations is my basic reality. What is right for me to do is defined in this reality. Thus, "an ethics of caring implies a limit on our obligation."[36] For people too far away, even if we would like to care, we simply cannot. While neither Confucius nor Mencius puts a limit on the scope of one's practicing *jen*, given their emphasis on one's filial duty and the extension to other family members and relatives, it is not possible for one to practice universal love directly to all the people in the world. If care as a natural sentiment arises from our daily life, it is only natural for us to start caring for people around us and then by extension for other people away from us; and if this kind of caring is the base for the highest moral ideal, then it is only reasonable to have gradations among those we care about.

In this regard, philosophers of the care perspective such as Noddings and the Confucian again jointly stand in opposition to Kantian and utilitarian ethics. Kantians and utilitarians subscribe to the concept of impartiality. For them all moral patients exert an equal pull on all moral agents. However, for the Confucian and the one-caring, parents and others who are closely related certainly have a stronger pull. Accordingly, although we should care for everyone in the world if possible, we do need to start with those closest to us. This is not to say that we should care only for people close to us. It means that starting with those close to us is the only reasonable way to practice *jen* and care. It would be perfect if a mother could care, in addition to her own baby and her neighbor's, for every little baby in the world who needs care. Unfortunately that is not possible. So she should be content with giving her care to her own baby and, perhaps, her neighbor's. This is as far as she normally can go, and this is our way of life as people of *jen* and care. Giving priority to people near us is not merely justified by the fact that the closer the needy are to us geographically the more efficient our aid is. Even if it were equally efficient, we would still feel more obliged to help the nearby. This feeling can be justified by the notion of care with gradations.[37]

4. Is Confucian Ethics a Care Ethics That Has Oppressed Women?

We have identified three major areas in which there are similarities between Confucianism and feminist care ethics. For a long period of time Confucian-

ism has been notorious for its suppression of women. Feminism is primarily a fighter for women's liberation. Is it possible for them to share philosophically significant common ground? My answer is affirmative. I think the similarities between the two are not in the ways they have treated women but in the way of their philosophical thinking, in the way they view the nature and foundation of morality, and the way they believe morality should be practiced. Based on these similarities, we can conclude that Confucian ethics is a care ethics.

If Confucian ethics is a care ethics, a question that naturally arises here is: How can it be possible for a care ethics to have been so uncaring for women and to have oppressed women? Apparently there is a discrepancy. To shed some light on the problem and to dissolve the apparent discrepancy, in this section I will first show, through a historical examination of the development of Confucianism, that to a large extent Confucius and Mencius, the founders of Confucianism, are not responsible for its history of oppression of women. Then I will show why it is not impossible, and hence not contradictory, for a philosophy that is essentially caring in nature to have oppressed women. If either of the two accounts succeeds, the discrepancy is dissolved.

Confucianism was founded by Confucius. The major doctrines of this philosophy are in his *Analects*. Mencius contributed a great deal to Confucianism by providing substantial arguments for ideas propounded by Confucius. It is safe to say that by the time Mencius died, Confucianism as a philosophy was already well established. It is not strange that in China Confucianism is called the "Philosophy of Confucius–Mencius" ("*Kong-Meng zhi dao* 孔孟之道"). Confucian scholars of later stages only developed or modified and hence more or less altered the philosophy. These versions usually have a specific name attached in addition to the generic term "Confucianism," e.g., "the Yin–Yang Confucianism" or "Neo-Confucianism." Since Confucianism was established by Confucius and Mencius, Confucianism without later modifications certainly well deserves the name of Confucianism.

It is a fact that under the name of Confucianism there has been oppression of women. But since when has it been so? If it can be shown that Confucianism became oppressive to women only at a later stage, since Confucianism had existed before it became so, one can say that oppressing women is not an essential characteristic of Confucianism, and hence Confucianism as propounded by Confucius and Mencius can be a care ethics.

The most notorious women-oppressive doctrine under the name of Confucianism is that the husband is the wife's bond. According to *Bai Hu Tong* 白虎通, the Encyclopedia of the Yin–Yang Confucianism, a bond ("*gang*" 綱) gives orderliness. It serves to order the relations between the superior and the inferior, and to arrange and adjust the way of humankind.[38] Then why should the husband be the wife's bond? Why is it not the other way around? The principal justification of this is the *yin–yang* doctrine.

In Chinese philosophy, *yin* and *yang* are two mutually complementary principles or forces. The words originally referred to two natural physical phenomena,

i.e., clouds shading the sun and the sun shining respectively. Later their meanings were expanded broadly to cover two general kinds of phenomena. *Yang* represents light, warmth, dryness, hardness, masculinity, activity, and so on, while *yin* represents darkness, cold, moisture, softness, passivity, and so on. Between *yin* and *yang*, *yang* is the superior and dominant principle, and *yin* is the inferior and subservient or subordinate principle. Accordingly, all phenomena in the world are results of the interplay of these two principles. Between male and female, male is the *yang* and female the *yin*. From this it follows that, prior to marriage, a woman must listen and yield to her father, after marriage, to her husband, and after her husband dies, to her son. In reality, domination has translated into oppression. Under this philosophy, the wife is judged almost entirely on the basis of her relationship to her husband. She must remain obedient to her husband. For her, "to die of starvation is a small matter, but to lose her chastity is a large matter." To serve and please her husband is her destined duty. When there is absolute power/domination there is abuse of the power/domination. Women's fate was thus doomed.[39]

But when was this *yin–yang* doctrine incorporated into Confucianism? Confucius himself did not talk about *yin–yang*. Like most of his contemporaries, Confucius believed in the Mandate of Heaven, but he never went so far as to attempt to work out a mysterious cosmological system, let alone a systematic theoretical justification of the oppression of women. The Chinese word for person or people is gender-neutral (*"ren"* 人). To say specifically "women" or "men" one must use a gender indicator, for example, "female *ren*" or "male *ren*." The *Analects* only specifically mentions women a few times. It never suggests that men should dominate or oppress women. In one place it is recorded that Confucius went to visit Nan Zi, the wife of the duke of Wei (6.26). But there Confucius did not make a statement in regard to relationships between men and women. In another place, Confucius did make a statement about women. He said, "Only young girls and petty people are hard to rear. If you are close to them, they behave inappropriately; if you keep a distance from them, they become resentful" (17.25; my translation). Here Confucius offered an observation of young women rather than a theory about women in general.[40] It probably reflects a social prejudice that already existed in his time. Given Confucius's later illustrious status in China, this short comment on (young) women may have considerably influenced people's view on women in general and probably reinforced people's prejudice against women. However, there is no reason for one to think that this view is an inherent or essential part of Confucius's thought or an inevitable consequence of his general philosophy.

Like Confucius, Mencius did not talk about *yin–yang* either. He, however, mentioned women in his book. For example, Mencius believed that, although men and women outside of marital relationships should avoid physical contact with each other, a man definitely should pull his sister-in-law out of a pond, by whatever means possible, including bare hands, if she were drowning. Although Mencius suggested that obedience was a virtue for women (for instance, 3B.2),

his general attitude toward women was not negative. This is so perhaps partly due to his relation with his mother, who brought him up single-handedly after his father died young. One can hardly imagine that a person from such a family would advocate a philosophy of the husband's being the wife's bond. According to Fung Yu-lan, a predominant historian of Chinese philosophy, the *yin–yang* doctrine probably did not enter the Confucian school until after Mencius died, and it was during the Chi and Han dynasties that the *yin–yang* doctrine came to be almost completely amalgamated with Confucianism.[41]

The philosopher most responsible for blending the *yin–yang* doctrine into Confucianism is Dong Zhong-shu 董仲舒 (179–104 B.C.E.). Dong's high position in the state and his great scholarship in Confucianism and the classics facilitated his effort in combining Confucianism with the *yin–yang* doctrine. A substantial portion of his major philosophical work, *Chun Qiu Fan Lu* (*Luxuriant Gems of the Spring and Autumn Annals* 春秋繁露), deals with *yin–yang*. Dong believed that *yin* and *yang* are two opposing forces that follow the constant course of Heaven. There is an intimate relationship between Heaven and humans. Dong said, "The relationships between ruler and subject, father and son, husband and wife, are all derived from the principles of the *yin* and *yang*. The ruler is *yang*, the subject *yin*; the father is *yang*, the son *yin*; the husband is *yang*, the wife *yin*. . . . The *yang* acts as the husband, who procreates (the son). The *yin* acts as the wife, who gives assistance (to the husband). The 'three bonds,' comprising the Way of the King (*wang tao* 王道), may be sought for in Heaven."[42] Thus among the human relationships discussed by Confucius, Dong singled out three. He believed that in the human world, the relationships between the ruler and the subject, the father and the son, and the husband and the wife are the same as that between Heaven and Earth. Corresponding to the *yang*, the ruler, the father, and the husband dominate over the subject, the son, and the wife respectively, who correspond to the *yin*, in the same way as Heaven dominates over Earth.

Now, we can see who is responsible for the women-oppressiveness of Confucianism. There is no evidence in works by Confucius or Mencius explicitly indicating that they had a women-oppressive view. If it is true that neither Confucius nor Mencius specifically spoke highly of women, it was so probably because women's social status was low at their times. There is no essential connection between their doctrine of *jen* on the one hand and their view on women on the other. It is Dong Zhong-shu who was most responsible for incorporating the *yin–yang* doctrine into Confucianism, which led to a women-oppressive version of Confucianism.

In the following section I will answer the question of how it is possible for a care ethics to have taken part in the oppression of women. My point is that people may hold the same principle while they disagree on the application of it. Later Confucians may have excluded women from the domain of the practice of *jen* because they did not believe that women are as fully persons as men are.

The apparent discrepancy between the oppressive view toward women and the concept of *jen* may be explained away by the account that many Confucians had a limited application domain of the concept of *jen*.

In history, it is not rare for people to hold a certain principle while practicing something that would appear contrary to that very principle. The ancient Athenians believed in democracy. Yet their democracy was limited to "citizens." Slaves and women were excluded from participation in democracy because they were not citizens. Imagine that a political change took place in the city–state and consequently all slaves and women were allowed to participate in democracy along with the "citizens." Now, should we say that the Athenians have changed their principle of democracy or that they continue to hold the same principle but expanded the domain of its participants? I think the latter is the appropriate answer. A Christian may have held a strong belief in brotherhood and sisterhood among her fellows, and yet at the same time may have taken a black slave. For her there was no contradiction simply because she sincerely believed that blacks were not among her fellow people to whom brotherhood and sisterhood would apply. Suppose later this person changed her view on blacks and realized that, after all, blacks were also her fellow people. Would one say that this person changed her principle of brotherhood and sisterhood or that she changed the application domain of the principle? I think the right answer is the latter.

The same logic holds true for our case on Confucianism. Assuming that Confucius and Mencius held restrictive views of women, it would not cause any contradiction for them to hold a care ethics. A care ethics may extend or reduce its application domain. For Confucius and Mencius, *jen* is a human relation. It does not apply to animals.[43] Today a Confucian who is firmly convinced by Peter Singer's (1979) argument for animal equality may hold that *jen* should be practiced on animals too. In the same way, if a Confucian was convinced that women were not fully persons, he might well have thought that *jen* did not fully apply to women. If it is the case, changing the view to include women into the domain of the application of *jen* will only alter the application domain of the concept, not the concept itself.

So, is Confucianism a care ethics that has oppressed women? If by Confucianism is meant Confucianism after Dong Zhong-shu's *yin–yang* philosophy, the answer to this question is definitely affirmative. If one wants to say that the genuine Confucianism is the one before Dong, then there is no evidence that the Confucianism of Confucius and Mencius themselves was really oppressive to women. I have also shown that it is possible for a person to hold a philosophy which is caring in nature and at the same time excludes women from its application. If this possibility is real, then it is possible for Confucianism as a care ethics to have oppressed women. And furthermore, if this in turn is accurate, then it is possible for us to fully restore the concept of care of Confucianism by eliminating the women-oppressive doctrine from it.

5. Observations and Discussions

Now we can make three interrelated observations. First, our investigation supports the claim that care orientation is not a characteristic peculiar to one sex or gender. Care is usually regarded as a feminine characteristic in Western culture, and care ethics is a "feminine" ethics. Confucian ethics has been one of a male-dominated society. For many, *jen* is primarily a male or manly characteristic. If by "male" we mean the patriarchal characteristic, Confucianism has surely been a male ethics. Yet the ethics is a care-perspective ethics, not a rights-perspective ethics. Whereas for feminist ethics men in Western culture are generally not so ready to think along the line of the care perspective, for many Confucians, women probably have to overcome more difficulties before they can be *jen*. If my "care" interpretation of the Confucian *jen* is correct, it will confirm a view shared by many that different perspectives in ethics are results of cultural nurturing rather than a natural difference based on sex.

Second and more important, my study shows that care-orientation is not a characteristic peculiar to a particular social group or culture either. Some feminists believe that the care-orientation in morality is somehow related to social subordination. This belief is unwarranted. For example, by focusing on the similarities between feminist moralities and African moralities, Sandra Harding suggests that this kind of morality is a result of social subjugation. She writes, "We are different, not primarily by nature's design, but as a result of the social subjugations we have lived through and continue to experience."[44] Accordingly, we should expect similar cognitive styles and world views from peoples engaged in similar kinds of social activities. She seems to suggest that, just as female moralities have a lot to do with male dominance, African moralities have a lot to do with Western imperialist dominance. But given the results of our investigation of Confucian ethics, even Harding's account is too narrow. Confucianism took its form more than two thousand years before China became dominated by Western imperialism, and has continued to maintain its influence over the Chinese people, with the exception of a few periods. Thus it would seem as incorrect to say that the care perspective is essentially a morality of the dominated as it would be incorrect to say that it is essentially one of the female sex.

Third, as feminism vigorously spreads, it will increasingly confront Confucianism. Then, what is likely to happen? One may think that feminism will conquer and thereby replace Confucianism, or one may think that the thousands-of-years-old Confucianism in its homeland will defeat feminism, as it has withstood so many other Western philosophies. It seems to me neither is likely to happen. Since Confucianism is so deeply rooted in China and some of its neighboring countries that it has become an essential way of life, it is unlikely to be replaced by a new Western philosophy. But Confucianism will not defeat feminism either. As a philosophy, feminism represents a world trend of

women's liberation. This trend is not likely to be defeated. Thus, given that Confucianism and feminism are not essentially opposed, we have reason to think that feminism may encounter no more, or perhaps even less, resistance in the Confucian world than in the West. Since, as we have shown, Confucianism and feminism share important common grounds, it is possible for them to work together in pursuing their causes.

Notes

1. By "care ethics" I mean the feminist ethics with an emphasis on care instead of rights or justice, represented by feminist philosophers such as Nel Noddings and Carol Gilligan. I do not regard care ethics as the only feminist ethics. Just like feminism itself, feminist care ethics is not a uniform theory. The views of feminist care ethics used in this paper are held by some influential feminist philosophers although other feminist philosophers do not consider them to be authoritative. Confucianism as a philosophy centers on morality and hence is essentially ethic in characteristic. In the essay I refer to Confucianism both as an ethics and a philosophy.

2. Held, 1987a, 114–5. Some feminist philosophers, however, have criticized this mother–child model of human relationship. See Hoagland (1991).

3. Gilligan, 1982, 21.

4. Ibid.

5. See Chan, 1955. Some terms used here are obviously gender-specific.

6. See Teruo, 1965.

7. See Tu, 1981.

8. In this chapter translations of Confucius and Mencius are, unless otherwise indicated, from Arthur Waley (1989), and D. C. Lau (1970) respectively, occasionally with my own slight revisions where it is appropriate. Following conventional practice, the source is indicated, for Confucius, for example, as "12.22," which stands for Confucius's *Analects*, Chapter 12, section 22, and for Mencius, as "2A.6," which stands for *Mencius*, Chapter 2A, section 6.

9. See Tong, 1973.

10. *The Doctrine of the Mean*, chap. 20.

11. Gilligan, 1982, 125.

12. Noddings, 1984, 5.

13. Gilligan, 1982, 139.

14. Ibid., 165.

15. Ibid., 62.

16. Noddings, 1984, 84.

17. Ibid., 7.

18. Ibid., 14, 61.

19. Ibid., 25.

20. Ibid., 55.

21. Ibid., 54.

22. Ibid., 109. Some feminists such as Virginia Held have been critical of Noddings in this regard. See Held (1987b).

23. Tronot, 1987, 658.

24. "Right" here is a translation/interpretation of "*yi* 義" which can also be understood as "appropriate." In *The Doctrine of the Mean*, chapter 20 states, "*yi* means setting things right and proper."

25. Noddings, 1984, 56–57.

26. For a discussion of care- and principle-orientation, see Blum (1988).

27. For a discussion of the difference between *jen* and sage, see Chang (1989, chap. 11). Later Confucians, such as Cheng Hao ("a person of *jen* forms one body with all things without any differentiation") and Han Yu ("universal love is called *jen*"), elevated *jen* to the level of sagehood, which is evidently not Confucius's belief.

28. *Mo Zi*, chap.15.

29. *The Doctrine of the Mean*, chap. 20.

30. *Mo Zi*, chap. 15.

31. Noddings, 1984, 83.

32. Ibid., 54.

33. Ibid., 16.

34. Ibid., 29. For a different view see Benhabib, 1987.

35. Ibid., 51.

36. Ibid., 86.

37. Many feminists, like many later Confucians, believe in universal love without gradations. This is not the place, nor is it the author's intention, to develop a full-fledged defense of graded love. If the argument for graded love presented here seems inadequate or unconvincing, I am content that I have shown that some feminists share the view with Confucians in this regard. For a recent defense of Confucian graded love, see Lai, 1991.

38. *Bai Hu Tong*, chap. 29. See Fung, 1953, 2: 44.

39. But according to Chang (1989, chap. 8), it was not developed to such an extreme until Southern Sung Dynasty (1127–1279).

40. For more discussion of this passage, see my introduction to this volume.

41. Fung, 1953, 2:9.

42. Dong Zhong-shu, *Luxuriant Gems of the Spring and Autumn Annals*, chap. 53, quoted in Fung, 1953, 2:42–43.

43. In the *Analects*, we are told that Confucius's stable was burned down when he was out. Upon his return Confucius asked, "Have any people been hurt?" He did not ask about the horse (10.12).

44. Harding, 1987, 311–312.

References

Benhabib, Seyla. 1987. "The Generalized and the Concrete Other: The Kohlberg-Gilligan Controversy and Moral Theory." In Kittay and Meyers, 1987.

Blum, Lawrence A. 1988. "Gilligan and Kohlberg: Implications for Moral Theory." *Ethics* 98 (April):472–91.

Card, Claudia. 1991. *Feminist Ethics*. Lawrence, KS: University Press of Kansas.

Chan, Wing-Tsit. 1975. "Chinese and Western Interpretations of *Jen* (Humanity)." *Journal of Chinese Philosophy* 2:107–29.

———. 1955. "The evolution of the Confucian Concept of Jen." *Philosophy East and West* 4(4):295–319.

Chan, Wing-Tsit, trans. and compiler. 1963. *A Source Book in Chinese Philosophy*. Princeton, NJ: Princeton University Press.

Chang, Tainien. 1989. *Studies of Chinese Ethical Theories* (中國倫理思想研究 *Zhong Guo Lun Li Si Xiang Yan Jiu*, text in Chinese). Shanghai, China: Shanghai People's Publishing House.

Confucius/Tzu Ssu. 1963. *The Doctrine of the Mean*. In *A sourcebook in Chinese philosophy*. See Chan 1963.

Fung Yu-lan. 1953. *A History of Chinese Philosophy*. Vols. 1 and 2. Princeton, NJ: Princeton University Press.

Gilligan, Carol. 1982. *In a Different Voice: Psychological Theory and Women's Development*. Cambridge, MA: Harvard University Press.

Harding, Sandra. 1987. "The Curious Coincidence of Feminine and African Moralities: Challenges for Feminist Theory." In Kitty and Meyers, 1987.

Held, Virginia. 1987a. "Non-contractual Society: A Feminist View." In *Science, Morality, and Feminist Theory*. Ed. Marsha Hanen and Kai Nielson. Calgary, Alberta: University of Calgary Press.

———. 1987b. "Feminism and Moral Theory." In Kittay and Meyers, 1987.

Hoagland, Sarah Lucia. 1991. "Some Thoughts about 'Caring.'" In Card, 1991.

Kittay, Eva Feder, and Diana T. Meyers, eds. 1987. *Women and Moral Theory*. Totowa, NJ: Rowman & Littlefield.

Lai, Whalen. 1991. "In Defence of Graded Love." *Asian Philosophy: An International Journal of Indian, Chinese, Japanese, Buddhist, Persian and Islamic Philosophical Tradition* 1(1):51–60.

Lau, D.C. 1970. *Mencius*. Harmondsworth: Penguin Books.

Mo Tzu. 1963. *Mo Tzu*. In Chan, 1963.

Noddings, Nel. 1984. *Caring: A Feminine Approach to Ethics and Moral Education*. Berkeley: University of California Press.

Ruddick, Sara. 1989. *Maternal Thinking: Toward a Politics of Peace*. Boston: Beacon Press.

Singer, Peter. 1979. *Practical Ethics*. Cambridge: Cambridge University Press.

Teruo, Takeuchi. 1965. "A Study of the Meaning of *Jen* Advocated by Confucius." *Acta Asiatica* 9:57–77.

Tong, Lik Kuen. 1973. "Confucian *Jen* and Platonic Eros: A Comparative Study." *Chinese Culture* 14(3):1–8.

Tronto, Joan C. 1987. "Beyond Gender Difference to a Theory of Care." *Signs: Journal of Women in Culture and Society* 12(4):644–63.

Tu Wei-ming. 1981. "*Jen* as a Living Metaphor in the Confucian *Analects.*" *Philosophy East and West* 31(1):45–54.

———. 1968. "The Creative Tension Between *Jen* and *Li.*" *Philosophy East and West* 18(1–2):29–39.

Waley, Arthur. 1989. *Analects of Confucius*. New York: Random House.

Feminism as Radical Confucianism: Self and Tradition

2

Joel J. Kupperman

My title is intended to be provocative, and to invite qualifications. Feminism represents a diverse collection of lines of thought, the relations among which may well be a matter of "family resemblances" rather than common possession of some feminist core. There is much diversity also in the rich history of Confucian philosophy.

Nevertheless there is a strong connection between concerns that have been prominent in Confucian philosophy and those characteristic of certain forms of feminist philosophy. Much of this has been brought out by Chenyang Li in a pathbreaking paper in *Hypatia* (Li 1994). My argument will be that the similarities are much more in the kinds of questions asked and issues that are focused on than in the answers typically given. Some strains of feminism raise issues that are opaque to most Western philosophers, but can be readily appreciated by Confucians. But then some of the answers go against a deeply entrenched element of the Confucian philosophical tradition.

1. Varieties of Philosophical Maps

Why are some feminist questions opaque to most Western philosophers? Many, it should be said, are not. Much of the feminist movement, including the elements most immediately involved in politics, has been concerned with issues of fairness (such as that of comparable pay for comparable work), equality of opportunity, and also the importance of people being treated with respect (which is part, although surely not the whole, of the problem of sexual harassment). There has been a good deal of resistance to all of this, even (one dares say) in philosophy departments. But there is no great difficulty in understanding the ethical issues on which this kind of feminist agenda centers. To the extent that Kantian ethics captures important elements of Western common sense about ethics, we can see that there should be no problem in appreciating appeals to fairness, including the ability to have a fair chance in life, and also to the importance of rational beings being treated with respect. Indeed, failures to understand often look willful.

Many would see fairness, equality of opportunity, and the right to be treated with respect as the core of feminism. But this is to miss a very different set of issues, which (although it demands separate treatment) is not entirely separate. This concerns the categories and roles in which we place people, or in which they place themselves. Most basically it concerns self-definition and the formation of self.

Here is why these issues of categories, roles, and the formation and the sense of self are not entirely separate from those of fairness. What seems fair depends heavily on the categories in which we put people and situations. Fairness does not require, for example, that we treat adults and children alike: we tend to put adults and children into separate categories, with very different rights and responsibilities. Because of this, the appeal to fairness to women looks a lot stronger if we resist any inclination to put women and men in separate categories or to differentiate very sharply their roles in life.

Equality of opportunity also is conditioned by the question "Opportunity for what?," and by what we think of as reasonable initial constraints. What counts in a democracy as equality of opportunity to have one's views considered? If the question is simply who may speak her or his mind, it may look as if there is very equal opportunity. But if the question concerns who is likely to be heard and taken seriously, then clearly money and access to the media will be major factors, and someone who lacks money and access will not have equal opportunity. In much this way, if equality of opportunity means more than equal chance to apply for positions, then there must be some rough equality in preparation for success—which will include not only educational opportunities but also a pattern of expectations of success that correspond to ability. What does equality of opportunity mean for someone after years of training for a subordinate role?

The issues of categories, roles, and the formation and the sense of self seem to me to include the deepest questions of feminist ethical philosophy. These have to do both with the ways in which roles or the expectation of roles enter into the formation of self, and with the choices about this that can or should be open. One persistent worry, which will be explored later in this paper, is that traditional "feminine" roles operate as a trap for some women, limiting their opportunities and also their chances for awareness of underlying desires and preferences. This is linked to a sense that rituals of niceness, unassertiveness, or being condescended to that are associated with traditional feminine roles can be stultifying.

This opens a door to the ethics of constituting or revising a self. I have argued that issues of this sort are central to most of the classics of Chinese and Indian philosophy (Kupperman 1999). Among these, none gives a more intricate account than the *Analects* of Confucius. But ethics of this sort would be seen by most contemporary Western philosophers as marginal, and also as hard to relate to what now are thought of as central questions of ethics. Certainly

the issues of formation or revision of self do not in themselves look like ones of fairness, and it might well appear that we could plot out a Kantian "realm of ends" without having to consider these issues. Perhaps a utilitarian blueprint for maximizing happiness should lead us to these concerns, but this would not be immediately obvious to most people (or even perhaps to most utilitarians). A contractarian ethics (such as that advanced by John Rawls) is concerned principally with a world of individuals, all of whom can be presumed to want various liberties and goods. The ethical questions of what kind of individual it is best to make oneself into, and of how that would affect the quality of life, are not part of this picture.

The major Western tradition that is closest to the kind of feminist ethics under discussion is that derived from Plato and Aristotle, in which indeed the person one becomes is treated as central. Aristotle's ideal especially includes revision of the self as one matures, so that the exercise of various virtues becomes second nature. Also, Plato and Aristotle both pay attention to social roles in their account of how a self best would be constituted. However the attention is chiefly to the generic importance of the social responsibility that the most able should have for the rest of society. Tradition and ritual, both of which loom large in the Confucian account, and (in different ways) in the feminist philosophy under discussion, are largely ignored.

The formation of self (or, as Hall and Ames put it, "person–making") is central to Confucius' thought (see Hall and Ames, 1987). Ritual is emphasized in the *Analects* and through the Confucian tradition as a major agent of the development and refinement of self. Confucius also emphasizes social roles, starting with those within the family and working outward. The differentiations of social roles and relations are never lost sight of. This is true throughout the Confucian tradition: Xunzi (Hsun Tzu), who places so much weight on social hierarchy as a prerequisite for the development of a moral society, is a notable example.

It is clearly assumed in the Confucian literature that the development and revision of self is not an entirely unconstrained process. The constraints include the role of tradition in validating rituals and social roles. The influence of tradition indeed operates as a kind of failsafe device. Whether Confucius himself was as devoted to tradition as he maintained is open to debate: certainly his philosophy can be argued to have a revisionist social agenda, promoting a new elite of gentlemen scholars. Be that as it may, attention to tradition, along with the social roles and rituals that it validates, has been characteristic of Confucianism.

In what follows I will expand on the importance to Confucianism of issues of the formation of self, and of the ethical functions of traditional social roles and rituals. I then will turn to a feminist treatment of these same topics. The result will disclose many similarities, and also one fundamental difference.

2. Confucian Selves

Confucius gives an account of the process of becoming a very good person that is as complex and subtle in its way as anything that Plato or Aristotle has to offer. At the center of this process is ritual. "Let a man first be incited by the *Songs*, then given a firm footing by the study of ritual, and finally perfected by music" (Book 8.8).

Many of the entries in the *Analects* refer to the *Songs*, an ancient collection of folksong-like poems that Confucius edited and that in the twentieth century have been translated into English by Arthur Waley and also by Ezra Pound. To a modern reader these poems are likely to seem charming and light, but Confucius and his students thought that important moral messages or guidance about life could be found embedded in them (1.15). Confucius not only loved music (playing a lute-like instrument), but considered that the right kind of music could have a major role in ultimate refinement of the self (cf. 17.20; 7.13; 8.15; 17.11). The wrong kind of music, conversely, could be damaging (cf. 15.10; 9.14). The importance of music was taken seriously enough in Confucius's immediate circle that one of his students, when appointed government of a town, immediately set out to promote musical performances. Confucius, coming for a visit, heard everywhere the sound of string instruments and singing. He teased his disciple about this, comparing it to using an ox-cleaver to kill a chicken, but had to admit that there was some basis in his philosophy for this policy (Book 17.4).

As important as the *Songs* and music are, ritual gets the most attention. A modern reader, especially in Western industrialized countries in which there is not as much explicit preoccupation with ritual as there apparently was in ancient China, may have difficulty in focusing on this topic. It may help to think of what amount to small rituals of everyday life. Examples might be thanking someone for a present, holding a door open for someone, or pulling out a chair for someone as people sit down at a table. Rituals can be absolutely habitual, requiring and provoking no thought. They also, in some circumstances, can draw attention. Think of a woman pulling out a chair for a man to sit in.

Ritual, Confucius says, comes after groundwork: i.e., the preliminary stages of formation of self, especially in the family relations that dominate early childhood. We will turn to these family relations, and the social roles that are subsumed under them, shortly. Ritual develops as a patterned way of acting in certain recurring types of situations. Although it is usually habitual, someone who is gifted may infuse attractive stylistic features into the performance of ritual. Also, to have internalized ritual and to have integrated it in one's personality is to manifest a harmony in the performance (1.12). Think of the difference between "please" or "thank you" said by someone who is genuinely a kind and considerate person, and the same words spoken by someone who has barely mastered the rules of good manners.

Much of ritual, as Xunzi argued more than two centuries after Confucius, relies on social differentiation. That is, the parties to a ritual are, either permanently or temporarily, in unequal positions. There is in a sense a very slight temporary inequality between the person holding open the door and the one for whom the door is being held open. In the long run of course it is utterly insignificant, unless, that is, the same person always is the one holding the door open. (Again, think of the pulling-out-the-chair-ritual.) Because of this relation between rituals and differentiated roles, much of the discussion of ritual inevitably centers on the different kinds of behavior that are appropriate to different roles.

In the usual ordering of entries, this is the major topic of the very first book of the *Analects*. These early entries are likely to seem to the vast majority of Western readers to be the least interesting. There may be a tendency for eyes to glaze and to skate down the page. The Western reader may be waiting for an account of how one makes moral or basic life choices. At least one prominent scholar has argued that such a reader will be disappointed, because the familiar concept of choice is not to be found in the *Analects* (see chapter 2 of Fingarette, 1972, "A Way Without a Crossroads"). Even if this point is somewhat exaggerated, it can be taken as a useful reminder that the central concerns of the *Analects* are not the central concerns of most contemporary Western ethical philosophy.

The very first entry of the *Analects* sounds some typical Confucian notes. It emphasizes the continuing importance of learning, and also that of having inner sources of satisfaction so that one is not soured by lack of recognition. The second entry (1.2) then focuses on basic family relations, behaving well toward parents and elder brothers, which are spoken of as the "trunk" of goodness. This theme is broadened in 1.6, which speaks of behaving well to parents and elders, and Book 1.7 which introduces social differentiations: you must treat your betters as betters. This is a clear signal to the modern reader that this is an ethics of a deferential society. 1.8 mentions also the importance of retaining the respect of inferiors as well as (of course) being faithful to superiors.

All of these relationships are played out in rituals of politeness and deference. To learn very early to perform rituals properly is to internalize the social relations and differentiated roles that the *Analects* refer to. Conversely, improper ritual is not merely embarrassing; it is a serious matter (cf. 3.1, 2, and 6).

A number of things may strike the modern reader who begins to focus on these passages, bearing in mind their fundamental importance as the "trunk" of goodness. First, the roles referred to are in general permanent. If your birth order is such that your brother is older, this will be important for life; and your behavior toward your brother always will be subtly (or perhaps not so subtly) different from your brother's behavior toward you. Both ritual and the fundamental sense of what it is to be a "good" person will involve, from the start, a strong and inescapable sense of one's place in a family and a social order.

Secondly, gender matters, in ways so much taken for granted that no one even bothers to talk about them. Given the pervasive influence of Confucianism on Chinese culture for more than two millenia, one can well imagine that a Chinese feminist would find much to blame Confucianism for. On the other hand, it is arguable that Confucianism in its initial phase simply took over (without any reconsideration) attitudes toward gender, family life, and also social hierarchy that had been deeply entrenched in the culture by the time of Confucius. By the time of Xunzi, more than two centuries later, it is clear that there was some debate about the need for, or justification of, social hierarchy. But it is not at all clear (at least to me) that the basic relations of gender and family life had by that time been seriously questioned. This suggests that much that a modern feminist would consider objectionable in classical Confucianism could be considered to have been an "add-on" dictated by accepted ideas of the time, and that a Confucianism that preserved the esential insights could simply remove most or all of these objectionable elements.

Be that as it may, it certainly is clear that older sisters will not play the ritual role that older brothers do in the *Analects*. Something of the sort is equally evident in Mencius' treatment of ritual. Consider for example the elaborate debate between Mencius and the philosopher Kao about whether benevolence and righteousness are "internal" or "external." The debate centers on some characteristic examples. First (6.A4) there is the honor owing to a man older than oneself. Kao considers this righteousness to be external. A second example is the love one has for a younger brother, but not for someone else's younger brother; Kao considers that the feeling is determined by oneself and therefore benevolence is internal.

The debate moves on to more difficult cases (6.A5). Who is owed greater respect: your elder brother, or a villager older than him by one year? The answer is the older brother, but the answer changes if the question is for whom you would first pour out wine at a feast. Mencius then suggests this pair of questions: (1) which do your respect most—your uncle or your younger brother? (2) If your younger brother is impersonating (i.e. playing the role of) a dead ancestor, to whom do you show greater respect?

The long discussion of which I have summarized only part is tangled and obscure. David Nivison has devoted an important paper to it (Nivison 1996). My concern here though is not with the issues of this debate but only with the examples used. They illustrate the intricate involvement of family and social roles in ritual behavior, and help to give a sense of how these play a part not merely in special moments of behavior but also in a basic orientation toward life. Also, it is again clear that women (except implicitly, as half of the group of parents) simply are not in the picture.

Xunzi often is opposed to Mencius because Mencius had argued that benevolence is an essential element of human nature (something also argued two thousand years later by David Hume). Xunzi presents a more negative view of

human beings. I have argued that Xunzi in fact, unlike Mencius, does not have a view of human nature, and that what he does have to say must be viewed in relation to Piaget-like stages rather than as outlining a fixed essence (Kupperman 2000). In any case, though, his view of opening-stage human nature is bleak: he compares it to warped wood that needs to be steamed in order to change its shape (Knoblock 1988, 1.1, vol. 1, p. 135). Xunzi's major concern is the process of properly shaping up our natures. It should not be a matter of fits and starts, but rather needs to be constant (1.6, vol. 1, p. 138; 2.8, pp. 155–6).

Ritual is an important part of this process, although Xunzi also speaks (as Confucius did) about the moral force of rulers, and assigns as well (as Confucius did not) a positive role to laws. Xunzi's elaborate account of rituals includes a distinction between what they are like in the early stages and their nature for people who have made real progress. "All rites," he says, "begin with coarseness." But they "are brought to fulfilment with form, and end with pleasure and beauty" (19.2c, vol. 3, p. 60). Ritual, to put the point differently, usually begins as compliance with an external requirement; but as participation in it becomes internalized, it becomes a kind of social dance which is both expressive of inner attitudes and also helps to refine them further.

Ritual, Xunzi argues, cannot exist in an entirely egalitarian society (19.1c, vol. 3, p. 56 ff.; also 9.3., vol. 2, p. 96). Perhaps the temporary inequalities, in our society, involved in such things as being the first one to the door (and to hold it open for others), are not enough to generate a substantive system of rituals. Xunzi is defending the importance to ritual—and through ritual, to development of self—of the fundamental inequalities of parent/child or of ruler/high official/low-ranked official/subject. Women are not present (except implicitly as parents) in this schema.

Confucius, Mencius, and Xunzi are the three great figures of classical Confucian philosophy; and, despite some differences among them, common features do emerge. It is natural to ask whether these common features add up to a viable and important philosophy. Is Confucianism useful in relation to problems of today? If it is, might it be especially useful to feminists?

Let me suggest that questions that call for judgment of the classic Confucian treatments of rituals and social roles that I have been outlining can be divided. We can ask first whether the classical Confucian philosophers were right in holding that an effective system of ritual requires differentiated social roles. Secondly, we can ask whether a sense of social roles, along with mastery of (and comfort in) rituals associated with permanent or temporary roles, is important in the good formation of personhood. Finally, would whatever is valuable in the Confucian approach be preserved if we inserted the assumption that women and men are in general equally important and equally deserving of respect and deference?

The first question itself can be subdivided. A modern reader might be more doubtful about the necessity of social hierarchy if there is to be an effective

system of ritual than about the necessity of the special importance of family roles (e.g., respect of children for parents). Confucius, with his paternalistic views of good government, clearly took general social relations to parallel, at least in broad outline, relations within a family. But we might ask whether effective ritual could be generated from the differentiated relations within a family, plus temporary inequalities of the door-holding kind, plus perhaps respect for someone who happens to have been elected mayor, governor, or president. I will not pursue the argument here, but my sense is that the answer is "Yes." There is no clear reason to suppose that a deferential society is required for there to be a sense of ritual. The persistence of rituals in our society is evidence to the contrary.

The second question, like many of the issues that come up in relation to Confucian philosophy (as for those, for that matter, that come up in relation to the ethical philosophies of Western figures such as Aristotle, Hume, and Nietzsche), requires answers that contain a mixture of normative judgment and moral psychology. It is to some degree, therefore, empirical. In answering it, we need to have a clear sense of how, for example, roles within a family play out in expected behavior patterns, and the effects of these on the development of personality. Normative judgments inevitably will be present as coloration of descriptions. Any proper answer to the second question in short would require massive research. Let me merely offer the opinion that much of our common experience of life suggests that the answer to the question is "Yes."

Would whatever is valuable in the Confucian approach be preserved if we inserted the assumption of gender equality? The obvious counter-question is "Why not?" If it is plausible to suppose that roles and rituals can play a useful role in the development of self without being based on massive and (largely) permanent social differentiations of a traditional hierarchical society, then it is far from clear that the differentiations included in gender inequality are required. As long as there are some important differentiations, many of them perhaps temporary, there will be enough foundation for the edifice of ritual.

3. A Feminist Self

It has been pointed out that leading nineteenth-century feminists, such as Elizabeth Cady Stanton, considered the reform of social roles to be of paramount importance. Stanton held that "the distress and misery that wracked economic and social life . . . were the consequence of male dominance" (Leach, 147). This had a wide range of implications, ranging from the personal to the legal: equality, based on love and friendship in marriage, for example, dictated that there be free divorce (ibid., 144).

Clearly the expectation of sharply differentiated social roles has been central to the upbringing of boys and girls in our culture since time immemorial. There has been a growing sense that much of this is damaging, certainly to the

girls and arguably as well to the boys. Simone de Beauvoir, a major pioneer of feminist philosophy in the twentieth century, pointed out that girls are taught to regard routines of menial household tasks as their lot in life and are pointed toward a feminine role of passivity, objectification, and repetitive chores (de Beauvoir 1953/1989, 282 ff.). This is bound to be discouraging to anyone of spirit, and seems designed to lower expectations and also the likely level of comfort with the idea of success in anything that is interesting and challenging and involves competition with men. It also contributes to the view that "to be feminine is to appear weak, futile, docile" (ibid., 336).

Basic childhood orientation can have enormous effects throughout life. Diana Meyers observes that in the dominant cultures of Western industrialized nations "men are encouraged to act more autonomously than women . . . are taught to be more independent and to exert greater control over situations" (Meyers 1989, 136; see also 189). It may well be, as many writers have argued, that men pay a price for this, especially in matters related to expression of emotions. But the price paid by many women is even more obvious. There is the risk of loss of independence, and of shrinking away from standing out in demanding pursuits. As Meyers points out, girls are taught to judge themselves by others' approbation (ibid., 158). Then there is traditional women's work, which as many recent studies have shown, even now tends not to be fully shared even by relatively enlightened, "liberal" men. Meyers comments that "the privatized regimen of largely menial services that make up the feminine role crushes women's creative initiative" (ibid., 159).

Bonnie Smith has provided an interesting case study of a group of unusually creative women who had to cope with the pressures and constrictions of traditional women's roles (see Smith 1998, especially chap. 7, "Women Professionals: A Third Sex?"). Smith remarks, of the first group of women who were professional historians, that many "lived for the most part in women's ghettos in academe." One could celebrate these communities, but "this would simultaneously mean celebrating their confinement, degradation, and limited opportunity" (ibid., 186).

Much has changed since the period of these women academic pioneers. But there remains a strong argument that women's roles and the rituals that go along with them, as well as the kinds of expectations that girls are brought up with, do harm many women. The harm is of three main sorts.

First there can be what almost might be termed a spiritual harm. A central argument of Diana Meyers' *Self, Society and Personal Choice* is that, largely because of role-expectations and also the roles they are pushed into, many women fail to get in touch with an "authentic self." Meyers defines the authentic self as "a self-chosen identity rooted in the individual's most abiding feelings and firmest convictions, yet subject to the critical perspective autonomy competency affords" (Meyers 1989, 61). A woman who never arrives at an authentic self may well do what is expected of her, but it is very possible that there will not be much

joy in it. The result may be one of those older women one sees who always has a fixed sweet smile on her face, even (and especially) when there is nothing to smile about.

Secondly, someone who accepts or half-accepts the traditional femininity package (if one may put it that way) may have diminished chances for success in a career or in a creative activity. The ideology of traditional femininity functions to limit confidence that one will succeed at all, and lack of confidence is a great handicap. So is ambivalence about the roles that careers and creative activities lead to.

Thirdly, someone who accepts or half-accepts traditional femininity, and somehow does succeed in a career or in a creative activity, will be likely to enjoy it less because of residual ambivalence. There also will be pressure from those who are prepared to carp at a successful person who happens to be a woman. To the extent to which she does not play traditional feminine roles, and does not participate in rituals of deferring to males and of accepting male condescension, she must be prepared to be scorned and sniffed at.

Let me say that Meyers's argument seems to me to be entirely convincing. This clearly creates a case for holding, as most feminists surely do, that general ongoing reform of the ways in which girls are brought up and educated must be supported, along with modification of cultural ideals of what it is to be a woman. One can agree with this, and yet hold up a small flag of caution.

Here is why. Even if one agrees that the femininity package has widepread harmful consequences, this does not imply that all parts of the package are equally undesirable. Indeed any realist about human life knows that, while there do exist some unmixed goods and some unmixed evils, these are much rarer than most people want to think. Most desirable outcomes will turn out not to be desirable in every respect, and something like this is true for most things that are undesirable.

Thus there are some rewarding features of the femininity package, even if these are very often outweighed by harmful features. Sara Ruddick's sensitive exploration of maternal thinking, in particular, has exposed some characteristically positive aspects as well as characteristic weaknesses and failures (Ruddick 1997). Simone de Beauvoir points out that the (on the whole) disadvantageous socialization of girls does have at least one compensation: it leads to women who are more aware of their feelings, more sensitive to nuances of psychological meaning, and more skilled in understanding other people as well as themselves (de Beauvoir, 625–6).

If we add to this the general truth that great political, social, and cultural transformations often have significant unintended consequences, caution is multiplied. My own view, for what it is worth, is that all of this is not reason for postponing change in gender roles, rituals, and role expectations. (Indeed, change is already taking place, and further change is inevitable.) Nor is it a reason for limiting change. It is however a reason for being careful in the process of change. One wishes to preserve as much as possible of what is desirable

while eliminating what is undesirable. (It would be sad, for example, if in the end the average successful woman were as insensitive as the average successful man.) Also, one need not assume that all changes that eliminate whatever is undesirable are therefore highly desirable. Some of the possible cures may be as bad as the diseases they cure.

4. Conclusion

The survey thus far of classical Confucianism and of a major strain of feminist philosophy reveals that indeed, as Chenyang Li first pointed out, they have a lot in common. Both take seriously the ethical importance of becoming a certain kind of person, and this implies reflection on ways of shaping oneself and also of shaping others to come. In ancient China self-shaping might include the decision to leave home, and to become one of the students who lived and traveled with Confucius (and who ultimately, after his death, compiled the *Analects*). It also might yield decisions to become more deeply immersed in the *Songs*, and in matters of ritual and of statecraft. A main goal of statecraft is to create a social and political life that then facilitates an orientation similar to this on the part of young people of ability: a good society creates more very good people than a bad society does.

In a feminist subculture, a sense of the ethical importance of becoming a certain kind of person might include cultivation of techniques for becoming more direct in the pursuit of creative goals, and becoming more comfortable with the idea of conspicuous success. For many it might include also distancing oneself from full involvement with the traditional array of women's roles and work. Above all, it is likely to emphasize commitment to social and educational reform so that able young girls have better chances to develop into fully autonomous and successful adults.

There also are similarities that I thus far have not mentioned. Carol Gilligan was the first prominently to argue that an orientation to ethics that emphasized responsibilities keyed to special relationships was more common among women than men (Gilligan 1982). Confucianism is above all an ethical philosophy in which special relationships, especially those within a family, are treated as central. Not only are these crucial to the focus of Confucian ethics, but they also shape the ideal of the philosophy. The ideal is not represented (as so often in Western philosophy) in terms of justice, but rather has a great deal to do with the full working out of human-heartedness.

So why can't we regard Confucianism and the strain of feminist philosophy under discussion as basically the same? There of course is the historical baggage, including hierarchical roles and gender relations, that classical Confucianism carries. But I have already suggested that this is largely or entirely disposable, that something that maintains the essential insights of Confucianism could be formulated without it.

What is left is one major difference. We can see what it is if we accept the

importance in formation (or revision) of self of social roles and associated rituals, and if we then ask what social roles we should fill and what rituals we should perform. Might we creatively adopt new, not previously heard of, roles and invent new rituals?

In my opinion this question comes close, as it were, to the bone of classical Confucian philosophy. It seems clear that the answer that goes along with the major Confucian texts would be "No." It is equally clear that feminism requires answers of "Yes." In what follows I will examine the reasons in both cases. It is already clear that my sympathies are with the feminist side. But I want to argue that the issues are more difficult than they first may appear, and that there is more than just habit and the limits of social imagination that supports an answer of "No."

The deeply entrenched Confucian respect for tradition may seem, at first glance, to be merely an unreflective element of ancient Chinese culture in general. Ancient sage kings are major figures in the *Analects*, where they are regarded as the best available examples of what rulers ought to be. Part of the message is that what Confucius advocates, including responsible paternalistic rule of the people, provided by an elite corps of cultured people of great integrity, is not truly novel: at least there was responsible paternalistic rule long in the past. Also there is the implicit point that there on the whole has been decline from a political and ethical golden age. Oddly enough, Daoism, despite its major differences from Confucianism in the image of what an ideal personal life and an ideal society should be like, shares the view that there has been decline from a golden age.

The wickedly funny poem no. 18 (in the numbering of most editions) of the *Daodejing* (*Tao Te Ching*) makes this point. When a primitive simplicity begins to break up, so that decent behavior is no longer entirely natural, then virtues (i.e. the ideas of virtues) begin to appear. Vices cannot be far behind. (The author or authors of the *Daodejing* appear to have believed in a kind of Newton's law that every social or political movement has equal and opposite consequences.) As society fragments and declines, the final symptom is the appearance of patriotism and official loyalty.

So it might be said that classical Chinese philosophers, whatever their philosophy, believed in the opposite of the old Western idea of progress, namely an idea of decline from a golden age. In fact there are exceptions to this: Mo Tzu and his followers, for example. But the more important point is that the Confucians had reasons for their respect of tradition that are quite independent of cultural assumptions. What is traditional is likely to have remained in place because it was not entirely unsatisfactory. Also traditions, examined closely, often represent accretions of trial and error; and they often evolve further after they are established, in such a way that undesirable features are rubbed away or diminished.

This is, it should be noted, a rather lukewarm defense of tradition. Perhaps more can be added to it. There are benefits to a sense of closeness with the

past. In a society, like Confucius's, in which ancestors are venerated, that would count for something. The main points though are (1) even though there clearly are traditions that are on balance harmful, one (so to speak) knows where one is with a tradition, and (2) it seems possible that whatever replaces a harmful tradition might turn out to be on balance even worse.

My guess is that the classical Confucians, if they had been challenged on their general respect for tradition, would particularly have wanted to make this point in relation to ritual. Obviously any ritual originally was invented or developed, at some point or in some gradual progression. But Confucius clearly believed that the traditional rituals, at least the ones he talked about, had been developed to be beautiful and highly meaningful. To replace them from scratch with something else would point toward the likelihood of a substitute that was neither beautiful nor highly meaningful. Simply to eliminate the ritual would be a definite loss.

If one thinks, as I do, that there is something to this point of view, and that in some cases tradition should be given the benefit of the doubt, this at most suggests (again) caution. A general attitude of respect for tradition admits of plenty of exceptions, starting with traditions that clearly are harmful. It does not entail a policy of neutrality in all culture wars, or one of general inaction.

To sum up: there is a feminist case for holding that social traditions, whatever some of their merits and uses may be, have contributed to limiting the capacities and possibilities of half of the human race, and through the rituals and social roles they validate have distorted the selves of most women in ways that rob them of fulfilling lives. This suggests the importance of policies of change in the roles and rituals expected of women, or that men play in relation to women. To the extent that a feminist ethics focuses on roles and rituals, and on the ways in which they function in the development of self, it is very like Confucianism in its philosophical vision. But it is like a Confucianism that is radicalized in fundamental ways.

Note: I am grateful to Bonnie Smith, and also to Diana Meyers, for helpful comments on a prospectus that led to this paper.

References

Confucius. (ca. 500 B.C.E.)/1938. *The Analects*. Trans. Arthur Waley. New York: Vintage Books.

De Beauvoir, Simone. 1953/1989. *The Second Sex*. Trans. H. M. Parshley. New York: Vintage Books.

Fingarette, Herbert. 1972. *Confucius: The Secular As Sacred*. New York: Harper and Row.

Gilligan, Carol. 1982. *In a Different Voice*. Cambridge, MA: Harvard University Press.

Hall, David L. and Roger Ames. 1987. *Thinking Through Confucius*. Albany, NY: SUNY Press.

Knoblock, John. 1988/1994. *Xunzi: A Translation and Study of the Complete Works*. Stanford, CA: Stanford University Press.

Kupperman, Joel J. 1999. *Learning From Asian Philosophy*. New York: Oxford University Press.

———. 2000. "Xunzi: Morality As Psychological Constraint." In *Virtue, Nature and Agency in the Xunzi*, ed. P. J. Ivanhoe and T. C. Kline III. Indianapolis, IN: Hackett.

Leach, William. 1980. *True Love and Perfect Union: The Feminist Reform of Sex and Society*. New York: Basic Books.

Li, Chenyang. 1994. "The Confucian Concept of *Jen* and the Feminist Ethics of Care: A Comparative Study." *Hypatia* 9 (1).

Mencius. 4th c. B.C./1970. *Mencius*. Trans. D. C. Lau. London: Penguin Books.

Meyers, Diana T. 1989. *Self, Society and Personal Choice*. New York: Columbia University Press.

Nivison, David. 1996. "Problems in the Mengzi: 6A3–5." In *Ways of Confucianism*, ed. Bryan W. Van Norden. La Salle, IL: Open Court, 149–66.

Ruddick, Sara. 1997. "Maternal Thinking." In *Feminist Social Thought*, ed. Diana Meyers. New York: Routledge., 584–603

Smith, Bonnie. 1998. *The Gender of History*. Cambridge, MA: Harvard University Press.

The Way of Life. Tao Te Ching. Trans. R. B. Blakney. 4th or 3rd c. B.C.E./1955. New York: Mentor Books.

Mengzi, Xunzi, and Modern Feminist Ethics

Philip J. Ivanhoe

1. Introduction

To those who study the classical Chinese tradition, the debate between Mengzi (or Mencius) and Xunzi (or Hsün Tzu) concerning the character of human nature and how it does or does not offer a sense of and justification for Confucian values are familiar issues. Though there is still a range of interpretations as to what each of these early Confucians thought and the sense in and degree to which they disagreed, most scholars would accept the idea that Mengzi believed that human nature offers us both some guidance to the ethically good life and an important part of the justification for that life.[1] Most too would accept the idea that Xunzi denied that our innate and untutored nature contributed to either of these aspects of the properly lived life.[2] What will seem less familiar and perhaps at first implausible is the idea that this early Confucian debate can contribute in significant ways to contemporary feminist ethics. I will argue that among contemporary forms of feminist ethical theory are two general types, that these types to a significant degree reflect the debate between Mengzi and Xunzi, and that comparing the views of these contemporary feminists and early Confucians can help us to gain a clearer understanding of both. Beyond descriptive advantages, such comparison raises serious and productive challenges to both early Confucian and contemporary feminist thinkers.

2. Mengzi and Xunzi

Mengzi and Xunzi are both virtue ethicists but they offer very different views concerning the foundations of the Confucian ethical vision. Mengzi sees the interpersonal roles and norms of Confucian society as the developed and mature expression of tendencies, feelings, and attitudes that are innate to human nature. These tendencies, feelings, and attitudes can be observed in nascent form in the "four sprouts" *siduan* 四端 which are the beginnings of the full virtues benevolence, rightness, propriety, and wisdom. These "sprouts" manifest themselves in certain of our spontaneous actions and reactive attitudes and hence offer us some guidance as to the form and direction of the ethical

life. Developing these nascent ethical tendencies is also thought to be necessary for complete human flourishing, and hence these inclinations provide an important part of the justification for the Confucian way of life.

Xunzi explicitly rejects Mengzi's theory of human nature and his use of it to ground Confucian values. In its place, Xunzi argues that our innate nature is bad and needs to be reformed and redirected through a prolonged and arduous process of practice, study, and reflection in order to conform to the social norms and roles of Confucianism. Such reshaping of our nature allows us to satisfy more of our standing, natural desires, but it also allows us to "conscript" other innate tendencies and capacities into the cause of the moral life, thus opening up new and profound sources of satisfaction that are not available to our raw nature and that cannot be found outside of a properly ordered society.[3] Only once we have our recalcitrant and disruptive natural desires under control, can we begin to see and appreciate the new sources of satisfaction that life in a cultured society has to offer, and in this way we are able eventually to move from following the Confucian Way for prudential reasons to loving it as an end in itself.

3. Two Types of Feminist Ethical Theory

We can identify at least two feminist models of virtue within the increasingly rich and sophisticated literature of contemporary feminist ethics. The two models that I shall describe are ideal types in the sense that one probably cannot find a completely pure example of either. Nonetheless, each model is fashioned in a manner that captures important sets of features common to the views of a number of actual contemporary feminist thinkers. The purpose of these models is to give us a helpful way to talk about certain kinds of theories within contemporary feminism and to facilitate our comparison of these theories with the early Confucians mentioned above.

The first type is the *gendered virtue* model. This model makes what are often called "essentialist" claims about the different natures of women and men. Such theories maintain that there are special virtues characteristic of men and women and that these arise out of and reflect their different basic natures. A clear and early non-feminist representative of this position is Rousseau. In his work *Emile, or on Education*,[4] he describes the ideal education that a young man should receive, an education that will develop the set of virtues that are the full manifestation of his "manly" nature. In this same book, though not occupying as important a position, is a description of the proper education Emile's ideal spouse, Sophie, is to receive. It too is described in terms of developing virtues that fully manifest her basic nature. But while Emile's virtues concern life in the public realm of a citizen, Sophie's virtues concern life in the private realm of the home. According to Rousseau, women not only have special virtues that are theirs alone, they lack many virtues that are seen as exclusively male. And the virtues that women are thought to lack are those required

for public, political life—the realm of not only a great deal of power but a distinctive range of human challenges and opportunities.

Mary Wollstonecraft attacks this view in her *A Vindication of the Rights of Woman*.[5] She argues persuasively against the idea that women have certain "domestic" or "feminine" virtues that reflect their particular nature and that men have a different set of "manly" virtues reflecting their particular nature. Wollstonecraft argues emphatically for the idea that virtues are in no way gendered in the sense I am now using the term, and that such appeals are not only mistaken but pernicious, for they deny women a large range of important challenges and opportunities for fulfillment. In her opinion, there are certain human excellences—traits of character that we have been calling virtues—and a given man or a woman might or might not possess these. But in no case or in any sense is this determined by the fact that the person is male or female. According to Wollstonecraft, neither men nor women have a biological advantage or greater tendency toward virtue.

More recently, some feminist writers have argued for a very strong version of what I am calling *gendered virtue*. They emphatically deny (or more usually simply do not discuss the possibility of) male possession of any special virtues; rather they focus on two related issues regarding this general topic. First, men, because they are male, possess or are more prone to exhibit certain vices. Second, women, because they are female, possess or are more prone to exhibit certain critically important virtues. In some cases, the second point is made more emphatically, taking the form of a claim that women possess exclusively or distinctively female virtues.

Mary Daly holds a strong version of this general position.[6] In representative works, she additionally insists that these female virtues can never be fully expressed in the present social context, which she contends is fatally contaminated with male vice. Contemporary society is so strongly "phallocentric" that it inevitably corrupts and distorts woman's true nature resulting in deformed "fembot" women. In order to avoid this profoundly damaging contamination, Daly urges women to retreat into female communities wherein they can preserve and nurture their true, good natures. If this seems overly radical and strange, one might pause to consider that throughout human history there have been special communities of men and women—often monks and nuns—who have sequestered themselves from the rest of us for quite similar reasons. In addition, there have been and still are a number of cultural traditions that argue for at least a clear separation between men and woman throughout the course of their lives. There are also informed and reflective people in industrialized Western democracies who today argue for a partial though substantial separation of men and women—particularly in educational institutions.

Though I do not offer a blanket endorsement of Daly's views, they impress me as worthy of serious consideration. If one reflects upon certain facts about human history or our contemporary society, some version of what she says about men does not seem altogether unreasonable. For example, if one simply

compares the number of violent crimes committed by men versus women or the respective representation of men versus women in the substantial prison population in this and other countries, it does not seem all that implausible to claim that, at least in certain respects, for some reason or other men are considerably less virtuous than women. And similar evidence is available for Daly's related claim that men's less virtuous character is a profoundly oppressive force on women. In any event, Daly presents a strong and elaborately worked-out example of the *gendered virtue* model.

Carol Gilligan, in her book, *In a Different Voice: Psychological Theory and Woman's Development*,[7] appears to hold a more moderate version of the *gendered virtue* position, one that stresses the central role that the emotions and interpersonal relationships play in woman's ethical thinking. At least in places in this early work, Gilligan sounds as if she is making essentialist claims about women's nature. Many people have read her in this way and such a reading would place her among advocates of the *gendered virtue* model. It is possible to understand Gilligan as being neutral on the issue of whether or not certain styles of ethical reasoning are part of women's nature or simply a function of the way they were psychologically formed, given the practices and character of our society. Such an interpretation sees her work as more closely related to the writings of scholars like Nancy Chodorow.[8] Minimally then, her point is that there simply are different styles of ethical reasoning that for some reason or other have come to be characteristic of women and men respectively. The main point of her argument would then be that the style characteristic of men has been arbitrarily established as "superior" to that of women and that this is bad for everyone.

One of Gilligan's primary goals is to present a case against a certain kind of abstract, ethical argumentation.[9] On such a reading, what she calls the "male" ethical perspective conceives of moral problems in terms of abstract rules and sees ethical reasoning on the model of geometric proof or arithmetic calculation. In contrast, what she calls "female" ethical reasoning conceives of moral problems more in terms of interpersonal relationships and sees ethical reasoning on the model of a conversation, a kind of dialogical negotiation informed by feelings and designed to maximize harmony and community. On such an interpretation, the styles of ethical reasoning Gilligan describes may only be contingently related to men and women. They may not really be more characteristic of men or women's nature but still may represent genuine, distinct and perhaps equally valid styles of ethical reasoning. However, if we read Gilligan in the first way proposed above, that is, as making essentialist claims correlating these different styles of ethical reasoning to "male" and "female" natures, then her view offers another excellent example of the *gendered virtue* model.

In her influential work, *Caring: A Feminist Approach to Ethics and Moral Education*, Nel Noddings[10] seems to present a strong statement of the *gendered virtue* model. She argues that the currently dominant analytic approaches to

ethics, because they leave out the many details of specific moral problems, do not provide an adequate account of how moral reasoning takes place or how ethical sensibilities develop. She sees the analytic approach as distinctively male and opposed to a characteristicly female way of reasoning: one that is focused on the local and specific details of each moral decision and that develops intuitions by working through many such cases over the course of a lifetime. Noddings clearly does make essentialist claims about differences between the ethical approaches of men and women. For example, at one point in her work, in the course of discussing Kierkegaard's use of the story of Abraham and Isaac, she remarks, "I suspect no woman could have written either Genesis or *Fear and Trembling*."[11] One could imagine a traditional Confucian thinker, particularly one of the Mencian persuasion, making a similar claim that no true Confucian could have written or even conceived of either text.

It should be clear that individual feminist thinkers have held different versions of the *gendered virtue* model. What virtues are thought more characteristic of men than women, whether women and men share a natural capacity for at least some virtues, and the degree to which women and men are capable of developing the virtues thought to be more characteristic of the other are all areas where significant disagreement can be found. Nevertheless, this kind of theory represents a distinct and important type of feminist ethical theory. The most extreme versions of the *gendered virtue* model claim that critically important virtues are distinctively a reflection of women's nature and that only women can develop such virtues fully. More moderate versions of the *gendered virtue* view maintain that by nature women, in contrast to men, have greater natural tendencies toward or resources for seeing and appreciating at least certain ethical values. This is because by nature they purportedly are more attuned to the particularity and context of ethical actions and events as a result of their greater awareness and sensitivity to the ethical dimensions of interpersonal relationships. Moreover, women again in contrast to men, are said to tend to make ethical judgments more by relying on feelings and intuitions than abstract, impersonal rule-following.

Historically, the beginnings of our second type of theory, the *vocational virtue* model, can be found in early feminist thinkers like Wollstonecraft who saw the lives of the women of their time as strongly influenced, if not practically determined, by socioeconomic conditions and societal norms and practices. The *vocational virtue* model is also related to and in the course of its development was greatly influenced by Marxist analyses of the status of women, to which a number of twentieth century feminist thinkers were attracted.[12] In rough and basic terms, Marxist approaches explain many actions, beliefs and attitudes in terms of people's class membership and the dynamic of class struggle. On such an interpretation, women are seen as an oppressed class. Men are the dominant class and exploit women in order to maintain their privileged status. Less plausible versions of this view make this exploitation of

women a conscious choice and active conspiracy on the part of all or most men. More plausible versions of it claim that the choice is subconscious or that the exploitation is a result of social institutions, practices, and beliefs that arose slowly, over extended periods of time, but without any overall intention or plan. It is but a small step from class to the notion I am calling vocation.

The basic idea behind the *vocational virtue* model is that a person's regular work and practices inform and shape many of their actions, beliefs, dispositions, and attitudes. In the language we have been employing, a given vocation gives rise to certain characteristic dispositions or virtues. The argument is that women historically have been relegated (to some degree for reasons perhaps originally having to do with biology but now primarily because of tradition or conscious oppression), to certain kinds of work (e.g., child rearing and home work, but also occupations such as primary school teaching and nursing). As a result of engaging in these "nurturing" or "care-giving" kinds of activities, woman have tended to develop a corresponding characteristic set of virtues (e.g., caring and nurturing) and a distinctive set of approaches (e.g., networking, relational reasoning, etc.). In other words, rather than being an expression of some innate female nature, these dispositions or virtues are seen as socially constructed. Such a view makes no essentialist claims regarding the nature of women; the dispositions or virtues characteristic of women are not held to be in any way essentially female. The high positive correlation between these characteristics and women is attributed to contingent historical causes and conditions. If men took part in childrearing, nursing, and teaching (as some men do) they too would develop what are characteristically described as "feminine" virtues. Advocates of the *vocational virtue* model argue not only that it is unjust to deny women equal access to all vocations and virtues or to undervalue "feminine" virtues, but also that failing to appreciate these particular virtues diminishes men's lives as well and distorts their understanding of the true nature of the good life.

Another important respect in which (especially earlier) feminist theories of this type show the influence of Marxist theory (and the influence is greatest from Chinese versions of Marxism) is their concern with "consciousness raising." The reasons for the prominence of this concern are complex, but most have to do with views about how sexist beliefs and attitudes are acquired and what it takes for people to ameliorate and work to rid themselves of them. Feminist thinkers influenced by Chinese Marxists believe that the unjust and oppressive practices, beliefs, and attitudes of patriarchal society are inculcated through a lifetime of subtle influences. These accumulate in multiple, often individually thin layers that grow thicker and more powerful over time, mutually interacting with and reinforcing one another. Exposure to such repeated, complex, and omnipresent influences obscures the overall structure and pattern of such ideologies and they eventually come to be regarded as background assumptions and "common sense." Thus they are not immediately available to the conscious-

ness and critical appraisal of even well-intentioned and reflective individuals. The thought then is that in order to become aware of such deeply ingrained sexism in ways that will enable us to begin to overcome it, we need a prolonged, diverse and intensive program of cognitive, emotional, and behavioral therapy. This feature of certain modern feminists not only is remarkably similar to aspects of Xunzi's ethical theory; one could argue that it is genetically related to this early Confucian thinker.[13]

As I have described it, there is nothing inherent to the *vocational virtue* model that sees one set of virtues as superior to another. In our own society the virtues associated with women are not rewarded monetarily or esteemed as highly as the more competitive "manly" virtues are, but according to this model that could be otherwise. However, even if this were the case, there would still be something objectionable to holding men or women to only one set of vocations, for such a policy would be purely ad hoc and would prevent large numbers of people, both men and women, from pursuing challenging and fulfilling work.[14]

In summary, the *vocational virtue* model claims that one can identify different sets of virtues that are to a large degree characteristic of contemporary men and women respectively. Thinkers who endorse versions of this model acknowledge that women manifest distinctive dispositions and tendencies but understand these as the result of the particular social roles and norms that women have been allocated under the systematic oppression of patriarchy. So, for example, because women in the past were only granted opportunities to be mothers, teachers, and nurses, they developed attitudes and dispositions like "nurturing" and "caregiving" that are characteristic of these lines of work. These contingent historical social conditions also inculcated in women certain "styles" of reasoning. In particular, women are thought to place greater emphasis on emotions and more value on local, "concrete" relationships. In contrast to men, they purportedly tend to conceive of and think about ethical situations in terms of recognizing and harmonizing different constituencies within local, interpersonal networks of relationships. The *vocational virtue* model differs from the *gendered virtue* model in denying that such characteristically "feminine" virtues, attitudes, or approaches are in any way manifestations of a distinctively female nature. If men were relegated to such roles and regularly engaged in such work, they too would develop these dispositions. Virtues are in no way correlated with conceptions of essential nature—male or female.

4. Mengzi, Xunzi and the Two Models of Virtue

Mengzi can be understood as holding something resembling the *gendered virtue* view while Xunzi holds something more like the *vocational virtue* model. For example, like those who argue for versions of *gendered virtue*, Mengzi sees the foundations of ethics in certain innate tendencies and attitudes (our moral

"sprouts") which are affective feelings or sensibilities as opposed to purely cognitive states. While not overtly crediting women or men with greater moral sensibility, Mengzi grounds ethics in species-specific, essentialist claims about human nature. Moreover, again like this group of theorists, Mengzi seems to insist that these innate tendencies and attitudes can only truly be found, or found in their most clear and palpable states, in concrete, context-sensitive ethical judgments and in actual, interpersonal—particularly familial—relationships.

Since approximately the tenth century C.E., versions of Mengzi's interpretation of Confucianism have been considered orthodox in China and as a result have had the most influence on the culture. Since regular contact with the West occurred many centuries after the ascendence of this school of interpretation, Mengzian-style Confucianism is the primary source of Western conceptions of the tradition. It is revealing that even well-informed Westerners have tended to describe Chinese thought and culture as "soft" and "feminine" in supposed contrast to the "hard" and "masculine" character of Western thought and culture. This standing prejudice, which is still easily found among educated people today, can be understood as a result of the significant similarities between Mengzi's thought and a certain conception of gender differences.[15]

In opposition to Mengzi, and like the *vocational virtue* model, Xunzi sees our ethical sensibilities as for the most part socially constructed, not directly arising out of our innate nature. We see things with a particular ethical hue because we have taken on a second nature in the course of embodying the roles and interiorizing the norms of culture. While reflecting certain brute facts about and developed capacities of human beings, ethical value arises out of and is inextricably bound up with cultural institutions, practices and ideology. Ethics is something human beings make more than something that they discover or *find*.

While Xunzi and this group of feminist thinkers share these important similarities, there are profound differences not only in the content but in certain theoretical aspects of their respective views. For example, feminist thinkers who advocate the *vocational virtue* model reject Mengzian-style views because they appeal to essentialist notions of human nature. Such notions have had a long and generally pernicious history in both China and the West because they claim that clearly oppressive traditions, institutions, practices, and attitudes are "simply" the exterior, social expression of interior essential differences between men's and women's natures. Xunzi expresses no such concerns with the Mengzian picture. He has no particular suspicion of essentialism *per se* and in fact makes essentialist claims of his own (though he would insist that these are simply empirical observations).[16] His objection is that the deeply rooted and resilient good tendencies that Mengzi claims are the most essential part of human nature simply do not exist. They therefore can provide neither guidance nor a reliable foundation for the Confucian way of life.

5. Contemporary Feminists and Early Confucians

The comparisons sketched above are helpful not only because they throw into relief certain aspects of each of the theories considered but also because they can draw attention to some of their shortcomings. Feminist theories in general offer devastating criticisms to all versions of Confucianism. The *gendered virtue* model raises particularly incisive challenges to Mengzi's interpretation of the tradition. For if a good human life requires cultivating certain innate moral sensibilities that are most clearly revealed and engaged in interpersonal relationships—particularly within the family but most clearly and poignantly in the care of infants and children—then it seems incredible to argue that women are somehow less able to cultivate these defining human characteristics.[17] To do so requires not only a massive and on-going denial of clearly demonstrated abilities of women; it is also obviously contrary to contemporary ideals about the "natural" tendencies of women that were widely held in Mengzi's own culture. Given the realities of early Chinese society (and for the most part these differences remain in most contemporary cultures as well) women obviously manifest the paradigmatic Confucian forms of caring "as if watching over an infant"[18] more often and less ambiguously than the men of Mengzi's society. While admittedly speculative, one is tempted to see the Confucian denial of full and equal ethical status and capability to women as a subconscious recognition of the failure on the part of most, if not all, men to live up to their own high ideals and as a convoluted projection and subsequent denial of their own caring nature.[19]

Mengzi and his later followers are not the only ones who are challenged by such a comparison. For many feminists who advocate versions of the *gendered virtue* model claim or at least strongly imply that we would avoid many of the problems of patriarchy if only our ethics were characterized by an appeal to certain innate feelings and sensibilities, took into account the concrete and context-sensitive nature of ethical judgments, and emphasized the central importance of interpersonal relationships.[20] But, as we have seen, Mengzi's ethics overtly and vigorously advocates all of these features and yet proved compatible with a profoundly patriarchal and at times deeply misogynistic form of life. This does not mean that the features of ethical life that such thinkers call attention to are not important and perhaps necessary for the actual achievement of a good human life, but it does show that alone they are not sufficient. It seems that we need both the more abstract, theoretical perspective they often reject as well as the sensitivity, discrimination, awareness, and judgment they insist upon.[21]

Xunzi's view too has much to learn from contemporary feminist ethics. Like Mengzi, he often indirectly appeals to essential differences in the capacities of men and women (though he does not seem to believe that either is well-constituted for the ethically good life). Xunzi tends to filter such appeals through

the "proven efficacy" of tradition in order to justify the sexist distribution of roles and obligations in Confucian society. He believes that, all things considered, traditional social practices and norms are the best possible arrangement for all concerned. He does give some play to the idea that past sages tried out various configurations of rituals and norms before arriving at the ideal set that defines the Confucian way of life. But he leaves no clear room for, much less an imperative for, engaging in Millsian-style "experiments in living."[22]

But the comparison of Xunzi with feminists who advocate versions of the *vocational virtue* model raises questions for these contemporary thinkers as well. At least some people who advocate this model seem to assume that human nature is, if not a blank slate, then a slate that can be easily erased and redrawn.[23] Such thinkers assume that human nature is extremely plastic and capable of taking on any kind of disposition or attitude.[24] Xunzi's theory about the content and tenacity of our original nature raises several important questions for such a view. For while he acknowledges the constructed nature of ethics, the human contribution to all that is good about us and our societies, Xunzi insists that such constructions are constrained by ineliminable features of both human nature and the natural world. In other words, he does not believe that we are blank slates or that we are easily and infinitely reprogrammable. On the contrary, he believes there is a specific and recalcitrant content to human nature.[25] This places critical constraints on ethical theory-building and implies a certain level of humility about what our ultimate possibilities may in fact be.

Such a view is unavoidably conservative (though not necessarily to the degree that Xunzi's thought tends to be). It counsels us to be extremely cautious about proposals that would wholly eliminate or undermine what appear to be deeply entrenched and widely observed features of human behavior. These and other aspects of current practice and belief should always be open to criticism and revision, but we should proceed with care and without the dogmatic beliefs that all tradition is bad and all change good. For example, we should be wary of proposals that call for the wholesale elimination of at least some conception of the family and the special obligations inherent to such institutions.[26] It may be that these traditional aspects of life are constraints upon a brave and beautiful new world. But while traditional conceptions of the family clearly need to be more broad and accommodating than they have been in the past (and of course this is already the case in many cultures) it may also be that they are the only available means we have for preventing us from pursuing even more demented, destructive, and dismal lives.

Our modern recognition that we are products of evolution and that we share much more with our follow creatures than many are willing to admit should make us cautious of accepting the very cerebral picture some social constructivists advocate. We are not brains in vats, nor computers waiting for the latest software to be downloaded into us. We are embodied, complex, frail,

and in many ways, frightened and potentially dangerous creatures. Along with our remarkable abilities to imagine, think, and reform ourselves and our natural inclinations to play with and care for one another, we also retain selfish, aggressive, and violent inclinations and attitudes that are often difficult for us to see and appreciate (especially in ourselves). If we are creatures of such parts — and all the evidence would support such a supposition — then perhaps it is impossible to fully erase these aspects of ourselves without destroying the very possibility of a good and fulfilling life.[27] It may be that Xunzi is correct in saying that in order to become good (or at least better) we must recognize and accept just how bad (by nature) we really are.[28]

Xunzi's account of how difficult it is to transform our natures, how it requires a combination of prolonged and protracted practice of rituals, extensive study, and sustained and deep reflection, challenges those who believe that altering even relatively minor aspects of our nature is easy and primarily a matter of proper understanding.[29] Related to this view is Xunzi's focus on the role of tradition. If much of our ethical orientation does indeed arise out of the pre-reflective practice of social roles and norms, then a critical perspective on what Confucians call our social "rituals" would seem to be an important part of ethical reflection. If, as Xunzi and many feminists would insist, the influence of society is powerful and vast while often furtive and subtle, then the perspective of social practices and norms is extremely important. Overcoming certain ethical challenges — and sexism and racism are prime candidates in this regard — requires a strenuous and well-coordinated effort on the social level of cultural practices and institutions as well as on the personal cognitive level.[30]

6. Conclusion

Among their many contributions to contemporary thought and culture, feminist thinkers have done important work increasing our awareness of how often hollow and wholly uncritical — even cynical — appeals to "essential human nature" or "tradition" have served to justify oppression, exploitation and cruelty. Mengzi's views are most vulnerable to those criticisms focussed on appeals to human nature while Xunzi's position is more susceptible to challenges directed at appeals to tradition. These early Confucians and nearly all of us still have much to learn and to do in order to address these weaknesses in our societies, our philosophies, and ourselves.

It is important though to realize that conceptions of human nature have at times been used to argue for the liberation of women and other human beings, and indeed some such theory seems necessary as a warrant for any kind of struggle for justice and equality. The problem is not with the idea of a theory of human nature per se but with many of the particular theories that have been offered. Since conceptions of human nature have almost always been developed and enforced by men, without the slightest attention to the issues of essentialism

mentioned earlier, they have traditionally reflected men's interests and thus served to exploit and oppress women, both directly and in more insidious ways. But these past errors should not lead us to forsake the search for plausible and defensible conceptions of human nature. For we may find that we have within us important resources for self-improvement (as Mengzi claims we do) and certain recalcitrant weaknesses and unsavory tendencies that we must work mightily to overcome (as Xunzi warns).

Appeals to "tradition" and what has "worked" no longer carry the force they once had, and in general this is a good thing. Such appeals cannot escape and should not avoid rigorous challenge and careful scrutiny. But this does not mean that we must dogmatically reject all appeals to tradition and what has worked. There is nothing fundamentally wrong with a pragmatic appeal to what has proven feasible and beneficial in the past. However, we must evaluate these appeals in terms of issues such as their basic justice, their overall benefits and harms, and their impact on the worst off. We must be particularly attentive to and even a bit suspicious about whose interests are being served; in other words, whose interests is tradition "working" for? But we must not overlook the fact that every living tradition, even those that are clearly and profoundly flawed, provides its members with many goods central to a flourishing human life. Our traditions—as well as more palpable "technologies" like our machines—define what we are or at least where we begin the task of becoming what we would like to be.[31] We simply can't rid ourselves of our institutions, practices and beliefs overnight, and even if we could, in many cases, we would be ill-advised to do so, for we would lose much of value. The options before us are not restricted to blind fidelity or revolution. We can have respect for what our ancestors and elders have achieved while at the same time criticizing aspects of our common way of life and seeking to improve upon it. This critical work can itself be seen as an expression of respect, even veneration.[32] And we should keep in mind that whatever we might achieve shall in turn be looked upon by future generations who, if we have taught them well, will undoubtedly surpass us as well. There is no end to history or to the challenge of being human.

Neither men nor women are destined to be a certain way simply because of their biology and no tradition is complete or without flaws. Even our most characteristic features and most cherished beliefs may be open to change through reconceptualization, training, or technological manipulation. On the other hand, the idea that nothing of what we presently are is given to us by biology may prove to be merely human conceit and ultimately a dangerous denial. It is hard to see how one could believe in evolutionary theory and the related idea that we are on a continuum with other animals and yet also believe that we make ourselves up in such a wholesale manner.

Many people underestimate the degree to which what they believe is characteristic about men and women is in fact simply a function of what kinds of

vocations each has had an opportunity to pursue. But accepting this as true does not necessarily entail believing that there are no significant differences between men and woman. At the very least, it would be premature to declare that this is so. The assumption that we are all the same may in fact create or perpetuate ignorance and injustice. Physiologically, hormonally, and chemically, men and women are significantly different and some of these differences may allow some of us to be more sensitive to certain aspects of what it is good to do and to be. For example, women who have carried and given birth to a child have a unique opportunity to gain a sense of how dependent human beings are upon one another. They also have a greater opportunity to become aware of the frailty of human life and the joy of nurturing another in a direct and physical way. But it is wrong to think that this somehow defines what women really are. Rather, it is one remarkable thing that many women can be and can do and that no man can. It is also wrong to think that those of us who have not or cannot have such experiences cannot come to understand, to a significant degree, what these insights are like and why they are important to us all. One just has to work at being a good and sympathetic listener, exercise one's imagination, inquire and discuss and engage in certain practices. In a similar way, someone who has suffered oppression has an opportunity to understand, in a more profound and nuanced way, how it works and why it is reprehensible. But in none of these cases does this preclude others from understanding why some things are virtues and others vices. There may well be important differences between men and women, but these differences may be narrowed by learning and practice, and they in no way define two irreconcilable perspectives on ethics or life. Indeed the most complete account of what we are and should be will be found by combining as many insights as we can find.

If there indeed are significant differences between women and men, they might be mitigated or even eliminated through technological innovation. Perhaps in the future children will be conceived and come to term in cocoons outside the womb. This would free many women from what is an undeniable danger and burden and might go a long way toward eliminating one of the biological bases for presently existing gender differences.[33] But such profound manipulation may not lead to more satisfying lives for women or men. If we ever do opt for having cocoon babies—and from an engineering point of view we surely can—we might find that we lose critically important psychological bonds and ethical orientations, evolved over many millennia and operating in subtle ways to support and hold ourselves and our societies together. The result might be disastrous for us all. This is not to say that we should not consider such options, only that we should be cautious and not ignore what we presently are in our rush to become something else.

The most sensible course to take would seem to lie between the opposing extremes described by the two models that we have used to carry out the foregoing exploration and comparison between two early Confucians and a number

of contemporary feminist ethicists. Perhaps keeping these two models and the various views they represent before us will help us to recognize the resources we are born with without abdicating the responsibility to make the most of ourselves. This is an approach that we can imagine both contemporary feminist philosophers and early Confucians might endorse.

My thanks to Mark Berkson, Mark Csikszentmihalyi, Eric L. Hutton, T. C. Kline, III, Pauline Chen Lee, Li Chenyang, and Joel Sahleen for very helpful comments and suggestions on earlier drafts of this essay.

Notes

1. The seminal work on Mengzi's conception of human nature is Angus C. Graham's "The Background of the Mencian Theory of Human Nature," *Tsing Hua Journal of Asian Studies*, n.s. 6:1–2 (1967): 215–274. Reprinted in Angus C. Graham, *Studies in Chinese Philosophy and Philosophical Literature* (Albany, NY: SUNY Press, 1990). My views of how Mengzi's conception of human nature informs his ethical theory and how his views differ from Xunzi's can be found in "Thinking and Learning in Early Confucianism," *Journal of Chinese Philosophy* 17 (1990): 473–93 and in chapters two and three of *Confucian Moral Self Cultivation* (Indianapolis, IN: Hackett Publishing Company, 2000).

2. For my interpretation of Xunzi's ethical thought, see chapter three of *Confucian Moral Self Cultivation* and "Human Nature and Moral Understanding in the Xunzi," in T. C. Kline and Philip J. Ivanhoe, ed., *Virtue, Nature and Moral Agency in the Xunzi* (Indianapolis, IN: Hackett Publishing Company, 2000): 237–49.

3. The most illuminating account of this aspect of Xunzi's ethical theory is provided by T. C. Kline. See his "Moral Agency and Motivation in the Xunzi," in *Virtue, Nature and Moral Agency in the Xunzi*, 155–75.

4. Jean-Jacques Rousseau, *Emile, or on Education*, tr. Alan Bloom (New York: Basic Books, 1979).

5. Mary Wollstonecraft, *A Vindication of the Rights of Woman*, ed. Miriam Brody Kramnick, ed., (Harmondsworth: Penguin, 1975).

6. Mary Daly has held a range of related and evolving views. The position discussed here is represented in works such as *Beyond God the Father: Towards a Philosophy of Woman's Liberation* (London: Woman's Press, 1973) and *Gyn/Ecology: The Metaethics of Radical Feminism* (Boston, MA: Beacon Press, 1978). As discussed below, Daly advocates a thorough separation of the sexes. For quite different reasons, traditional Confucians also maintained a fairly strong separation of the sexes.

7. Carol Gilligan, *In a Different Voice: Psychological Theory and Woman's Development*, (Cambridge, MA: Harvard University Press, 1982). In her "Letter to Readers, 1993" preface to the reprint of this seminal work, Gilligan deflects the question of essentialism, claiming that it is not among "my questions" (p. xiii).

8. For Chodorow's view of gendered childhood development, see Nancy Chodorow, *The Reproduction of Mothering: Psychoanalysis and the Sociology of Gender*, (Berkeley, CA: University of California Press, 1978).

9. The particular statement of this view that Gilligan explicitly challenges is Lawrence Kohlberg's; see his The *Philosophy of Moral Development: Moral Stages and the Idea of Justice* (San Francisco: Harper and Row, 1981). Kohlberg has offered a response to criticisms like Gilligan's in "Synopses and Detailed Replies to Critics," in Lawrence Kohlberg, Charles Levine, and Alexandra Hewer, *Essays on Moral Development* (San Francisco: Harper and Row, 1984). See also the incisive discussion by Seyla Benhabib in her *Situating the Self: Gender, Community and Postmodernism in Contemporary Ethics* (New York: Routledge, 1992): 148–202.

10. Nel Noddings, *Caring: A Feminist Approach to Ethics and Moral Education*, (Berkeley: University of California Press, 1984).

11. Noddings, 1984, p. 43.

12. It is difficult to single out examples of early feminists who were influenced by Marxism as the influence were so pervasive. Aside from obvious examples such as Alexandra Kollontai, who were both Marxist and feminist, such influence is widespread and easily seen in contemporary thinkers such as Catharine A. MacKinnon (who offers some searing criticisms of Gilligan's views) and Debra Satz, whose work I discuss briefly below. As is true of intellectual criticisms of racism in this century, much of the vocabulary for challenging systematic oppression came from sophisticated expressions of Marxist theory. Gender, race, and class were often regarded as different expressions of a single corrupt and oppressive social and economic structure. Recently, this more organic perspective is less pronounced.

13. I mean that "consciousness raising" comes into modern feminism primarily by way of distinctively Chinese forms of Marxism and these owe this particular feature to traditional and largely Confucian forms of self-cultivation. For an interesting article describing some of the continuities between traditional Chinese thought and Chinese Marxism, see David S. Nivison, "Communist Ethics and the Confucian Tradition," *Journal of Asian Studies* 16.1 (November 1956): 51–74.

14. K. Anthony Appiah makes a similar criticism about what he calls racial "scripts," narratives "that people can use in shaping their life plans and in telling their life stories." See his "Identity, Authenticity, Survival: Multicultural Societies and Social Reproduction" in *Multiculturalism*, ed. Amy Gutmann (Princeton, NJ: Princeton University Press, 1994): 149–63.

15. Such preconceptions about the nature of ethics and the different tendencies and capacities of men and women lie behind many aspects of what has been called "Orientalism." These, rather than "Imperialism" as Edward Said suggests, are a more plausible source for prejudice regarding "Far" as well as "Near Eastern" peoples and cultures. For Said's views see Edward W. Said, *Orientalism* (New York: Vintage Books, 1979).

16. For example, Xunzi sees women as by nature disruptive to social order, presumably because of their "seductive powers" (see John Knoblock, tr., *Xunzi: A Translation and Study of the Complete Works*, vol. 2 (Stanford, CA: Stanford University Press,

1990): 242). Moreover, he regularly describes the relationship between men and women in terms of the latter's natural subservience to the former (see Knoblock, tr., vol. 2, p. 103 and vol. 3 [1994], p. 19, 216, etc.).

17. One of Mengzi's primary examples of ethical sensitivity is the alarm and concern one would feel if suddenly seeing a child in imminent danger. See *Mengzi* 2A6.

18. The example is from the "Announcement of Kang" section of the *Book of History*, one of the Confucian classics. It also appears in chapter 9 of the commentary section of the *Great Learning*. It is quoted by an opponent as a well–known Confucian principle in *Mengzi* 3A5.

19. In much of the Western tradition there was a fairly strong distinction drawn between emotion and reason. The latter was described as the essence of rational and ethical deliberations and thought to be characteristic of men. The former was seen as inimical to all forms of reasonable deliberation and described as characteristic of women. As misguided as such beliefs are, not only in the essentialist ascriptions along gender lines but also in their demarcation between reason and emotion, such beliefs at least provided some justification for discrimination. In the case of the Mengzian strand of Confucianism, no such appeal was possible. According to their own views about the nature of ethical deliberation and the nature of men and women, there could be no such "justification" and so discrimination against women is even more difficult to understand.

20. The care of children is often presented as a paradigmatic example of this perspective on ethics which again offers a remarkable similarity to Mengzian-style Confucians. For a particularly clear example, see Noddings, 1984.

21. For an impressive attempt to combine these perspectives see Benhabib, 1992.

22. For this idea, see John S. Mill, *The Subjection of Women*, ed. Susan Moller Okin (Indianapolis, IN: Hackett Publishing Company, 1988). One could revise Xunzi's view to accommodate such review and reform while holding many of his other ideas in place. But an adequate account of how this might be done is beyond the scope of the present work.

23. In order to capture the extent to which this view entails the idea that it is easy to erase and write over our nature, it might be helpful to think of this as the "Etch-A-Sketch" theory of human nature.

24. An example of the tendency to dismiss even the possibility that there may be psychological constraints on human possibilities is Debra Satz's claim that the vocation of prostitution is wholly compatible with a full and happy life. Satz is prematurely certain that prostitution is bad only because of social taboos, low financial remuneration, and dangerous working conditions. Now it is true that more open minds, better conditions, and better pay would make prostitution much less bad, but it simply does not follow that it would thereby be found unproblematic. Such a life would seem to make psychologically difficult, if not impossible, to find deep satisfaction in an intimate relationship, which may prove to be a basic human good. In any case, this is an open question, an experiment in living. We all have to await the results of such an experiment. To claim to know the outcome of such experiments a priori is to abandon

Mill's open-minded approach. This kind of view, at least the form that is found among contemporary thinkers, can be traced back to Sartre's wholly unattested, though still often invoked, insistence that "existence precedes essence." For Satz's view see her "Markets in Woman's Sexual Labor" *Ethics* 106, no. 1 (1995): 63–85.

25. In this respect, Xunzi resembles certain aspects of Freudian theory. However, unlike Freud he believes that we can transform, not merely sublimate, our basic needs and desires and that the good society not only can offer us the most satisfying or "contented" life but that such lives can only be found in such societies. For Freud's contrasting views, see his *Civilization and Its Discontents*, tr. James Strachey (New York: W. W. Norton and Company, 1961). Perhaps a better comparison on this issue is found between Xunzi and P. F. Strawson. See for example, his "Freedom and Resentment" in *Free Will*, ed. Gary Watson (Oxford University Press, 1990): 59–80.

26. Jean Grimshaw offers a revealing discussion of these general issues in her "Human Nature and Women's Nature" in *Feminist Philosophers* (Brighton, Sussex: Wheatsheaf Books, 1986): 104–138.

27. Aristotle insightfully observed that the good life for human beings must lie somewhere between what would be good for animals or gods (*Nichomachean Ethics*, X.8; 1178b24–29). In our own time, Mary Midgley offers one of the most balanced and revealing accounts of how we are creatures that both remain within and to some degree transcend our evolutionary legacy. See her *Beast and Man: The Roots of Human Nature* (London: Routledge, 1995).

28. See the "Human Nature is Bad" chapter of the Xunzi. For a translation, see Burton Watson, tr., *Hsün Tzu: Basic Writings* (New York: Columbia University Press, 1963): 161–62.

29. Toward the end of her edifying article, "Virtue Ethics and the Emotions," Rosalind Hursthouse discusses something like the kind of concern that I am pointing to. She worries about whether it is possible for a mature adult who has been raised in a racist society to ever really eliminate such prejudice. Confucians too worry about people reaching states of degradation that make it practically very difficult for such change to occur. Even for the very young, they insist that change requires a broad and concerted effort at transformation. Upon this general issue early Confucians, especially Xunzi, and contemporary feminists, especially those who insist on the need for and difficulty of "consciousness raising," are in close agreement and raise an immensely important objection to ethical theories that disregard the management and cultivation of desires, emotions, and beliefs. For Hursthouse's essay, see Danial Statman, ed., *Virtue Ethics: A Critical Reader* (Washington, D.C.: Georgetown University Press, 1997): 99–117.

30. Alasdair MacIntyre presents a strong argument that the nature of rationality itself is always embedded in actual historical traditions. See his *After Virtue* (Notre Dame, IN: University of Notre Dame Press, 1984); *Whose Justice? Which Rationality?* (Notre Dame, IN: University of Notre Dame Press, 1988) and *Three Rivals Versions of Moral Enquiry: Encyclopedia, Genealogy and Tradition* (Notre Dame, IN: University of Notre Dame Press, 1990).

31. The most original and illuminating discussion of the ways in which part of what we are is what we have made is found in Martin Heidegger's classic essay, "The Question Concerning Technology." See William Lovitt, tr., *The Question Concerning Technology and Other Essays* (New York: Harper Torchbooks, 1977).

32. For a poignant expression of how one's respect and love of a person, tradition, society, or culture can provide one with a particular (in this case non-violent) imperative to engage in protest with the hope of reform, see Martin Luther King, Jr., "Loving Your Enemies," in *Strength to Love* (Philadelphia: Fortress Press, 1981): 49–57 and "The Power of Nonviolence" and "Letter from A Birmingham Jail" in *I Have A Dream* (San Francisco: Harper San Francisco, 1986): 29–33, 83–100.

33. Shulamith Firestone has argued what several feminist thinkers have claimed or strongly implied: that childbearing itself is the primary cause of woman's oppression. She calls for the kind of "technological fix" that I have proposed but does not share my anxieties about what cascading effects this might have for human life in general. See her *The Dialect of Sex* (London: The Woman's Press, 1979).

Sexism, With Chinese Characteristics

David L. Hall and Roger T. Ames

In *Thinking from the Han: Self, Truth, and Transcendence in Chinese and Western Culture*, we have argued that an explanation of the classical Chinese model of self requires an appeal to a significantly different vocabulary from that which has framed those conceptions of self dominant in the development of Western cultures.[1] A failure to appreciate the real degree of difference between prevailing Western assumptions about self and their Chinese counterparts has had important consequences for some issues in cross-cultural studies. Perhaps none of these issues is more significant than that of the symbolism associated with the understanding of sexual difference. In this essay, we want to explore the implications of factoring the symbolic treatment of sexuality into the question of what it means to be a person.

Given the pervasiveness of the masculine prejudice in Chinese culture, we certainly will not pretend that the Chinese tradition is anything but sexist. We shall argue, however, that the shape that sexism takes in the Chinese tradition is culturally specific and reflects an alternative model for the interpretation of gender differences, a model which might offer a fruitful line of inquiry and practice for Western thinkers.

The Gender of Thinking

A generation of feminist reflection in the West has provided us with the useful distinction between "sex" and "gender." Sexual distinctions between males and females are associated with biological factors such as the possession of XY as opposed to XX chromosomal structures (in human beings), or, more generally, with the production of relatively small or large gametes, respectively, or with differences associated with reproductive physiology, and secondary sexual characteristics. "Gender," on the other hand, refers to specific roles and functions performed by men and women in various societies. Whereas, on this view, sexual differences may be said to constitute a transcultural phenomenon, gender distinctions are held to be culturally specific and often to vary significantly from one social or cultural complex to the next.

In considering the contrast between sex and gender we immediately encounter the predicament that the Cartesian dualism, an object of continual

scorn among contemporary late modern thinkers, stands behind this distinction.[2] This being the case, we are confronted with the question: how, if the dualistic nature of Western discourse is itself the product of a male-dominated society, shall we ever be able to escape the bonds of that way of thinking in order to appreciate the possibilities of a parity of the sexes? How can the instrument of our bondage at the same time serve as the instrument of our escape? The only reasonable response seems to be an undogmatic, pragmatic one, which suggests that we reckon with the fact that the Platos and Descarteses and Hegels of Western culture produced a discourse which, because of the vagueness and ambiguities of their own identities, is itself sufficiently ambiguous and vague to permit its productive employment by those opposed to its dominant import. Without some such assumption, any effort to create or to construct nonrepressive forms of sexual and gender identity are quite obviously doomed.

The one gender-related trait that seems practically pervasive in the human species is that of the dominance of the male sex over the female, when dominance is construed in broadly political terms. If it can be shown that this dominance is not a definite implication of biologically determined sexual differentiation, or that cultural evolution has reached a point that such natural determinants can be transcended, then social and cultural changes leading to parity between the sexes can more easily be pursued.

At the extremes, many sociobiologists provide the conservative "biology is destiny" arguments. The most familiar argument runs something like this: Females produce a small number of large gametes; males produce a large number of small gametes. The aims of procreation are served best by a "male tendency" to disperse gametes in as large a population as possible, and by a "female tendency" to nurture her fertilized eggs. Activities associated with male promiscuity and polygamous sentiments, as well as female domesticity and nurturance, are accounted for in this way. Thus behavioral differences at the cultural level are accounted for by appeal to genetic determinants. Gender is reduced to sex.

At the other extreme are those who argue for the pluralism associated with the original Darwinian vision of the variability of species. In the absence of any essential shared characteristics, there are no fundamental "natural kinds." Variations within a species constitute a primary expression of the mutability of species. By analogy, morphologically and genetically grounded variations among the members of a single sex argue against the use of sexual differentiation to ground explanations of behavioral differences. When one adds to the categories "male" and "female" those of "hermaphrodite" and "neuter," and supplements the gender-based notion of "heterosexuality" with that of "homosexuality," the degree of biological and cultural diversity is increased sufficiently to challenge the idea that sexual differences among human beings reflect "natural kinds."

Our own, distinctly pragmatic approach to the issues of sexuality and gender is well-expressed in the words of John Dupre:

What is unique about human beings is not their tendency to contravene an otherwise unvarying causal order, but rather their capacity to impose order on areas of the world where none previously existed. In domains where human decisions are a primary causal factor, I suggest, normative discussions of what ought to be must be given priority over claims about what nature has decreed.[3]

This is a classic illustration of the claims of *nomos* over *physis*. We endorse this view entirely as long as it is not (mis)understood in the stereotypically Protagorean form that interprets culture as the imposition of order through expressions of the human will. Viable human order is, as we have argued throughout our published work, an aesthetic achievement constituted by culturally specific activities. Applying this insight to our present subject leads to the following claim: Rather than gender differences being ruled by sexual distinctions, the reverse seems largely to be true.[4]

The outline of our argument is as follows: In Western cultures broadly, the sexual differentiation of male and female has tended to be rooted in dualistic categories which arguably ground the gender distinction. There is first the diremption of the range of possible human traits and dispositions into male and female. Male dominance has then led to the definition of the truly human person in terms which by and large privilege masculine gender traits. The achievement of humanity is thus construed as the realization of "maleness." Freedom from male dominance at the level of *sexual* differentiation has not freed the female to realize female *gender* traits, but rather has required that she, like the male, employ the gender roles of the male as the standard.

By contrast, in China the realized person has been broadly defined as an achieved harmony of the full range of human traits and dispositions. Male dominance is a consequence of sexual differentiation into "male" and "female" which has tended to exclude the female from the achievement of becoming human. Thus, the male has been free to pursue the task of realizing his personhood though the creation of an androgynous, or perhaps multigendered, personality.

The distinctive feature of the Chinese conception of gender is that, *per impossible*, were the female to be allowed freedom to pursue realized personhood, she could do this by seeking a harmony of the same range of human traits which the male employs as standard. Chinese sexism which denies to the female the possibility of becoming a human being is brutal in the extreme. The resolution is perhaps more humane. The status of women in Western cultures might be deemed less humbling, but the means of becoming truly human advertise a more subtle kind of dominance: To be human you must be male.

In her work on the relationship between gender and the Chinese cosmology in which gender relationships are subsumed, Alison Black notes:

We may legitimately pursue the possibility that some of the basic concerns of Chinese metaphysics and cosmology transcend questions of gender. . . . It is probably safe to say that the basic polarity is not one of gender. Not only do *yin* and *yang* not *mean* "feminine" and "masculine" etymologically or invariably or primarily. Gender in fact depends on too many other concepts in order to develop into something significant itself.[5]

Black then pursues those more fundamental conditions of the culture in which the gender distinction has emerged:

Is there any governing factor that lends consistency to the transitions and permutations of gender concepts in Chinese correlative thinking? Can we identify *the* basic polarity?[6]

We would argue that the first step in this recovery is to acknowledge that the contrasting senses of order described above have grounded and empowered sexist attitudes in both the Chinese and Western traditions. The cosmological contrasts in the Western tradition have tended toward exclusive dualisms; those in China toward complementary pairings. The basic polarity in China will doubtless involve the mutually implicated contrasts ("light" and "dark," "active" and "receptive"). The basic polarity in the West will involve mutually inconsistent pairings. An extremely influential illustration of this is the Pythagorean Table of Contraries as recorded in Aristotle's *Metaphysics*.[7] Characteristic of this set of pairings based upon the contrast of "limit" and the "unlimited" is the radical exclusivity of the categories.

PYTHAGORAS' TABLE OF CONTRARIES

LIMIT	UNLIMITED
ONE	MANY
ODD	EVEN
LIGHT	DARKNESS
GOOD	BAD
RIGHT	LEFT
STRAIGHT	CURVED
SQUARE	OBLONG
REST	MOTION
MALE	FEMALE

In the left column are listed the formal qualities which are so called because they are determined by number, the root metaphor of the Pythagoreans. On

the right are the inchoate properties or qualities which are indeterminate with respect to number. This is the basis of the form/matter distinction which would later become central to Aristotle's thinking. This set of dualistic associations has been ramified throughout the Western philosophical and literary tradition until it has taken on almost a truistic status.

One of the more influential responses on the part of contemporary feminists to this dualistic assessment of sex and gender differences is found in Carol Gilligan's distinction between a "feminine" and "masculine" voice.[8] Gilligan argues, first, that virtue is gendered, and second, that, contrary to the common notion that the female is less developed morally than is the male, the ethic which can be derived from the "feminine" voice has many qualities preferable to those of the male ethic.

Although Jean Grimshaw is unpersuaded herself that such a masculine/ feminine distinction can be meaningfully articulated and sustained, she does provide us with clear language for pursuing the distinction, citing a range of feminists in reconstructing what is fundamentally this same dichotomy between "the maleness of philosophy" and "the idea of a female ethic." Grimshaw presents the following list as six characteristics that advocates of the distinction, notably Jane Flax,[9] would identify as most revealing of the "maleness" of philosophy:

1. A denial of the social and interactive character of human development; a stress on the separateness or isolation of human beings.

2. Forms of individualism which stress autonomy; for example, the autonomy of the individual will or the autonomy of the knower and the radical separation of the knower from what is known.

3. Oppositions between mind and body, reason and passion, reason and sense.

4. Themes of the mastery, domination, and control of the body, the passions or the senses; and fears about loss of control.

5. Fear of women and of anything that is seen to be associated with them: sexuality, nature, the body.

6. Devaluation of all that is associated with women, and a need not to be dependent on it.[10]

Grimshaw then identifies the following three themes as recurring in those feminists who seek to pursue the lineaments of a female ethic:

1. A critique of "abstraction," and a belief that female thinking *is* (and moral thinking in general *should be*) more contextualized, less bound to abstract rules, more "concrete."

2. A stress on the values of empathy, nurturance or caring, which, again, are seen as qualities that women both value more and tend more commonly to display.

3. A critique of the idea that notions of *choice* or *will* are central to morality, and of a sharp distinction between fact and value; a stress, instead, on the idea of the *demands* of a situation, which are discovered through a process of *attention* to it and require an appropriate response.[11]

Although this contrast between "male" philosophy and the possibilities for a "female" ethic seems initially plausible, one may observe that, with respect to the mainstream of Chinese cultural self-articulation, there is a tacit rejection of those characteristics which define the maleness of Western philosophy in favor of what at least initially seems to be those same themes defining of a female ethic. *Ren* 仁, the central virtue of Confucianism, asserts the relationality and interdependence of human beings:

> Authoritative persons establish others in seeking to establish themselves, and promote others in seeking to get there themselves.[12]

Daoism and its notion of the "authentic person" (*zhenren* 真人) is a celebration of the pursuit of full contextualization for the always unique person within an ever-changing world. On the surface at least, it would seem that the patriarchs of both Confucian and Daoist philosophy expressed themselves in what is being described as a feminine voice, and given the pervasiveness of Confucianism and Daoism in the formative period of Chinese philosophy, it can be fairly argued that the development of Chinese culture has been strongly colored by feminine gender characteristics.

The observation that Chinese philosophy, taken in broad strokes, seems to promote either a sex- or gender-based ethic has at least three immediate implications for this discussion of feminist concerns.

First, given that Chinese philosophy has been no less a male-dominated occupation than Western philosophy, it would seem to support Grimshaw's resistance to the notion that philosophical temperaments and positions are physiologically based. After all, Chinese males seem to embody at least some of the characteristics that feminists who embrace the distinction between male and female gender have assigned to a female ethic. There seems to be something more fundamental than gender difference at issue. Where "female voice" and "male voice" might be serviceable categories in the context of Western culture, these categories seem irrelevant to Chinese society.

Secondly, the Chinese example is surely a caution to those feminists who would promote a female ethic as an adequate resolution to Western sexist problems. If we take the Confucian experience into account, the reign of what is being described as a female ethic, far from precluding sexism, seems to have spawned an alternative, equally pernicious strain.

Thirdly, the specific characteristics that define the so-called maleness of the dominant Western style of thinking, such as autonomy and self-sufficiency, in contrast with the femaleness of a nurturing, caring tradition, suggests at least one reason why Western philosophy, so defined, has failed to take the Chinese philosophic tradition seriously as real philosophy. And to the extent that the Western tradition has allowed Chinese philosophy a place, it is a place defined through the imposition of the disciplinary categories and standards of Western thought. As long as Western philosophers maintain their commitment to the Enlightenment project which promises it a self-sufficient certainty and which makes alternative traditions interesting only as a source of corroboration, Chinese philosophic and cultural activities will remain on the periphery.

2. Dualistic Sexism

Above we have suggested that the idea of a sex- or gender-based ethic seems, on the surface, to be consonant with the aesthetic understandings of the Confucian/Daoist tradition. On inspection this turns out not to be the case, as we shall now argue. The primary argument against such compatibility is that the notions of either a sex- or a gender-based ethic reside within a dialectical context predominantly shaped by the recalcitrant male voice. What is at issue here is not simply the sex or gender distinctions, but the more general dualisms associated with the dominant Western tradition of thinking. This dualism begins at the cosmogonic level with the distinction between the procreative relations of Heaven (Male) and Earth (Female) which reflects, ultimately the contrast of Cosmos (rationality, Male) and Chaos (nonrationality, Female), and is instantiated philosophically in the contrasts of the worlds of being and becoming and of the rational and irrational souls in Plato. The dualism is of fundamental importance to Aristotelian thought expressed as the form/matter distinction. Its modern avatar, of course, is the mind/body dualism spawned by Cartesian mechanics.[13]

Proponents of a female, or feminine, voice differ as to whether this voice is a function of sex or gender. Some ground this difference in biological nature and its consequences.[14] Others claim only that it is a function of existing social practices and roles.[15]

Jean Grimshaw expresses at least two concerns about the elaboration of a sex- or gender-based ethic. First, whether the male and female voices are natural or cultural, they resist adequate description and remain unclear, a problem which seems related to the empirical observation that however these voices are distinguished, they do not seem to be characteristic of *all* males or *all* females. Secondly, the acceptance of such a distinction, entailing as it does claims so fundamental that women are perceived as reasoning in a way typically different from men, might well reinforce precisely those repressive stereotypes that we are anxious to overcome.[16] If one employs the male/female or masculine/feminine distinctions within a context in which the male voice is independent,

autonomous, and self-sufficient, the female voice remains marginalized. This is true regardless of how we elaborate, amplify, and promote the gender traits assigned to the female.

It is clear that both of Grimshaw's concerns are important. First, this dualism threatens to instantiate an unnegotiable set of differences between the two categories. The conditions of what is being described as the male voice—autonomy, independence, individual freedoms and so on—renders it self-sufficient and exclusive. As such, it stands beyond the influence of the "female" voice which is at best incidental to it, and at worst, irrelevant. The female voice is derived from it, dependent on it, and inferior to it. As long as the male voice is maintained on its own terms, it continues a standard that, far from being able to tolerate or accommodate the female voice, exercises control over it. Under such a regime, interaction and reconciliation are not possibilities. The priority and strict transcendence of the one over the other precludes any substantive interaction between the two.

The question whether we can adequately discriminate a male and a female, or a masculine and feminine, voice in Western culture has to be addressed historically. While sympathetic to Grimshaw's argument for the richness and diversity of the positions that are being truncated to fit the potted characterization of "maleness," certain minimum generalizations can stand. When Grimshaw searches the inventory of Western philosophic positions, she is able to discover great divides among these positions that seem to preclude any broad generalizations or assertions. The definition of reason, mind, and masculinity posited in any univocal sense is open to counter-example. But, even allowing for the richness and diversity of both the Western and Chinese philosophic traditions, and for the presence of both an aesthetic as well as a logical sense of order within both cultures, comparative philosophy does provide us with a perspective from which to generalize meaningfully about dominant features of these philosophic traditions. For example, where major players such as Plato and Kant do have significantly different conceptions of reason, and of the manner in which sexuality affects or is affected by rationality, the gap closes measurably when we compare assumptions about the nature, the place, and the importance of reason in these two Western philosophers with any Confucian representative.

The pervasive nature of this Western dualism explains the often unannounced affinity that feminism has with many of the other philosophic initiatives of our historical moment that have been marginalized by it: environmental issues, philosophical pluralism, comparative philosophy, the status of animals and children, socialism, homosexuality, racial equality, and so on. The resolution of any one of these problems seems in important measure dependent on the resolution of them all.

The bad news, then, is that our particular forms of sexism are culturally entrenched, and cannot be fundamentally resolved without a radical philo-

sophical revolution. A truly nonsexist society cannot exist in the presence of social, political, and religious commitments that still promote dualistic thinking. The best nonsexist society possible under the continuing hegemony of dualistic categories would be achieved through the promotion of female to the status of an *honorary male*. To a significant degree, this has been the direction of women's liberation in Western society. However, this development entails precisely what Carol Gilligan has worried over: gender sameness at the very real expense of sacrificing a range of human qualities that ought to be retained. In the presence of dualism, gender parity in difference is not a possibility.

The good news is that the point of convergence which we can identify in current philosophical trends, such as pragmatism, hermeneutics, and various forms of post-structuralist thinking, is their various attempts to deny the gambit of dualistic thinking. This turning.in Western philosophy seems essential if we are to dislodge the sort of thinking which has funded our Western brand of sexism.[17]

3. Correlative Sexism

In the *Analects*, Confucius is on record as stating:

> It is only women and petty persons who are difficult to provide for. Drawing them close, they are immodest, and keeping them at a distance, they complain.[18]

Reflecting on the predicament of women in the Confucian tradition, the May Fourth author and critic, Lu Xun 魯迅, observes with undisguised cynicism:

> According to the ideas of present-day moralists who have stipulated the definition of chastity, generally speaking a chaste woman never remarries nor does she elope with another man after her husband has died. The sooner her husband dies and the more impoverished her family is, the more magnificent is her chastity. There are two more kinds of rigorously chaste women: the first one kills herself when her betrothed or husband dies, whether she has married him yet or not; the second one, when confronted by a rapist who will defile her, manages either to commit suicide or to have him take her life in the struggle to resist him. The more brutal and painful her death, the more magnificent is her chastity. . . . In summary, if a woman's husband dies, she should remain chaste or die with him; if she encounters a rapist she should also die. And when such persons are everywhere praised, morality prevails in the world, and China can still be saved.[19]

From China's classical beginnings to the present moment, it has been and still is male-dominated and sexist. Perhaps the most devastating charge against the tradition is the way in which this bias has insinuated itself into the Chinese language. We must recognize that language not only conveys ideas, but also

constitutes and perpetuates them. And in its written form, the Chinese language has been, more or less, a male-controlled discourse. If we look at the range of characters that have been grouped with the "woman" classifier, *nu* 女, as the signific portion of the graph, we find that, by and large and with some notable exceptions, these characters can be divided into three categories.

The first category is what we might expect: female roles and relationships such as "mother" (*ma* 媽), "aunt" (*gu* 姑), "wife of one's husband's elder brother" (*si* 姒) and "sister-in-law" (*zhou* 妯) are quite reasonably identified as female, where the remarkable and culturally revealing feature is the specificity of the relationship. The second category is a rather damning collection of negative character traits and attitudes which are directly associated with the female gender: "absurdity" (*wang* 妄), "jealousy" (*ji* 嫉), "envy" (*du* 妒), "greed" (*lan* 婪), "lewdness" (*jian* 奸), "flattery" (*mei* 媚), and "slavehood" (*nu* 奴). In the third category, we have innumerable ways of saying "handsome" and "graceful" with subtle nuances: "alluring" (*yao* 妖), "good-looking" (*jiao* 姣), "agreeable" (*wan* 婉), "graceful" (*ting* 婷), and so on, suggesting that physicality was a major consideration in the male evaluation of the female.[20]

It is essential that we begin by stressing the pervasively sexist character of classical and contemporary China, because, attempting to distinguish the particularly Chinese strain of correlative sexism from the kind of dualistic sexism pervasive in our own tradition, we will have to employ the language of interdependence rather than independence, of complementarity rather than autonomy, of process rather than of substance. On the surface, such terminology may seem less pernicious than characterizations of sexism and male-dominance in Western societies. But the problem of sexism is likely as great, or even greater, in China than in industrialized Western societies. The primary point we wish to make is that the understanding of gender-construction in China is quite different from that dominant in the West. Grasping that difference will further our appreciation of the distinctiveness of these two cultures. And moreover, in order to evaluate culturally specific forms of sexism, and to take appropriate action to resolve them, we first need to understand them.

In the West, gender construction reflects insitutionalized male dominance, while in China masculine and feminine gender traits form complementary characteristics that together suggest the range of possibilities for self-cultivation. In spite of the fact that, historically, gender occupations were demarcated along the lines of sexual differences ("silk worms and the plow") and further, that only members of the male sex were given access to the cultural prerequisites for personal realization, we will see that the correlative model of gender-construction offers the possibility of "polyandrogyny."[21]

In the classical Chinese tradition, personal realization in both the Confucian and Daoist traditions has been articulated in terms of the cultivation of the full range of gender traits. In Chinese culture, heart-and-mind (*xin* 心) make emotion and rationality copresent and inseparable. The same is true of

yin-yang gender traits. As a corrective on what we take to be a popular but nonetheless unfortunate reading of Daoist philosophy, we will take the Daoist case as our example here.[22]

Joseph Needham is typical of contemporary commentators in casting the Daoist-Confucian relation as *yin* versus *yang*:

> Confucian knowledge was masculine and managing: the Daoist condemned it and sought after a feminine and receptive knowledge which could arise only as the fruit of a passive and yielding attitude in the observation of Nature.[23]

Needham is committed to the significance of the "feminine symbol" in Daoism to the extent that on the basis of this interpretation (and seemingly unsupported by any documentable evidence), he suggests that ancient (proto) Chinese society "was in all probability matriarchal."[24]

The popular characterization of Daoism as *feminine* stresses all that is tolerant, permissive, withdrawing, mystical, and receptive, and advocates feminine yieldingness in all social and political relationships.[25] From a personal perspective, it recommends the observation of nature as opposed to the management of society, receptive passivity as opposed to commanding activity, and freedom from preconceived theories as opposed to an attachment to a set of social conventions.[26] Needham's discussion of the feminine symbol is in tandem with the water metaphor which suggests submissiveness and yielding.[27] That Needham is equating this feminine symbol with *yin* almost to the exclusion of *yang* seems to be his intention when he asserts:

> If it were not unthinkable (from the Chinese point of view) that the Yin and the Yang could ever be separated, one might say that Taoism was a Yin thought-system and Confucianism a Yang one.[28]

On this reading of Daoism (and it is *not* ours), it would be claimed that the *Daodejing* as a text supports the "feminine" interpretation in the following ways. There is the direct assertion in the text that the feminine overcomes the masculine, and corollary assertions such as soft overcomes hard, weak overcomes strong. Throughout the text, there seems to be an identification between the female reproductive organs and the reproductive *dao*, where, for example, the female vagina is often represented metaphorically as "the river valley," "the gorge," "the gateway of the mysterious womb," "the ravine of the world," and so on.

The key metaphors such as water, the infant, the valley, the mother, and the source, which parallel references to the female, are all defined in the language of feminine gender traits: softness, weakness, darkness, tranquillity, receptivity, and so on. Again, the ideal ruler is described in feminine terms: humility, submissiveness, passivity, quietude, receptivity.

According to Needham, the *Daodejing* sponsors an ideal ruler who, rejecting the "masculine, managing, hard, dominating, aggressive, rational and donative" attitudes of the rival Confucian and Legalist traditions, opts for the "feminine, tolerant, yielding, permissive, withdrawing, mystical and receptive" approach to social and political order.[29] This interpretation usually centers around protracted discussions of *wuwei* 無為 translated as "non-action," *buzheng* 不爭 as "not contending," *rouruo* 柔弱 as "softness and weakness," *jing* 靜 as "tranquillity," and *xu* 虛 and *wu* 無 as "vacuity," portraying the sage ruler as the embodiment of these qualities.[30]

We will argue that the rehabilitation and reinstatement of the feminine traits in the *Daodejing* is compensatory, and that a failure to appreciate this has resulted in a misreading of Daoism as passive, quietistic, and escapist. Against this reading, we contend that Daoism pursues a positive conception of the consummate human being, where attainment of this ideal demands sustained effort and authentication of one's understanding in action. It affirms the reality and the worth of the world as such, and seeks not to escape from it, but to appreciate it in all of its complexity.

Dao pursues balance and harmony, and when this is upset, it works to restore it. Similarly, the *Daodejing* embraces *yin* characteristics as an appropriate antidote for the imbalance in the human world. The *Daodejing* is not advocating the substitution of *yin* values for the prevailing *yang* ones. On the political level, the *Daodejing* is not advocating the application of *yin*-based techniques to achieve the *yang*-inspired end of political control. Rather, the text pursues both the personal and the political ideal that reconciles the tension of opposites in sustained equilibrium and harmony. Whatever else "grasping onto continuity" might mean, it would seem to imply the interdependence of opposites, and their reconciliation through an achieved harmony and balance that recognizes the value of difference. *Dao* activity is repeatedly described in the paradoxical language of the reconciliation of opposites:

> Radiant *dao* seems obscure,
> Advancing *dao* seems to recede,
> The greatest form is formless.[31]

The consummate person, modeling nature and achieving a posture consistent with the prescriptive *dao*, is also the reconciliation of opposites:

> One who realizes the male and yet preserves the female
> Is the river gorge of the world . . .
> One who realizes whiteness and yet preserves blackness
> Is the model of the world . . .
> One who realizes glory and yet preserves tarnishedness
> Is the valley of the world.[32]

This passage has a parallel elsewhere in the text which reinforces our reconciliation reading:

> The world had a fetal beginning
> And takes it as mother of the world.
> Having gotten the mother, thereby know her progeny.
> Having gotten to know her progeny, again preserve the mother,
> And live to the end of your days without peril.[33]

What appears here as feminine symbolism more appropriately represents a reconciliation between the feminine and the masculine. "Mother," for example, is impregnated woman—a union of the masculine and the feminine.

There is a related passage which again describes harmony and productivity as a coalescing of *yin* and *yang*:

> The myriad things shoulder the *yin* and embrace the *yang*,
> And blending this *qi* 氣,
> They attain harmony.[34]

Daodejing is, at least at one level, a political treatise, and because of its focus on the person of the ruler, we can claim that at least this person is described in androgynous terms. We can go beyond this and infer, however, that the ruler is perceived as setting the political and social conditions for the pursuit of personal realization generally, and inasmuch as his values serve as models for the empire, such realization is androgynous. Such speculation is not inconsistent with the passages in the text in which the sage-ruler is referred to as the "model of the world"[35] and in which, under the conditions of this model, the people are free to pursue their own realization:

Thus, the sage says:

> I am nonassertive (*wuwei*)
> And the people transform themselves;
> I cherish stillness,
> And the people attune themselves;
> I do not intervene,
> And the people are prosperous of their own accord;
> I am objectless in my desires,
> And the people retain their natural genuineness of their own
> accord.[36]

The conditions which the ruler wants for the people are the same as those which he seeks for himself. A consummate person is one who has the tolerance to respond appropriately and efficaciously to any circumstance.

In the dominant models of Western cosmology, individuals move from "where they are" to "where they ought to be" by siding with the superior element in a set of dualistic categories. These categories include God and world, being and becoming, knowledge and opinion, reality and appearance, spirit and flesh, truth and falsity, and so forth. On the "*dao*" model, realized individuals become correlates of *dao*, having available to them the full range of *yin-yang* traits: both sides of the divine/human (*tianren* 天人) complementarity, both sides of the reason/emotion (*zhiren* 知仁) complementarity, both sides of the theory-practice (*zhixing* 知行), stuff/function (*tiyong* 體用), spirit/flesh (*xinshen* 心身), practice/language (*xingyan* 行言) complementarities.

It is important to realize that all correlative oppositions in the classical Chinese tradition are themselves hierarchical, with the dominant member usually expressed first: Heaven/human being (*tianren* 天人) heart-and-mind/body (*xinshen* 心身), and so on. What is curious in the *yin-yang* case that does distinguish it from standard Confucian correlates is that *yin* comes first, suggesting that the preferred posture is certainly androgynous, but with the *yin* character traits being on balance superior to those associated with *yang*.

In the correlative understanding, gender is more fluid and lacks exclusivity. Although correlativity more easily promotes the redefinition of roles and gender characteristics than does the dualistic model, in practice the weight of tradition is a formidable obstacle to the instantiation of such redefinitions. Still, it is plausible to assume that, in the absence of transcendental commitments to the contrary, alterations in practice may be more easily made if there are concomitant changes in cultural attitudes and practices reinforcing sexual inequalities.[37]

On the Confucian side, different players in the personalization of gendered roles can express their own uniqueness as persons in a way that can be compared with the way one "ritualizes" oneself to find a place in community. Neither human nature nor gender is a given.[38] A person is not born a woman, but becomes one in practice. And gender identity is ultimately not one of kind, but resemblance. The sexist problem, then, will be one of degrees of disparity rather than strict inequality. Males and females are created as a function of *difference in emphasis* rather than *difference in kind*. Richard Guisso suggests as much in defining "difference" in the Chinese culture:

> The essential perception they [the Chinese classics] offer was the most basic of all—that male and female were different, as different as heaven and earth, *yang* and *yin*. The corollary, however, is what distinguished the Chinese view from most others. In an organically holistic universe, male and female were inextricably connected, each assigned a dignified and respectable role, and each expected to interact in co-operation and harmony. The fact remains, however, that the relationship is not an equal one. . . .[40]

In his survey of the *Classics*, Guisso tries to clarify this relationship between subordination and difference:

. . . while there may be an implicit connotation of superiority and inferiority in the cosmology, the greater emphasis fell on the difference between male and female. Each sex had a distinct and complementary function and woman's place was neither dishonorable nor necessarily inferior to man's except in so far as earth was inferior to heaven or moon inferior to sun.[41]

Within the correlative model, the richest correlations are those that stand in the greatest degree of contrast. Hence, equality defined in terms of univocity and sameness is a casualty of difference and diversity. At the same time aesthetic coherence demands that there be centers which draw differences into harmony and have implicate within them a sense of a broader field. Corollary to difference then is the necessity of hierarchy. Without hierarchy, there cannot be a center. Creativity is dependent upon the degree of difference that exists between the polarity of male and female, and the tensions that it produces:

> The Confucian solution to male–female conflict was therefore threefold: separation of function, acknowledgement of hierarchy, and the idealistic injunction that mutual love and respect would be infused into the relationship.[42]

The culturally stipulated differences in function stimulate an interdependence between male and female that is cumulative and ideally is productive of mutual interest, need, and affection.

In the dominant strains of the Western tradition, even though a woman must resign her difference to become a person, she can still lay claim to an essential humanity that distinguishes her from her context. Essential human nature is a guarantee. Regardless of how degraded woman's role, she is still potentially and irrevocably a human being. The correlative model is more fluid and less stable than the dualistic one. The flexibility that permits a greater degree of creativity in the correlative model also permits a greater degree of abuse and grosser violations of human dignity.

The limits that restrict creativity in the dualistic model also establish boundaries on what is acceptable conduct. For example, the classical Confucian notion that the difference between beast, human being, and gods is simply cultural, means that while those human beings who are important sources of culture have a claim to divinity, human beings who resist enculturation are quite literally, animals.

In the absence of some essential nature that guarantees the sanctity of all human life, there is justification for worshipping some human beings while abusing others as chattel. In the dualistic model, one may argue that a woman has not been permitted to be a man. In the correlative scheme, females have historically not been allowed to be persons.

Another feature of the correlative model is that the male/female complementarity cannot be divorced from other significant correlations. As Guisso observes:

If the *Five Classics* fostered the subordination of woman to man, they fostered even more the subordination of youth to age. Thus, in every age of Chinese history where Confucianism was exalted, the woman who survived, the woman who had age and the wisdom and experience which accompanied it, was revered, obeyed and respected . . . even if her son were an emperor. It is perhaps this fact more than any other, which enabled the woman of traditional China to accept for so long the status imposed upon her.[43]

If we begin from the assumption that humanity is an achievement, age becomes a significant factor. Woman achieves status by growing old. However, a simple-minded reverence for the aged is not to be encouraged. Confucius himself says repeatedly that age in the absence of achievement should be a source of embarrassment:

> The young should be held in high esteem. After all, how do we know that those yet to come will not surpass our contemporaries? It is only when one reaches forty or fifty years of age and yet has done nothing of note that we should withhold our esteem.[44]

The downside of the respect for cultural contribution and the age that necessarily attends it, however, is that it reduces the relative value of the young, and in extreme cases, has even served as a warrant for infanticide. Still, as a test for the claim that in the classical Chinese world view, personal realization precedes the gendering of human characteristics, we can ask the question: In those cases when woman becomes matriarch, is she evaluated on the same terms as the patriarch, or is some distinctively "feminine" standard applied?

Another significant difference between dualistic and correlative sexism can be brought into focus by considering the private/public dichotomy. Jean Grimshaw points out that in our Western experience, both women themselves and the sphere of activity (the family and the home) with which they are associated have been devalued:

> Masculinity, membership of the community of men, is something over and against daily life, to be achieved in opposition to it, in escaping from the female world of the household.[45]

This does not seem to be the case in the same degree in the Chinese world, where public and private are not severely separated. In fact, in all aspects of Chinese life—social, political, religious—it is the family rather than the individual which constitutes the basic unit of humanity. What is most significant about a person religiously, politically, and morally is derived from his or her participation in a ritually ordered familial world to the extent that, in the absence of family, one has little claim on humanity. A person lives within the interstices of the changing relationships and hierarchical patterns of deference

that define family and lineage, and the person's realization is a function of the deepening significance of these same relationships. Without discounting the impoverishing effect of the patriarchal prejudice, we must allow that the relational definition of person in some degree shares both loss and gain in personal worth across the membership of the family unit.

As we saw above, the continuity and the wholeness of the family means that both the feminine and masculine contributions to the familial order are implicated in the person who embodies the authority of the tradition. In the Confucian tradition, the ruler is described not just as the father, but as "the father and the mother" (*fumu* 父 母) of the people. Just as ruler *is* empire, so patriarch *is* family. The "roundness" of the realized person is an androgyny that enables him/her to draw on the resources of both male and female gender traits and to respond efficaciously to all circumstances.

There is one final feature of the correlative model that follows from this "achievement" conception of human being. Becoming a human being presupposes a perpetual revolution, an ongoing renegotiation and reconstitution of the roles and rituals that structure society. The portrait of women in history is certainly definitive of the historical situation, but still the uniqueness and fluidity of the present moment do allow in degree for a new configuration of the male/female roles. We must allow that the extent to which the biological female has been deprived of meaningful participation in the culture has taken a toll on human possibilities. Stated the other way, a Chinese individual will undoubtedly be both different and qualitatively more interesting when women are liberated from patriarchy.

However, there is a persistent worry in the project of woman's liberation in a Chinese society. Unlike the dualistic model in which some equality can be sought by recourse to a woman assuming the gender traits of a man, there is no such basis for essential equality in the correlative structure. Hierarchy would seem to be inevitable. The only possibility which might seem acceptable would be a qualitative hierarchy where status is a function of nongendered personal achievement rather than biological sex or cultural gender.

We should stress once more that our motive for articulating this alternative model of gender construction in the Chinese tradition has not been apologetic. Rather, ours is simply an effort to separate baby from bath water when engaging Chinese culture. One familiar pattern in the literature which reports on gender in China has been to equate traditional Chinese culture with Confucianism, and then to condemn Confucianism because of its unrelenting patriarchy. This is analogous to disposing of all of the accomplishments of liberal democratic thinking—human rights, representative democracy, the modern university, the technologies of mass communication, and so on—because of a recalcitrant sexism within this tradition. Neither traditional Chinese culture nor Confucianism reduce to footbinding, any more than the richness of Western art and music reduce to breast implants.

Our argument has been that an understanding of gender construction and the prejudice that has attended it within Chinese society can be used as a resource for reflecting on our own experience, and further, can be appropriated as a supplemental resource from which a new conception of person can be derived for a new world.

Notes

1. Hall and Ames, 1998.
2. On this point see, for example, the preface to Lloyd, 1993.
3. Dupre, 1993, 14.
4. See Hall, 1982 for a discussion of the reshaping of sex and gender identities by recourse to technological processes.
5. Black, 1989, 184.
6. Ibid., 184–185.
7. Adapted from Aristotle, *Metaphysics*, 986a22–986b2. See Aristotle, 1984, 1559–1560.
8. See Gilligan, 1982.
9. See Flax, 1989 passim.
10. Grimshaw, 1986, 59; see also Grimshaw, 1992.
11. Grimshaw, 1986, 203.
12. Ames and Rosemont, 1998, 6.30.
13. An intelligent discussion of the role of this dualism in shaping the sexual symbolism associated with the Western tradition is Lloyd, 1993.
14. See, for example, Flax, 1989.
15. See, for example, Gilligan, 1982.
16. Grimshaw, 1992, 228–229.
17. Not all poststructuralist thinking converges with feminist concerns. See the reservations with respect to certain aspects of postmodern thought in Tatyana Klemenkova, 1992. An important conversation has been initiated by the pragmatist Richard Rorty. In his "Feminism and Pragmatism" (Rorty, 1991, 231–258), Rorty provides an analysis of the manner in which pragmatism might serve as a resource for contemporary feminism. Rorty notes that if, as many feminists argue, language itself is largely a male product, some sort of intervention may be essential. Such intervention might take the form of a self-imposed exile of representative numbers of women from present social institutions, allowing, over some generations, for the production of a more empowering language. Reading his essay, one can't avoid the suspicion that Rorty might be offering this "solution" as a hyperbolic response to what he conceives to be extreme claims an the part of some feminists. We, however, think the proposal to be perfectly sound—even if difficult to imagine being implemented.
18. Ames and Rosemont, 1998, 17.25.

19. Lu Xun, 1981, 117.

20. Female (*nü* 女) is distinguished from male (*nan* 男), but *nan* is not used to classify characters that identify specifically "male" gender traits. Rather the contrast is between "female" (*nü*) and "person" (*ren* 人), defining human traits. The fact that such a parallel exercise in the Chinese language cannot be carried out with respect to "male" supports our claim that the gender prejudice in the Chinese tradition has been that woman has not been allowed to be person. We owe this insight to Lisa Raphals, although we cannot hold her responsible for our answer.

21. We are using the "monoandrogynism–polyandrogynism" distinction of Trebilcot, 1982.

22. For an earlier version of this argument, see Ames, 1981.

23. Needham, 1956, 33. Other scholars who make this same association between feminine gender traits and the Daoist ideal are the following: Chan, 1963, 13; Kaltenmark, 1969, 58ff; Waley, 1934, 57; E.M. Chen, 1969, 402–404.

24. Needham, 1956, 105.

25. See ibid., 1956, 59.

26. Ibid., 1956, 57.

27. Needham uses the words "feminine" and "female" interchangeably in his discussion of Daoism. This is understandable, perhaps, given the absence of a female/feminine distinction in the classical Chinese language. We follow the convention here in distinguishing between biological sex (male/female) and psychosocial gender traits (masculine/feminine). Were we to enforce this distinction, "feminine" would be more appropriate in Needham's discussion.

28. Needham, 1956, 61.

29. Ibid., 1956, 59.

30. The familiar alternative to this "feminine" interpretation of Daoism is the H.G. Creel inversion of "feminine" and "masculine." These seemingly "feminine" qualities are simply a purposive device for effectively maintaining political control. "Not contending," for example, is the best way to contend. This basically *Hanfei* understanding of the *Daodejing* reduces the text to a political stratagem whereby an ambitious and aggressive ruler can impose his will on his people, keep them ignorant, and manipulate them to his own ends.

31. *Daodejing*, 41.

32. Ibid., 28.

33. Ibid., 52.

34. Ibid., 42.

35. Ibid., 22 and 28.

36. Ibid., 57.

37. Soon after Mao Zedong's assumption of power in China, he proclaimed the equality of the sexes. By all accounts some real changes did take place, and rather quickly. The gains in sexual parity have since been eroded under the weight of the persistent Confucian tradition.

38. See Ames, 1991.

39. See the description of the relationship between the neo-Confucian Li Yong and his mother in which the mother on the death of the father becomes "father" to Li Yong in Birdwhistell, 1992.
40. Guisso, 1981, 59.
41. Ibid., 50.
42. Ibid., 59.
43. Ibid., 60.
44. Ames and Rosemont, 1998, 9.23. See also 14.43 and 17.26.
45. Grimshaw, 1992, 227.

References

Ames, Roger T. 1981. "Taoism and the Androgynous Ideal." In *Women in China*. Edited by Richard W. Guisso and Stanley Johannesen. Youngstown: Philo Press, 1981.

——. 1991. "The Mencian Conception of *Renxing* 人性, Does it Mean 'Human Nature'?" In *Chinese Texts and Philosophical Contexts: Essays Dedicated to Angus C. Graham*. Edited by H. Rosemont, Jr. La Salle, IL: Open Court.

Ames, Roger T., and Henry Rosemont, Jr. 1998. *The Analects of Confucius: A Philosophical Translation*. New York: Ballantine.

Aristotle. 1984. *The Complete Works of Aristotle*. Volumes 1 and 2. Ed. Jonathan Barnes Princeton, N.J.: Princeton University Press.

Birdwhistell, Anne. 1992. "Cultural Support for the Way of Mother and Son." In *Philosophy East and West* 42:3.

Black, Alison H. 1989. "Gender and Cosmology in Chinese Correlative Thinking." In *Gender and Religion: On the Complexity of Symbols*. Ed. C.W. Bynum, S. Harrell, and P. Richman. Boston: Beacon Press.

Chen, Ellen Marie. 1969. "Nothingness and the Mother Principle in Early Chinese Taoism." In *International Philosophical Quarterly* 9.

Creel, H.G. 1970. *What is Taoism?* Chicago: University of Chicago Press.

Dupre, John. 1993. *The Disorder of Things: Metaphysical Foundations of the Disunity of Science*. Cambridge, MA: Harvard University Press.

Flax, Jane. 1989. *Thinking Fragments: Psychoanalysis, Feminism and Postmodernism in the Contemporary West*. Berkeley: The University of California Press.

Gilligan, Carol. 1982. *In a Different Voice*. Cambridge, MA: Harvard University Press.

Grimshaw, Jean. 1992. "The Idea of the Female Ethic." In *Philosophy East and West* 42:2.

——. 1986. *Philosophy and Feminist Thinking*. Minneapolis: University of Minnesota Press.

Guisso, Richard W., and Stanley Johannesen, eds. 1981. *Women in China: Current Directions in Historical Scholarship*. Youngstown, NY: Philo Press.

Hall, David L. 1982. *The Uncertain Phoenix*. New York: Fordham University Press.

Hall, David L., and Roger T. Ames. 1998. *Thinking from the Han: Self, Truth, and Transcendence in Chinese and Western Culture*. Albany: State University of New York Press.

Kaltenmark, Max. 1970. *Lao Tzu and Taoism*. Trans. Roger Greaves. Stanford: Stanford University Press.

Klemenkova, Tatyana. 1992. "Feminism in Postmodernism," *Philosophy East and West* 42:2.

Lloyd, Genevieve. 1993. *The Man of Reason*. Minneapolis: The University of Minnesota Press.

Lu Xun. 1981. "Wo de jielieguan 我的節烈觀 (My Views on Chastity)." In *Lu Xun quanji* 魯迅全集 (*Complete Works of Lu Xun*). Peking: Peoples' Press.

Needham, Joseph. 1956. *Science and Civilisation in China*. Vol. II. Cambridge: Cambridge University Press.

Rorty, Richard. 1991. *Objectivity, Relativism, and Truth*. [Philosophical Papers, vol. 1]. Cambridge: Cambridge University Press.

Trebilcot, Joyce. 1982. "Two Forms of Androgynism." In *"Femininity," "Masculinity," and "Androgyny."* Totowa, NJ: Rowman and Littlefield. 1982.

Waley, Arthur. 1934. *The Way and Its Power: A Study of the Tao Te Ching and its Place in Chinese Thought*. London: George Allen and Unwin.

From Confucius through Ecofeminism to a Partnership Ethic of Earthcare

Ingrid Shafer

In this chapter I will take a look at Confucianism as it relates to ecofeminism and especially, but not exclusively, to the thought of theologian Rosemary Radford Ruether, one of the pioneers who made the initial connection between feminism and ecology only a year after Françoise d'Eubonne introduced the term in *Le féminism ou la mort* (*Feminism or Death*) and Sheila Collins published *A Different Heaven and Earth*. In *New Women/New Earth* (1975) Ruether argued that the ecological movement and the women's movement should be united. I am focusing on Reuther in part because in the past quarter century the ecofeminist movement has grown immensely, and has become so complex and internally divided that it would take several volumes to do justice to the diverse streams. As a philosopher of religion and practitioner of interreligious dialogue, I am especially concerned with the theological implications of combining feminism and ecology, and Ruether's *Sexism and God–Talk: Toward A Feminist Theology* (1983) provides a solid point of departure, while her more recent volume, *Gaia and God: An Ecofeminist Theology of Earth Healing* (1992) explores the roles played by religion both negatively, to rationalize and reinforce oppressive use of power, and positively, to serve as a resource for liberation from domination.

Like Julia Ching, I consider Confucianism a religion rather than merely a secular ideology or philosophy. Ching points to Confucius's faith in Heaven and his desire to do the Will of Heaven. She sees this thrust toward transcendence—albeit not necessarily as worship of a personal deity (and certainly not an Abrahamic creator god)—manifested in Confucianism from the very beginning and calls the Confucian quest for following "the Way" a form of spiritual teaching of sagehood or self-transcendence (Küng 95, 116). Hence, while the spiritual/transcendent is not absent in the Confucian world view, it is not dualistically severed from the material/immanent, and that is a crucial point. This non-dualism may well be a function (and/or reflection) of written Chinese, in the sense that the Chinese character *tian* that has traditionally been translated as "Heaven" only partially shares connotations with Western notions of heaven.

For that reason, Roger Ames and Henry Rosemont, in their recent translation of the *Analects*, deliberately do not translate the term into English but rather use the phonetic transcription of the Chinese word and describe *tian* as "living culture—crafted, transmitted, and now resident in a human community. *Tian* is anthropomorphic, suggesting its intimate relationship with euhemerization—historical human beings becoming gods—that grounds Chinese ancestor reverence" (47). They continue: "In the absence of some transcendent creator deity as the repository of truth, beauty and goodness, *tian* would seem to stand for a cumulative and continuing cultural legacy focused in the spirits of those who have come before" (47). Hence, *tian* itself (much like the Christian notion of the Incarnation) appears to be simultaneously transcendent and immanent.

Next a word about ecofeminism in general: Ecofeminists link the exploitation of the natural world and the subordination of women. They both challenge and bring together elements of the feminist and the so-called "green" ecological movements. Ecofeminists tend to agree that all living organisms must be seen in relation to each other and their natural environment. As one species of living organisms among other species of living organisms, they view humans as no more or less embedded within and limited by local and global ecosystems than elm trees, deer, or fungi. Like the more radical among the "greens" (generally called "deep greens" in contrast to "light greens"), ecofeminists tend to consider humans not merely embedded within an ecological matrix but parts of an interconnected and interdependent whole that removes them from any sort of privileged status. According to Greta Gaard, "no attempt to liberate women (or any other oppressed group) will be successful without an equal attempt to liberate nature" (1). Hence there is at least a strong faction among ecofeminists who are opposed to animal experiments and eating meat.

When they insist that men and women, by virtue of their gender, stand in different relationships to the natural world, ecofeminists often find themselves at odds with ordinary feminists. Since the ecological impact of human practices, such as the use of pesticides on farms, is experienced through bodies, and the unborn and very young are especially sensitive to such environmental agents, a disproportionate number of women bear the consequences of biohazards. They experience spontaneous abortions and stillbirths, or find themselves caring for infants and children with birth defects. In addition, some ecofeminists disagree with the arguments of ordinary feminists that it is wrong to depict women as uniquely connected with the natural world. Many ordinary feminists dismiss such a woman–nature association as rooted in a romantic notion of innate differences of men and women that has been used to justify the subordination of women. On the other hand, at least some ecofeminists might consequently be more likely to appreciate the traditional Chinese notion of the *tao* as archetypally feminine, associated with water, womb, infancy, earth, mud, darkness, and inner life. Ruether speaks of women's bodies "in mysterious tune with the cycles of the moon and the tides of the sea" (1996, 4).

The current volume is concerned not only with feminism but with the ways feminism and the worlds of women intersect with Confucianism and Chinese ways of thinking in general. Fortuitously, in *Sexism and God–Talk*, Ruether introduces the French Jesuit paleontologist and philosopher Teilhard de Chardin's *The Phenomenon of Man* as presenting a path toward what she calls an "ecological–feminist theology of nature" (85). Teilhard spent some sixteen years of his life in China (1924–1946, with periodic interruptions), and his "first Peking period" (1932–1938) was the time when many of his most original notions germinated. Thus he wrote in a letter of 3 July 1933: "I have the obscure feeling that something stirs and grows within me; as if, during his period of complete liberty, the true 'me' continues to free itself of the world of conventions" (Cuénot 213). The imagery is clearly birth imagery. China appears to have been the catalyst for his emergence from the pupa stage. Teilhard is especially important for the present essay because of his organic, non-dualistic vision of the gradual and ongoing birth of the universe through transformation (spiritualization and/or humanation) of matter. This vision of cosmogenesis establishes a bridge between the mind–matter dualism of the West, with its static, transcendent "'God-model,' where an independent and superordinate principle determines order and value in the world while remaining aloof from it" (Ames 31), and the Chinese "commitment to the processional, transformative, and always provisional nature of experience," a sense of dynamic immanence that "renders the 'ten thousand things [or, perhaps better, 'events'] . . .'" which make up the world, including the human world, at once continuous one with another, and at the same time, unique" (31).

At the present there is simply no more important issue than to stop "the mistreatment of the natural world, and the subordination of women and other Others" (Cuomo 4), and to lay the foundation for doing so throughout the world by encouraging ecologically responsible and humane ways of thinking that expose the immorality of exploitative modes of interaction—whether involving person-to-person interaction or humanity-to-environment interaction. This is not a passing fad of preparing for the millennium, which, after all, is a true millennium only for Christians (and one based on faulty chronology—Jesus was born around 4 B.C.E., and the "real" millennium has come and gone) and will be forgotten for another thousand years as soon as the Y2K crisis has passed and the last trinkets have been sold at a discount. This is a matter of halting the destruction of the biosphere and of setting up broad, global paradigms for political, social, economic, and religious theory and action that respect the earth and acknowledge the inalienable value of persons as persons. It is a call for genuine transformation from a dualistic, mechanistic world view to one that is holistic and organic. In the words of Leonard Swidler, it is a call for the conscious transition from the age of monologue to the age of dialogue with its focus on mutuality and relationality (19). The urgency of this call derives from the pressure exerted on both the environment and humanity by the

sheer number of people inhabiting the earth, especially combined with the potential of contemporary technology to do serious and irreversible damage to the biosphere. Ultimately, this is clearly a concern that affects all of humanity, men no less than women, and it demands careful and nuanced consideration, involving both selective critique and selective acceptance of aspects of so-called non-Western and Western "master paradigms."

The term "transformation" does not mean utter annihilation of that which is being transformed. Transformation implies a gradual and orderly transition and synthesis. Transformation assumes a "both–and" ontology. It is the dialogical process at work. Spirit–nature dualism, linear thinking, excessive faith in rationality, and unbridled individualism are clearly destructive, but so is a tendency to collapse all categories into an undifferentiated muddle of "everything goes" relativism, emotionalism, uncritical acceptance of everyone's opinion as equally valid, and the exclusion of all hierarchies as organizing principles. Feminists in general and ecofeminists in particular have tended to reject what they themselves defined as the "sins" of the "Western Imperialists" and "European Enlightenment mentality" without acknowledging the important contributions to a more humane world that have their origins in the very mindset some among them would condemn. The appeal to a "rights" or "justice"-based ethic, for example, is often denounced as "patriarchal" and rooted in a competitive, adversarial male "sense of self as separate (Gaard 2) and set in opposition to a supposedly more womanly ethic based on "responsibility or care" (2), developed by Carol Gilligan among others, in which "the moral problem arises from conflicting responsibilities rather than from competing rights and requires for its resolution a mode of thinking that is contextual and narrative rather than formal and abstract" (19). Gilligan adds that a conception of morality as a function of care "centers moral development around the understanding of responsibility and relationships, just as the conception of morality as fairness ties moral development to the understanding of rights and rules" (19).

In addition to Gilligan's work, Gaard also mentions "Toward an Ecofeminist Ethic," in which Karen Warren describes eight conditions that distinguish ethical decision making as uniquely feminist, including "coherence within a given historical and conceptual framework, an understanding of feminism as striving to end all systems of oppression, a pluralistic structure, and an inclusive and contextual framework that values and emphasizes humans in relationships, denies abstract individualism, and provides a guide to action" (Gaard 2). While I see no reason not to accept both the fairness–justice–rights ethical paradigm and the care–responsibility paradigm as complementary and mutually supportive approaches to building a better world, I still find the fact that Confucius continuously emphasized relationality, placed the virtue of *jen/ren* at the very center of his teachings, and insisted that words are empty without action, another strong indicator of the confluence of Confucianism and ecofeminism.

Of all human qualities and virtues Confucius considered *jen/ren* the most admirable. The term has been translated as goodness, humaneness, human-heartedness, benevolence, care, and by Ames and Rosemont, as quality of the "authoritative person." While this choice of terminology seems at first cumbersome and unfortunate, especially given my claim that Confucianism and ecofeminism have much in common, the difficulty can, I believe, be removed through further elucidation. The authors explain that while partially accurate, none of the traditional interpretations capture the fullness of the meaning of *jen/ren*, which is so much more than a one-dimensional quality. It is a process of "growing" certain constitutive relationships within one's social force-field into "vital, robust, and healthy participation in the human community" (49).

For Confucius, to manifest or achieve *jen/ren* represents the essence of being a good person. It is something we do and become as we are our own projects and give birth to ourselves within society. It involves empathy, "doing one's utmost and putting oneself in the other's place" (*Analects* 4.15), living in the community of one's neighbors (4.24), "[being] generous in attending to needs of the common people" (5.16), and having little or no concern for financial gain, especially if it "requires deviating from the way" (4.5). "Exemplary persons," Confucius said, "help out the needy; they do not make the rich richer" (6.4). Finally, the exemplary person has the following characteristics: "Deference, tolerance, making good on one's word, diligence, and generosity" (17.6). Except for deference, if it is understood as submission to some unjust power, every one of those Confucian characteristics matches the ecofeminist program. Clearly the spirit–nature, mind–body, individual–community, theory–praxis dualism that has been so prevalent in Western thought since at least Plato simply does not affect Chinese thought. And that makes Confucianism and Chinese hermeneutical lenses in general very attractive to those among us who are concerned about the future of the world and hope to develop a ground-up humanity based approach to setting up a global ethic.

Ruether traces the development of Western spirit-matter, soul-body dualism from its Hebrew origin (the Creator God who is above nature and humanity) through its intensification among the Greeks (divinization of male rationality trapped by evil, feminine matter) to the doctrine of the Fall and radical rejection of embodiment and sexuality by the Church Fathers. Nature, in that perspective, is cursed, and woman is portrayed as inextricably embedded in nature (1983, 77–82). She argues that "an ecological–feminist theology of nature must rethink the whole Western theological tradition of the hierarchical chain of being and chain of command" (85), including the dominance of human over nonhuman nature, the right of humans to exploit the nonhuman, and the structures of social domination, male over female. "Finally, it must question the model of hierarchy that starts with nonmaterial spirit (God) as the source of the chain of being and continues down to nonspiritual 'matter' as the bottom of the

chain of being and the most inferior, valueless, and dominated point in the chain of command" (85). "The 'brotherhood of man'," she insists, "needs to be widened to embrace not only women but also the whole community of life" (87). Humans are given the "privilege of intelligence" not to rape, plunder, and subjugate the earth but rather in order to become responsible "caretaker[s] and cultivator[s] of the welfare of the whole ecological community upon which our own existence depends"(89). Hence "we need to learn how to use intelligence to mend the distortions we have created and how to convert intelligence into an instrument that can cultivate the harmonies and balances of the ecological community and bring these to a refinement" (89). Linear thinking tends to dichotomize and is blind to patterns of relationality and interdependence. "Ecological thinking demands a different kind of rationality . . . a different kind of order that is truly the way nature 'orders,' that is, balances and harmonizes" (90). Ruether concludes this crucial chapter, "Although we need to remake the earth in a way that converts our minds to nature's logic of ecological harmony, this will necessarily be a new synthesis, a new creation in which human nature and nonhuman nature become friends in the creating of a livable and sustainable cosmos" (92).

Despite its hierarchical and patriarchal external appearance, Chinese thought, and especially the Confucian tradition, has implicitly contained resources for this kind of transformation for some 2,500 years. The Confucian vision of humans as learners, the Confucian assumption of the perfectibility of humanity, the Confucian emphasis on the virtue of *jen/ren*, and the Confucian insistence on the importance of moral education and self-cultivation (Tu 1998, 3) represent a complex built-in self-regulating "mechanism" that permits correction of faulty or immature assumptions, such as the assumption that women are by nature inferior to men, in other words, not fully human. As Huey-li Li notes, China presents the puzzling combination of deep reverence for nature combined with culturally approved oppression of women (276). The absence of what Ruether calls transcendent dualism in Chinese society in no way mitigates the tradition of relegating women to an inferior social position. Li cites Tu Wei-ming's[1] description of the central motifs of Chinese cosmology:

> The idea of all-enfolding harmony involves two interrelated meanings. It means that nature is all-inclusive, the spontaneously self-generating life process which excludes nothing. The Taoist idea of *tzu-jan* ("self-so"), which is used in modern Chinese to translate the English word "nature," aptly captures this spirit. To say that "self-so" is all-inclusive is to posit a nondiscriminatory and nonjudgemental position, to allow all modalities of being to display themselves as they are. This is possible, however, only if competitiveness, domination, and aggression are thoroughly transformed. (Tu 1984, 118)

Thus, the Chinese tended to view the enduring pattern of nature as "'union rather than disunion, integration rather than disintegration, and synthesis rather than separation'" (119). If Western feminist arguments were correct, then the Chinese holistic world view should have prevented the oppression of women in China (Li 276). Instead, Chinese society has been among the most misogynist on earth; hence, there must be other forces at work that are in no way related to transcendent dualism (I tend to favor simple, biological explanations, such as the fact that until the development of contemporary reliable birth control techniques women tended to spend most of their adult lives pregnant, nursing, and caring for infants and children; in addition, they frequently died fairly young in childbirth). On the other hand, given the Chinese respect for nature combined with Confucian insistence of the importance of continuing to change by learning and improving, there is hope that women will in fact become full partners in the human enterprise.

Since Confucian education is process-oriented and the purpose of Confucian education is learning to become fully human, the educational enterprise itself is permanently and continuously capable of adapting to new understandings of humanity when the time for such an "evolutionary leap" has come—as it was for Confucius when he decided to educate himself at age fifteen (Tu 1998, 10), and that includes contemporary egalitarianism. We need to keep in mind that Confucius saw himself not as an agonistic Socratic gadfly intent on tormenting people into giving birth to themselves but as a non-adversarial friend who sought to awaken humans to the transcendent potential of their inner nature. In addition, like B. F. Skinner some 2,500 years later, Confucius appreciated the effectiveness of positive reinforcement rather than the aversive conditioning of negative fault-finding. He is reported to have said, "The exemplary person helps to bring out the best in others but does not help to bring out the worst. The petty person does just the opposite" (*Analects* 12.16). An alternate—albeit more sexist—translation makes my point even more strongly: "The gentleman calls attention to the good points in others; he does not call attention to their defects. The small man does just the reverse of this" (Beck). Looking at a fascinating online edition of the *Analects*, in which every Chinese character is linked to a detailed etymological explanation of how that particular character is used in various contexts, yields an earthy bit of advice in which the person of nobility is shown emphasizing accomplishment and a rise toward heaven rather than focusing on that which disgusts, while the "petty person who urinates" does the opposite.

Much like contemporary Western feminists, the Chinese, in contrast to the Greeks, have considered human beings not primarily rational but distinguished by a conjunction of heart and head, affection and reason, compassion and cognition, love and intellect. In fact, Mencius and his followers considered empathy, our "inability to bear the suffering of others" (Tu 1998, 7), the "'beginning'

(*duan*) of humanity" (7). Does this mean that people who enjoy inflicting pain on others for the delight of watching them suffer, are not fully human? Confucians also capitalize on the natural affection that binds parents and children. In general, Confucians, like Taoists, don't fight nature but work with nature. On the other hand, respecting nature does not necessarily mean practicing vegetarianism and insisting that animals have a right to life. Still, one of the greatest sages of the Neo-Confucian tradition, Master Chou, who will be discussed in more detail later, did in fact object to hunting. However, he was in the minority. In one of Chuang-Tzu's stories, the butcher named Ting of the Kingdom of Wei explains to King Hui how it is possible that he has used the same knife to carve thousands of slaughtered bulls without nicking or denting the blade for nineteen years: "Where part meets part there is always space, and a knife blade has no thickness. Insert an instrument that has no thickness into a structure that is amply spaced, and surely it cannot fail to have plenty of room" (Anderson 219). King Hui noted that the butcher's words had taught him how to conserve his vital forces. He was obviously unconcerned about the bull's vital forces.

Since embodiment is not seen as negative, neither are sexuality (if practiced within the bounds of propriety) and the biological mother-father-child relationship. In the Confucian view—similar to the ancient Hebrew understanding—bodies are not prisons of the soul but our means for spiritual self-transformation.

Furthermore, again much like feminists (and Catholics when they are not infected with the dualistic virus), the Chinese tend to think in terms of "both–and" rather than "either–or," and consider self-cultivation in concrete, relational, communal terms (the Chinese ability to harmonize Confucianism, Taoism, and Buddhism is another manifestation of this pattern of non-exclusive thinking, and could serve as a template for developing a global ethic). The notion of "learning for the sake of the self" shows that individuality and autonomy are not sacrificed to other-relatedness. The ego is accepted as the basic reference point for all our relationships. It helps us determine how to treat others and how to become responsible members of the community. Caring for one's self and caring for others are complementary aspects of the dynamic actualization of authentic, full personhood leading to an ever-widening network of mutual relationships that can expand to include the cosmos.

Ch'êng Hao (1032–85) defined benevolence as regarding heaven and earth as one body, "and the different things and innumerable forms within heaven and earth as the 'four limbs and hundred members.'" He asks, "How can any man regard his four limbs and hundred members without love?" (Graham 1959, 372). Confucian humanism is not limited to compassion for fellow humans; it allows people to empathetically form "one body" with Heaven, Earth, and the myriad things, leading to a harmonious relationship between humans and their natural matrix and full self-actualization. This description of benevolence is also kin to the Confucian notion of concentric circles of love

that radiate outward from the way people care for members of their families and clans toward the region of strangers. While Confucius taught that one's family should come first, he also insisted that others should not be excluded.

Confucian thought here is fully in tune with Val Plumwood's call for a common-sense approach to ethics in which "care for particular others is essential to a more generalised morality," because from a psychological point of view, "special relationships with, care for or empathy with particular aspects of nature as experienced, rather than with nature as abstraction, are essential to provide a depth of concern" (1988, 186–87). She explains that if such special relationships are not exclusive, the "experience of and care and responsibility for particular animals, trees, rivers, places and ecosystems which are known well, are loved and are appropriately connected to the self, enhance rather than hinder a wider, more generalised concern for the global environment" (187).

A parallel approach is taken by ecofeminist Deborah Slicer who, in her discussion of animal research, appeals to our tendency to care for our immediate family and animal companions, suggesting that these feelings "should extend some, via imagination and empathy, to our feeling for, our caring about, the plight of more extended others" (109). She adds that among "those who have a rich enough moral imagination, this regard will cross species boundaries" (109).

Along similar lines, but from an entirely different perspective, Teilhard de Chardin predicted in the 1940s that the spherical shape of the earth combined with exponential growth of populations and proliferation of communication — including "those astonishing electronic machines (the starting point and hope of the young science of cybernetics) . . ." would lead to the convergence of previously diverging cultures (1966, 111). He argued that global consciousness would precipitate creative unions which would intensify and focus individuality and diversity. He used the metaphors of sexual love and radioactivity: By merging in the generative core of their being, creative nuclei release new energy which engenders greater complexity which precipitates a chain reaction of further creative unions. "The more 'other' they become in conjunction, the more they find themselves as 'self.'" (1965, 262).[2]

Long before the schools of Confucianism and Taoism developed, Chinese thinkers had already formulated a cosmic theory of a cyclic pattern of waxing and waning, of expansion and contraction. They symbolized this dynamic interplay of forces in the *t'ai-chi t'u* (Diagram of the Supreme Ultimate—a circle divided by an S-curve into complementary light and dark halves). As one focuses one's gaze on the diagram, it becomes a vortex of rapid circular motion round an absolutely still center. Teilhard's imagery resembles this diagram of the *tao* as source of the "ten thousand things" through a process of transformation. The Diagram of the Supreme (or Great) Ultimate is so important to Chinese culture that it still appears in several national flags of countries affected by the Chinese.

Wing-tsit Chan points out that literally all of Neo-Confucian metaphysics was based on Chou Tun-i's (1017–1073) "Explanation of the Diagram of the Great Ultimate," which was in turn inspired by the sentence "The essence is very real" in the *Lao Tzu* (Chan 1963, 150). This is of major importance once we realize that Chinese philosophy in general can be characterized as an occasionally rather argumentative dialogue between the representatives of Confucian rationalism and Taoist mysticism. The fact that Chou's seminal essay represented a merging of Taoist and Confucian ideas was to affect all of Neo-Confucianism by allowing certain basic Taoist concepts to be internalized by their opposing principle. Through this addition of the Taoist spark of life, Confucianism became once again a vital, dynamic movement, instead of the rather dry pedantry to which it had degenerated after the times of Confucius (551–479 B.C.E.) and Mencius (371–289 B.C.E.?) (461). Master Chou was highly regarded by later scholars. I suspect he would feel quite at home among the deep green ecofeminists. He is described as loving waterfalls and lotus flowers, and respecting animal and plant life so much that he would not hunt or even cut the grass outside his window (462). Like ecofeminists, he also consistently sounds the "both–and" theme when he insists, for example, that "the sage equally stresses the internal and the external life" (461) or that "the many are [ultimately] one and the one is actually differentiated in the many" (474). The latter statement is one of Neo-Confucianism's most fundamental tenets. Chou emphasizes the gentle power of transformation, noting, "Heaven produces the ten thousand things through *yang* [the masculine principle of the *yin-yang* syzygy] and brings them to completion through yin" (470). Typically inconsistent, he saw no contradiction between honoring the "Supreme Ultimate," the *tao*, envisioned as a feminine principle, and blaming women's tendency to quarrel for causing disunity in the family. As Chenyang Li points out, the similarities shared by feminism and Confucianism "are not in the way they treat women but in the way of their philosophical thinking, in the way they view the nature and foundation of morality, and the way they think morality should be practiced" (1994, 81).

In the *t'ai-chi-t'u, yin*, the dark, receptive, yielding, intuitive, archetypally feminine principle is inextricably intertwined with *yang*, the luminous, creative, active, rational, archetypally masculine principle. They are of macro-and microcosmic significance, representing in their union the *tao* as well as the two prime modes of human consciousness which contemporary psychologists have identified with the two brain hemispheres (Ornstein 1975, 81–82) both of which are aspect of the psyche of men as well as women. While the *yang* has generally been considered the superior principle that is supposed to be in charge of the subservient *yin* (Li 1984, 82), in fact, both are equally essential to the whole and there is no reason—except for habit—not to give them equal weight. The *tao* offers a powerful paradigm of an androgynous source of all reality. Chou writes in reference to the Diagram of the Supreme Ultimate:

The Great Ultimate through movement generates *yang*. When its activity reaches its limit, it becomes tranquil. Through tranquillity the Great Ultimate generates *yin*. When tranquillity reaches its limit, activity begins again. So movement and tranquillity alternate and become the root of each other, giving rise to the distinction of *yin* and *yang*, and the two modes are thus established. . . . When the reality of the Non-ultimate and the essence of *yin*, *yang*, and the Five Agents come into mysterious union, integration ensues. *Ch'ien* [Heaven] constitutes the male element, and *k'un* [Earth] constitutes the female element. The interaction of these two material forces engenders and transforms the myriad things. The myriad things produce and reproduce, resulting in an unending transformation. (Chan 1963, 463)

The balance of self and other, the understanding of the cosmos as a web of interrelated events, as well as the concept of creative unions, give rise to the partnership model of the relationship of women and men as well as humanity and nature. In her book *Earthcare*, Carolyn Merchant presents precisely that kind of model, a "Partnership Ethic" that does not reject the valid aspects of such other models as egocentric, homocentric, and ecocentric ethics or unilaterally condemn certain approaches as unacceptable simply because they are viewed as "western" or "misogynist." Merchant's Partnership Ethic could be based on Confucian principles minus Confucian interpretation of paradigmatic humanity as exclusively male. At least linguistically, this step would be relatively simple because Chinese does not indicate gender or use personal pronouns the way Indo-European languages do (Ames 1998, 41). Hence, the supposed "Confucian gentleman" (*junzi*) might have been interpreted as a "Confucian gentlewoman" or, more appropriately, a "Confucian gentleperson" all along.

Merchant explains:

An alternative that transcends many of these problems is a partnership ethic. A partnership ethic sees the human community and the biotic community in a mutual relationship with each other. It states that "the greatest good for the human and the nonhuman community is to be found in their mutual, living interdependence.". . . The term partnership avoids gendering nature as a mother or a goddess (sex-typing the planet), avoids endowing either males or females with a special relationship to nature or to each other (essentialism), and admits the anthropogenic, or human-generated (but not anthropocentric, or human-centered) nature of environmental ethics and metaphor. A partnership ethic of earthcare means that both women and men can enter in mutual relationships with each other and the planet independently of gender and does not hold women alone responsible for "cleaning up the mess" made by male-dominated science, technology and capitalism. . . . [Partnership ethics] is grounded in the concept of relation. A relation is a mode of connection. This connection may be between people or kin in the same family or community, between men and women, between people, other organisms,

and inorganic entities, or between specific places and the rest of the earth. . . . A partnership ethic of earthcare is an ethic of the connections between a human and a nonhuman community. The relationship is situational and contextual within the local community, but the community is also embedded in and connected to the wider earth, especially national and global economies. (1996, 216–217)

As Kelley Ross notes in his online site concerning the "Six Relationships," for Confucius reciprocity and mutual respect are obligatory. Except for twins or friends who were born the same day, each relationship involves a pair of two unequal parties. The so-called "superior" member (male, older, parent, husband, or person of higher status) has the duty of benevolence and care toward the "subordinate" (female, younger, child, wife, or person of lower social status) member. The latter has the corresponding duty of obedience. However, "obedience in the Six Relationships in China was contingent on the superior member [sic] actually observing their duty to be benevolent and caring. Since the highest Confucian 'obedience' is to do what is right, 'true' obedience to parents, husband, ruler, etc. is to refuse to obey any orders to do what is wrong" (Ross, 1999). This notion of universal balance, fairness, and obligation to honor certain fundamental but constantly evolving cosmic principles of goodness eventually turned into the "Mandate of Heaven" which was viewed as justifying a ruler's right to reign in terms of transcendent (and yet also immanent) approbation. A ruler who violated the moral order of the universe could legitimately be overthrown, and the degree of legitimacy of the insurrection was empirically determined by its success or failure.

It seems then that in the present age, this appeal to a universal cosmic moral order calls out to be reinterpreted to include the new recognition of gender equality and hence expose misogyny as a violation of the "obligation to do what is right." In his essay on developing a universal ethic from a Neo-Confucian perspective, Shu-hsien Liu notes that Chinese "language and culture have a tendency to transcend their present horizon and move toward a fusion of horizons" (1998, 166) which can include acknowledging the need for "a universal ethics which would complement the declaration of human rights" (169) with its call for an end to inequality of the sexes. The Chinese hermeneutical perspective with its emphasis on the dynamic, evolving, relational structure of reality is in a unique position to help us strike a balance between conflicting paradigms and demands. *Yin* and *yang* can finally be recognized and appreciated as truly equal partners, supporting and engendering one another in a dynamic, mutual relationship. Ironically, and significantly, in line with Confucian respect for the past, they already appear to be such equal partners in the *t'ai–chi–t'u* if one only looks at and ponders the meaning of this ancient diagram without preconceived notions of superiority and inferiority.

Let me conclude these deliberations with a reference to a poem that has touched me more deeply than any other among the hundreds of poems from

many cultures I have read over the past fifty years. I first "met" this poem in 1961, in Archibald MacLeish's *Poetry and Experience*. It is Emperor Wu-ti's (r. 156–87 B.C.E.) tribute to his dead mistress, Li Fu-jen, written over 2,000 years ago. Wu-ti was one of the most powerful emperors of the Han dynasty, who mobilized giant armies, conquered vast territories, extended Han power to Central Asia, Manchuria, Korea, and Vietnam, established Confucian centers of learning, had the civil service program and imperial bureaucracy reorganized, and made Confucianism the state religion. But he also appears to have been capable of deep and lasting affection for a member of the second sex. In Arthur Waley's translation the poem reads:

> The sound of her silk skirt has stopped.
> On the marble pavement dust grows.
> Her empty room is cold and still.
> Fallen leaves are piled against the doors.
> Longing for that lovely lady
> How can I bring my aching heart to rest?
> (MacLeish 1960, 47)

No one whose loss continued to evoke such sadness and who was remembered as leaving behind such a poignant void so many months or even years after her passing could possibly not have been honored and loved as a person while she was alive.

Notes

1. Huey-li Li actually refers to Tu Wei-ming as "Tu Wei Mi" in both the chapter and the notes.

2. It is unfortunate that Jane Caputi fails to see Teilhard's pivotal role in developing a non-dualistic paradigm of a cosmic evolutionary process energized by love combined with a vision of humanity embedded in nature. Instead, she links Teilhard's fascination with radial energy to millennial necroapocalyptic fundamentalists and accuses him of condoning the "ultimate rape of nature" by approving of "'laying hands' on the very core of matter/mother" (1993, 240).

References

Ames, Roger T., and Henry Rosemont, Jr. 1998. *The Analects of Confucius: A Philosophical Translation*. New York: Ballantine.

Anderson, G. L., ed. 1961. *Masterpieces of the Orient*. New York: W. W. Norton.

Beck, Sanderson. September 11, 1999. "Confucius: Contents and Topics." *Confucius and Socrates: The Teaching of Wisdom*. http://san.beck.org/CONFUCIUS4-What.html.

Caputi, Jane. 1993. "Nuclear Power and the Sacred." *Ecofeminism and the Sacred*. Ed. Carol J. Adams. New York: Continuum. 229–250.

Chan, Wing-tsit, trans. and ed. 1963. *A Source Book in Chinese Philosophy*. Princeton: Princeton University Press.

de Chardin, Pierre Teilhard. 1965. *The Phenomenon of Man*. San Francisco: Harper & Row.

———. 1966. *Man's Place in Nature: The Human Zoological Group*. New York: Harper & Row.

Cuénot, Claude. 1965. *Teilhard de Chardin: A Biographical Sketch*. Baltimore: Helicon.

Cuomo, Chris J. 1998. *Feminism and Ecology: An Ethic of Flourishing*. London: Routledge.

Gilligan, Carol. 1982. *In a Different Voice: Psychological Theory and Women's Development*. Cambridge, MA: Harvard University Press.

Graham, A.C. 1959. "Confucianism." *The Concise Encyclopedia of Living Faiths*. Ed. R. C. Zaehner. New York: Beacon. 365–384.

Küng, Hans, and Julia Ching. 1988. *Christentum und chinesische Religion*. München: Piper Verlag.

Li, Chenyang. "The Confucian Concept of Jen and the Feminist Ethics of Care: A Comparative Study." *Hypatia* 9 (Winter 1994): 71–89.

Li, Huey-li. 1993. "A Cross-Cultural Critique of Ecofeminism." *Ecofeminism: Women, Animals, Nature*. Ed. Greta Gaard. Philadelphia: Temple University Press. 272–294.

Liu, Shu-hsien. 1999. "Reflections on Approaches to a Universal Ethics from a Contemporary Neo-Confucian Perspective." *For All Life: Toward a Universal Declaration of a Global Ethic. An Interreligious Dialogue*. Ed. Leonard Swidler. Ashland, OR: Whitecloud Press. 154–171.

MacLeish, Archibald. 1960. *Poetry and Experience*. Cambridge: Riverside Press.

Mellor, Mary. 1997. *Feminism & Ecology*. New York: New York University Press.

Merchant, Carolyn. 1996. *Earthcare: Women and the Environment*. New York: Routledge.

Ornstein, Robert E. 1975. *The Psychology of Consciousness*. New York: Penguin.

Plumwood, Val. 1993. *Feminism and the Mastery of Nature*. London: Routledge.

Ross, Kelley H. September 14, 1999. *Confucius*. http://www.friesian.com/confuci.htm.

Ruether, Rosemary Radford. 1975. *New Women/New Earth: Sexist Ideologies and Human Liberation*. New York: Seabury.

———. 1983. *Sexism and God-Talk: Toward a Feminist Theology*. Boston: Beacon.

———. 1992. *Gaia and God: An Ecofeminist Theology of Earth Healing*. San Francisco: Harper San Francisco.

———, ed. 1996. *Women Healing Earth: Third World Women on Ecology, Feminism, and Religion*. Maryknoll: Orbis.

Slicer, Deborah. 1996. "Your Daughter or Your Dog? A Feminist Assessment of the Animal Research Issue." *Ecological Feminist Philosophies*. Ed. Karen J. Warren. Bloomington: Indiana University Press. 97–113.

Swidler, Leonard. 1990. *After the Absolute: The Dialogical Future of Religious Reflection*. Minneapolis: Fortress.

Tu, Wei-ming. 1984. "The Continuity of Being: Chinese Visions of Nature." *On Nature*. Ed. L. S. Rouner. Notre Dame: University of Notre Dame Press. 113–129.

——. "Self Cultivation as Education Embodying Humanity." Unpublished paper presented at the XXth World Congress of Philosophy, Boston, 10–16 August, 1998.

Zhongwen.com. September 16, 1999. *Chinese Characters and Culture*. http://zhongwen.com/lunyu.htm.

Li Zhi and John Stuart Mill: A Confucian Feminist Critique of Liberal Feminism

Pauline C. Lee

1. Introduction

In contemporary feminist scholarship there exist a diversity of schools, of which liberal feminism, Marxist feminism, existentialist feminism, and psychoanalytic feminism are but a few. These various approaches, for the most part, arise from intellectual traditions which throughout their histories have voiced ideas that serve to subjugate women. To give one example, psychoanalytic feminism finds its origins in the works of Sigmund Freud, a thinker well-known in popular culture for his dismissive and rather unflattering views on women. Woman, according to Freud at his worst, is nothing more than a morally, intellectually, and physically castrated version of man. Despite the oppressive vision of women threading through these various intellectual traditions, feminists have nevertheless recognized the wealth of intellectual resources within them. These feminists have chosen to construct upon, reformulate, and contest the ideas within a given tradition in order to fashion effective and even formidable tools for undermining the systematic subjugation of women.

While there is an extensive corpus of secondary literature describing and analyzing the history of these numerous forms of feminist thinking, one finds little if any scholarship on the history of Confucian feminism. Not only is there little study on this subject, but prevalent within contemporary Confucian scholarship is the presupposition that such a form of feminism does not exist. In this paper, I describe the conception of women articulated by the iconoclastic, Ming Dynasty, Neo-Confucian thinker Li Zhi 李贄 (1527–1602).[1] By doing so, I aim to illustrate that there does exist a rich and vibrant Confucian feminism of which Li's is one form. Confucianism has its own distinctive expression of feminism which focuses on the project of self-cultivation. While liberal feminists view legal reform as the most effective tool for overcoming gender inequality, and Marxist feminists conceive of the subversion of capitalist social structures as the prime method for overturning the subjugation of women, Li Zhi, a Confucian feminist, understands the process of *self-cultivation* to be the most effective strategy for addressing the problem of patriarchy.

In order to better discern the distinctive aspects of Confucian feminism as articulated in the writings of Li Zhi, I will compare Li's ideas with one of the most influential forms of feminism in Western feminist discourse, that of liberal feminism. More particularly, I will compare Li's thinking with that of the Utilitarian philosopher John Stuart Mill (1806–1873). In the conclusion, I will identify one of the merits and shortcomings of both Mill's and Li's feminist agendas, and then describe one way in which liberal and Confucian feminism are compatible and even complementary theories for efficaciously addressing the problem of the subjugation of women.

2. An Orientation to Li Zhi and J. S. Mill

Upon first reading Li Zhi's arguments for gender equality, it is striking to see how similar they are to those forwarded by Mill in his feminist treatise *The Subjection of Women* (1869). Both appear to be arguing that the cloistering of women in the domestic sphere has created creatures who appear "naturally" subrational and submissive, and that gender equality can be attained by giving women the same educational and professional opportunities as men. For example, Li Zhi writes,

> [T]o say that there exists woman's vision and man's vision, how can that be acceptable?. . . From our contemporary times we can observe the following: Yi Jiang, a woman, completed the ranks of King Wu's ministers. Nothing hindered her from joining esteemed men such as Zhou, Chao, and Tai-gong as one of the ten able ministers. Wen Mu, a sagely woman, edited and compiled the airs of the Southern states. Nothing prevented her from being praised along with commentators such as San Yi-sheng and Tai Dian as the four friends. . . . [P]eople who have heard of these women no longer dare to link shortsightedness with women and farsightedness with men. How much more so would people's views on women change if a woman were to apply herself to the study of the transcendent. . . .[2]

Mill argues for

> [women's] recognition as the equals of men in all that belongs to citizenship—the opening to them of all honourable employments, and of the training and education which qualifies for those employments.[3]

However, if one interprets Mill's and Li's thinking through an understanding of the social structures by which each perceives their own social world, these facile similarities quickly dissolve.

Put briefly, Mill conceives of the world as divided between a private, domestic sphere and a public sphere comprised of economic and political activity. In contrast, Li, as a Confucian thinker, conceives of society as delineated along

the lines of "inner" 內 *nei* and "outer" 外 *wai*. Scholars have commonly identified the inner with the concept of private (or domestic) and the outer with that of public. For example, in *Confucian Thought: Selfhood as Creative Transformation* (1985), Tu Wei-ming makes such an identification when he writes, "The division of labor between the inner (domestic) and the outer (public) realm of responsibility makes it functionally necessary for the wife to assume a major role at home."[4] While there are similarities between the inner and the private (or domestic), and the outer and the public, I will show that much more significant are the differences between the inner/outer and the private/public model. In brief, the private/public model is one that is impermeable and categorical, while the inner/outer model is one that is permeable and graduated.

The dichotomy between the private and public sphere is central in much of contemporary Western feminist discourse. This distinction is not only of interest to feminists, but it has been a topic of sustained analysis and debate among thinkers throughout the Western philosophical tradition.[5] There have been a wide range of conceptions concerning what constitutes the public versus the private realms. What is characteristic about the model that feminists take as an object of critique is the separation and opposition between the two spheres. Much feminist scholarship identifies this impermeability as one of the primary sources of gender inequality. As I will argue later in this paper, impermeability between the two spheres is the source of many of the problems in Mill's feminist thinking.

In *Feminist Theory: From Margin to Center* (1984), bell hooks brings African-American women into the realm of feminist scholarship and in doing so, offers a good illustration of the problematic nature of the public/private distinction. She argues that although the separation and opposition between private and public may be a major source of subjugation for white, upper-middle-class women, it is not so for African-American women. This is because many African-American women, as well as other women from non-elite classes, have regularly crossed and to some extent effaced the sharp distinction between a private, domestic realm and a public realm of wage-earning labor. Many women in the margins of society have had to work outside the home in order to support their families.[6] And so, in this critical respect, the private/public model born from liberal thought is an inadequate lens through which to identify the sources of gender inequality among African-American women.

For different reasons, the application of the private/public distinction also obscures rather than illuminates the sources of gender inequality in traditional Confucian society. An analysis of the ideas of Mill and Li in light of their dissimilar conceptions of social structure can give us insight into at least one fundamental and important difference between their feminist views, as well as those between liberal and Confucian feminist thought in general. First, we turn to a discussion on the private/public distinction.

3. Conceptions of the Private/Public Dichotomy in Western Philosophy

In order to better understand the model of private/public that will help illuminate Mill's argument for gender equality, it will be productive to describe three of the more prevalent models of the private/public dichotomy. One way of defining the private and the public is to contrast the domestic world with the world of citizenship. Aristotle deploys such a distinction. He distinguishes the household (*oikos*) centered on domestic life (which in his time was tied to economic trade and production) from the political community (*polis*), the world of communal discourse and action.

Today, one of the most prevalent ways of thinking about the private and the public sphere is in terms of the administrative state on the one hand in contrast to civil society and the market economy on the other.[7] This model, well represented in the works of John Locke, differs in one important way from models such as Aristotle's in that the former defines the two spheres as bifurcated and distinct while the latter envisions the spheres in a relation of relative continuity. Also of significance, unlike the Aristotelian model which distinguishes between a sphere of "natural" inequality (i.e., the *oikos*) and a sphere of equality and autonomy (i.e., the *polis*), this second model distinguishes two spheres which are both characterized by equality and autonomy.

Yet another form of the private/public distinction, one that is of particular significance to the discussion in this paper, was first articulated by feminists such as Michelle Zimbalist Rosaldo,[8] and has since been applied by countless feminist scholars and social activists as a productive tool for analyzing the subject of gender inequality. This model bears a resemblance to that represented in both the thinking of Aristotle and Locke. It is akin to the Aristotelian model both in that it identifies the private sphere with the domestic, and in that the private sphere is one characterized by "natural" inequality while the public is characterized by autonomy. At the same time, it is similar to the Lockean model and differs from Aristotle's conception in that the private and public spheres are impervious to each other. Much feminist scholarship identifies the alleged impermeability between the private and public spheres as one of the primary sources of gender inequality. In order to distinguish this model from other forms of the private/public, feminists have often referred to it as the domestic/public distinction. In the following pages, I too will refer to this model as such.[9]

One aspect of the domestic/public model that is often left ambiguously defined is the issue of what constitutes the public sphere. The most common version of the domestic/public model defines the public sphere as comprised of the market economy, civil society, and the state. The private, domestic world is predicated on particularity and sentiment, while the public sphere of economics and politics is, in contrast, governed by universal principles founded on reason. In contemporary scholarship, the private/public distinction is also cast in terms such as nature/culture, personal/political, and female/male.

Respect for the individual and the individual's autonomy is at the center of liberal thought. But throughout most of the Western liberal tradition, not all humans have been considered autonomous individuals. Women, like children, were regularly conceived of as subrational by nature and their interests were subordinated under the paternal care of the male head of the household. This male head of the household is the paradigmatic individual in traditional liberalism. In order for this individual to fully flourish, he needs a private sphere separate from the political domain where he can freely pursue his particular vision of the good life. At the same time, he needs the state to help protect his privacy from intrusion by other individuals. The paradigmatic individual of liberal thought moves between two independent spheres, the public and the private. A woman, because of her nature, is necessarily relegated to the private realm. Her interests in the political sphere are assumed to be identical to that of her husband's. Again, our concern is with this domestic/public model because of its role in feminist scholarship and in helping shed light on the merits and oversights of Mill's feminist thinking.

4. *Inner* and *Outer* in the *Book of Rites*

On first examination, the Confucian delineation between the inner and outer realm appears to bear significant resemblance to that between the domestic and the public sphere. As with the domestic/public dichotomy, the inner realm centers around the family with women as protagonists, while the outer realm is primarily constituted of the economic and political aspects of society and is directed by the wills of men. However, the structural differences between these two models go beyond any superficial similarities in content. The Confucian inner/outer delineation, which is graduated and permeable, can be envisioned as a series of nested concentric circles with the family as the fountain of moral energy at the center of the well-ordered political and economic world.

In recent feminist scholarship, a number of scholars have criticized the conflation of the domestic/public with the inner/outer model.[10] For example, Susan Mann remarks,

> . . . the distinction between *nei* and *wai*—between women's inner sphere and men's outer sphere—is quite unlike the Western dichotomy separating the "domestic" from the "public" spheres. [Men and women] . . . are part of a family system that constitutes a seamless, unitary social order centered on the home and bounded by the outer reaches of the imperium.[11]

Dorothy Ko insists,

> Although often rendered in English as "domestic" and "public," "inner" and "outer" in their Chinese contexts are always relative and relational terms.[12]

What follows here is a schematic presentation of the inner/outer division as described in the *Book of Rites* 禮記 *Li Ji*,[13] a Confucian text commonly considered to be as influential in shaping the Confucian tradition and the consciousness of the Chinese gentry as are the *Analects*, the *Mengzi*, and the *Xunzi*. It is in the *Book of Rites* that we find one of the first and fullest accounts of the inner/ outer division in Confucian literature.[14]

The vision of differences as graduated rather than oppositional is well captured in the oft-used image in Confucian literature of the relationship of root to branch.[15] For example, in the *Xunzi* we find, "[Through rituals] the root and the branch are put in proper order; beginning and end are justified."[16] And in the *Book of Rites*, "It cannot be, when the root is neglected, that what should spring from it will be well ordered."[17] Inherent in this image of root to branch is also the notion of permeability.

Permeability within the Confucian social structure is manifested in at least two ways. First, the virtuous individual situated in the family is the necessary root of a harmonious society. Discussion of the powerful radiating influence of the virtuous individual situated in the family on all other aspects of social life is famously articulated in the "Great Learning" chapter of the *Book of Rites*. One must first cultivate the self before one is equipped to regulate one's own family, properly care for one's family before one can then govern the state, and govern the state well before one can then bring harmony to the world. In the "Great Learning" we find,

> The ancients who wish to illustrate illustrious virtue throughout the kingdom, first ordered well their states. Wishing to order well their states, they first regulated their families. Wishing to regulate their families, they first cultivated their persons.[18]

Traditional Confucian sources base society on "five human relations" 五倫 *wu lun*: father-son, ruler-subject, husband-wife, old-young, and that between friends.[19] In the concept of the five relations one also finds reference to the notion that cultivation of oneself within the family necessarily precedes proper governing of society. The fluidity between the domestic and the political is apparent in that proper ruler-subject relations spring from harmonious and upright spousal relations. This notion is articulated throughout the *Book of Rites* where, for example, it states,

> From the distinction between man and woman came the righteousness between husband and wife. From that righteousness came the affection between father and son; and from that affection, the rectitude between ruler and minister.[20]

While we have just discussed how permeability in the Confucian social structure radiates outward, influence also does radiate inward. For example, one of the recurring images in Confucian literature is that of the virtuous ruler

possessing a charismatic transformative influence over all those around him. This image is captured in *Analects* 2.1: "The Master said, 'One who rules through virtue can be compared to the Pole Star which commands the homage of the multitude of stars without leaving its place.'"[21] The root, though, of all that is admirable in the world find its very beginnings and sustenance in the virtuous individual. It is in the family that individuals begin the demanding and yet deeply fulfilling project of self-cultivation. The Confucian political order is founded on the virtue of individuals.[22] It is only when the individual has cultivated his virtue that he can then properly perform his role-specific duties whether as son, husband, father, minister, ruler, or friend.

This brings us to the second respect in which permeability is manifested in the Confucian social structure. The virtues and skills one gains through cultivating the self and caring for one's family are necessary and transferable to the task of governing the state. Generally speaking, within the Western philosophical tradition, markedly different skills and virtues are required for operating within the domestic in contrast to the public sphere. For example, the public sphere is one that ought to be governed by justice upheld with impartiality, while the domestic sphere is filled with loving care. In the Confucian society structured by the division between inner and outer, however, the mechanisms that govern the cosmos are the same ones that ought to govern the state and the family. The cosmos, the state, and the family are reflections of each other. The state, for example, is a microcosm of the cosmos, the family a microcosm of the state. This reflective relationship is one that is isomorphic in that each realm is of identical structure to the other. At the same time, the relationship is causal in that proper familial relations contribute to a more harmonious cosmos, and vice versa. This conception of the family as microcosm of the state and the state as microcosm of the empire is arguably first articulated in Chinese literature in the *Mengzi*,

> "The Empire, the state, the family." The Empire has its basis in the state, the state in the family, and the family in one's own self.[23]

The transferability of skills and virtues from the inner to the outer sphere is also evidenced in the analogy of the ruler to the parent. Repeatedly, the ruler is analogized to a father and mother:

> The happy and courteous sovereign
> Is the father and mother of the people . . .[24]

And later,

> When (a ruler) loves what the people love, and hates what the people hate, then is he what is called 'The Parent of the People.'[25]

The permeability between the inner and outer exists not only in the relationship between the family and the political sphere, but also between the family and the economic domain. In order for a woman to properly fulfill her role-specific duties in the family, she was expected to help support her family through weaving and embroidery, and these works were then sold in the marketplace.[26]

In its details, the location of the boundary and the degree of permeability between the inner and outer spheres is negotiated differently both practically and theoretically throughout Chinese history.[27] What is held constant in the inner/outer model is that the source of moral energy finds its locus in the family, and the same principles that govern the domestic sphere also apply to the political and economic sphere.

For anyone interested in the subject of feminism, the relationship between family and political life is an important one. During the last decade, feminist scholars have devoted much of their efforts to arguing for the notion that the personal is political. A careful study of how the Confucian tradition conceives of the relationship between family and political life has much to offer to such an inquiry.

More to the purpose of this paper, having drawn out the significant differences between the domestic/public and the inner/outer models, we now turn to a discussion on J. S. Mill's feminist philosophy, followed by an analysis of Li Zhi's arguments for gender equality.

5. J.S. Mill:
Initiating Women into the Public Sphere

J. S. Mill, one of the great philosophers in the liberal philosophical tradition, contributed to a broad spectrum of fields: logic, political philosophy, metaphysics, and economics. In the following pages, I describe the main argument in Mill's feminist philosophy in order to compare his ideas with those of Li Zhi.[28] Through such a comparison, I intend to bring to light one interesting and important aspect in which Confucian feminism, as articulated in the works of Li Zhi, can productively address a shortcoming in liberal feminism, as represented in the writings of Mill, as well as contribute to contemporary feminist discourse at large.

Legal and educational reform for the purpose of initiating women into the public sphere, a world constituted of the rights and duties of full citizenship and opportunities for employment, is the centerpiece of most versions of liberal feminism. In J. S. Mill's *The Subjection of Women*, we find one of the classical formulations of this seminal approach to the problem of the systematic oppression of women. Mill's treatise begins with a call for legal reform. He writes,

[T]he principle which regulates the existing social relations between the two sexes — the legal subordination of one sex to the other — is wrong in itself, and now one of the chief hindrances to human improvement; and . . . ought to be replaced by a principle of perfect equality. . . .[29]

Legal reform resonates throughout this work and is indeed at the heart of Mill's agenda for overturning gender inequality.

The concept of equality undergirds all of Mill's political philosophy. Before further examining Mill's feminist political philosophy, it thus seems profitable to first examine Mill's conception of equality. Equality has been conceived of by thinkers throughout history in various senses. One useful way to define equality is by distinguishing between *difference equality* and *sameness equality*.[30] In respect to the subject of gender, sameness equality is the notion that equality consists in allotting identical amounts of a given thing to both men and women alike. Difference equality is the notion that equality is allotting amounts of a given thing in respect to what men and women need in order to obtain identical degrees of power and privilege in society. Giving men and women the same time-off for maternity and paternity leave is an instance of sameness equality. Giving women longer time off for maternity leave because women, not men, carry and bear children and are thus physically and emotionally taxed is an instance of difference equality. In legal literature, sameness and difference equality in reference to gender have also been termed gender neutrality and special protection, respectively.

Mill, as is characteristic of liberal feminists in general, articulates a notion of equality that can be identified as sameness equality. In light of his conviction that identical treatment between men and women in the professional sphere will enable women to attain equal privilege and power both in the domestic and public world, Mill devotes his feminist treatise to pushing for legal and educational reform that will enable women to participate equally alongside men in the public sphere.

While Mill chooses to focus his discussion of legal reform on two subjects in particular, that of marriage and professional employment, the crux of his vision for overcoming gender inequality turns on legal reform that will open up professional opportunities to women. Mill argues that for at least two reasons, admission into professional vocations is necessary and of significant importance if women are to become equal members alongside men both at home and in society at large. First, in order for a woman to possess equal power alongside her husband in the domestic sphere, she cannot be wholly dependent on him for every essential need and in particular, her economic needs. By opening up professional opportunities to women, women then possess the invaluable *option* of pursuing wage-earning labor. This option makes independence construed as economic self-sufficiency a real possibility. A woman

then is freed from the state of being forced to rely on her husband's good graces for her every happiness, and also possesses the real option, if relevant reasons arise, to dissolve the bond of marriage.

Second, Mill believes that a fulfilling professional career contributes importantly to a meaningful life and therefore, such opportunities ought not be denied to women. In order to understand why Mill holds a professional career in such high regard, we must understand Mill's conception of the self. Mill differs from earlier Utilitarians, such as his father, James Mill, and Jeremey Bentham, in that the younger Mill envisions an organic rather than a mechanistic model of the self. In other words, Mill believes that human beings grow and develop, and this process of intellectual and moral maturation is an essential aspect of a fulfilling life. Pursuit of a self chosen profession is intrinsically a joy but even more important to Mill, is also one of the prime ways humans can cultivate what is best in them—their intellectual and moral capacities. Engagement in a career of one's choice, then, is one important way to cultivate oneself. This self-cultivation in turn enables one to enjoy the more deeply rewarding things in life, such as poetry rather than pushpin, and in this way, live a more meaningful life.

Even though Mill sees the option of pursuing a professional career as necessary to women's liberation, peculiarly enough, in the end he insists that given the choice between a profession outside of the home and marriage, which in his mind entails the full-time care of home and children, most women will desire the option of marriage. He admits that there are women who possess unusual talents and sensibilities which cannot be satisfyingly stimulated in the capacity of wife and mother. For these women, and in order to guarantee women the real possibility of economic independence, it is necessary that respectable professional opportunities be opened up to both genders.

In arguing that women be freed from the fetters that tie them to the domestic sphere, one of Mill's chief foes is the age-old stereotype of women as "naturally" submissive and subrational and therefore best relegated to the domestic sphere. Mill's prime tactic in arguing against the subordination of women is to deconstruct this caricature of the "natural" women, one which runs throughout much of the history of Western philosophy.[31] Mill argues that men and women possess the same talents and virtues, and that the cloistering of women within the domestic sphere has only served to create warped creatures with stifled talents and frustrated ambitions. He writes,

> What is now called the nature of women is an eminently artificial thing—the result of forced repression in some directions, unnatural stimulation in others. . . . [I]n the case of women, a hot-house and stove cultivation has always been carried on of some of the capabilities of their nature . . . while other shoots . . . are left outside in the wintry air. . . . [M]en, with that inability to recognize their own work . . . indolently believe that the tree grows of itself in the way they have made it grow,

and that it would die if one half of it were not kept in a vapour bath and the other half in the snow.[32]

Mill's prime strategy, then, for attaining gender equality is to bring women into the public sphere. By doing so, he thus transforms the substance of the division between the domestic and public sphere, but holds onto the traditional formal structure defined by impermeability between the two spheres. Put in other terms, Mill deviates from liberal thinkers before him in that he innovatively applies cherished liberal principles of freedom and equality to women and argues that women, too, ought to be given the opportunity to enjoy the goods brought by participation in the public realm. Where he falls short is in taking for granted the inalienability of the traditional distinction drawn between the public and the private. Mill sees society structured in such a way that the public and private are so rigidly set apart that domestic chores and child rearing are all consuming tasks. Mill liberates women by giving them a choice between a family life and a public career. However, while men, in Mill's world, can have both, women still must choose one or the other. In terms of Mill, then, contemporary feminists who identify impermeability between the domestic and public spheres as one of the prime sources of women's subjugation have their collective finger on one of the foremost problems in Mill's feminist philosophy. One of the shortcomings in Mill's feminist vision is indeed his inability to imagine a social world where there exists permeability between the spheres of the domestic and the public.

While the main focus of Mill's feminist agenda is on legal reform, Mill does also recognize the importance of self-cultivation, or put in more limited terms familiar to contemporary social activism, consciousness raising. Self-cultivation in Mill's philosophy, though, is always of secondary importance to legal reform. We will return to this subject later in this paper. First, we turn to a discussion on a thinker who does place self-cultivation at the center of his philosophy for overturning the oppression of women.

6. Li Zhi: Liberation through Self Cultivation

Li Zhi, a renowned iconoclast of the late Ming dynasty, is one of the most trenchant critics of Confucian orthodoxy. His books, of which over thirty are extant (the most famous being *A Book to Burn* 焚書 *Fen Shu* and *A Book to Hide* 藏書 *Cang Shu*), have consistently aroused great interest among intellectuals. However, because his books are deeply controversial and many of them are also so vitriolic and incisively critical of Confucian bureaucracy, they were banned for much of the Ming and Qing dynasties.

Since that time, much Chinese and Japanese scholarly attention has been devoted to Li's writings. While this secondary literature ranges across a diversity of topics, whether it be Li's literary criticism or his critiques on the Cheng-Zhu

school of Neo-Confucianism, still, relatively little attention has been paid to one extremely interesting aspect of Li's thought, that is, Li's innovative views on women.

Upon first reading Li's writings on women, one striking aspect is the resemblance of Li's defense of gender equality to that of Mill's. Li too holds that women's lives are unfairly restricted to domestic affairs and insists that this seclusion is responsible for fashioning women, who innately possess the same talents and virtues as men, into petty, shortsighted creatures. Not only are these two thinkers' arguments akin in many ways, historically speaking, Mill and Li occupy similar roles in their respective traditions. Both are seminal feminist thinkers who find themselves arguing against cultural traditions whose major thinkers throughout history viewed women as submissive, morally developed but intellectually lacking, and best belonging in the domestic sphere. Despite the initial striking similarities, in fact what is much more interesting and substantive are the differences between Mill's and Li's arguments for gender equality. While Mill believes that gender equality can be achieved by bringing women into the public sphere, Li focuses his discussion on one of the most fundamental concerns to any Confucian, that of self-cultivation.

The primacy of self-cultivation in the Confucian tradition is forcefully articulated in the "Great Learning" chapter of the *Book of Rites* which states, "From the son of Heaven down to the multitudes of the people, all considered the cultivation of the person to be the root (of everything besides)."[33] Self-cultivation is central to the Confucian tradition and from antiquity through the present has been envisioned in various nuanced ways by different thinkers.[34] For example, the two great interpreters in ancient China of Confucius' thought, Mengzi (391–308 B.C.E.) and Xunzi (310–219 B.C.E.), conceived of self-cultivation in significantly different terms. Mengzi believes that self-cultivation is a process which involves nurturing and *developing* nascent moral inclinations. This process requires both reflection and study. In contrast, Xunzi argues against Mengzi, claiming that humans are born with various passions, and that part of being human is learning to *re-form* these passions. Self-cultivation, then, involves reigning in and channelling innate inclinations. Since there is little that is innately morally good about humans, reflection in Xunzi's program is much less efficacious in the process of self-cultivation than is diligent study of the proper texts and with the proper teachers. Another significant contrast in conceptions of self-cultivation in the Confucian tradition arises between ancient Confucian thinkers such as Mengzi and Xunzi, and Neo-Confucians such as Zhu Xi (1130–1200) and Wang Yang-ming (1472–1529) who, influenced by Buddhist thinking, articulate a *discovery*[35] model of self-cultivation. For these Neo-Confucians, we are all born with a fully developed moral mind which is obscured by murky selfish desires. The project of self-cultivation involves dissipating these desires. The way in which Neo-Confucians differ among themselves on the subject of self-cultivation is in regard to the process by which the

moral mind is discovered. Zhu Xi, for example, looks outward and emphasizes investigation of the external world while Wang Yang-ming asks us to focus on our mind's reactions to situations and things. Having briefly discussed the centrality of self-cultivation to the Confucian tradition in general, let us survey Li's conception of self-cultivation as it relates to his arguments for gender equality.

One of Li's fundamental beliefs is the innate goodness of all people. He holds *preservation* of the innate heart–mind, or what he terms the "child-like mind" 童心 *tong xin*, as the key to intellectual, moral, and spiritual self-cultivation. Unlike most Neo-Confucians, Li's model of self-cultivation is not a *discovery* model but rather a *preservation* model which rests in preserving the innate child-like mind. For Li, it is contact with the alluring stimulation and corrupting hypocrisy of the external world that causes us to lose our birthright of sagehood. In order to preserve one's child-like heart, Li insists on the necessity of focusing on one's own mind. While much of what the physical and social world offers only serves to deaden the senses of the child-like mind, Li believes that certain texts and teachers can help protect one's original mind and that withdrawal from the physical world can also shield one's child-like mind from these harmful influences. Books that aid in preserving one's original mind are those that are the spontaneous, natural products of a child-like mind. Li dispenses with the traditional canon of classics and judges literature by his own yardstick, that of sincerity. Wearing the hat of a bold iconoclast, Li exhorts in his famous essay "On the Child-like Heart,"

> And so, if I am inspired by writings which spontaneously come from the child-like mind, then what need is there to talk of the Six Classics, the *Analects*, and the *Mengzi*? As for the Six Classics, the *Analects*, and *Mengzi*, where do they not consist either of excessive praise by official historians or adulation by imperial ministers, they are merely what impractical followers and dimwitted apprentices recalled the master as saying. . .[36]

Li also believes that physical withdrawal from the social world can help protect one's original mind from the obscuring influences of hypocritical social life. In fact, Li himself chose this route of self-cultivation when at the age of seventy-three he retreated into a Buddhist monastery.

Regarding self-cultivation, Li's chief concern not only in literature but in all aspects of life is with genuineness and sincerity. Li's sage is one whose actions and words are the natural outpourings of the child-like mind, and Li's greatest foe is hypocrisy. In a barely veiled critique of the artifice and hypocrisy of the aristocracy, Li exclaims,

> It seems to me that once a person is hypocritical, nothing he does will not be hypocritical. In this way, hypocritical words are used to talk to hypocritical people,

making those who are hypocritical happy. When hypocritical things are done by hypocritical people then those who are hypocritical are happy. When hypocritical writing is discussed, then those who are hypocritical are happy. When everything is hypocritical, there is nothing that those who are hypocritical do not like.[37]

Li holds that all humans are born with a pure and fully developed moral mind, and for Li, this belief in the moral goodness of all humans translates into the belief that males and females are endowed with the same talents and virtues. Li insists on the equality between the sexes in his letter "In Response to a Letter Claiming that Women Cannot Understand the Dao Because They are Shortsighted." He writes,

To say that woman and man exist is acceptable. But to say there exists woman's vision and man's vision, how can that be acceptable? To say that shortsightedness and farsightedness exist is acceptable. But to say that a man's vision is entirely farsighted and a woman's is wholly nearsighted, once again, how can that be acceptable?[38]

In speaking of equality, both Li and Mill refer to the notion that humans, regardless of sex, possess nascent capacities that are similar in kind. Li and Mill differ in that while Mill has in mind intellectual and moral capacities, Li additionally identifies spirituality as a capacity. In fact, among the moral, the intellectual, and the spiritual, Li extols the spiritual to be the worthiest. Spiritual development is not only a good in itself, but also gives one an ineffable power that has a transformative moral and spiritual effect over those around oneself. As such, spiritual cultivation is also an essential means to any form of truly effective political leadership.

Like Mill, Li also argues that women's deficiencies are due to confinement. However, the two differ on the kind of confinement each has in mind. Mill focuses on the fact that women have been excluded from the public sphere of citizenship and professional careers. In contrast, Li argues that women suffer intellectually, morally, and spiritually because of socially prescribed gendered differences in methods of self-cultivation. Confucian educational segregation based on gender lines is described throughout the *Book of Rites*. For example we find that "a boy [was taught to] respond boldly and clearly; a girl, submissively and low."[39] By the age of ten, boys and girls were reared in separate quarters: "A girl at the age of ten ceased to go out [from the women's apartments]. Her governess taught her [the arts of] pleasing speech and manners, to be docile and obedient," to manage the household, and to assist in ritual ceremonies.[40] Li operates within the Confucian framework where self-cultivation is the basis of all other forms of social transformation. Predictably, then, Li identifies self-cultivation as the central concern in his argument for gender equality.

Unlike in the Western philosophical tradition, in which women on the whole have been conceived of as subrational and docile in contrast to men who are conceived of as rational and assertive,[41] in the Confucian tradition, men's and women's ways of thinking differ not in mode (e.g., intuition, reason) but in content. Li Zhi refers to this difference as one between "shortsighted-ness 短見 *duan jian*" and "farsightedness 遠見 *yuan jian*." Women think in the same way as men do, but regarding different subject matter. In traditional Confucian society, women's vision is considered shortsighted. Li describes the shortsighted as ones who "hear only the chatter in the streets, the viewpoints of those in the alleys, the talk in the marketplace, and the words of children."[42] Their cares are about the "transient realm" and are limited to the sphere of the personal rather than the larger society. Men, in traditional Confucianism, are identified with farsightedness. Such people, writes Li, devote their minds to great literature, government, the "thoughts of sages," and the "transcendent." In refuting the assertion that women are by nature shortsighted, Li points to the "small minded person in the marketplace."[43] Peddlers and other men of a variety of professions, Li remarks, also dwell on the petty and transient and so too are shortsighted.

The women Li extols as "farsighted" are those who are given the opportunity to apply themselves to the study of the most refined subjects. For example, Li writes,

> How much more would people's views on women change if a woman were to apply herself to the study of the transcendent and desire to be like Shakyamuni and Confucius . . .

And later,

> What if one were to meet a woman who wandered in the refined world with an understanding achieved by studying the Buddha's teachings? If one were to meet a woman who transcended this material world, would it be possible for anybody not to greatly admire her?[44]

For Li, women's deficiencies arise from lack of opportunities for self-cultivation. In order for women, like men, to develop into the rational, moral, and spiritually sensitive beings that they can be, women too need to be given the same opportunities as men for engaging in self-cultivation.

7. A Confucian Feminist Critique of Liberal Feminism

We began this paper by describing the significant differences between the domestic/public dichotomy as conceived by contemporary Western feminists, and the inner/outer delineation as articulated throughout the Confucian

tradition. We then argued that the facile identification of the domestic/public with the inner/outer model when reading the Confucian tradition conceals rather than reveals what is distinctive about Confucian feminism as found in the writings of Li Zhi.

The Confucian tradition envisions the virtuous individual as the source of moral energy at the center of a harmonious society. Consequently, the tradition places moral, intellectual, and spiritual self-cultivation at the heart of its moral and political philosophy. Li contests the traditional Confucian vision of women as shortsighted, and in a radical reformulation of the tradition, argues that opportunities for self-cultivation ought to be available to both men and women. In concluding, I outline one way in which Li's feminist thinking can redress a shortcoming in liberal feminism as represented in the writings of Mill.

While Li forges a feminism with self-cultivation as the basis of social transformation, Mill turns his attention to legal reform. Although Mill focuses on ensuring certain basic rights, it would be inaccurate to claim that he wholly overlooks the importance of self-cultivation or the limitations of mere legal reform in advancing social change. For example, throughout *The Subjection of Women*, he voices the notion that part of what is wrong with the cloistering of women within the narrow confines of the domestic sphere is that it leaves men with intellectually dull wives. This lack of stimulation in an intimate relationship robs men of one important resource for self-cultivation. Mill writes,

> Any society which is not improving is deteriorating: and the more so, the closer and more familiar it is. Even a really superior man almost always begins to deteriorate when he is habitually (as the phrase is) king of his company: and in his most habitual company the husband who has a wife inferior to him is always so.[45]

However, despite this cognizance of the importance of self-cultivation, for many reasons Mill's vision of social transformation differs from Li's not merely in degree but in kind. For one thing, in Mill's philosophy, legal reform comes logically prior to possibilities for self-cultivation. For example, it is only when women are given the legal right to work in the public sphere that they can pursue professions of their choice, which in turn offers them challenges conducive to self-cultivation. Also, Mill's understanding of self-cultivation as primarily intellectual but also moral, is significantly more limited than that of Li's, which encompasses a richly developed notion of moral, intellectual, and spiritual cultivation. Indeed, then, Mill is primarily concerned with legal reform, Li with self-cultivation. These two prescriptions, whatever their marked differences, are at the same time compatible and even complementary strategies for addressing the problem of patriarchy.

Self-cultivation is essential to any meaningful and substantive form of social change. At the same time, self-cultivation is a long and arduous process and

one which some never understand or fully engage in. Li expresses a richly developed understanding of the crucial role of self-cultivation in advancing the position of women in society. Where he falls short in his feminist thinking is that he overlooks how important it is to guarantee basic rights in order to protect society and its most marginalized from at least the worst kinds of oppression. Mill, in contrast, apprehends the necessity of guaranteeing basic rights. However, he does not fully appreciate the fact that meaningful and substantive social transformation requires tremendous and protracted efforts in self-cultivation and consciousness raising.

By giving further analysis and drawing out the significant differences between two models of social structure, domestic/public and inner/outer, that at first glance appear to bear striking resemblance to each other, we have discerned in Li Zhi's thought a particular feminism that is distinctive to Confucianism. A careful study of the varieties of feminist thinking within the Confucian tradition can only serve to further nuance and deepen our understanding of the sources of gender oppression, and aid us in formulating efficacious strategies for addressing the injustices wrought by patriarchy.

Notes

* I would like to thank Shari Epstein, David Johnson, Julius Moravcsik, Claudia Santosa, Julius Tsai, Lee H. Yearley, and especially Philip J. Ivanhoe for their invaluable comments on earlier versions of this paper.

1. For the most extensive bibliography in English on the topic of Li Zhi, see Hok-lam Chan, ed., *Li Chih (1527–1602) in Contemporary Chinese Historiography* (New York: M. E. Sharpe, Inc., 1980).

2. Li Zhi 李贄 *Da yi nu ren xue dao wei jian duan shu* 答以女人學道為見短書 in *Fen-shu/Xu Fen-shu* 焚書 / 續焚書 (Taibei: Hanjing wenhua shiye youxian gongshi, 1984): 59. The translation of this letter is my own.

3. John Stuart Mill, *The Subjection of Women*, ed. Susan M. Okin. (Indianapolis, IN: Hackett Publishing Company, 1988): 86.

4. See Wei-ming Tu, *Confucian Thought: Selfhood as Creative Transformation* (Albany: State University of New York Press, 1985): 143.

5. For an analysis of the various ways thinkers have conceptualized the private in contrast to the public, see Jeff Weintraub's "The Theory and Politics of the Public/Private Distinction" in *Public and Private in Thought and Practice: Perspectives on a Grand Dichotomy,* ed. Jeff Weintraub and Krishan Kumar (Chicago: The University of Chicago Press, 1997).

6. See bell hooks, *Feminist Theory: From Margin to Center* (Boston: South End Press, 1984).

7. For a discussion of the relationship between the administrative state and civil

society in late imperial and modern China, see the collection of essays in *Modern China* 19, no. 2 (1993).

8. See Michelle Zimbalist Rosaldo and Louise Lamphere, eds., *Woman, Culture, and Society* (Stanford: Stanford University Press, 1974).

9. See Carole Pateman, "Feminist Critiques of the Public/Private Dichotomy" in *Private and Public Social Life*, ed. Stanley Benn and Gerald Gaus (London: Croom Helm, 1983). Pateman distinguishes two ways in which liberals have defined the private/public distinction. Liberals have defined the division first, as one between the economic and political realm from the domestic sphere, and second, as one between the state and all other aspects of social life. Feminists take the former model as their object of critique and often refer to it as the domestic/public distinction.

10. See Dorothy Ko, *Teachers of the Inner Chambers: Women and Culture in Seventeenth-Century China* (Stanford: Stanford University Press, 1994): 12, 13, chapters 3–5; Francesa Bray, *Technology and Gender: Fabrics of Power in Late Imperial China* (Berkeley: University of California Press, 1997): 53, 95, 180; Susan Mann, *Precious Records: Women in China's Long Eighteenth Century* (Stanford: Stanford University Press, 1997): 15.

11. Mann, 15.

12. Ko, 13.

13. The *Book of Rites* consists of 49 records written by Confucians from the late Zhou, Qin, and Han periods, and was compiled in the first century B.C.E. In the Sung dynasty, two chapters in the *Book of Rites*, the "Great Learning" and the "Doctrine of the Mean," were canonized along with the *Analects* and the *Mengzi* as the "Four Books." For a short introduction on the *Book of Rites*, see Jeffrey K. Riegel's "Li Chi 禮記" in *Early Chinese Texts: A Bibliographical Guide*, ed. Michael Lowe (Berkeley: The Society for the Study of Early China and The Institute of East Asian Studies): 293–297. Also, see the introduction by Ch'u Chai and Winberg Chai in *Book of Rites,* vol. 1, tr. James Legge. (New York: University Books): liii–lxxx.

14. For a discussion on conceptions of women in the *Book of Rites*, see Richard W. Guisso, "Thunder Over the Lake: The Five Classics and the Perception of Woman in Early China" in *Women in China: Current Directions in Historical Scholarship*, ed. Richard W. Guisso and Stanley Johannesen (Youngstown, New York: Philo Press, 1981): 47–61.

15. See Legge, vol. 2, 411, 420. Also, Tu vividly articulates this particular mode of thinking in "The Continuity of Being: Chinese Visions of Nature." See Tu, 35–50.

16. Watson, 94.

17. Legge, vol. 2, 412.

18. Ibid., 2, 411.

19. See *Mengzi* 3A.4.

20. Legge, vol. 2, 430.

21. D. C. Lau, tr. *Confucius: The Analects* (New York: Penguin Books, 1979): 63, with slight emendations.

22. See, for example, *Analects* 2.1 and Legge, vol. 2, 418.

23. See *Mengzi* 4A5.

24. Legge, vol. 2, 278.

25. Ibid., 420.

26. For example, see Legge, vol. 2, 431.

27. For example, in *Teachers of the Inner Chambers*, Ko writes that seventeenth-century China is a period where the boundary between the inner and outer is heatedly contested among the gentry. In a social world defined by rapid urbanization, commercialization, and an emerging print culture, a significant number of talented elite women challenged and enlarged the domestic sphere by means of successfully taking on traditional men's roles as professional teachers. See Ko, especially 115–142.

28. For an introductory discussion on liberal feminism, including a discussion on J. S. Mill, see Rosemarie Tong, *Feminist Thought: A Comprehensive Introduction* (San Francisco: Westview Press, 1989): 11–38. Also, for a discussion on J. S. Mill's feminist philosophy, see Susan Moller Okin, *Women in Western Political Thought* (Princeton: Princeton University Press, 1979): 197–232.

29. Mill, 1.

30. For a discussion and critique of this distinction, see Catherine A. MacKinnon, "Difference and Dominance: On Sex Discrimination" in *Feminist Legal Theory*, ed. K. Bartlett and Rosanne Kennedy (San Francisco: Westview Press, 1991): 81–94.

31. With the exception of Plato, the major thinkers in the Western philosophical tradition have all held some version of the view that women are *naturally* submissive and subrational. This conception of women is well represented in Jean-Jacques Rousseau's *Emile*. For an analysis of this subject, see Susan Moller Okin, *Women in Western Political Thought* (Princeton: Princeton University Press, 1979).

32. Mill, 22–23.

33. Legge, vol. 2, 412.

34. For a detailed discussion of this subject see Philip J. Ivanhoe, *Confucian Moral Self Cultivation* (New York: Peter Lang, 1993); and also Philip J. Ivanhoe's "Thinking and Learning in Early Confucianism" in *Journal of Chinese Philosophy* 17 (1990): 473–493.

35. I borrow this distinction among a *development*, *discovery*, and *re-form* model of self-cultivation from the works of Philip J. Ivanhoe and Lee Yearley. See Ivanhoe's *Confucian Moral Self Cultivation* and Lee H. Yearley, *Mencius and Aquinas: Theories of Virtue and Conceptions of Courage* (Albany: State University of New York Press, 1990): 53–111.

36. Li Zhi 李贄 *Tong xin shuo* 童心説 in *Fen-shu/Xu Fen-shu* 焚書 / 續焚書 (Taibei: Hanjing wenhua shiye youxian gongshi, 1984): 98. The translation of this letter is from Tobie Meyer-Fong's unpublished work with slight emendations of my own. For a published translation of this letter, see Stephen Owen, ed. and tr., *An Anthology of Chinese Literature: Beginnings to 1911* (New York: W. W. Norton and Company, 1996): 808–811.

37. Li, 98.

38. Li, 59.

39. Legge, vol. 1, 477.

40. Legge, vol. 2, 477.

41. The topic of women's in contrast to men's ways of thinking is a subject of considerable debate in contemporary feminist scholarship. For example, see Carol Gilligan's seminal work *In a Different Voice: Psychological Theory and Women's Development* (Cambridge: Harvard University Press, 1982).

42. Li, 59.

43. Li, 59.

44. Li, 59.

45. Mill, 101.

The View of Women in Early Confucianism

<div style="text-align:right">7</div>

Paul Rakita Goldin

1. The Problem of Confucian "Sexism"

It has become something of a scholarly commonplace to criticize traditional Chinese thought—and especially traditional Confucian thought—for its perpetuation of repressive and depreciating stereotypes of women.[1] Indeed, there appears to be no shortage of textual justification for this point of view. Several poems in the canonical *Book of Odes* 詩經, for example, depict vividly the chaos that must ensue when women have too much influence over political affairs. Consider the oft-cited case of "I See on High" ("Chan-yang" 瞻卬, *Mao* 毛 264):[2]

> People had land and fields
> but you possess them.
> People had followers
> but you seize them.
> This one is properly without guilt
> but you arrest him.
> That one is properly with guilt
> but you set him loose.
>
> A clever man completes a city;
> a clever woman overturns a city.
> Alas, that clever woman!
> She is a *hsiao*-bird 梟;[3] she is an owl.
> Women have long tongues.
> They are the foundation of cruelty.
> Disorder does not descend from Heaven.
> It is born of woman.
> There is no one to instruct or admonish [the king]
> because those who attend him are always women.[4]
>
> They exhaust others; they are jealous and fickle.
> At first they slander; in the end they turn their backs [on authority].

Will you say it is not so extreme?
Oh, how they are wicked!
They are like merchants who make a threefold profit.
The noble man knows this.
There is no public service for women.
They stay with their silkworms and weaving.

These stanzas are evidently addressed to a ruler whose domain is in complete disorder. The innocent are arrested, the guilty set free, and the people deprived of their land and livelihood. As we go on to read, all the problems stem from the fact that the ruler surrounds himself with women. Who are these women? It is never clear whether the designation is singular or plural — one woman or many. There is a brief reference to a certain "clever woman" who brings down a clever man's work, but then the poem lapses into contexts where the female sex is clearly intended generally: "Women have long tongues"; "There is no public service for women"; etc.

Later commentators have attempted to take this poem as the work of one Earl of Fan 凡伯 criticizing his lord, the King Yu of Chou 周幽王 (r. 781–771 B.C.E.), and the King's concubine, Pao Ssu 褒姒 (or "Ssu of Pao").[5] Pao Ssu was a petulant girl of supposedly miraculous birth who manipulated the benighted King Yu, finally persuading him to set aside his rightful queen and designate her own son as heir apparent. But this fateful decision proved short-sighted; for Pao Ssu was imprisoned when the Marquis of Shen 申侯, the queen's father, killed King Yu and set in his place the queen's son, who is known to history as King P'ing 平王 (r. 770–720 B.C.E.). Many of the later traditions surrounding Pao Ssu are manifestly romanticized. We are told, for example, that there was a system of alarm beacons that the king would use to summon his vassals to battle; King Yu would repeatedly light these beacons in vain, because it amused Pao Ssu to see the feudal lords rushing to the rescue but finding no enemy. Unfortunately, the King tried this trick so often, that by the time of the climactic battle with the Marquis of Shen, none of the King's allies heeded the alarm beacons, and so he was overpowered quickly.[6] This story is, in other words, the ancient Chinese counterpart of our "Little Boy Who Cried 'Wolf!'"

In spite of these suspicious details, however, there may have been some kernel of truth to the story, which must originally have been the tale of a fierce succession dispute. The Marquis of Shen wished to see his grandson crowned as King of Chou; the king himself had other ideas. But with the increasing weakness of the Chou throne in the eighth century, it turned out that the Marquis of Shen had enough military might to realize his ambition. The affair served as a harbinger of times to come. From this point on, real administrative power in Chou China would lie with feudal lords in the mold of the Marquis of Shen.

So if the Earl of Fan *really did* write "I See on High," we can appreciate the momentous concerns of the poem. His point would be not that *all* women are inherently wicked—only those, like Pao Ssu, who scheme to alter the line of succession and thereby bring on catastrophes which they cannot have thought through. And of course King Yu himself is ultimately to blame for everything; for it is he who has failed to keep his women in their appropriate place. I believe an interpretation along these lines is warranted for several reasons. Most importantly, other passages in the *Odes* and other canonical works do not represent women as uniformly wicked and conspiratorial. On the contrary, as we shall see, the nature of men and women and their proper sex roles is acknowledged in these texts to be one of the most difficult problems in the world of human philosophy. Moreover, Pao Ssu is mentioned by name elsewhere in the *Odes* ("Cheng-yüeh" 正月, *Mao* 192), so we know that her legacy was indeed prominent in the authors' minds:

> The sorrow of my heart
> is as though someone tied it.
> This ruler now—
> how can he be so cruel?
> The flames, as they rise—
> will someone extinguish them?
> The majestic capital of Chou—
> Pao Ssu destroyed it.

Several rhetorical features of this stanza invite the reader to compare it to "I See on High." For example, the reference at the end to "the majestic capital of Chou" recalls the "city" that the clever man completed and the clever woman overturned. Furthermore, the poem appears in a section of the *Odes* that includes a number of poems contrasting the prosperous and blessed reigns of virtuous rulers with the harsh and blighted reigns of rulers who neglect their Mandate 命. A common theme in the poems is the ruler who does not tend to the "king's business" (*wang-yeh* 王業), but indulges himself in women and drink; thus the poem "I" 抑 (*Mao* 256):

> Does he not exert himself, he who is humane?[7]
> Are the four quarters not instructed by him?
> Sensing his powerful conduct,
> the four regions obey him.
> With grandiloquent counsel he confirms his Mandate.
> With farsighted plans and timely announcements
> he is reverently cautious about his awesome deportment.
> He is a pattern for the people.

The one of today
is aroused and seduced by disorder in government.
He overturns his own power.
He abandons and dissipates himself in wine.
You devote yourself only to dissipated pleasures.
You do not ponder your lineage.
Why do you not apply yourself to seeking the [Way of the]
 former kings
so that you could hold fast to their enlightened law?

These two stanzas illustrate the difference between a ruler who cultivates his "power" (*te* 德) and one who "overturns" it. The "power" is the quality that a ruler obtains through his pious obedience to Heaven and tireless efforts to effect virtuous government on earth.[8] "The one of today," whom later commentators identify as King Li of Chou 周厲王 (r. 857/53–842/28 B.C.E.),[9] turns his back on the ancient practice of his ancestors ("You do not ponder your lineage") and spends all his energy in dissolute pleasures. The poem delineates two paths that a ruler can follow. He can dedicate himself to "enlightened law," and thereby cause his subjects in all quarters of the realm to submit of their own will, thus confirming his Mandate. This path, however, is the more difficult of the two; the ruler must be prepared to "exert himself." Or the ruler can simply waste his days in leisurely debauchery, like King Yu with his concubine. Words like "seduced" and "pleasure" merely hint at the sexual nature of the king's excesses; unlike "I See on High," the present poem does not mention the destructive women directly. For the proper object of blame is unquestionably the ruler himself.

These poems from the *Odes* highlight some of the problems in assessing references to women in classical Chinese texts. The bipolar discourse of virtuous government versus immoderate licentiousness is so basic to the political consciousness of the literature, that the mere mention of "women" at the royal level is often intended to evoke a king who has failed to consider his priorities. But it would be a mistake to take the manifold, and indeed stereotyped, images of "long-tongued" women as an authorial attitude that can be extended to cover all women. After all, the *Odes* contain at least as many references to virtuous women whose moral perfection contributes to the flourishing of the age. A favorite heroine is the mother of King Wen 文王, the founder of the Chou dynasty, as in "Ta Ming" 大明 (*Mao* 236):

Jen 任, the second princess of Chih 摯,[10]
from that Yin-Shang 殷商,
came to marry in Chou.
Oh, she became his wife in the capital.
And she, with King Chi 王季,

acted only with *te*.
T'ai Jen became pregnant
and bore this King Wen.

This King Wen
was circumspect and reverent.
Brilliantly he served Ti Above 上帝.
Thereupon he caused many blessings to arrive.
His power was never refractory.
Thus he received the surrounding states.

T'ai Jen was the second princess of Chih, a state within the realm of the Yin or Shang overlord; she married King Chi of Chou and gave him a son, the future King Wen. The phrase "and she, with King Chi" emphasizes that her own virtuous conduct contributed to the brilliant success of her husband and son. Similarly, another poem in the sequence ("Ssu chai" 思齊, *Mao* 240) praises King Wen's mother for her relationship to her mother-in-law and daughter-in-law:

Ah, reverent was T'ai Jen,
the mother of King Wen!
Ah, loving was she to Chiang of Chou 周姜,
the woman of the royal chamber!
T'ai Ssu 大姒 inherited her excellent reputation.
Thus she had her many sons.

"Chiang of Chou" is T'ai Chiang, the mother of King Chi. Thus the poem lauds T'ai Jen for treating her mother-in-law with respect, which has always been a principal duty of a wife in traditional China. T'ai Ssu was King Wen's wife; she is also praised in the collection for her womanly virtues.[11] In the word *tse* 則 ("thus"), the poem takes pains to point out that T'ai Ssu was able to bear her many sons and continue the Chou line precisely because she followed in the exalted footsteps of her own mother-in-law. Thus T'ai Jen played a pivotal role in the history of the Chou lineage: she honored her mother-in-law, as was appropriate, and then influenced her daughter-in-law to carry on the noble tradition of the Chou wives. Indeed, these poems assert that it was the *women* of Chou who played a critical role alongside their husbands in the establishment of the dynasty. T'ai Jen and T'ai Ssu are hardly "long-tongued" vixens like Pao Ssu who conspire to disrupt the royal line. They are the exact opposite: chaste and industrious women who lay the foundations for the splendid accomplishments of their husbands and descendants.[12]

To be sure, such poems seem to allow for female virtue within very narrow boundaries. Women earn recognition only when they excel at their allotted sex

roles of wife and mother. Female paragons such as T'ai Jen and T'ai Ssu are singled out precisely because they prove helpful to their husbands and sons. Nowhere in the *Odes* do we find women praised for artistic or intellectual accomplishments—and even their moral attainments are never explained in any detail. Of T'ai Jen we know only that she shared in her husband's virtue, honored her mother-in-law, and impressed her daughter-in-law with her conduct; of T'ai Ssu we know even less: she learned from her mother-in-law's example and bore many talented sons. It is with this background in mind that scholars often accuse Confucian education of concentrating solely on training females to "meet the demands of motherhood and household management."[13]

Even this assessment, however, does not tell the entire story. It is important to remember that the proper fulfillment of one's social role represents one of the most estimable human accomplishments in the context of Confucian philosophy; this is no less true of men than it is of women.[14] Confucius 孔子 (i.e., K'ung Ch'iu 孔丘, 551–479 B.C.E.) himself, for example, is said in the *Application of the Mean* (*Chung-yung* 中庸) to have declared:

> There are four things in the Way of the noble man of which I have not been able to accomplish one. I have not been able to serve my father as I require of my son. I have not been able to serve my lord as I require of my servant. I have not been able to serve my elder brother as I require of my younger brother. I have not been able to undertake first for my friends what I require of them.[15]

Since the *Application of the Mean* is a relatively late work, these cannot be taken as the genuine words of Confucius, but the duty to behave towards others as one would want them to behave towards oneself represents one of the cornerstones of the Confucian tradition. This is precisely what Confucius meant by *shu* 恕 in the *Analects* 論語.[16] So by acting like model wives and mothers, women such as T'ai Jen and T'ai Ssu actually discharged their ethical duties more successfully than Confucius himself, who considered himself imperfect as son, brother, subject, and friend. Let us keep in mind, also, that Confucius considers the moral obligations of those of lower social status more difficult than those of their superiors. It is in his behavior as *son, subject, and younger brother*, and not father, lord, and elder brother, that Confucius finds cause to chastise himself. How much more difficult would he have found the job of wife and daughter-in-law, at the very bottom of the domestic hierarchy? Knowing his own failings despite his relatively privileged position, Confucius can only have admired T'ai Jen and T'ai Ssu's virtue all the more; therefore we must take care not to underestimate the magnitude of these heroines' achievements in the minds of classical readers as well.

And it is indisputable that Confucius placed women at the very bottom of the domestic hierarchy, as in the following infamous comment:

The Master said: Only women and petty men are difficult to nourish. If you are familiar with them, they become insubordinate; if you are distant from them, they complain.[17]

Like "I See on High," this quote from Confucius is frequently cited in the recent literature as the quintessential expression of the Master's sexism.[18] He compares women to "petty men" 小人, or the antithesis of the Confucian moral ideal of the "noble man" (*chün-tzu* 君子). The charge that they are "difficult to nourish" is more severe than is commonly recognized. It does not mean simply that women and petty men are difficult to handle. "Nourishing" frequently has a philosophical or paedagogical component in Confucian parlance (as in the phrase "nourishing the mind," for example);[19] so Confucius may in fact be questioning women's ability to grow in an intellectual sense. The ramifications of this passage are considerable. Self-cultivation is the foundation of Confucian ethics, and if Confucius means to say that women are physiologically unable to learn and improve themselves, then he has effectively excluded them from the Confucian project. If Confucius believes that women cannot participate in moral discourse, it is unclear how he distinguishes them from animals. From the point of view of the later thinker Mencius 孟子 (i.e., Meng K'o 孟軻, 371–289 B.C.E.), "petty men" is what we call all those who fail to cultivate their moral minds, thereby obscuring the slight difference that exists between humans and animals.[20] Where women lie in this scheme is problematic.

Commentators have sometimes tried to soften the impact of Confucius's utterance in a number of ways. One of the oldest methods seems to have been to read the phrase *nü-tzu hsiao-jen* 女子小人 as nothing more than a reference to male and female servants.[21] But there are many other expressions that Confucius might have used had he so intended his saying; it is difficult to ignore the usual connotations of *hsiao-jen* as men who are *morally*, and not socially, inferior. Another recent attempt to "rehabilitate" the quote takes *nü* 女 in *nü-tzu* 女子 as an alternate form of *ju* 汝, "you": thus, "Only your children and petty men are difficult to nourish."[22] The obvious problem with this reading—aside from the fact that this is not how Confucius's statement was ever understood—is that it is a complete mystery whose "children" Confucius would be talking about. Finally, chapter 17 of the *Analects*, where this statement occurs, is part of a section at the end of the book that scholars have long suspected might be spurious. One suggestion places the chapter around 270 B.C.E.—or more than two centuries after Confucius's death.[23] So Confucius might never have said such uncomplimentary things about women after all.

Two points about this passage are not often observed. First, Confucius says that women are *difficult* to nourish, not that they *cannot* be nourished, and the Confucian mode of self-cultivation is not exactly "easy" for men, either.

Later thinkers, such as Hsün-tzu 荀子 (i.e. Hsün K'uang 荀況, ca. 310–ca. 210 B.C.E.), would go on to emphasize just how difficult it is for *anyone* to become a "noble man."[24] Furthermore, Confucius made other more important statements about women. Elsewhere in the *Analects*, he points out that an exceptional woman can be just as talented as an exceptional man:

> Shun 舜 had five ministers and the world was ordered. King Wu 武王 [of Chou, r. 1049/45–1043 B.C.E.][25] said: I have ten ministers who make order. Confucius said: Is it not so that talent is rare? The time after[26] T'ang 唐 and Yü 虞 [i.e., the sages Yao 堯 and Shun] flourished to this extent. There was a woman among them, so there were no more than nine men.[27]

The early commentator Huang K'an 皇侃 (488–545 C.E.) fastened onto the significance of this passage. He explains the "woman among them" as King Wen's mother, or T'ai Jen, and goes on to note:

> Moreover, when he clearly says, "there was a woman," this is to make clear that the flourishing of the Chou was not due to only the men's talent; the abilities of the women also assisted in the transformation of their government.[28]

Whether or not Huang K'an is right that the "woman" refers specifically to T'ai Jen, his general conclusion, which is in line with the admiring view of T'ai Jen that we have seen in the *Odes*, cannot be far removed from Confucius's intended lesson. The main thrust of the passage is that talent is exceedingly rare and *potent*. The offhanded comment that one of King Wu's ministers was a woman is made to show that there were not even ten capable men serving the dynasty at the time, and yet it was an era of unparalleled moral excellence. But Confucius's argument rests on an idea that is even more revolutionary: namely, the unspoken assumption that a woman could take her place alongside the most capable men in the world.

This extraordinary woman, moreover, is singled out not for her virtuous behavior as wife or mother, but as one who contributed to the flourishing of an entire era. If indeed Confucius was thinking of T'ai Jen, it is doubtless the case that he would have considered her virtuous behavior as wife and mother to have been an essential part of that contribution. But it is a form of virtuous behavior that is taken seriously for its power to effect moral government. A model wife and mother is not simply a woman who silently obeys her husband and gently nourishes her son, but one who participates in bringing about the kind of universal moral transformation that the Confucian tradition upholds as the ultimate purpose of humanity.

Thus Confucius may have considered women "difficult to nourish," but he emphatically did not believe that they were incapable of moral self-cultivation; on the contrary, he placed the most cultivated women, rare though they were,

on a level no lower than that of the most cultivated men. These points come out especially clearly in the following saying, also attributed to Confucius:

> A girl's knowledge is not like that of a woman; a boy's knowledge is not like that of a man. The wisdom of the woman of the Kung-fu clan 公父氏 is like that of a man! She desired to make clear her son's estimable virtue. [29]

This passage is from the *Discourses of the States* (*Kuo-yü* 國語), a collection of speeches and anecdotes compiled approximately 300 B.C.E. [30] Given the source, we might be reluctant to treat this as a genuine statement from the mouth of the Master, but it is still representative of the Confucian tradition in its earliest stages, and the idea that it articulates is not inconsistent with what we have heard from Confucius in the *Analects*. The "woman of the Kung-fu clan" is Lady Ching 敬姜, who was the mother of Kung-fu Ch'u 公父歜 (better known as Kung-fu Wen-po 文伯), a high official in the state of Lu 魯. She is praised by Confucius or his disciple in the *Discourses of the States* on no fewer than six occasions. [31] In this passage, Confucius has heard the instruction that she has given her son's concubines after his death. She has told them not to weep or grieve demonstratively for her son, but to "follow the rites and be silent," lest it be said of him that he was fond of household pleasures. [32]

Perhaps Lady Ching and Confucius both made too much of this affair—they may strike us as excessively concerned with *appearances*—but the episode is valuable for our purposes because of the light that it sheds on early Confucian views of women. In the prefatory comment that "a girl's knowledge is not like that of a woman," Confucius implies that a girl can grow intellectually as she matures. The statement confirms again that women are not barred by the tradition from the lifelong journey of self-cultivation. Furthermore, Confucius asserts that the wisdom of Kung-fu Wen-po's mother is like that of a man, showing once again that he thinks women can be as wise as men. Granted, it is only an exceptional woman who earns such praise; but it is no less true that Confucius is characteristically interested only in exceptional people, never the run-of-the-mill. He does not mince words when criticizing men whom he considers mediocre and unconscientious. [33]

Lady Ching's concerns about her son's reputation highlight another crucial theme in early discussions of women.

> I have heard: If a man loves the inner, women die for him. If he loves the outer, men die for him. [34] Now my son has died young; I would hate for others to hear of him on account of his love of the inner. [35]

This distinction between "the inner" (*nei* 內) and "the outer" (*wai* 外) informed much of the traditional Chinese discourse concerning the difference between women and men. [36] In this particular passage, it seems clear enough

what Kung-fu Wen-po's mother means: "the inner" refers to the women in his household, "the outer" to the business of governmental administration that her son undertook outside his home. But the precise contours of this dichotomy are very difficult to reconstruct. In effect, the terms *nei* and *wai* come to refer to women and men, respectively, but the reasoning behind these associations is complex and indeed varies from text to text as well as from period to period.[37]

In this sense, *nei* seems to have originally denoted the "interior" area of a domicile where the women of the household had their apartments. Consequently, it often means "harem." Thus, for example, the "Minor Official of the Interior" 內小臣 is listed in the *Rites of Chou* (*Chou-li* 周禮) as the one who "handles the commands of the royal queens."[38] Similarly, *i-nei* 易內, "to exchange interiors," appears as a euphemism for wife-swapping among elite men:

> Ch'ing Feng 慶封 of Ch'i 齊 loved hunting and was fond of drink. He gave over the government to [his son] Ch'ing She 慶舍, and then moved with his harem and valuables to Lu-p'u Pi's house 盧蒲嬖氏. They "exchanged interiors" and drank wine.[39]

Given these connotations, we can empathize with Mother Kung-fu's wish that her son not be remembered for his "love of the interior"; Ch'ing Feng was just the kind of wastrel from whose image she was trying to distance her family name.

As a term that referred to women in their role as consorts to men, *nei* came to be used generally for anything and everything that was considered appropriate for women, especially in contrast to *wai*, or subjects that were considered appropriate for men. Thus "Males do not speak of *nei*; females do not speak of *wai*."[40] But this distribution of terms according to gender is precisely where the ambiguities arise, because not everyone agreed as to what is appropriate—or inappropriate—for women. Most later writers routinely took *wai* to refer to politics, as for example when the Han 漢 official Yang Chen 楊震 (d. 124 C.E.) presented to the emperor several august precedents establishing that "women ought not participate in government affairs."[41] This understanding of the difference between *nei* and *wai* appears to conform to that of Kung-fu Wen-po's mother, who wants her son's memory to be honored for his political accomplishments. Any other reputation would not befit his manhood. These nuances of *nei* and *wai* therefore suggest that "being fond of the inner" does not simply constitute a moral failing; it is fundamentally *unmanly*. *Nei* is the province of women, and a man who spends too much time in the interior apartments is a man who is devoted to womanly pursuits.

The potential consequences of this view are manifold. Most immediately, there is the inescapable and problematic implication that excessive sexual desire—like that of Ch'ing Feng, who went everywhere with his harem and abdicated his responsibilities as a politician—is somehow essential to women

and effeminate in men. That is to say, it is unseemly in either sex, but it is more basic to women's nature, since they are creatures of the "interior." For we find precisely this opinion expressed unabashedly in certain passages in the classics that approach outright misogyny.

The *Tso-chuan* 左傳, for example, records an event dated to 636 B.C.E.: King Hsiang of Chou 周襄王 (r. 651–619 B.C.E.), grateful to a nation known as the Ti 狄 for military assistance, proposed to take one of their women as his queen. His minister objected:

> Fu Ch'en 富辰 remonstrated, saying: You cannot. I have heard: "When the one who rewards has become weary, the one who receives is still not satisfied." The Ti are covetous and greedy, yet Your Majesty begins [to appease them]. Female *te* is without limit; the complaints of women are without end. The Ti will surely become a vexation.[42]

What is "female *te*" (*nü-te* 女德)? The phrase is used revealingly in a diagnosis performed by one Doctor Ho 醫和. Duke P'ing of Chin 晉平公 (r. 557–532 B.C.E.) is suffering from a certain malady, which the learned doctor identifies immediately as *ku* 蠱, or the disease that arises when one "keeps males at a distance and brings females close." The disease is incurable. When later asked to elaborate, the doctor remarks that the only way to mitigate the ravages of *ku* is to surround oneself with "male *te*," and "diminish female *te* at night." In practical terms, this means surrounding oneself with male advisors and not sleeping so frequently with women.[43] So we might translate "female *te*" as "female potency," the innate sexual power of females that can sap a man's strength if he copulates with them excessively.[44]

This view of women as sexually insatiable beings became widespread in later periods of Chinese history. The famous political philosopher Han Fei 韓非 (d. 233 B.C.E.), for example, composed an essay on palace women with the basic presupposition that they are interested in nothing other than satisfying their lust.[45] The logical conclusion of this trend came in the eleventh century, when Ou-yang Hsiu 歐陽修 (1007–1070) declared that "females are nothing more than sex."[46] But such passages are purely chauvinistic, because the more reflective thinkers of the ancient period admitted frankly that sexual desire was a basic problem in men as well.

For example, "female potency" is sometimes used even by women to refer to sexual pleasure:

> Ch'ung-erh 重耳 [i.e., the future Duke Wen of Chin 晉文公, r. 635–627 B.C.E.] said: Human life is peaceful and pleasant; what else is there to know? I am resolved to die here [i.e., in exile in Ch'i]; I cannot go. The girl of Ch'i [i.e., his wife, the daughter of Duke Huan of Ch'i 齊桓公, r. 685–643 B.C.E.] said: You are the Ducal Son of a state. When you came here in straitened circumstances, your

numerous warriors took you as their destiny. You do not hasten to return to your state and reward your toiling vassals, but cherish female potency. I am ashamed on your account. [47]

In this little lecture, the future Duke Wen is upbraided by his sagacious wife for neglecting the serious, manly business of claiming his rightful place as ruler of Chin—and enjoying instead the "peace and pleasure" of his wife's sex. But it is Ch'ung-erh, and not his wife, who is to blame for frittering away his life. When the girl of Ch'i refers to "female potency," then, she does not mean voracious sexual appetite on her part, but her natural sexual allure, which her own husband has been enjoying in excess. She is "ashamed" on his account precisely because she does not wish to be known unjustly as a sexually destructive woman who sapped her husband's vital energy and prevented him from establishing his name. Her husband has been harming his reputation all by himself.

This very anecdote may have been the background to Confucius's famous saying—which he uttered twice: "I have yet to see someone who loves virtue as much as sex."[48] Here Confucius is decisively using the term *te* in the ethical sense that we have seen anticipated in the *Odes*: as the moral power that one attains through virtuous conduct. Simply put, the problem is one of conflicting *te*. We are all naturally enticed by the pleasures of sexual "potency," but we must learn to rein in these desires and strive for the moral "potency" that is the hallmark of a cultivated person.

This theme of transcending one's sexual appetite in order to lead a moral life is basic to early Confucianism. Consider, for example, the question posed by Mencius: "If you could get a wife by passing over the wall of the house to your east and dragging off [your neighbor's] virgin child, but could not get a wife if you did not drag her off, would you drag her off?"[49] The question is never answered; Mencius's interlocutor is supposed to answer forthwith that he would rather forego the pleasures of a wife than drag off his neighbor's virgin daughter. The context is a discussion of ritual (*li* 禮). Mencius intends to make the point that we must learn to subdue our appetitive desires lest we come to violate the rituals in the process of satisfying ourselves.[50] The idea and manner of framing the issue is thoroughly Confucian; not long after Mencius, Hsün-tzu would build famously on the principle of using rituals to curtail our desires and make it one of the cornerstones of his ethical philosophy.[51]

It is understandable, then, that some early Confucians considered the separation of the sexes to be the germ of all morality. Consider the orthodox commentary to "The *Kuan*-ing Ospreys" 關雎, the first poem of the *Odes*:

The royal consort takes delight in her lord's virtue. There is nothing in which she does not accord with him, and she is not licentious about her sex. Her caution is firm and her seclusion deep, like the *kuan*-ing ospreys that have separation amongst themselves. Then she can transform the world. When husband and wife have sepa-

ration, father and son are intimate; when father and son are intimate, lord and vassal are respectful; when lord and vassal are respectful, the court is upright; when the court is upright, the royal transformation is complete.[52]

The above interpretation starts from the belief that male and female ospreys naturally congregate in different places. This is what is meant by the ospreys' "separation." A "cautious and secluded" queen imitates the ospreys in observing the separation of male and female, and thereby lays the foundations for the completion of the "royal transformation" (*wang-hua* 王化), or establishment of perfect morality throughout the world. The lengthy argument by *sorites*, leading from the separation of husband and wife all the way to the achievement of utopia on earth, is understandable only in the context of the Confucian belief that human morality entails the suppression of our animalistic desires, of which lust is simply taken to be the cardinal example.[53] Once we have learned to regulate our sex drives, the process of self-transformation has already begun.

Once again, the morally persuasive power of the virtuous female is singled out in this program for special praise. The basis of this attitude, therefore, lies not in any demeaning view of women, despite what is commonly alleged. But the difficulty of this view is that it does not conceive of any form of morally acceptable sexual activity other than for the express purpose of producing offspring. All non-procreative sex is corrupting and enervating. The highest gift that a man can receive from Heaven is a girl who might give him sons. This we read explicitly in the *Odes*.[54] But the sexual pleasures of sexual love, as we have seen, are continually feared rather than explored. To us living in the world today, this is probably the most alienating aspect of the Confucian ideal of sexual relations.[55]

Given such forthright admissions of the possibility of moral weakness in men, why do some texts insist on portraying women as sexual miscreants? I suspect that many of the fulminations against women represent carelessly articulated animadversions that are really aimed at dissolute men. We have seen in "I See on High," for example, that the underlying issue was probably not a universally conceived evil in women, nor even the destructive power of Pao Ssu, but the irresponsibility of King Yu himself for allowing the situation to deteriorate as it did. Consider also the following:

> The people of Ch'i sent some female musicians. Chi Huan-tzu 季桓子 [i.e., Chi-sun Ssu 季孫斯, d. 492 B.C.E.] received them, and for three days court was not held. Confucius left.[56]

Obviously, Confucius did not leave his native state of Lu because there were female musicians in the land; he would be sure to find female musicians wherever he chose to go. Confucius left because the ruling parties in Lu suspended court for three days for no better reason than to gratify their desires. They chose pleasure and idleness over statecraft and deliberation, or *nei* over *wai*.

2. The Inadequacy of *Nei* and *Wai* as Philosophical Categories

Aside from the danger that the commonplace distinction between *nei* and *wai* could evoke unreflective generalizations about men and women, there is the additional problem that the terms are not used consistently.

We remember Kung-fu Wen-po's mother, who urged her son's concubines not to make a grand show of mourning for his death, lest he go down in history as a man who was more devoted to the feminine pleasures of domestic life than the masculine pursuit of service to the state. Elsewhere, she expands on the notions of *nei* and *wai* along similar lines.

> Kung-fu Wen-po's mother went to the Chi clan. K'ang-tzu 康子 [i.e., her great-nephew Chi-sun Fei 季孫肥, d. 468 B.C.E.] was in the courtyard. He spoke to her; she did not respond to him. He followed her to the door of her bedroom; she did not respond to him, and entered. K'ang-tzu left the courtyard and entered [her apartment] to see her, saying: "I have not heard your command; have I offended you?" She said: "You have not heard it? The Son of Heaven and the feudal lords tend to the affairs of the people in the outer court; they tend to the affairs of the spirits in the inner court. From the chamberlains down, they tend to official duties in the outer court; they tend to affairs of the household in the inner court. Within the doors of her bedroom is where a woman conducts her business. This is the same for superiors and inferiors. The outer court is where you should take the lord's official duties as your business; the inner court is where you should regulate the governance of the Chi clan. These are all matters on which I dare not speak." [57]

Chi K'ang-tzu was an important official in the state of Lu who is mentioned on a number of occasions in the *Analects*.[58] In this passage, his actions betray his ignorance of the difference between the "inner court" (*nei-ch'ao* 內朝) and the "outer court" (*wai-ch'ao* 外朝). The former is the locus of the house and hearth, the latter that of the ruler's deliberations on matters of state. Lady Ching's handling of the incident seems to suggest that Chi K'ang-tzu was out of place by barging into a woman's bedroom, since this is the "inner" area of the house where women "conduct their business."[59] She also seems to imply that it was wrong of him to expect advice from her: since her place belongs properly to the "inner court," she dares not speak of matters that do not pertain to her.

Her lecture, however, raises more questions than it answers. First, her conclusion implies that Chi K'ang-tzu should be in charge of *both* the "inner court" *and* the "outer court." The duties belong to different categories, but as the head of his clan and a premier official at court, he is expected to regulate both courts. Therefore, when Lady Ching says that "these are all matters on which I dare not speak," she cannot mean that she dares not speak on *wai* because she

belongs to the world of *nei* as a woman; she must mean that she dares not speak on either *nei* or *wai*, because her great-nephew is her superior in both realms. But this does not make much sense either. The fact that her great-nephew is her superior is no reason why she might not still advise him. Indeed, we find her elsewhere *continually* advising Chi K'ang-tzu, and not solely on affairs pertaining to the "inner court":

> Chi K'ang-tzu asked Kung-fu Wen-po's mother, saying: "Do you have something else to say to me?" She replied: "I have simply been able to become old; what would I have to say to you?" K'ang-tzu said: "Though that is the case, I wish to hear from you." She replied: "I have heard my former mother-in-law say: 'If a noble man is able to toil, his posterity will continue.'"[60]

On another occasion, she instructs her son in subjects that can only be considered *wai*:

> Therefore the Son of Heaven salutes the sun in the morning in his five-colored robes. With the Three Dukes and Nine Chamberlains, he studies and knows the potency of Earth. At midday he considers the government and participates in the governmental affairs of the many officials. The Grand Masters direct the troops, regional representatives, and ministers; they set in order all the affairs of the people. He sacrifices to the moon in the evening in his three-colored robes. With the Grand Scribe and Director of Records, he investigates and reveres the laws of Heaven. When the sun has set, he oversees the Nine Concubines; he commands them to clean and present the millet vessels for the Ti and Chiao sacrifices 禘郊. Only then does he rest.[61]

How do we reconcile Lady Ching's earlier unwillingness to advise Chi K'ang-tzu with these other passages—in which she not only proves eager to instruct, but also apparently transcends the boundaries between *nei* and *wai* by discoursing at length on the Son of Heaven's administrative and religious duties? I do not believe there are any answers that account for the widely varied usage that we have encountered. For it is *never* clear in *any* early text how the authors conceive of the difference between *nei* and *wai*, and consequently what they consider to be appropriate subjects for women to discuss. There is no shortage of references to women who give wise political counsel, or who influence the government of the world through their behavior.

In the course of a philosophical discussion in the *Mencius*, for example, we read:

> The wives of Hua Chou 華周 and Ch'i Liang 杞梁 were good at crying for their husbands and changed the customs of the state. What one possesses on the inside, one must formulate on the outside.[62]

The extant records include several accounts of the story alluded to here. Hua Chou (or Hua Hsüan 華旋) and Ch'i Liang (or Ch'i Chih 杞殖) were soldiers in the army of Ch'i who refused to accept a bribe from the Viscount of Chü 莒子 and were killed as a consequence of their loyalty. According to the *Tso-chuan*, Marquis Chuang of Ch'i 齊莊侯 (r. 553–548 B.C.E.)[63] then met the wife of Ch'i Liang in the suburbs, and sent someone to offer his condolences; she protested that the Marquis should have sent his condolences to her in her house.[64] The commentaries explain that it is improper to offer condolences outside for anyone other than commoners and the lowest ministers;[65] Ch'i Liang's widow apparently believed that her deceased husband deserved more formal rituals of commemoration from his thoughtless ruler. In the statement that the wives of Hua Chou and Ch'i Liang "changed the customs of the state," we are evidently given to understand that the Marquis of Ch'i learned a lesson about valuing loyal soldiers more highly.[66]

Weeping for one's late husband, as we know from the instructions of Kung-fu Wen-po's mother, is a characteristically *nei* form of behavior. We remember that Lady Ching warned her son's concubines not to mourn excessively after his death, lest their grief reflect poorly on Wen-po's reputation as a statesman. In this story, however, the mourning of Ch'i Liang's widow is not taken as a sign that her husband was overly fond of domestic pleasures. On the contrary, this is a story of a woman whose skillful and pointed demonstrations of *nei* behavior succeed in transforming the *wai* world over which she is not expected to have any influence. For this accomplishment, she is recorded as a moral heroine and subtle instructress for the age. But readers of texts that incorporate the stories of Kung-fu Wen-po's mother and Ch'i Liang's wife are likely to find the messages conflicting.[67] Is a widow supposed to cry for her dead husband or not? There are no universally valid answers. Part of the solution comes in the statement that "what one possesses on the inside, one must formulate on the outside." If, in crying, a widow might impart a moral lesson on an observer, then there is nothing wrong with making her *nei* sentiments known to the world outside. On the other hand, if a concubine seems to convey nothing more than that she will miss her husband's sexual favors, then it is unseemly for her to make a spectacle. This difficult idea, in bridging the distinction between *nei* and *wai*, opens the way for women to the outside world. If people's "inner" sentiments are necessarily reflected in their "outer" demeanor, then everyone who has an inner life—male or female—must be a participant in the space of *wai*.

Other passages show that women can have an effect on *wai* by transcending the conventional requirements of *nei* behavior. Consider the wife of one Hsi Fu-chi 僖負羈:

When [Ch'ung-erh, who was famous for his outlandish ribs] arrived at Ts'ao 曹, Duke Kung of Ts'ao 曹共公 [r. 652–618 B.C.E.] asked about his linked ribs and

wanted to see his nakedness. While [Ch'ung-erh] was bathing, [the Duke] ob-
served him through the curtain. The wife of Hsi Fu-chi said: "When I observe the
followers of the Ducal Son of Chin [i.e., Ch'ung-erh], they are all adequate to
being the prime minister of a state. If he is advised by them, he will certainly
return to his state. When he returns to his state, he will certainly fulfill his ambi-
tion with the feudal lords. When he fulfills his ambition with the feudal lords, he
will punish those who are without ritual. Ts'ao will be at the head of the list."[68]

This wife's behavior does not conform to *nei* in any respect whatsoever.
She speaks entirely on the basis of her observations and knowledge of the
political world—which are evidently extensive. And unlike that of many wise
women in these stories (such as Ch'ung-erh's wife from Ch'i, discussed above),
the rare knowledge of Hsi Fu-chi's wife does not derive from the fact that she
is a mother or husband of one of the men in question. The Duke of Ts'ao is her
lord, Ch'ung-erh a stranger in her country. Yet this woman proves herself well
versed in protocols of ritual, as well as an incisive judge of human talent. Her
prognostication in this passage, as we might expect, is verified five years later,
when Ch'ung-erh, now having taken his rightful place as Duke of Chin, decides
to attack Ts'ao as part of a larger campaign against Ch'u.[69] As far as the action
is concerned, it is irrelevant that Hsi Fu-chi's wife is female. Indeed, she is
placed in a role hardly different from that of an exemplary male sage, minister,
or general.[70]

Why then, do the sources paint such an inconsistent picture of *nei* and *wai*,
of appropriate areas of concern for males and females? What end is served by
this paradigmatic dualism when it is clear from so many passages that the
distinctions are blurry at best, and often thoroughly irrelevant? The early Con-
fucian tradition never resolved these potential contradictions, precisely because
its view of women was too sophisticated for it to make very much use of the
simple rubrics of "inner" and "outer." Confucian thinkers insisted on the moral
autonomy of all human beings regardless of sex, and when this commitment
forced them to break down the traditional categories of *nei* and *wai*, they were
not reluctant to do so. In their own time, therefore, it is not surprising that
they were criticized bitterly for the extraordinary respect with which they re-
garded women.[71]

3. Confucian Views of Women
in Comparative Perspective

There are at least three reasons why Confucianism has been repeatedly assailed
as "sexist"[72] despite the fact that the sources we have surveyed typically allow
for women to participate meaningfully in the Confucian project, and reserve
places in the pantheon of moral paragons for heroines as well as heroes. First,
the tradition does not argue for the *social* equality of women—only their *moral*

equality. It is taken as a matter of course, for example, that women should follow their husbands.[73] But ancient China was not a civilization that identified social equality as an especial value. Men, too, were allotted hierarchical social roles which they were required to fulfill whether it pleased them or not—all the way up to the ruler, who, in theory at least, could not escape his obligations to Heaven and the spirits. It is therefore misleading to say, as has one eminent scholar, that "from Confucius down, Confucianists have always considered women inferior."[74] This is certainly not the case if we mean "inferior" in an aretaic sense. As we have seen, Confucians did not consider virtuous women inferior to immoral men—just as they did not consider an upright minister inferior to a wicked overlord.

The second reason why Confucianism is frequently accused of sexism has to do with *later* manifestations of sexism and misogyny perpetrated in the name of the tradition. It is in imperial times that we see the proliferation of those sanctimonious manuals which outline "appropriate" behavior for women—serve wine and food in silence, obey thy husband and mother-in-law unquestioningly, etc.—without attributing to women the same moral and intellectual capacities that we find them exhibiting in the original Confucian canon. Examples of this odious genre suffer from the twofold inadequacy that they trivialize the value and abilities of women as well as the rich discussions of the value and abilities of women found in the Confucian classics. As is well known from the example of Pan Chao 班昭 (48–116? C.E.), it was possible for women themselves to compose such works.[75]

Finally, and most importantly, texts from the Confucian tradition (such as "I See on High") are sometimes compared simplistically with certain vaguely uplifting passages from the *Lao-tzu* 老子 which marvel at the "Mysterious Female":

> The Spirit of the Valley never dies; it is called "Mysterious Female." The Gate of the Mysterious Female is the root of Heaven and Earth. Gossamer, it seems to exist; it is not exhausted by use.[76]

And similarly:

> A great state is a low-lying flow. It is the Confluence of the World, the Female of the World. The Female constantly overcomes the Male through quietude. She lies low in her quietude.[77]

These passages exemplify the characteristic image of the soft, yielding Female, which the *Lao-tzu* contrasts with the image of the rigid and competitive Male. The *Lao-tzu* focuses here on the Female's traditional position of inferiority, and surprises the reader by identifying this very inferiority as the

foundation for the Female's success. It has been rightly pointed out that the "Spirit of the Valley" and the low-lying "Female" (*p'in* 牝) are probably intended as a calculated attack on Confucian rhetoric, which typically describes the process of self-cultivation as a journey higher and higher.[78]

However, it is important to temper these paeans to the "Female" with a few observations. The main point here is that the sage must recognize the value of the "Female" as well as that of the "Male," not that the "Female" is inherently superior to the "Male." The text stresses the "Female" only because it is more likely to be ignored than the "Male." Thus we read:

> Know the Male; maintain the Female; become the ravine of the world. When you are the ravine of the world, constant power will not desert you; you will return to being an infant.[79]

It is only by knowing the Male *and* maintaining the Female that one can reach the pure state of being "the ravine of the world." The deepest secret is not how to be "Female" rather than "Male"—but how to be both.[80]

Similarly, we must take care not to misread these appreciative references to the "Female" as an indication that the author of the *Lao-tzu* especially appreciated women. The "Female" and "Male" are illustrative motifs designed to shed light on the complementary aspects of the universe. They need not refer to actual females or males. The text itself was probably aimed exclusively at men—or more precisely, at the ruler of men. This explains why the passages dealing with the "Female" and her "quietude" are intertwined with a sustained political discourse. "A great state is a low-lying flow"; a lord can transform his domain into "a great state" if he learns how to embody the characteristics of the "Male" and "Female" as the circumstances warrant.

Later political writers of the so-called "Huang-Lao" 黃老 school adopted wholesale the *Lao-tzu*'s rhetoric of "Female" and "Male," but it is always evident in their work that the intended audience is a male ruler, and that the salubrious "Female" element is to be understood as nothing more than a convenient abstraction. The essay on the "Female and Male Modes" ("Tz'u-hsiung chieh" 雌雄節), for example, consistently favors the "Female":

> The Emperor collected and calculated the constancy of auspiciousness and inauspiciousness, in order to distinguish the Female and Male Modes. He divided the provinces of misfortune and fortune. To be stubborn, proud, haughty, and arrogant—this is called the Male Mode; to be [*lacuna*] reverent and frugal—this is called the Female Mode. . . . Whenever people are fond of using the Male Mode, this is called obstructing life. A great person will be destroyed; a small person will be doomed. . . . Whenever people are fond of using the Female Mode, this is called receiving favor. A rich person will prosper; a poor person will be nourished.[81]

Nevertheless, these same texts make clear that "using the Female Mode" does not by any means entail sharing power with women.

> When there are two rulers, [the state] loses its brilliance. Male and female contend for power and there are disorderly troops in the state; this is called a doomed state. . . . When there are two rulers, and male and female divide power; this is called a great seduction. Within the state there are armies. A strong state will be broken; a middling state will be doomed; a small state will be destroyed.[82]

"When there are two rulers" (*chu-liang* 主兩) refers to a situation that is vividly described by Han Fei:

> The queen and other wives are disorderly in their licentiousness. The ruler's mother accumulates uncleanliness. *Nei* and *wai* are confused and interconnected. Males and females are not separated. This is called having two rulers.[83]

Despite all the imagery of the "Female Mode" and the "Spirit of the Valley," therefore, we must not be misled into thinking that the writers who popularized this idiom were feminists—or had views of women that were any more charitable than those of the Confucians. In fact, the opposite is more likely.

4. Conclusion

The entire spectrum of views of women examined in this chapter share one important conviction: that the natural differences between males and females constitute one of the most difficult problems in all philosophy, and, more specifically, that moral and political excellence are attainable only after the relations of the sexes have been properly ordered. For Confucius and his followers, the Chou rulers brought about a society that came as close to utopia as was humanly possible, and it is no coincidence that the discussions of their greatness continually stress the virtue of founders' wives and mothers. Like the chaste queen in the Confucian interpretation of "The *Kuan*-ing Ospreys," these women contributed to their husbands' success by separating male and female, thereby eliminating licentiousness; and this single achievement laid the foundations for everything else, all the way down to the "royal transformation." No Confucian ever gives a practicable definition of *nei* and *wai*—of the "inner" and the "outer" spaces of human interaction—that can account for the various uses to which these terms are put. In the end, this is because *nei* and *wai* are acknowledged as the two most elemental, and therefore problematic, concepts that one can master. One who knows how to organize *nei* and *wai* has already taken the first and most difficult step towards sagehood.

The political thinkers who took their inspiration from the *Lao-tzu* did not formulate the problem in the same way, but still agreed that mastering the

"Female" and the "Male" was a precondition for effecting a well-ordered government. Their model ruler had to learn how to appreciate the "Female" and the "Male" as ideal types—and also how to rule *human* females and males. Like the Confucians, these writers also placed great store in the value of "separating male and female"—that is, assigning appropriate tasks to males and females. But the frequency with which writers of *all* persuasions invoked the phrase, and the rarity with which they explained it clearly, betrays the extent to which they struggled for a solution to the basic problem. There was a natural consensus that males and females are different, and an equally natural interest in articulating the essence and consequences of that difference. At that point, there ceased to be any consensus.

Notes

1. See, e.g., Julia Ching, *Mysticism and Kingship in China: The Heart of Chinese Wisdom*, Cambridge studies in religious traditions 11 (Cambridge, 1997), 94–97; and Richard W. Guisso, "Thunder over the Lake: The Five Classics and the Perception of Woman in Early China," in *Women in China: Current Directions in Historical Scholarship*, ed. Richard W. Guisso and Stanley Johannesen, Historical Reflections/Réflexions Historiques: Directions 3 (Youngstown, N.Y.: Philo Press, 1981), 59f. Recently, Lisa Raphals, *Sharing the Light: Representations of Women and Virtue in Early China*, SUNY Series in Chinese Philosophy and Culture (Albany, 1998) has questioned such "widely held assumptions about women in traditional China" (259). However, most of her arguments rely on the *Lieh-nü chuan* 列女傳, which, as she concedes (105–112), is a spurious text from mid-Han times at the very *earliest*, and so she misses a golden opportunity to re-examine such scholarly clichés on the basis of genuine pre-imperial material. Consequently, I have taken care in this chapter only to use accounts from the most ancient texts, though I shall point out later versions of some stories in the notes for the reader's reference.

2. This poem has become the standard source which contemporary scholars rehearse as an example of ancient Chinese misogynism. See, e.g., Henry Rosemont, Jr., "Classical Confucian and Contemporary Feminist Perspectives on the Self: Some Parallels and Their Implications," in *Culture and Self: Philosophical and Religious Perspectives, East and West*, ed. Douglas Allen (Boulder, Colo.: Westview, 1997), 65; Alison H. Black, "Gender and Cosmology in Chinese Correlative Thinking," in *Gender and Religion: On the Complexity of Symbols*, ed. Caroline Walker Bynum, et al. (Boston: Beacon, 1986), 171; and R.H. van Gulik, *Sexual Life in Ancient China: A Preliminary Survey of Chinese Sex and Society from ca. 1500 B.C. till 1644 A.D.* (Leiden: E.J. Brill, 1961; rpt., New York: Barnes and Noble, 1996), 29.

3. The *hsiao* is an unfilial bird that eats its mother before it can fly. See, e.g., Chiang Jen-chieh 蔣人傑, *Shuo-wen chieh-tzu chi-chu* 說文解字集注, ed. Liu Jui 劉銳 (Shanghai: Shanghai ku-chi, 1996), 6A.1266; and the commentary of Meng K'ang

孟康 (fl. ca. 225–250 C.E.) to *Han-shu* 漢書 (Peking: Chung-hua, 1962), 25A.1219n.4. On owls in general, see Marcel Granet, *Danses et légendes de la Chine ancienne*, Bibliothèque de philosophie contemporaine; Travaux de l'Année sociologique (Paris: Félix Alcan, 1926), II, 515–48.

4. Following the commentary of Cheng Hsüan 鄭玄 (127–200 C.E.), *Mao-Shih cheng-i* 毛詩正義, in Juan Yüan 阮元 (1764–1849), *Shih-san ching chu-shu fu chiao-k'an chi* 十三經注疏附校勘記 (1817; rpt., Peking: Chung-hua, 1980), 18E.578a. James Legge, *The Chinese Classics*, vol. IV: *The She King, or Book of Poetry* (N.d.; rpt., Taipei: SMC, 1991), and Bernhard Karlgren, tr., *The Book of Odes* (Stockholm: Museum of Far Eastern Antiquities, 1950), both take *ssu* 寺 (which is intended in the sense of *shih* 侍, "attend") to mean "eunuchs"; thus they both construe the couplet to mean that women and eunuchs cannot be taught or instructed (or that they cannot teach or instruct). However, I suspect that the "eunuchs" represent something of an anachronism; moreover, Cheng Hsüan's interpretation has the added advantage that it easily accounts for the word *shih* 時 ("constantly"), whereas other readings force it into the sense of *shih* 是, "are [women and eunuchs]." Also, Bernhard Karlgren, "Glosses on the Ta Ya and Sung Odes," *Bulletin of the Museum of Far Eastern Antiquities* 18 (1946), 139 and 141f., misrepresents Cheng Hsüan's explanation of *ssu*.

5. Thus the "Minor Preface" 小序, *Mao-Shih cheng-i* 18E.577b. See also the commentaries of Cheng Hsüan and K'ung Ying-ta 孔穎達 (574–648). Pao was a minor state vanquished by Chou; *ssu* 姒 is usually explained as Pao Ssu's surname, but can also mean simply "elder sister."

6. See, e.g., *Kuo-yü* 國語 (Shanghai: Ku-chi, 1978), 7.255 and 16.519; and *Shih-chi* 史記 (Peking: Chung-hua, 1959), 4.147ff. and 42.1757ff. Pao Ssu is also the subject of a biography in *Lieh-nü chuan*; text in Wang Chao-yüan 王照圓 (fl. 1879–1884), *Lieh-nü chuan pu-chu* 列女傳補註 (*Kuo-hsüeh chi-pen ts'ung-shu* 國學基本叢書), 7.127–29. See also Raphals, 64ff.; Herrlee G. Creel, *The Origins of Statecraft in China* (Chicago and London: University of Chicago Press, 1970), 438f.; and Granet, II, 558f.

7. *Wu* 無 is usually explained as an "empty particle" 發語詞, but Karlgren, "Glosses on the Ta Ya and Sung Odes," 101, suggests persuasively that its function is to turn a clause into an "oratorical question." Following Cheng Hsüan, *Mao-Shih cheng-i* 18A.554c, most commentators take *ching* 競 to mean simply "strong" 強, but I prefer to retain its basic sense of "struggle, compete." Compare, e.g., *Analects*, 8:7: "Tseng-tzu said: The *shih* 士 cannot but be capacious and resolute. His duties are heavy and his path long. He takes humanity as his duty—is that not heavy? Only at death does he stop—is that not long?" Text in Ch'eng Shu-te 程樹德 (1877–1944), *Lun-yü chi-shih* 論語集釋, ed. Ch'eng Chün-ying 程俊英 and Chiang Chien-yüan 蔣見元, Hsin-pien Chu-tzu chi-ch'eng (Peking: Chung-hua, 1990), 15.527.

8. See David S. Nivison's pathbreaking study of the notion of *te* in early Chinese thought: "'Virtue' in Bone and Bronze," in *The Ways of Confucianism: Investigations in Chinese Philosophy*, ed. Bryan W. Van Norden (Chicago and La Salle, IL: Open Court, 1996), 17–30.

9. Thus the "Minor Preface," *Mao-Shih cheng-i* 18A.554b. For the dates of King Li's reign, see Edward L. Shaughnessy, *Sources of Western Zhou History: Inscribed Bronze Vessels* (Berkeley: University of California Press, 1991), 272–86. He seems to have acceded in 857 B.C.E. and started to rule in his own name in 853; he was exiled in 842, and died in 828.

10. Chen Zhi, "A New Reading of 'Yen-yen,'" *T'oung Pao* 85.1–3 (1999), 18f., argues that this "Chung-shih Jen" 仲氏任 does not refer to T'ai Jen, but to the wife of the Duke of Chou 周公. However, the rest of the stanza, and especially the line *nai chi Wang Chi* 乃及王季 ("and she, with King Chi"), is hard to reconcile with this novel suggestion. In any case, it is clear that at least part of this poem deals with T'ai Jen.

11. As in *Mao* 236 ("Ta Ming").

12. The three "mothers of Chou" have their own biographical section in *Lieh-nü chuan pu-chu*, 1.6–7.

13. Dorothy Ko, *Teachers of the Inner Chambers: Women and Culture in Seventeenth-Century China* (Stanford: Stanford University Press, 1994), 53. Cf. also Guisso, 48; and Julia Kristeva, *About Chinese Women*, tr. Anita Barrows (New York: Urizen, 1977), 76, who states that according to Confucianism, a woman either "leaves the bedchamber to be acknowledged—but only as genetrix—the mother of the father's sons; or she gains access to the social order (as poet, dancer, singer) but behind the door of the bedchamber, an unacknowledgeable sexual partner." In other words, the only morally acceptable role for women is that of wife and mother.

14. This point is made forcefully in the context of a discussion of Confucianism and feminist philosophy in Rosemont, "Classical Confucian and Contemporary Feminist Perspectives on the Self," 71ff. See also Chenyang Li, "The Confucian Concept of Jen and the Feminist Ethics of Care: A Comparative Study," *Hypatia* 9, no. 1 (1994), 71f.

15. "Chung-yung," *Li-chi cheng-i* 禮記正義 (*Shih-san ching chu-shu*), 52.1627af. Compare the translation in S. Couvreur, S.J., tr., *Li Ki ou Mémoires sur les bienséances et les cérémonies*, 2nd edition (Ho Kien Fou: Mission Catholique, 1913), II, 437.

16. E.g., *Analects* 5.12, *Lun-yü chi-shih* 9.316; and *Analects* 15.24, *Lun-yü chi-shih* 32.1106. For more on *shu*, see, e.g., Herbert Fingarette, "Following the 'One Thread' of the *Analects*," in *Studies in Classical Chinese Thought*, ed. Henry Rosemont, Jr., and Benjamin I. Schwartz, *Journal of the American Academy of Religion* 47.3, Thematic Issue S (1979), 373–405. Fingarette's essay is discussed in Philip J. Ivanhoe, "Reweaving the 'One Thread' in the *Analects*," *Philosophy East and West* 40, no. 1 (1990), 17–33; see also David S. Nivison, "Golden Rule Arguments in Chinese Moral Philosophy," in Nivison's *Ways of Confucianism*, 66.

17. *Analects*, 17:25; *Lun-yü chi-shih* 35.1244. Compare the translation in D.C. Lau, *Confucius: The Analects* (New York: Penguin, 1979), 148.

18. See, e.g., Bettina L. Knapp, *Images of Chinese Women: A Westerner's View* (Troy, N.Y.: Whitston, 1992), 2; Black, 171; and Kristeva, 75 (with an idiosyncratic translation). David L. Hall and Roger T. Ames, *Thinking from the Han: Self, Truth, and Transcendence in Chinese and Western Culture* (Albany: State University of New York

Press, 1998), 88, adduce the quote without comment. Chenyang Li, 83, sees Confucius's remark as an example of "social prejudice," and not "an inevitable consequence of his general philosophy."

19. *Mencius* 7B.35; text in Chiao Hsün 焦循 (1763–1820), *Meng-tzu cheng-i* 孟子正義, ed. Shen Wen-cho 沈文倬, Hsin-pien Chu-tzu chi-ch'eng (Peking: Chunghua, 1987), 29.1017. Compare also the famous usage in *Mencius* 2A.2, *Meng-tzu cheng-i* 6.199: "I am good at nourishing my flood-like *ch'i*."

20. See, e.g., *Mencius* 4B.19, *Meng-tzu cheng-i* 16.567; and *Mencius* 4B.28, *Meng-tzu cheng-i* 17.595.

21. This is the position attributed to "the standard interpreters" by Arthur Waley, tr., *The Analects of Confucius* (New York: Random House, Vintage Books, 1938), 217, n.1. Waley is probably thinking of Chu Hsi 朱熹 (1130–1200 C.E.), who writes that *hsiao-jen* refers to *p'u-li hsia-jen* 僕隸下人 (by which he means male servants), and *nü-tzu* to *ch'ieh* 妾 (which can mean either "concubines" or "handmaidens"). See his commentary to *Lun-yü chi-shih* 35.1244.

22. E. Bruce Brooks and A. Taeko Brooks, *The Original Analects: Sayings of Confucius and His Successors*, Translations from the Asian Classics (New York: Columbia University Press, 1998), 166, report this reading without attribution.

23. Thus Brooks and Brooks, e.g., 240. The idea that the *Analects* are made up of separate strata goes back several centuries. See, e.g., John Makeham, "The Formation of *Lunyu* as a Book," *Monumenta Serica* 44 (1996), esp. 6ff.

24. Thus, e.g., Wang Hsien-ch'ien 王先謙 (1842–1918), *Hsün-tzu chi-chieh* 集解, ed. Shen Hsiao-huan 沈嘯寰 and Wang Hsing-hsien 王星賢, Hsin-pien Chu-tzu chi-ch'eng (Peking: Chung-hua, 1988), 17.23.442ff.

25. For the dates, see Shaughnessy, 241.

26. Following the commentary of Liu Pao-nan 劉寶楠 (1791–1855 C.E.). Most earlier commentators take *chi* 際 to mean the time during which Yao and Shun had contact with each other.

27. *Analects* 8.20, *Lun-yü chi-shih* 16.552–56. Compare the translation in Lau, *Analects*, 95.

28. *Lun-yü chi-shih* 16.558.

29. *Kuo-yü* 5.211.

30. On the textual history of the *Kuo-yü*, see, e.g., Chang I-jen et al., "*Kuo-yü*," in *Early Chinese Texts: A Bibliographical Guide*, ed. Michael Loewe, Early China Special Monograph Series 2 (Berkeley, 1993), 263–68; Chang I-jen 張以仁, "Lun *Kuo-yü* yü *Tso-chuan* te kuan-hsi" 論國語與左傳的關係, *Chung-kuo Chung-yang Yen-chiu-yüan Li-shih Yü-yen Yen-chiu-so chi-k'an* 中國中央研究院歷史語言研究所集刊 33 (1962): 233–86; and Bernhard Karlgren, *The Authenticity and Nature of the Tso Chuan* (Göteborg: Elanders, 1926).

31. See, in addition to the above, *Kuo-yü* 5.202, 5.208, 5.209, 5.210 (where she is praised by "Music-Master Hai" 師亥), and 5.212. She is also the subject of a biography in *Lieh-nü chuan pu-chu*, 1.10–14. Cf. also Raphals, 92–98.

32. For other classical versions of this anecdote, see (in addition to *Lieh-nü chuan*): *Han-Shih wai-chuan* 韓詩外傳 (*Ssu-pu ts'ung-k'an* 四部叢刊), 1.6b-7a; *Chan-kuo ts'e* 戰國策 (Shanghai: Ku-chi, 1978), 20.692f.; and "T'an-kung hsia" 檀弓下, *Li-chi cheng-i* 9.1304b.

33. See, e.g., *Analects* 6.12, *Lun-yü chi-shih* 11.388; *Analects* 9.23, *Lun-yü chi-shih* 18.616; and especially *Analects* 14.43, *Lun-yü chi-shih* 30.1043.

34. *Ssu-chih* 死之 is sometimes taken in this passage to mean the *opposite*: i.e., that he will die for women or for men. Grammatically, this reading is unjustifiable. Moreover, the parallel account in *Chan-kuo ts'e* says that sixteen of his women committed suicide on his account after his passing; see *Chan-kuo ts'e* 20.692.

35. *Kuo-yü* 5.211.

36. For more on *nei* and *wai*, see, e.g., Raphals, 195–234; and Black, 169 and 191, n.11.

37. The excavated sex manual "T'ien-hsia chih-tao t'an" 天下至道談, for example, offers its own creative understanding of the *nei/wai* distinction: males should be stimulated sexually on the outside and females on the inside. In other words, the male is the penetrator and the female the penetrated. For the text and commentary, see Ma Chi-hsing 馬繼興, *Ma-wang-tui ku i-shu k'ao-shih* 馬王堆古醫書考釋 (Ch'ang-sha: Hu-nan k'o-hsüeh chi-shu, 1992), 1071.

38. *Chou-li chu-shu* 周禮注疏 (*Shih-san ching chu-shu*), 7.686b.

39. Yang Po-chün 楊伯峻, *Ch'un-ch'iu Tso-chuan chu* 春秋左傳注, 2nd edition, Chung-kuo ku-tien ming-chu i-chu ts'ung-shu (Peking: Chung-hua, 1990), III, 1145 (Duke Hsiang 襄公 28th year, or 545 B.C.E.). (References to the *Tso-chuan* are conventionally cited by the name of the appropriate duke and the year of his reign.) Compare the translation in Legge, V, 541.

40. "Nei-tse" 內則, *Li-chi cheng-i* 27.1462c; see the commentary of Sun Hsi-tan 孫希旦 (1736–1784), *Li-chi chi-chieh* 集解, ed. Shen Hsiao-huan and Wang Hsing-hsien, Shih-san ching Ch'ing-jen chu-shu (Peking: Chung-hua, 1989), 27.735f. Compare also the "T'uan" 彖 commentary to hexagram 37 (*chia-jen* 家人) in the *I-ching* 易經: "The correct position for females is inside; the correct position for males is outside"; text in *Chou-I cheng-i* 周易正義 (*Shih-san ching chu-shu*), 4.50a.

41. *Hou-Han shu* 後漢書 (Peking: Chung-hua, 1965), 54.1761. Cf. also van Gulik, 86f., although the translation there silently omits whole sections of the original.

42. *Ch'un-ch'iu Tso-chuan chu*, I, 425 (Hsi 僖 24 = 636 B.C.E.). See also the parallel account in *Kuo-yü* 2.48ff., where Fu Ch'en constructs a different argument: marriage is an affair that can bring about fortune or disaster, and by marrying an alien, the King is courting disaster. Compare the translation in Legge, V, 192.

43. *Kuo-yü* 14.473–74. See also the parallel account in *Ch'un-ch'iu Tso-chuan chu*, IV, 1221ff. (Chao 昭 1 = 541 B.C.E.). The doctor goes on to explain that *ku* is derived from "worms," after the larvae that infest grain and fly away as insects. Eating food contaminated by such worms can be fatal. Compare also the usage in *Ch'un-ch'iu Tso-chuan chu*, I, 241 (Chuang 莊 28 = 666 B.C.E.), where one Tzu-yüan 子元 desires to

"expend himself" 蠱 with the widow of King Wen of Ch'u 楚文王 (r. 689–677), his deceased brother. The several meanings of the term are explained in the commentaries to the *I-ching* entry for the hexagram by the same name, *Chou-I cheng-i* 3.35bf.; as well as the commentaries to the entry in *Shuo-wen chieh-tzu chi-chu* 13B.2836. For one of the oldest uses, see Chang Ping-ch'üan 張秉權, *Hsiao-t'un ti-erh pen: Yin-hsü wen-tzu ping-pien* 小屯第二本:殷虛文字丙編 (Taipei, 1957–72), 415.5. The excavated text "Wu-shih-erh ping-fang" 五十二病方 contains a section dealing with remedies for *ku*; see Ma Chi-hsing, 631–35. Cf. further Kidder Smith, Jr., "*Zhouyi* Divination from Accounts in the *Zuozhuan*," *Harvard Journal of Asiatic Studies* 49.2 (1989), 444f.; Paul L-M. Serruys, "Towards a Grammar of the Language of the Shang Bone Inscriptions," *Proceedings of the International Sinological Conference* (Taipei: Academia Sinica, 1982), 349; H.Y. Feng and J.K. Shryock, "The Black Magic in China Known as *Ku*," *Journal of the American Oriental Society* 55 (1935), 1–30; and especially J.J.M. de Groot, *The Religious System of China* (Leiden: E.J. Brill, 1892–1910; rpt., Taipei: Southern Materials Center, 1989), V, 826–69.

44. Compare also the usage in *Han-shu* 60.2668.

45. See Ch'en Ch'i-yu 陳啓猷, *Han Fei-tzu chi-shih* 集釋, Chung-kuo ssu-hsiang ming-chu (Peking: Chung-hua, 1958; rpt., Taipei: Shih-chieh, 1991), 5.289.

46. *Hsin Wu-tai shih* 新五代史 (Peking: Chung-hua, 1974), 26.406. On the deteriorating position of women in Sung China, see, e.g., Patricia Buckley Ebrey, *The Inner Quarters: Marriage and the Lives of Chinese Women in the Sung Period* (Berkeley: University of California Press, 1993), esp. 267–70; and James T.C. Liu, *Ou-yang Hsiu: An Eleventh-Century Neo-Confucianist* (Stanford: Stanford University Press, 1967), 23.

47. *Shih-chi* 39.1658.

48. *Analects* 9.18, *Lun-yü chi-shih* 18.611; and *Analects* 15.13, *Lun-yü chi-shih* 32.1094. Compare the translation in Lau, *Analects*, 98 and 134.

49. *Mencius* 6B.1, *Meng-tzu cheng-i* 24.809. Compare the translation in D.C. Lau, *Mencius* (New York: Penguin, 1970), 171.

50. Cf. Jeffrey Riegel, "Eros, Introversion, and the Beginnings of *Shijing* Commentary," *Harvard Journal of Asiatic Studies* 57.1 (1997), 151.

51. See esp. *Hsün-tzu chi-chieh* 13.19.346–78. For more on this issue, see, e.g., Paul Rakita Goldin, *Rituals of the Way: The Philosophy of Xunzi* (Chicago and La Salle, IL: Open Court, 1999), 65ff.

52. *Mao-Shih cheng-i* 1A.273b. Compare the translation in Pauline Yu, *The Reading of Imagery in the Chinese Poetic Tradition* (Princeton: Princeton University Press, 1987), 50.

53. Riegel, 150ff., points out that the commentary to "Kuan-chü" in the recently excavated *Wu-hsing p'ien* 五行篇 emphasizes the importance of observing ritual "in spite of strong sexual urgings" to the contrary. See the text in *Ma-wang-tui Han-mu po-shu* 馬王堆漢墓帛書 (Peking: Wen-wu, 1980), I, 24.

54. *Mao* 247 ("Chi tsui" 既醉").

55. Even contemporary essays in the philosophy of sex have been criticized for treating the sex act as merely a means to some end (whether it be procreation, inter-

personal communication, etc.), and not coming to grips with the consequences of sex for the sake of sexual pleasure. See esp. Alan Goldman, "Plain Sex," *Philosophy and Public Affairs* 6:3 (1977), 267–87.

56. *Analects* 18.4, *Lun-yü chi-shih* 36.1258. Compare the translation in Lau, *Analects*, 149.

57. *Kuo-yü* 5.203–4.

58. For the references, see, e.g., Lau, *Analects*, 237. He was the son of Chi Huan-tzu (mentioned above).

59. In *Han-Shih wai-chuan* 9.62bf., Mencius's mother reprimands him for entering his wife's bedroom unannounced and thus catching her in a compromising position. Compare also the parallel account in *Lieh-nü chuan pu-chu* 1.16.

60. *Kuo-yü* 5.202.

61. *Kuo-yü* 5.205. The language of this passage is archaic and difficult; I suspect that Lady Ching might be quoting from a lost ritual codex. For administrative titles, I follow Charles O. Hucker, *A Dictionary of Official Titles in Imperial China* (Stanford: Stanford University Press, 1985). My translation is based largely on the commentaries of Yü Fan 虞翻 (164–233 C.E.), Wei Chao 韋昭 (204–273 C.E.), and others in *Kuo-yü* 5.206f., with one major exception. Wei Chao adduces the following quote from the "*Rites*" 禮: "The Son of Heaven salutes the son in the spring." This evidence then leads Wei Chao to the deduction that the Son of Heaven sacrifices to the moon in the autumn. However, I think this interpretation is unwarranted here, since the text clearly describes the ruler's daily activities from morning to night. Thus I take *chao* 朝 and *hsi* 夕 in their basic senses of "morning" and "evening."

62. *Mencius* 6B.6, *Meng-tzu cheng-i* 24.831. Compare the translation in Lau, *Mencius*, 175.

63. Albert Richard O'Hara, *The Position of Woman in Early China*, Catholic University of America Studies in Sociology 16 (Washington, D.C., 1945), 113, gives Chuang's reign dates as 794–731 B.C.E.; he has the wrong Duke Chuang of Ch'i, of which there were two.

64. See *Ch'un-ch'iu Tso-chuan chu*, III, 1084f. (Hsiang 23 = 550 B.C.E.). Hua Chou's personal name is given here as Huan 還.

65. See, e.g., the commentaries of Tu Yü 杜預 (222–284 C.E.) and K'ung Ying-ta, *Ch'un-ch'iu Tso-chuan cheng-i* (*Shih-san ching chu-shu*), 35.1978bf.

66. For other early accounts of this story, see "T'an-kung hsia," *Li-chi cheng-i* 10.1312af.; *Shuo-yüan* 説苑, in *Han-Wei ts'ung-shu* 漢魏叢書 (1592; rpt., Ch'ang-ch'un: Chi-lin Ta-hsüeh, 1992), 4.402c and 11.428c; and *Lieh-nü chuan pu-chu* 4.68–69. In the later versions, the widow's crying causes a wall to collapse, which impresses bystanders. Cf. also Siegfried Englert, *Materialien zur Stellung der Frau und zur Sexualität im vormodernen und modernen China*, Heidelberger Schriften zur Ostasienkunde 1 (Frankfurt: Haag und Herchen, 1980), 36ff.

67. The "T'an-kung," for example, includes both stories.

68. *Ch'un-ch'iu Tso-chuan chu*, I, 407 (Hsi 23 = 637 B.C.E.). Compare the translations in Burton Watson, tr., *The Tso chuan: Selections from China's Oldest Narrative*

History, Translations from the Oriental Classics (New York: Columbia University Press, 1989), 42; and Legge, V, 187. See also *Kuo-yü* 10.346–47; Ch'en Ch'i-yu, *Lü-shih ch'un-ch'iu chiao-shih* 呂氏春秋校釋 (Shanghai: Hsüeh-lin, 1984), 19.1256; *Han Fei-tzu chi-shih* 3.10.200; Liu Wen-tien 劉文典, *Huai-nan Hung-lieh chi-chieh* 淮南鴻烈集解, ed. Feng I 馮逸 and Ch'iao Hua 喬華, Hsin-pien Chu-tzu chi-ch'eng (Peking: Chung-hua, 1989), 18.614; *Shih-chi* 39.1658; and *Lieh-nü chuan pu-chu* 3.44. Cf. Raphals, 102–4.

69. See, e.g., *Ch'un-ch'iu Tso-chuan chu*, I, 451ff. (Hsi 28 = 632 B.C.E.).

70. Cf. Raphals, 27.

71. See, for example, the castigations of the Mohists in Wu Yü-chiang 吳毓江, *Mo-tzu chiao-chu* 墨子校注, ed. Sun Ch'i-chih 孫啓治, Hsin-pien Chu-tzu chi-ch'eng (Peking: Chung-hua, 1993), 9.39.436f.

72. Thus even supporters of the tradition; see, e.g., Henry Rosemont, Jr., *A Chinese Mirror: Moral Reflections on Political Economy and Society* (La Salle, IL: Open Court, 1991), 74f.

73. Cf., e.g., Tu Wei-ming, "Probing the 'Three Bonds' and 'Five Relationships' in Confucian Humanism," in *Confucianism and the Family*, ed. Walter H. Slote and George A. De Vos, SUNY Series in Chinese Philosophy and Culture (Albany, 1998), 123 *et passim*.

74. Wing-tsit Chan, *A Source Book in Chinese Philosophy* (Princeton: Princeton University Press, 1963), 47.

75. For some examples, see, e.g., Marina H. Sung, "The Chinese Lieh-nü Tradition," in Guisso and Johannesen, 66ff.

76. *Lao-tzu* 6; text in Kao Ming 高明, *Po-shu Lao-tzu chiao-chu* 帛書老子校注, Hsin-pien Chu-tzu chi-ch'eng (Peking: Chung-hua, 1996), 6.247ff. This is a convenient variorum edition of the received *Lao-tzu* and the Ma-wang-tui versions, with collected commentary. I cite from the received text. Compare the translation in Victor Mair, *Tao Te Ching: The Classic Book of Integrity and the Way* (New York: Bantam, 1990), 65.

77. *Lao-tzu* 61, *Po-shu Lao-tzu chiao-chu* 61.121ff. Compare the translation in Mair, *Tao Te Ching*, 31.

78. See, e.g., Black, 173f.; Joseph Needham, *Science and Civilisation in China* (Cambridge: Cambridge University Press, 1956–), II, 59; and Max Kaltenmark, *Lao Tzu and Taoism*, tr. Roger Greaves (Stanford: Stanford University Press, 1969), 59f.

79. *Lao-tzu* 28, *Po-shu Lao-tzu chiao-chu* 28.369. Compare the translation in Mair, *Tao Te Ching*, 93.

80. Cf. esp. Chad Hansen, *A Daoist Theory of Chinese Thought: A Philosophical Interpretation* (New York and Oxford: Oxford University Press, 1992), 223ff.; Graham, 228ff.; and Roger T. Ames, "Taoism and the Androgynous Ideal," in Guisso and Johannesen, 21–45.

81. *Ma-wang-tui Han-mu po-shu*, I, 70. Not all of the editors' emendations strike me as necessary; thus I retain *hsiang* 鄉, for example, in the sense of "provinces," rather than changing it to *hsiang* 向, which I presume the editors understand as "directions."

Compare the translation in Robin D.S. Yates, *Five Lost Classics: Tao, Huang-Lao, and Yin-Yang in Han China*, Classics of Ancient China (New York: Ballantine, 1997), 129. (Yates renders *chieh* 節 as "tally" where I have "mode.")

82. *Ma-wang-tui Han-mu po-shu*, I, 49. Compare the translation in Yates, 67f.

83. "Wang-cheng" 亡徵, *Han Fei-tzu chi-shih* 5.15.269. Yates, 227, n.72, refers to this chapter erroneously as "Wang-cheng" 王徵. Compare the translation in W.K. Liao, *The Complete Works of Han Fei Tzu: A Classic of Chinese Legalism*, Probsthain's Oriental Series 25 (London, 1939), I, 139.

Prudery and Prurience: Historical Roots of the Confucian Conundrum Concerning Women, Sexuality, and Power[1]

Sandra A. Wawrytko

1. Reevaluating Cultural Stereotypes: The Confucian/Daoist[2] Continuum

Paradigms associated with sexuality mirror gender relationships and the disposition of power within those relationships. Correspondingly, changes in those paradigms reflect changes in the relative status of women and men within a society, in terms of politics, economics, and religion. The androcentric bias of many cultures has relegated women to an ancillary role, defined in terms of the desires and needs of males. Often the only textual references to women (even in fairly recent works of the "liberated" West) are sexual in nature: woman as sexual partner or, taking the next logical step in the process, woman as mother.

In regard to traditional Chinese culture, deemed to be irrevocably patriarchal in structure, caution must be exercised in interpreting its paradigms. Seeking to enforce the self-created myth of male superiority combined with moral self-righteousness, the increasingly dominant forces of Confucianism, and most especially Neo-Confucianism, demonstrated a marked tendency toward a revisionist view of history. The result has been the prevailing stereotype of sexual repression as an ingrained Chinese trait, and the oppression of women as a social given. For example, a recent book surveying Chinese values claims: "From the beginning of Chinese civilization until 1950, women in China were generally treated as the property of men, and were used and abused according to male needs and whims."[3]

Yet, appearance and reality often are found to be at variance. What is obvious on the surface of a culture can obscure or seem to nullify a deeper reality hidden beneath. Publicly performed rituals do not always accurately inform us about private practices. The *persona* that acts on the stage, defined

by familial and social parameters, does not necessarily coincide with the individual person who resonates with their own nature and Nature as a whole.[4] Such seems to be the case in Chinese culture, with its paradoxical poles of prudery and prurience regarding the intertwining issues of sexuality and women's roles. Contacts with other cultures also had an inhibiting effect on women's roles, at least in public. R. H. Van Gulik interprets this as a defensive strategy periodically adopted by the Han Chinese in the face of foreign conquest—Mongol, Manchu, and Western in succession. The aim was to protect the "purity" of Chinese women through a posture of prudery, again not necessarily a reflection of reality.[5]

In evaluating Chinese attitudes toward women, we must not allow the text that dominates the foreground to obliterate the underlying subtext. Nor should we assume simplistic polarities of lascivious Daoist spontaneity versus puritanical Confucian repression. Glib generalizations reinforcing these stereotypes can readily be shown to be fallacious. Through the centuries there have been Daoists and Confucians who spontaneously embraced human nature, while flaunting the much-vaunted conventions of an overly restrained society.[6] Both Daoism and Confucianism can be traced to ancient sources that valued women, although for different reasons. Daoists, regarding women as manifestations of or beings primally in tune with *yin* energy, see them as worthy role models. Dao is glorified as the Mother and the "profoundly dark female" (*xuanpin/hsüan-p'in*) is extolled. For Confucians women were an indispensable means to the primary end of family continuity, allowing fulfillment of one's obligations to past ancestors and future posterity. Women also were necessary to insure domestic harmony by complementing men, just as Earth supports and Heaven overarches.

How, then, can we account for the emergence of doctrines that assume male superiority and corresponding female inferiority? I will argue that the very perception of women's power over male sexual arousal as well as procreativity led to women's subsequent suppression, repression, and oppression. Abject male fear of this life-giving power, which men did not and could not share, gave rise to gynophobia.[7] In "self-defense" men attempted to deny women all socially sanctioned power and to circumscribe their natural power. Structures were imposed to reinforce men's psychological power (through rigid gender roles), biological power (by asserting the superiority of *yang* over *yin*), and political power (by banishing women from the public sphere). Hence the original assumption of complementarity and mutual benefit between *yin* and *yang*, female and male, wife and husband degenerated into a battle of the sexes in which women were the primary casualties. The concept of "separate, but equal" energies evolved into a hierarchy of dominant and subordinate roles sanctioning sexual discrimination as "natural."

2. China's Dual Cultural Roots: Sexual Power as Women's Power

The roots of Chinese culture, as of its subsequent historical and philosophical expressions, have proven much more complex than hitherto acknowledged. Increasing archaeological evidence exists that two areas can lay claim to being cradles of Chinese civilization, dating back as early as the fifth millennium B.C.E. Both sources need to be considered in understanding Chinese culture as a whole and its Confucian manifestations.

Previously recognized as the cradle of Chinese civilization, the northern plains are dominated by the Yellow River (Huang He), a region of temperate climate and sparse rainfall but fertile soil, suited to a variety of grains, especially millet. Nomadic tribes settled here to pursue agriculture, evolving into the Zhou society, whose patriarchal values were inherited by Confucius. The priority given to human-imposed controls was reflected in the orderly patterns of Zhou bronzeware as well as their elaborate codes of social mores (*li*).

Further south, in the Yangzi River valley, lies a subtropical region that shows evidence of human habitation dating back at least as far as in the north. This became a center for intensive rice cultivation, where fertility also was of utmost importance. In the ancient state of Chu shamans (*wu*), both male and female, represented the broader population in contacts with spirits of rivers and mountains. Supernatural favor was solicited through dance, song, and stage performances, often erotic in nature (paralleling the precursors of ancient Greek theater). Matriarchal social structures were followed. The flowing, imaginative motifs of Chu art demonstrate the culture's embrace of spontaneity. Such were the roots of Daoist philosophy.[8]

Xia, Shang, and Zhou in the North: Sexuality in the Shi Jing

Like the Chu state, the pre-Zhou dynasty of the Xia (Hsia) originated in the Yangzi region.[9] Numerous scholars have cited evidence of a matriarchal society in pre-Zhou times, remnants of which lingered into the Zhou (1,100?–221 B.C.E.), at least in its early period. This orientation is reflected in the Chinese character for surname, *xing* (*hsing*), which includes the component for woman beside another meaning "to produce," a recognition of the maternal family lineage. The woman component likewise appears in numerous terms for family relationships.[10]

Evidence of goddess worship has been uncovered in many parts of China, largely associated with woman's procreativity.[11] Numerous female immortals were recognized, including the Queen Mother of the West and the creatrix Nü Wa.[12] Significantly, the birth legends recorded about the ancient sage-kings make no mention of human paternity. The Xia sage Yu (Yü) was born after his mother ate the Job's tears plant (*Di Wang Shi Ji/Ti Wang Shih Chi*); Qi (Chi)

of Yin's mother became pregnant after eating a black bird egg (*Shi Ji/Shih Chi*); the pregnancy of Jiangyuan (Chiangyüan), mother to Houji (Houchi) of Zhou, was reputedly due to her having walked on a heavenly footprint ("Sheng Min," *Shi Jing/Shih Ching*).

Although the Shang Dynasty (1,600–1,100 B.C.E.?) seems to have had an essentially patriarchal social organization, women were not entirely excluded from power. Archeological investigations of Shang sites have disclosed evidence of prominent administrative roles for women within the palace.[13] Women's public presence was much more extensive than would be the case later, when they were largely confined to the domestic sphere. Oracle bone inscriptions mention women military leaders, divinators, and keepers of state archives, as well as supervisors of rituals and agricultural administrators.[14] The richest Shang tomb yet unearthed is the final resting place of a court lady known as Fu Hao, reputed wife of Emperor Wuding (Wu Ting). Among its nearly 2000 artifacts are two nude human figures, one male and one female. The female figure appears to be exposing her genitalia, perhaps in connection with some fertility ritual.[15]

Sinologist Bernard Karlgren was perhaps the first scholar to explore the sexual symbolism of early Chinese art.[16] Like many ancient civilizations, the Chinese incorporated phallic designs into their ritual objects, as well as representations of female breasts.[17] Cowrie shells were highly prized in the Shang dynasty, being used as a form of currency. However, they symbolize the female vulva.[18] Anticipating the *yin/yang* motif that dominated Zhou culture, the Shang *li-ho* wine vessel is said to incorporate depictions of female breasts for the legs with female buttocks and pubic region for the container, surmounted by a projecting penis as spout.[19]

Under the leadership of a Shang vassal, Wen, the Shang Dynasty was overthrown and Zhou rule inaugurated. Confucian accounts sanitize the rebellion as an expression of divine will, based on the corruption of the last Shang ruler, Zhou Xin (Chou Hsin). Among his many crimes were charges of sexual abandon, in collusion with his evil queen, including orgies on the palace grounds incited by a lake filled with wine from which courtiers were forced to drink on all fours (i.e., a decline into unrestrained bestiality). The Shang had used similar justifications for their overthrow of the preceding Xia dynasty. Yet the Zhou rituals themselves were far from puritanical.

Both the *Zhou Li* (*Chou Li*) and the *Li Ji* (*Li Chi*) mention yearly fertility rituals, such as the *jiaomu* (*chiaomu*), held in spring, which sanctioned sexual license in wilderness areas. The women and men who participated embodied the cosmic forces of *yin* and *yang* respectively. These rituals were required to insure the fertility of crops and livestock, as well as the survival of the human community. Even Confucius is reported to have engaged in such a wilderness tryst with an unknown woman by the *Shi Ji*.[20] Seemingly the source of later

poetic conventions linking spring to erotic activity, such unions were formalized by marriage in autumn, following the harvest. Songs and dances were important parts of the rituals, examples of the former being included in later compilations of poetry, most prominently the *Shi Jing.*

As China's oldest poetry anthology, the *Shi Jing* is an invaluable written record of the ancient Zhou oral tradition. A careful reading of religious hymns, courtly airs, and folk songs reveals much about gender relationships, especially courtship practices. Many of the songs describe romantic longings, assignations, and partings, carried out under a very liberal set of sexual mores for both men and women. For example, in the song "Zhong Zi" (Chung Tzu), a young woman cautions her lover about his clandestine visits, not out of any sense of moral outrage, but for fear of having the affair publicly revealed.[21] Women's voices are often heard in the songs, praising the charms of a beloved, berating a faithless man, or describing married life (not always in glowing terms). Other songs follow the progress of the bride to her new home, a function of the patriarchal rule that uprooted women from their parental homes. Hence a recurring theme is the sadness of women separated from their families.

Following the lead of their Master, Confucians relied heavily on verses in the *Shi Jing* to provide behavioral guidelines. Confucius summarizes his own teachings with one sentence from the collection: "'Thinking devoid of depravity/ abnormality" (*si wu xie/ssu wu hsieh*).[22] He is said to have personally culled some three hundred poems from an original collection of three thousand (leaving us to speculate on the more explicit contents of those omitted). Beginning a tradition of Confucian revisionism, even frankly sexual poems were reinterpreted in moral ways. For example, a song about osprey birds ("Guan Ju/Kuan Chu") expresses the longing of a lord for a beautiful young lady. Confucius's comment on the song, however, draws a decidedly trans-erotic moral lesson: "elated but not lewd; sorrowful but not griefstricken" (*yue er bu yin, ai er bu shang/yüeh erh pu yin, ai erh pu shang*).[23]

The perceived value of the songs is perhaps best expressed in the *Shi Jing*'s "Great Preface" (*Da Xu/Ta Hsü*), in which the ancient kings are credited with using poetry to regulate social roles, transforming the people by instructing them in proper behavior. Most importantly, poetry teaches us to restrain our emotions, as prescribed by the rules of propriety (*li*) and righteousness (*yi/i*). The Confucian agenda is clear here: emotions (*qing/ch'ing*; genuine feeling) are natural components of human nature, but in the interest of social harmony they must be properly channeled by moral principle. Sexual activity, which like poetry is stirred by the emotions, must follow the same channeling process. Despite their potential volatility, both sexuality and emotions possess "redeeming social value." Rather than rejecting the power of sexual desire, Confucius laments never having met someone whose desire for sex (*se*) equaled their desire for virtue (*de*).[24]

For the Confucian, the seeds of human emotion must be carefully nurtured in children by the family, especially parents, and in subjects by the parental ruler (referred to as "the people's father/mother"; *min zhi fu mu/min chih fu mu*). Without this broader social network the full flowering of humanness cannot be realized.[25] While the individual is the "root," maximizing human potential requires a supportive social context of family, community, and country.[26] A mutuality of responsibilities and benefits between the individual and the group creates a complex interdependency that often necessitates the sacrifice of personal preferences (including sexual preference) for the good of the whole. Later Confucians and Neo-Confucians misunderstood the original message, substituting the extremes of suppression and repression for a controlling moral force. As a consequence, emotions, sexuality, and, by "logical" association, women as primarily emotional and sexual creatures, were all to be restricted.

The Southern State of Chu: Qu Yuan, Poetic Voice of Eroticized Shamanism

Complementing the Confucian social orientation, the Daoist perspective is reflected in the differing nature and intent of its poetic roots as well as its attitudes toward sexuality and women's roles. Suppression and repression are inconceivable here, for spontaneous expression is the way (Dao/Tao) of Nature. In emulation of Dao's naturalness (*ziran/tzu-jan*) one must decultivate, removing all distorting impediments, including stifling social rules and regulations. Thus one acts without [artificial] action (*wu-wei*). For Daoists, Confucian cultivation constitutes an unnatural and counterproductive interference with the Way.[27]

Such spontaneity can be found in the work and person of the poet Qu Yuan (Ch'u Yüan; b. 340 B.C.E.), who incorporated the then-fading shamanistic culture of his southern homeland, the state of Chu, in his works.[28] Shamanistic functions were originally performed by the royal family, to invoke the good will of the forces of Nature on behalf of society. Mountains were considered sacred sites, while the character for immortal (*xian/hsien*) consists of components for a person beside a mountain. Confucians throughout East Asia came to denigrate shamanistic practices, taking their cue from the fact that Confucius advised reverence of the spirits—but at a safe distance.[29] In the first century C.E. (32–31) this statement was later cited to support a ban on shamanistic practices at court.[30] By then shamanistic connections also barred one from assuming any official positions.[31]

Qu Yuan obviously has no such reservations, as he openly courted the manifestations of spiritual power, invoking the sexual attraction between the shaman/shamaness and a chosen deity. Among his "Nine Songs" (*Jiu Ge/Chiu Ke*) from *The Songs of the South* (*Chu Ci/Ch'u Tz'u*) is "The Mountain Spirit"

(*shangui/shan-kuei*), wherein the poet addresses a goddess of the mountain as a longed-for lover.[32] The resulting spirit possession is not a passive but a truly interactive encounter.[33] The expansive style of his verse contrasts sharply with the terse, secular songs of the north, the lushness and sensuality of Qu Yuan's images mirroring the verdant mountainous landscapes.

"The Mountain Spirit" is alive with vegetation (a sweetly scented potpourri of magnolia, orchids, herbs, etc.) and a host of vibrant creatures (twittering monkeys, red leopards, and stripped civets). All our senses are engaged by the vivid portrayal of gusting winds, magical rains, rustling leaves, and sweeping clouds. Flirtatiously the spirit asks: "Have you taken a fancy to me? Do I please you with my lovely ways?"[34] Other songs in the collection shift the focus from male to female deities, presumably presented from the perspective of a shamaness or shaman respectively. The human pursuit of the divine and the lovelorn plaints of the deserted human lover are recurrent themes.[35]

The mountain rendezvous motif was not confined to Qu Yuan. King Xiang (Hsiang; third century B.C.E.) is said to have dreamed of a tryst with a goddess on Wu Shan (Witches' Mountain), with the goddess seizing the initiative. After their union she told him to look for her in the morning clouds and the evening rains. This episode evolved into a powerful literary allusion repeated throughout East Asia.[36] The phrase "clouds and rain" (*yun yu/yün yü*; vaginal secretions and semen respectively) thereby entered the Chinese erotic vocabulary as a refined way of referring to sexual intercourse.[37]

Continuing Qu Yuan's erotic tradition, a southern poet known only as "Lady Night" (Ziye/Tzu Yeh; c. 265–420 C.E.) penned provocative lines to her human lovers suffused with erotic sensuality:

> Spring flowers
>> seductive thoughts
> Spring birds
>> sad thoughts
> Spring winds
>> (chaotic thoughts)
> Blow open
>> my silk net skirt.[38]

One hundred and seventeen poems have been attributed to Ziye, most of which explore aspects of the same amorous theme. Many flattering imitations of her style also were produced. Devoid of even a hint of a social-minded self-consciousness, the poems focus on individual lovers pursuing, and ruing, their personal choices while acting on natural impulse (*ziran/tzu-jan*). Despite the erotic references, their literary value for Chinese culture was not diminished, as attested to by their faithful preservation.

3. Yin/Yang Complementarity:
Cosmic Paradigms and Inner Alchemy

Of the core concepts shared along the North/South, Confucian/Daoist continuum, two are noteworthy in reference to gender roles and sexual practices: (1) the priority of harmony with the one Tao, literally "the Way" of reality and (2) the twofold metaphysical principles of *yin* and *yang*, existing in a complementary relationship. Grounded in humanism, Confucian philosophy sought harmony primarily within a human social context, conceiving Humanity as forming a cosmic triad with Heaven and Earth. Daoists tended to see themselves in relation to Nature as a whole, transcending human group identity.

Both philosophies embrace an organic world view. Close observers of Nature's cyclical patterns, the ancient Chinese were sensitized to the ebbing and flowing of the life energies reflected in the waxing and waning of the moon and seasonal cycles, along with their own internal rhythms. These patterns were distilled into the poles of *yin* and *yang* as a framework for organizing all aspects of reality. Even prior to the use of this terminology, a distinction was made between two ways of being in the world: "soft" (*rou/jou*) and receptive or "hard" (*gang/kang*) and unyielding. The former became associated with females and the latter with males, possibly by analogy to corresponding differences in sexual organs. This would also explain the representations of *yin-rou* as a receptive or open line (the accommodating vulva) and *yang-gang* as an unyielding, rigid line (the erect penis). Each requires the other for completion and consummation.

THE CORE ELEMENTS OF YIN AND YANG

YANG-GANG	*YIN-ROU*
sunny side of the mountain,	shaded side of the mountain
sun on the horizon	overcast sky
male/masculine; sun/solar	female/feminine; moon/lunar
the assertive; bright/brilliant	the receptive; cloudy, shady,
this worldly; heaven	the underworld; earth
qi (*ch'i*) or vital energy	blood
movement, action; opening	quiescence/reaction; closing
flow, waxing	ebb, waning
hot, dry, pungent, sweet foods	cold, sour, bitter, salty foods
systolic action (blood forced out of the heart chamber)	diastolic action (blood filling the heart chamber)
positive charge of electricity	negative charge of electricity

Cosmic Complementarity in the Yi Jing

Confucian forces used cosmic paradigms to insure harmony, as documented in the ancient text of divination central to the Zhou dynasty politico-religious establishment, the *Zhou Yi* (*Chou Yi*), better known as the *Yi Jing* (*I Ching; Classic of Change*). Its contents are grounded in the endless interchange between *yin* and *yang*, applied to sexual practices by later Daoists and to politics by Confucians.

The text of the *Yi Jing* we have today has been heavily layered with Confucian values and interpretations, the accretions of many centuries (traditionally beginning with Confucius's editing of the work).[39] In their earliest forms, *yin* and *yang* lines were combined into eight trigrams (*bagua/pa kua*), representing natural phenomena (Heaven, Earth, Thunder, Wind, Water, Fire, Mountain, and Lake). The trigrams in turn generated sixty-four hexagrams. Each hexagram was assigned an image (*xiang/hsiang*) epitomizing the flow of the complementary cosmic forces through the six lines. Later, commentaries were added to each line, as well as overall Omens or Judgments (*ci/tz'u*).

Hexagram sixty-three, *Ji Ji* (*Chi Chi*) or After Completion, is associated with sexual union: the trigram for fire/light/male (*li*) is surmounted by water/clouds/female (*kan/k'an*). Significantly, this represents the only "perfect" hexagram among the sixty-four, "the only one in which all the lines stand in their proper place";[40] "the culmination of the mutual completion of *yin* and *yang*."[41] Its equilibrium derives from the convergence of the trigrams as *li* moves upward from below and *kan* moves downward from above, each in accord with its respective *yang/yin* energy.

Composed as an ancient divination guide, the core text is both brief and opaque. Consequently it invites interpretations that tend to be highly speculative and even biased. In terms of our present discussion we must emphasize the balanced approach taken toward *yin* and *yang*, acknowledging that some situations call for *yang* assertiveness where others demand *yin* receptivity. Only later was *yin* denigrated as an "evil" to be avoided by the endless commentators and would-be clarifiers of the text. This fanatical championing of *yang* to the detriment of *yin* contradicts the underlying philosophy of the *Yi Jing*. If life is in fact characterized by endless change, it is pure stubbornness to cling to either pole. Thus, hexagram 1, Heaven (*Qian/Ch'ien*), composed of six *yang* lines, recommends increasing self-development, yet ends with "haughty dragons" as a cause for regret by failing to practice *yin* receptivity. Hexagram 2, Earth (*Kun/K'un*), with six *yin* lines, cautions receptivity, and ends with a warning about fighting dragons, the resurgence of *yang*, once *yin* has overstepped its limit. Success is not a matter of choosing *yin* over *yang* or vice versa, but of the timely application of both *yin* and *yang*.[42] The *Yi Jing* accepts the Law of Enantiodromia, the reversion to opposites, also espoused by Daoism. When a situation has been sufficiently saturated with either *yang* or

yin, it cannot do otherwise than revert to its opposite. This observation under-scores the importance of recognizing limits in Nature, in human nature, and in one's own personal nature. The text emphasizes when the limit is about to be reached precisely so it may be avoided, which is perfectly consistent with Confucian aspirations for control.

Related to this Zhou dynasty cultural inheritance are the rituals for main-taining social order instituted by the Duke of Zhou (reputed author of the *Yi Jing*'s Appended Judgements, *Xiao Ci/Hsiao Tz'u* and *Xi Ci/Hsi Tz'u*).[43] Mar-riage ceremonies resonate with the *yin/yang* complementarity.[44] The marriage relationship, formerly the private concern of the couple, was formalized and placed firmly within the context of an alliance between two families in which all members shared an interest. Appropriately, then, the ceremony was to be held before the ancestral altar. The joining of the bride and groom, a micro-cosmic reenactment of the merging of *yin* and *yang*, was scheduled either at dawn or dusk, that is, when the cosmic forces of *yin* and *yang* were exchanging places. K. C. Wu argues that the symbols attached to the rituals leave no doubt that the Duke of Zhou was advocating a monogamous form of union, as shown by the offering of wild geese (who mate for life) from the groom and his role as the driver (i.e., servant) for the bride's carriage. Wu also considers Confucius a stout defender of the monogamous marriage system.[45] Despite a later de-generation of women's power, Confucians and Neo-Confucians continued to safeguard the unique status of the wife over lesser-ranking concubines.[46]

The gradual transition from *yin/yang* complementarity to a hierarchy of *yang* over *yin* is reflected in the changes to state rituals during the Zhou. Origi-nally two sets of rites were performed on behalf of the people. In the first month of spring, when *yang* was ascending, the king and his lords enacted the *jitian* (*chi t'ien*) ceremony to insure success in agriculture. The queen and her ladies performed the *gongsang* (*kung sang*) ceremony in the last month of spring by planting mulberry trees, promoting sericulture. However the male rites were obviously more highly regarded, as shown by the inclusion of animal sacrifices, as opposed to the sacrifice of grains by women.[47] Eventually the women's rituals were totally eclipsed by those associated with men.

Assumptions About Sexuality and Power

Why did complementarity between *yin* and *yang*, women and men, change into dualistic opposition and ultimately male superiority? How can we account for the growing fear of women that led to a lowering of their social status? To answer these questions we need to examine assumptions about the power imparted by and through sexuality. Some of the earliest texts associated with the Daoist philosophical school are sexual in nature, including *Secrets of the Jade Chamber* (*Yu Fang Bi Que/Yu Fang Pi Chüeh*) and *The Classic of Su Nu* (*Su Nu Jing/Su Nü Ching*). Although great antiquity is claimed for these texts,

existing versions date from around the first century C.E. The contents are thus not necessarily faithful to the originals, having been subjected to revisionist tampering.[48] Of special interest is the fact that mysterious women serve as sex consultants to authoritative males, for example, the Plain Girl who instructs the legendary Yellow Emperor Huang Di (Huang Ti).[49]

The manuals recognize the inherent power of *yin* as an essential ingredient for male survival and even the secret to longevity.[50] However, unlike the unlimited, renewable supply of *yin* in women, a man's *yang* was distinctly limited and thus had to be carefully guarded. Consequently, although men had to monitor and restrict their emissions, women were free to indulge themselves.[51] *Yin* and *yang* could be nourished and health maintained through the proper performance of sexual intercourse. A mutual exchange of energies was envisioned: men supplemented women with their *yang* while women imparted *yin* essence to men. However, a man could derive no benefit from his partner unless she had reached orgasm.

The importance of regular sexual intercourse to insure health became a permanent assumption of Chinese culture. It created one of the first objections to the introduction of Buddhism, since the celibate lifestyle demanded was deemed not only unfeasible, but suicidal (not to mention being hazardous to the propagation of family life by the Confucians). This belief was so deeply ingrained that stories arose about rampant sexual profligacy in nunneries and monasteries.[52] The perserverance of this view is reflected in Lin Yutang's fairly recent discussion of "Celibacy as a Freak of Civilization."[53]

Another practical aspect of the manuals, for both Daoists and Confucians, relates to the practice of polygamy in the upper classes. For a Confucian the highly structured rituals (*li*) of family life regulated even the frequency of sexual intercourse, with a strict hierarchy imposed based on a woman's rank. Men were held liable for the sexual dissatisfaction of all their women. This was essential for maintaining domestic harmony, since any lack of fulfilment could fuel dissension in the household (where the man was in the minority, despite his titular leadership). Accordingly, the patriarch of a Ming Dynasty household advises: "It is the duty of every enlightened householder to acquire a thorough knowledge of the Art of the Bedchamber, so that he can give complete satisfaction to his womenfolk every time he copulates with one of them."[54] Although the man might visit courtesans, it was usually more to enjoy their artistic gifts than their sexual favors, for he owed his *yang* to the women of his own household.

Under such conditions a man was at a distinct disadvantage, physically and psychologically.[55] The pressures of satisfying multiple women necessitated that he abjure his own climax, except in special circumstances (i.e., the optimum time for impregnating the wife). In effect, the man was reduced to the status of sex object, the means to the end of sexual fulfilment in and impregnation of women, while he himself was forced to exert amazing powers of self-control.

The belief that excessive expenditure of *yang* essence in emissions was hazardous to a man's health obviously provided a strong motivation for even Confucians to learn and engage in Daoist practices.[56]

4. Gynophobic Backlash: Late Zhou Through Han Dynasties

The Waning Zhou Dynasty: Voices of Primal Confucianism

Despite the growing political prominence of Confucianism throughout most of Chinese history, Daoism continued to exert a significant, if largely subterranean, influence on society. Noted sexual historian R. H. Van Gulik has suggested that this was in part due to the complementary nature of their doctrines. Daoism continued to fill a void left by Confucianism in areas where the staid Confucian feared (but was morally obligated) to tread, most especially sexual relationships.[57]

Both of the earliest shapers of the Confucian school, Confucius and Mencius, were the product of single-parent homes. Raised and nurtured by widowed mothers under difficult economic circumstances, they had virtually no direct influence from their fathers. Each mother recognized the extraordinary talents of her son and did her utmost to encourage his educational development. Thus, one might expect them to be kindly disposed toward women and their abilities.

However, a gynophobic undercurrent expressed as moral self-righteousness is discernible in their thought. Confucius had two children, but almost nothing is known of his wife, who may have been divorced by him for some breach of ritual (*li*). He was also quite punctilious about his personal behavior.[58] Similarly, a story is told about the high standards of propriety, bordering on priggishness, upheld by Mencius. When he came upon his wife in an unseemly position in her private apartment, he complained to his mother, expressing his intention to divorce the wife for "want of propriety." His mother, however, took this opportunity to criticize his own failure in regard to propriety, citing passages from the ancient texts that required one to make one's approach known to others as a matter of simple courtesy. Mencius had no choice but to admit his error and drop the divorce plans.[59] His mother speaks for pragmatic rationalism, the hallmark of the primal Confucian tradition. The true Mean that resonates with *Yi Jing* complementarity avoids the tempting excesses of prudery.

The wisdom of the Mean likewise was recognized by the early Daoist masters, Lao Zi (Lao Tzu) and Zhuang Zi (Chuang Tzu), under their own definition. Their main proviso was to avoid the negative effects of the Principle of Reversion (DDJ, 40), that is, to avoid going to extremes. To attain the apex is to invite the nadir. Even the most positive of pleasures inevitably degenerates into its opposite. Still, the philosophy propounded by Lao Zi has a definite

yin-rou orientation, with many references made to the role of the female and feminine values. In the *Dao De Jing* (*Tao Te Ching*), Lao Zi strongly emphasizes such roles and values, implying that they were being devalued in his own time. To reinstate the desired balance between *yin* and *yang*, reestablish cosmic harmony within the individual as in the world, he deemed it necessary to reassert *yin* (chapter 28).

The fact that *yin-rou* power cannot be depleted, in contrast to the limitations of *yang-gang*, is proven by numerous examples readily observable in Nature (see DDJ, 43; 76; 78). The laudatory qualities associated with softness and suppleness (*yin-rou*) suggest the technique of soft entry advocated in Daoist sex manuals. The sexual connection is made even more explicit in the following passage (ostensibly concerning politics): "The female always subdues the male by tranquillity,/Tranquilly taking the lowly position" (DDJ, 61).[60] Read in the context of the sexual arts, this passage reveals the source of women's erotic power, such that men are ultimately doomed to defeat in the battle of the sexes. The penis, although stiff and hard (*yang-gang*), succumbs to the receptive vagina. Once the semen has been spent, so has the man's power, his *yang*, which lacks *yin*'s natural power of renewal. Rather than lamenting this unavoidable fact of biology, or blaming women for their biological advantage by labeling them the voracious enemy, Lao Zi recommends the same course taught by the mysterious females in the early manuals. Men must learn the life-giving techniques of *yin* and incorporate them into their practice, sexual and otherwise (see DDJ, 9; 13; 15; 20; 55; 64).

The Onset of the Han Dynasty: The Battle of the Sexes is Joined

The Han Dynasty (206 B.C.E.–220 C.E.) represents an important expansionist period in Chinese history. Government centralization was solidified under an eclectic ideology of State Confucianism, intended to maintain social order by instilling internal mechanisms of control. This strategy pointedly rejected the use of external force and violence associated with the previously much-hated First Emperor (Qin Shi Huang/Ch'in Shih Huang; 259–210). Nonetheless, the latter's ability to unify the country and institute cultural standards could not but be admired by the newly installed court. Thus they sought the best of both worlds: control that avoided the appearance of coercion.

Despite the veneer of Confucianism, the Chu sources of Han culture have been noted by scholars such as Li Zehou:

> Although in their political, economic, and legal systems, the Han ruler had basically retained Qin Dynasty patterns, in certain ideological spheres, especially in literature and art, they preserved the features of southern Chu, which was their ancestral home. . . . the rational spirit of the Pre-Qin, whose hallmark was Confucianism and whose content was historical experience, gradually pervaded the south's

art and literature and the thoughts of the people resulting in the fusion of north-
ern and southern cultures into a unique heterogeneous congeries. . . . It was still
a romantic world of the imagination, rich but chaotic, and of passions ardent and
undisguised.[61]

The internalized duality of perspective is demonstrated in the case of the
great Han emperor Wu (ca. 100 B.C.E.). Although responsible for instituting a
Confucian-based educational system, Emperor Wu was also capable of romantic
and erotic sentiments. His poem, "The Autumn Wind," commemorating a
boat trip with his beloved, does not present the object of his passionate affec-
tions as a mere means to the Confucian end of progeny and family solidarity:

>
> I cherish a fair one
> I cannot forget.
>
>
> Though pleasure's at its peak
> Sad feelings arise:
> Hale youth cannot last,
> There's no stop for old age.[62]

Although the peak of pleasure referred to seems obviously erotic in nature,
implicit in these lines is a tinge of foreboding associated with the aging pro-
cess, symbolized by autumn, the beginning of seasonal decline. The diagnosis
of sexual exhaustion was not uncommon in medical annals, with the cause
being traced to the seductive powers of women.[63] In "self-defense," consciously
or unconsciously, men may have sought to limit women's power at its source
by eliminating their previous access to sexual knowledge, sexual empower-
ment, and sexual independence.

The precise point at which gender relationships change to the disadvan-
tage of women is difficult to determine. Woman's special virtue/power (*nude/*
nü-te), a kind of mana, was noted as early as the Shang and Zhou dynasties.[64]
Gradually the inherent power of women, their procreative power as well as
their power to arouse the male, gave rise to gynophobia, a morbid fear of that
power. In the Han it was assumed that a woman was unable to control her
own power to injure others.[65] Hence, even a good (Confucian) woman could
be a threat to men, despite her best intentions, simply through her biologically
and cosmically grounded womanliness. To quote the *Zuo-zhuan* (*Tso-chuan*):
"The *te* (*de*) of a girl is without limits, the resentment of a married woman is
without end" and "Woman is a sinister creature, capable of perverting man's
heart."[66]

Popular culture incorporated gynophobic legends of foxes who assumed
the guise of seductive young women. The ensuing fatal attraction ended with

the death of the man as his life essence (e.g., *yang* force or semen) was sucked out of his body.[67] The message of Lao Zi becomes substantially rewritten, if not entirely ignored, by the religious Daoists in their search for immortality:

> The glorification of *yin* in early Daoist philosophy, and the emphasis on the balance of *yin* and *yang* in traditional Chinese medicine, gives way to the search for pure *yang* in alchemy, meditation, and sexual yoga. In early Daoism, *yang* in its aspect of hardness was to be avoided and *yin* softness to be cultivated; in later Daoism, *yang* in its aspect of spirit was to be cultivated and *yin* materiality to be avoided.[68]

One key for pinpointing this change can be found in the growing "androcentric" perspective of sexual practices expounded on in "pillow books." Early Han texts take a forthright, descriptive approach to sexual practices, noting the symptoms and stages of sexual response in detail. The oldest extant texts, "Uniting Yin and Yang" (*Ho yin yang*) and "Discourse on the Highest Dao Under Heaven" (*Tian xia zhidao tan /T'ien hsia chih-tao t'an*), lack pejorative references to women. In these works women are not perceived as sources of energy to be exploited, but rather as equal partners in the ensuing benefits of intercourse. Perhaps most importantly, if the woman does not achieve orgasm at each encounter the entire procedure fails; success depends on her gratification. Polygamy, later assumed to be essential to such practices, is not mentioned.

Ambivalence on the part of the male soon seeped into these texts. The very term for the erotic arts, "the battle of stealing and strengthening" (*caibu zhi zhan/ts'ai-pu chih chan*), reflects a decline in women's status. No longer referred to as woman, she degenerates into a consummate sex object, the "other," "crucible," or "stove."[69] Moreover, men are directed to keep this knowledge from their partner; her ignorance insures his ultimate bliss. Multiple partners are advised as a defensive tactic, and rigorous standards of physical beauty are elaborated as signs of the most efficacious *yin* to be coopted by the male combatant.

The abiding fear of women's sexual power over men was equally prevalent in the political arena. A woman's beauty was said to be "able to topple an empire."[70] The social solution was to impose controls on the overwhelming destructive feminine power by restricting them to the inner circle of the household and excluding them from the public sphere of male power. K. C. Wu argues that paternalistic attitudes toward women initially arose as a matter of necessity in an early period when nomadism was prevalent. Under such conditions it was unsafe for women to be unescorted by men, hence they were to be protected by fathers, husbands, and sons in succession.[71] Only later was this formula reinterpreted (notably by Confucians) as a caveat for a woman's blind obedience to men. Thus a practice intended to protect women evolved into the sanctioning of abject submission.

Symptomatic of this internalized mode of repression is Lady Ban Zhao (Pan Chao; d. 116 C.E.), author of *Instructions for Women* or *Women's Precepts* (*Nujie/Nü-chieh*), a training manual for young ladies. Brilliant and talented, but seemingly a co-conspirator in women's denigration, she remains a highly controversial historical figure for feminists.[72] However, an objective reevaluation of her work reveals some important "feminist" features, argued for from the standpoint of Confucian orthodoxy. For example, she advocates equality of education for women and men based on the Confucian association between morality and scholarship: "Is not then the fact that those gentlemen do teach their sons and do not teach their daughters, unreasonable discrimination?"[73] She also takes a forthright stand against spousal abuse, either verbal (on the part of women towards husbands) or physical (on the part of men toward wives), considering such acts to be inconsistent with a harmonious marriage (III).

The case of Ban Zhao exemplifies the ambivalent views of women in early China within the Confucian tradition. Much of her advice can be seen as astute psychological counseling for coping in a social role fraught with difficulties and dangers. An accomplished educator, moralist, and author, she transcended her gender liability, becoming the only woman to serve as Historian of the Imperial Court. It is no coincidence that she begins her chapter on the relations between husband and wife by invoking *yin/yang* complementarities. Rather than denouncing Confucian philosophy for its sexist offshoots, Ban Zhao seeks a return to its roots and a sense of complementarity. Her insistence on the importance of marriage harks back to the Duke of Zhou's reverence for this relationship as the foundation of society, a necessary mergence of cosmic forces.

The Golden Tang Dynasty: Cosmopolitan Liberalism and Collapse

Often deemed the high point of Chinese civilization, the complex Tang Dynasty (T'ang, 618–907 C.E.) was awash with the dual currents of sexual attitudes. In this period erotic literature was, for the first time, produced for its entertainment rather instructional value, although much of it has been lost in the intervening centuries. One such text, discovered earlier this century in Dunhuang (Tun-huang), is entitled "Poetical Essay on the Supreme Joy" (*Dalofu/Ta-lo-fu*), aptly conveying the role sexual activity had now assumed.[74]

On the one hand the Tang produced Empress Wu Zhao (Wu Chao; 625?–706?), the only woman in Chinese history to reign in her own name. Beginning her life in court as the concubine of Emperor Taizong (T'ai-tsung; r. 626–649), Wu Zhao skillfully maneuvered herself into a position of power before his death by eliminating her rivals. Not content to rule as regent for her son, she declared herself emperor and established a new dynasty. To solidify her precarious position as a woman ruler in a patriarchal society, she further claimed to be the incarnation of the Buddha Maitreya.

Empress Wu favored esoteric Buddhist practices, bolstered by the magical rituals of religious Daoism. Emulating her male counterparts, she had a stable of young male concubines, whom she entertained in her mirrored bedroom (courtesy of an unsuspecting Buddhist monk). Her ruthless strategies to maintain power in an uncooperative patriarchal society (including the deaths of two of her own grandchildren) sealed her fate as possibly the most vilified woman in Chinese history. Few mourned her passing, for in retrospect her actions seemed to confirm the worst stereotypes of feminine perfidy. Nonetheless the modern scholar Hu Shi (Hu Shih; 1891–1962) has praised her as "a woman of great literary talent and political genius."[75] During the reign of Empress Wu the dynasty achieved its widest geographical expansion. An avid patron of Buddhism, she promoted its expansion intellectually as well as artistically. Her reforms also transformed the official bureaucracy into a more effective meritocracy, in which talent could outweigh aristocratic heritage.

Empress Wu's successor, Emperor Xuanzong (Hsüan-tsung; r. 713–756) presents another side of the Tang anomaly. A paragon of Confucian virtue and patron of the arts in his early reign, Xuanzong ended his life as a Daoist dilettante, presumably due to the corrupting influence of femme fatale Yang Guifei (Yang Kuei-fei). Their doomed affair was immortalized by the late Tang poet Bai Juyi (Po Chü-yi; 772–846) in "The Song of Unending Sorrow" (*zhang hen ge/chang hen ke*). The poem portrays an aging monarch totally swept away by raging erotic passions. The once disciplined ruler "forsook his early hearings/ And lavished all his time with her with feasts and revelry" in wanton abandon.[76] The numerous ladies of the court were summarily abandoned, another sign of his abdication of Confucian responsibility for the sake of personal indulgence. Even her death could not sever his ties to Yang Guifei. Through the intercession of a Daoist priest, they reaffirmed their vows "to fly in heaven, two birds with the wings of one,/And to grow together on earth, two branches of one tree."[77]

This romantic depiction of a good Confucian corrupted by a seductress notwithstanding, Xuanzong showed signs of deviance from the Confucian path even before meeting Yang Guifei. For example, he had a long-standing interest in the Tantric practices of esoteric Buddhism, predating his liaison with Yang Guifei. The formal entry of the school into China is traced to the "Three Bodhisattvas of K'ai-yüan"—Śubhākarasiṁha (Shan-wu-wei; 637–735), Vajrabodhi (Jin-gang-zhi/Chin-kang-chih; 671–741), and Amoghavajra (Bu-kong Jingang/Pu-k'ung Chin-kang; 705–774), all of whom were honored guests of the emperor at his palace in the capital years prior to his Daoist idyll with Yang Guifei. She did not arrive at the palace until 745, at which time both Śubhākarasiṁha and Vajrabodhi had already died.

Another failed love affair outside the immediate court circle helps to clarify deeply ingrained conflicts of Confucian values and gender relationships in Tang society. The details are given in "The Story of Cui Ying-ying" (*Ying-ying chuan/*

Ying-ying zhuan) by Yuan Zhen (Yüan Chen; 779–831), a close friend of the poet Bai Juyi. The story has been hailed as "the first and most important study of love and sex in Chinese society . . . it reveals a complex relationship, the core of which is the fundamental conflict between society and the individual."[78] Although it is told in the third person, as an account of a young scholar named Zhang (Chang), many consider it to be autobiographical. The sizzling passions and torrid tensions experienced by the couple expose the double standard applied to sexual conduct.

While Zhang is instantly attracted to Ying-ying, she does her utmost to ignore him, being characterized by her maid as one who "clings steadfastly to her chastity."[79] When a provocative poetic proposition is met with feigned acceptance, the couple meets secretly. However, Ying-ying uses the occasion to vent her proper Confucian outrage, denouncing Zhang for seeking to "make me a partner to your own licentious desires" (293). Paradoxically, a few nights later, she unexpectedly appears in his room "languid and flushed, yielding and wanton in her air" (294). The description of their sexual encounter, and the couple's frank enjoyment of intercourse over many weeks, demonstrates the liberality of the times, in fact if not in theory. Indeed, the opening paragraph depicts Zhang as unusual since at age twenty-three "he had not yet enjoyed a woman's beauty" (292).

Yuan Zhen justifies the subsequent abandonment of Ying-ying in terms of the repressive ideal of sexual conduct typical of State Confucianism. His critics, however, chastise the hypocrisy of the faithless seducer, while praising Ying-ying for following her genuine feelings (*qing/ch'ing*), following Primal Confucian philosophy.[80] Indeed, in her final letter to Zhang (which he proudly flaunts before his friends), Ying-ying grounds her eloquent final appeal on Confucian principles:

> The good man uses his heart; and if by chance his gaze has fallen on the humble and insignificant, till the day of his death he continues the affections of his life. The cynic cares nothing for people's feelings. He will discard the small to follow the great, look upon a former mistress merely as an accomplice in sin, and hold that the most solemn vows are made only to be broken. He will reverse all natural laws—as though Nature should suddenly let bone dissolve, while cinnabar resisted the fire. (297)

Zhang's cold response is grounded in gynophobic prejudices. He lists many great men who have been led astray by the wiles of "women disasters" (*nü-huo*): "dissipating their hosts [through sexual exhaustion?] and leading these monarchs to the assassin's knife, so that to this day they are a laughingstock to all the world." The implication is that he is shrewd enough to escape the dangers these great men succumbed to: "I know that my constancy could not withstand such spells, and that is why I have curbed my passion" (298). The final

line of the story reveals a sense of self-gratification combined with pride of accomplishment as his "contemporaries praised the skill with which he extricated himself from this entanglement" (299).

Nonetheless, some women in the Tang did have an opportunity for self-fulfillment and independence. Outside the official circles of Confucian propriety, women could and did lead liberated lives as Daoist nuns (*nü guan/nü kuan*), among them court princesses. Unencumbered by marital obligations, they were not confined by the increasingly rigid expectations imposed on married women. Professional entertainers and/or courtesans were freed from "normal" (Confucian) family obligations, and thus were able to exercise considerable control over their sexual behavior.[81]

The famous poet Xue Tao (Hsüeh T'ao; 768–831) belonged to this group. Highly educated and multi-talented, her early life was spent as a government hostess to Confucian scholar–officials. In that capacity she came in close, often intimate, contact with some of the most powerful and influential men of her day. Among her poetic correspondents were Bai Juyi and Yuan Zhen. Some accounts report that she was nominated to and/or granted the imposing official title of "Collator" (*jiaoshu/chiao shu*) in recognition of her outstanding literary abilities.[82] Retiring in her forties, Xue Tao moved to a country house on the Brocade River, near Chengdu (Ch'eng-tu), spending her final days as a Daoist recluse. She is probably best know for her "Ten Partings," a cycle of poems suffused with clever double entendre of a decidedly erotic nature.[83]

The Song and Yuan Dynasties: Prudery Ascendent

A definite conservative, even reactionary, current emerged in post-Tang times, in large part as a reaction against the cosmopolitan openness associated with the previous dynasty's decline and fall. Since Yang Guifei was held responsible for the faltering of Tang power, women became natural targets for the new constraints. During the Song (Sung; 960–1279) sexual manuals first came to be identified as Daoist, and thereby distanced from the prevailing Neo-Confucian forces. Previously such texts either had their own classification (in the Han) or were included under the medical category (during the Sui and Tang).[84] Even the past was recast to fit the high "moral" tone. Yuan Zhen's *Ying-ying* was now assumed to have been a prostitute, it being inconceivable that a respectable young lady would engage in premarital sex.[85] Correspondingly, an early twelfth-century account damns Xue Tao with faint praise: "Although Tao lost her chastity and was lowly [in social rank], she had a refined manner . . . She wrote characters without the air of a woman; the power of her pen was strict and strong."[86]

Lin Yutang has denounced "the puritanico-sadistic background created by the Confucian scholars from the tenth century onward."[87] Oppressive psychological and physical measures were enacted against women, usually in association

with the rigid codes of Neo-Confucianism. Zhu Xi (Chu Hsi; 1130–1200) championed a strict prohibition against the remarriage of widows, thereby condemning countless women to lives of sexual frustration, often without a socially-sustaining network of offspring. Under these circumstances many chose suicide, or were "assisted" to commit suicide by male relatives eager to acquire the enhanced status given to families who produced such paragons of womanly virtue.

Footbinding was one particularly gruesome means to restrict movement of women, "for their own good," and effectively limit their sphere of activity to the home. The practice apparently began among the elite, perhaps as early as the Five Dynasties period (907–960). It became increasingly widespread as a manifestation of a family's social status, a sign that its women need not engage in physical labor. In addition, it was a most effective means of reinforcing authority within the family structure, patriarchal authority as well as the authority of older women over a household's younger women.[88] The mutilated female foot came to embody the height of erotic fetishism, as reflected in the art of the time in which female figures sport dainty "lotus feet." Even when the women themselves are depicted as naked, their feet remain discreetly covered. It was claimed that the practice improved the woman's sexual performance along with the man's sexual pleasure due to an alteration of musculature in the genital area.[89]

Contradictions continued to exist, even in this reactionary period. The same emperors who officially supported the forces of Neo-Confucianism as public policy were avid practitioners of Daoist sexual techniques in their private lives.[90] Nor were the sexual arts completely neglected by the general population. Consider the case of China's premier female poet, Li Qing-zhao (Li Ch'ing-chao; 1084–1151). Although she was a respected matron, currents of sexual desire and its frank fulfillment appear unmistakably in her work, often under the familiar iconography of Spring.[91] Paralleling the family-centered conventions of erotic paintings, Li Qing-zhao focuses her amorous thoughts on her beloved husband Zhao Ming-cheng (Chao Ming-ch'eng), who was her partner in literary as well as physical pursuits. Illustrating how easily the lines of sexual expressions can be blurred, several erotically explicit poems attributed to Li Qing-zhao have alternately been identified as the work of an anonymous courtesan.[92]

Guan Daosheng (Kuan Tao-sheng; 1262–1319) provides another far from staid depiction of marital relationships. In her poem "Married Love," she described her relationship with her husband in terms of a burning flame, their identities merged, like mixing clay from two figures before reshaping them. Allegedly Guan Daosheng wrote the poem to dissuade her husband from taking a concubine. Whether or not this story is true, the fact that it was circulated demonstrates that even in this repressive period women did not always resign themselves to the polygamous penchants of their spouses. Moreover, the poem was said to have had the intended effect, drawing the husband, Zhao Meng-fu

(Chao Meng-fu; 1254–1322) back to his wife of many years.[93] A noted painter and calligrapher, Zhao was particularly known for the high quality of his erotic paintings.[94]

The Ming Dynasty: Prurient Interest with Salvific Ends

The Ming Dynasty (1368–1643) has the distinction of having produced the two best known classics of Chinese erotic literature: the multi-volumed *The Plum Blossom in a Golden Vase* (*Jin Ping Mei/Chin P'ing Mei*), better known in the West as *The Golden Lotus,* and the unself-consciously risque *Prayer Mat of Flesh* (*Rou Bu Duan/Jou Pu Tuan*). Both works assume the moralistic air of inculcating virtue by exposing the evils of sexual license, after first presenting that license in great detail. Not all commentators are convinced by this device. A poetic preface to *The Golden Lotus,* attributed to Wang Shizheng (Wang Shih-cheng; c. 1573–1619), casts the novel as an extended admonition. A gynophobic sentiment from past eras is sounded, attributed to Tang poet Chun Dangzi (Ch'un Tang-tzu):

> Beautiful is this maiden; her tender form gives promise
> of sweet womanhood,
> But a two-edged sword lurks between her thighs, whereby
> destruction comes to foolish men.
> No head falls to that sword: its work is done in secret,
> Yet it drains the very marrow from men's bones.[95]

The hero, Xi-men (Hsi-men), is a wealthy merchant who seems insatiable in his pursuit of women. The pages of the novel (four volumes in English translation) are filled with couplings between Xi-men, the six women of his official household, and various others. His unabashed lack of restraint reveals a complete lack of understanding of Daoist sexual arts and the dangers inherent in that ignorance. Not surprisingly, his death comes as a direct consequence of his debauchery when he is a mere thirty-three, while appropriate punishments are meted out to his "murderous" partners in lust.

The Prayer Mat of Flesh, attributed to Li Yu (Li Yü; 1611–1680) presents itself as a Buddhist tale of redemption clothed in erotic garb to attract the attention of the dissolute, those most in need of its moralizing message. Various subtitles have been associated with the novel, underscoring its connection with Buddhism, including "After Awakening, Return to the Service of Buddha" and "Cycle of Retribution." The story traces the amorous adventures of a young scholar, Wei-yang Sheng (After Midnight or Morning Dusk Scholar), described as "a demon of lust." Eschewing meditational practice on a monk's prayer mat, he seeks another kind of "Nirvānic" bliss through profuse sexual practice. Eventually, through the efforts of the hermit Lonely Summit, the young man takes

refuge in Buddhism. Assuming the name, Stupid or Stubborn Pebble, Wei-yang Sheng finally rids himself of his disruptive desires by self-castration.

The novel ends on a hopeful note of universal salvation, with a condemnation of men who abuse and exploit women. The author explains that the erotic content has been a skillful means of capturing the attention of the reading audience in order to convey his underlying moral message. In other words, the intent is to enlighten the lascivious reader to the consequences of wallowing in the mire of illicit sexual passion. Rather than repudiating sexuality, however, Li Yu advocates what amounts to both a Confucian Mean and a Buddhist middle path of socially sanctioned pleasure.

Alongside these literary masterworks cautionary tales of dangerous women were produced in popular fiction during the Ming period. One can speculate that it would be unnecessary to write such pieces, and no one would have an interest in reading them, unless they concerned what was perceived to be a true "social threat," i.e., a rising tide of lascivious women. One author of such works, Feng Menglong (Feng Meng-lung; 1574–1646), was both a Confucian scholar-official and a man well known for his dalliances in the pleasure quarters. Writing in the vernacular on very earthy themes, Feng nonetheless incorporated appropriately Neo-Confucian morals. Sexual betrayal leads inevitably to righteous retribution against all culprits, but especially against the wanton women who incited violations of social mores for their personal satisfaction.[96]

The Qing Dynasty: Soaring Censorship and the Erotic Underground

The Qing (Ch'ing) Dynasty (1644–1911) was led by non-Han rulers, the Manchus, under whom a period of oppression set in, motivated by Neo-Confucian desires for social order. The destruction of erotic texts was mandated by the government. In 1781 Emperor Qianlong (Ch'ien-lung; r. 1736–1795), renowned as a connoisseur of the arts, issued an edict ridding the imperial collection of items "with any suggestion of incest, or deviating in the slightest from orthodox austerity."[97] As newcomers to Chinese culture, and Sinophiles of the highest order, perhaps the Manchu rulers were seeking to validate their reign by becoming more Confucian than even the most demanding Neo-Confucians.[98]

Following out the dual nature of the culture, an erotic underground blossomed in the eighteenth and nineteenth centuries. Texts of a sexual nature were surreptitiously collected, and much of the erotic art that remains today dates from this period. Not even the imperial court was immune from these temptations, for the brother of Emperor Kang Xi (K'ang Hsi; r. 1661–1722) personally translated the infamous *Golden Lotus* into Manchu.

Feminist elements also can be discerned during this period, championed by those intent on defying governmental authorities by denouncing corrupt social values. One of the most effective, and subtle, of these protests was under-

taken by Li Ruzhen (Li Ju-chen; 1763–c.1830), whose rambling one-hundred-chapter opus, *Flowers in the Mirror* (*Jing-hua yuan/Ching-hua yüan*) stands as a testament to women's power, ability, and needless suffering.[99] In fact, women are the flowers who are provided with a mirror image in the story, dominated by female characters, which is set in the era of Tang Empress Wu. The connection to the infamous Empress Wu accomplished two things: first, it placed the action at a safe distance in time, and second, it created a shield in the universal condemnation of her by casting her as the main villain of the piece.

One chapter is particularly clear in demonstrating the feminist intent of the author.[100] Two merchants encounter the Country of Women during their travels, a land where a complete role reversal reigns for women and men. When one character objects to the inappropriateness of women parading around as men, another remarks "Wait a minute. Maybe when they see us, they think 'Look at them, isn't it a shame for them to dress like women.'" After considering the situation, his companion agrees, adding "Whatever one is accustomed to always seems natural."[101]

When a member of the group, Lin, catches the eye of the "king," he is seized and subjected to the same kind of beautification process routinely undergone by women, including footbinding. The excruciating agony of the ordeal is described in lurid detail—from the initial burning pain accompanying the wrapping process through the gradual rotting of the toes requiring daily medical treatment.[102] This was probably the first time most male readers stopped to consider the human cost of this sine qua non of sexual attraction. Understandably, women readers reacted quite positively to having their ordeal treated so frankly. A later chapter protests against the practice of concubinage, as a female character challenges her husband to consider how he would feel if she were to take additional husbands.[103]

Finally the new consort-to-be is judged ready for the arms of the "king," who is suitably impressed by the transformation of this diamond in the rough: "a Lin whose face was like a peach blossom, whose eyes were like autumn lakes, whose eyebrows suggested the lines of distant hills, . . . stood before her in a willowy stance" (113). Having gained such favorable attention, Lin is expected to repay his torturer with gratitude, and indeed he has no power to rebel (previous rebellious refusals having been met with swift physical punishment). Fortunately for Lin, his friends come to rescue at the final moment, in the midst of the wedding ceremony.

Another Qing feminist, Yuan Mei (Yüan Mei; 1716–1799), demonstrates that Li Ruzhen was not alone in his outrage over social conditions. In a scathing letter condemning a hypocritical Confucian, Yuan Mei sets forth his doctrine of sexual freedom:

The matter of sex is like wine. Some cannot touch a drop of it and some can drink gallons. We are born so differently, in our nature as in our face. There is no use trying to cover up one's romance or lack of romance. And a man's character after

all doesn't depend on his being romantic or not. King Wen loved women and Confucius approved; King Ling of Wei also loved women and Confucius disapproved. Lu Chi had not a single concubine and yet he was a cad; Hsieh An went about with sing-song girls and yet he was a gentleman.[104]

Note that Confucius is invoked as an authority for what might otherwise be dismissed as Daoist prurience, indicating that the author saw no oxymoron in a Confucian eroticism.

The voice of the oppressed also can be heard in muted defiance during this period. Artist and poet Luo Qilan (late eighteenth century) wrote on many subjects, from her travel experiences to philosophical musings. But in a series of eight poems about her "strange dreams" Luo conjured up a different world than the one in which had been cruelly confined. In "Record of a Dream, Number Seven" she appears as "the 'Rebel' star" bravely leading "wolfish and tigerish men" to victory in hard-fought battles. The liberating spell of the dream is broken by the sound of a bell, and she returns to the real world with "bow-shaped slippers still on my feet."[105]

Conclusion

A careful reading of ancient Chinese sources demonstrates that the anti-feminist stance attributed to Confucian philosophy is both an oversimplification and a hasty generalization. Attitudes toward women, mirroring attitudes toward sexuality, were much more complicated than they have been portrayed. The accompanying timeline (figure 1) tracks the superficial changes in Chinese culture through successive dynasties. The seeming poles of prurience and prudery in fact constitute a continuum of oscillating values, combining Daoist views with various versions of Confucian principles. One extreme, "prurience," presupposes a cosmic complementarity between *yin-rou* and *yang-gang*, and is more obvious in early stages of China's history. China's dual cultural roots—south and north, misty mountains and open plains, matriarchy and patriarchy, naturalistically grounded shamanism and humanistic ancestral practices—later emerged as the philosophies of Daoism and Confucianism respectively.

The Zhou stands as a transition period during which the cultural priorities and heritage of the dynasty were formalized by Confucius and his school. Simultaneously, the Daoist view was clarifying its own distinctive foundations, following the model of the kingdom of Chu. Both groups agreed on the importance of harmony, but sought it in different ways. They also agreed on the need to express natural emotions, including sexual desire. However, Daoists emphasized spontaneity (*zi-ran*) and decultivation, while Confucians preferred controlled channeling and self-cultivation. The association of women with the forces of nature and sexuality led to divergent attitudes toward them. Mutual benefit was anticipated from a cooperation between the forces of *yin* and *yang*,

Figure 1

THE CONFUCIAN CONUNDRUM CONCERNING WOMEN, SEXUALITY, AND POWER

PRURIENCE

XIA, SHANG

dual cultural roots:
matriarchy/shamanism
patriarchy/family focus

ZHOU TRANSITION

means to harmony:
Daoist spontaneity (Nature)
Primal Confucian channeling
(human nature)

HAN

State Confucianism
control priority
(Qin Authoritarianism)

POST-HAN THROUGH TANG

renegotiating value systems:
Daoist distancing
conflicting Confucian views

SONG, YUAN, MING, QING

Neo-Confucian dominance
conservative and/or
reactionary constrictions
Daoist/Confucian underground

PRUDERY

EXPRESS SUPPRESS/REPRESS (gynophobia ascendent) OPPRESS

MUTUAL BENEFIT BATTLE OF THE SEXES

COMPLEMENTARITY DUALISTIC OPPOSITION

UNDERLYING OSCILLATION OF DAOIST AND MULTI-LAYERED CONFUCIAN VALUES

women and men. For the Daoists, *yin-rou* provided a model for individuals to avoid challenging the flow of Nature. Confucians preferred *yang-gang*, whereby humanity was co-creative with Heaven and Earth, men procreative with women.

The rise of Confucianism as an ideology, State Confucianism, in the Han, reoriented the original concept of channeling natural emotions in the direction of control (having absorbed the authoritarian stance of the defeated Qin). Women were perceived as the embodiment of that which needed to be controlled. The mutual benefit perceived between *yin* and *yang*, men and women, now became a battle for supremacy; the principle of complementarity was displaced by dualistic opposition. The previous ideal of guided expression degenerated into suppression, whereby emotions, and women, were constrained, vanishing from view. This in turn led to repression, inhibiting emotions and restraining women. The cultural adjustment was gradual, occurring over many centuries. Proponents of Daoist spontaneity and early Confucian expression did not die out, but did become increasingly muted.

By the Song, Neo-Confucianism was the apparent victor, as signaled by the outright oppression of women. Fueled by conservative and reactionary motivations, Confucian mechanisms for social control underwent grostesque mutations. It was no longer sufficient to confine women to the inner recesses of their homes; their feet had to be mutilated by footbinding to prevent them from wandering astray (as their "natural" tendencies dictated). Furthermore, constraints were applied even to a woman's "legitimate" sexuality by imposing celibacy (or a convenient death) upon widows. Nonetheless, an underground countermovement of Primal Confucians and Daoists persisted, surfacing sporadically during succeeding dynasties in literary forms.

Before discounting the contemporary relevance of Confucian thought and depriving world culture of its many profound insights, we would do well to undertake a careful reinvestigation of its root principles and their actual implementations. A Confucian message that rises above its historical misunderstandings will be able to contribute to the new millennium. Confucius does not speak to men to the exclusion of women, but rather to all human beings concerned about their roles in human society and the world in the interest of harmony and mutual benefit.

Notes

1. This chapter is based on a longer work, "Prudery and Prurience: Sexuality in Traditional Chinese Culture," presented at the Triangle East Asia Colloquium, "Gay, Lesbian, Bisexual, and Gender Issues in China and Japan," at Duke University, March 30, 1996.

2. The transliteration of Chinese characters in this paper uses the *pinyin* system, followed by equivalents in the Wade-Giles system for first occurrences.

3. "Funi [sic] Wenti: 'The Woman Problem'," in Boye Lafayette De Mente, *NTC's Dictionary of China's Cultural Code Words* (Lincolnwood, Illinois: NTC Publishing Group, 1995), 98.

4. Lin Yutang (1895–1976) deftly exposes the multilayered complexity of Chinese culture, observing: "So deep is our histrionic instinct that we often forget that we have real lives to live off stage. And so we sweat and labor and go through life, living not for ourselves in accordance with our true instincts, but for the approval of society." *The Importance of Living* (New York: John Day, 1937), 105.

5. R. H. Van Gulik, *Sexual Life in Ancient China: A Preliminary Survey of Chinese Sex and Society From ca. 1500 B.C. Till 1644 A.D.* (Leiden: E. J. Brill, 1974), 245–46.

6. Two such examples can be cited briefly. The Han Confucian Yang Yun (Yang Yün; ca. first century C.E.), grandson of Grand Historian Sima Qian (Ssu-ma Ch'ien; 144–90 B.C.E.), wrote a famous letter setting forth his ideology to a disapproving friend, Sun Huizong (Sun Hui-tsung). Yang Yun describes how in his simple life in exile he enjoys an occasional feast with his family, accompanied by music, song, and drink: "At such times I flap my robes in delight, wave my sleeves up and down, stamp my feet and dance about. Indeed it is a wild and unconventional way to behave, and yet I cannot say that I find anything wrong in it." "Letter to Sun Hui-tsung" (*Bao Sun Huizong shu/Pao Sun Hui-tsung shu*), Burton Watson trans., in *Anthology of Chinese Literature*, comp. and ed. Cyril Birch (New York: Grove Press, 1965), 160–61.

Later, during the Three Kingdoms, the avowedly Daoist Xi Kang (Hsi K'ang; 223–62), key member of the seditious Seven Worthies of the Bamboo Grove, wrote a similar letter of self-defense to a critical friend. "Letter to Shan T'ao" (*Yu Shan Juyuan xue jiao shu/Yü Shan Chü-yüan chüeh chiao shu*), trans. J. R. Hightower in *Anthology of Chinese Literature*, Birch ed., 163.

7. Erich Neumann, a student of Carl Jung, has exhaustively explored cross-cultural gynophobic tendencies under the heading of the "Negative Elementary Character" in *The Great Mother: An Analysis of the Archetype*, Bollingen Series XLVII, trans. Ralph Manheim (Princeton, NJ: Princeton University Press, 1963). British wit Samuel Johnson (1709–1784) has succinctly captured gynophobia in his observation, "Nature has given women so much power that the law cannot afford to give her more."

8. See Min Jiayin, "Daoist Culture and Matriarchal Society," in *The Chalice and the Blade in Chinese Culture: Gender Relations and Social Models*, ed. Min Jiayin (Beijing: China Social Sciences Publishing House, 1995), 590–94.

9. Min, 593.

10. See Cecilia Lindqvist, *China: Empire of Living Symbols*, Joan Tate trans. (New York: Merloyd Lawrence, 1989, 1991), 43–44. Lindqvist also mentions a matriarchal society still existing in modern southwestern China, the Naxi, who revere a goddess. See also K. C. Wu, *The Chinese Heritage* (New York: Crown Publishers, Inc., 1982), 21 and Min, 61–75.

11. See Jiao Tianlong, "Gender Relations in Prehistoric Chinese Society: Archeological Discoveries," in *The Chalice and the Blade in Chinese Culture*, 91–126.

12. Min, 594.

13. See Chang Cheng-lang, "A Brief Description of Fu Tzu," in *Studies of Shang Archeology: Selected Papers from the International Conference on Shang Civilization*, ed. K. C. Chang (New Haven: Yale University Press, 1986), 103–19. Speculation is that the name Fu Tzu is a title of office held by a succession of women in the Shang court.

14. See Du Jinpeng, "The Social Relationships of Men and Women in the Xia-Shang Era," chapter 3 of *The Chalice and the Blade in Chinese Culture*, 152–54.

15. A photograph of these figures may be found in Lindqvist, 27.

16. See Bernard Karlgren, "Some Fecundity Symbols in Ancient China," *Bulletin of the Museum of Far Eastern Antiquities*, 1930.

17. See Hugo Munsterberg, "Sexual Symbolism in Ancient Chinese Art," chapter 10 of *Symbolism in Ancient Chinese Art* (New York: Hacker Books, 1986), 215–31. Munsterberg cites a contemporary report from V. R. Burkhardt describing a phallic altar dedicated to the soil deity used by villagers near Hong Kong, 218.

18. Munsterberg, 225–29. Some seven thousand cowrie shells were found in the Fu Hao tomb.

19. Munsterberg, 229–31. A photograph of a *li-ho* is given on 231. Later Daoist practitioners revived these biologically based vessels for use in rituals to insure longevity. Ever aware of the potent power of *yin*, these tended to take on the form of female genitalia, used as a cup for afflicted men to imbibe the healing power of *yin*. Phallic vessels were employed to cure women. See Philip Rawson and Laszlo Legeza, VII, "Secret Practices," in *DAO: The Chinese Philosophy of Time and Change* (Singapore: Thames and Hudson, 1973), 121–24, for photographs and discussion.

20. Du Jinpeng in *The Chalice and the Blade in Chinese Culture*, 141–44.

21. Similar "night-crawling" expeditions were undertaken by aristocrats in Japan's Heian court. Virtually any and all sexual experimentation was permitted, as long as it remained clandestine. For a fuller discussion of the sexual liberality of early China, see Wu, 423.

22. *Analects*, 2:2 (my translation).

23. *Analects*, 3:20 (my translation). See also 8:15. The Neo-Confucian scholar Zhu Xi (Chu Hsi; 1130–1200) projects much more onto these simple lines. In his interpretation, virtue is the basis for the lord's attraction to the reclusive lady, while the estranged birds symbolize the ideal of sexual segregation. See Pauline Yu, *The Reading of Imagery in the Chinese Poetic Tradition* (Princeton: Princeton University Press, 1987), 52.

24. Unfortunately, most translators avoid a clear rendering of the word *se*, clinging to euphemistic and misleading phrases such as "love of beauty." Arthur Waley is a refreshing exception to this prudish trend; see his translation *The Analects of Confucius* (New York: Vintage, 1938), 142.

25. See Mencius's view of human nature (*Mencius*, 2A.6). He attributes four innate feelings (compassion, shame, deference, and a sense of right and wrong) to human

nature. Each of these feelings is said to be the source of the Confucian virtues (respectively *ren/jen, yi/i, li*, and *zhi/chih*). It is the responsibility of the True King to see that these positive emotions are actualized in the people.

26. The eight threads outlined in *The Great Learning (Da Xue/Ta Hsüeh)*, one of the Four Books of Confucianism, begin with individual cultivation (one through five) and culminate in world peace (eight).

27. Confucius describes his own attainment to spontaneity near the end of his life, after years of "cultivation": see *Analects*, 2:4.

28. Chu occupied territory now located in parts of Hunan, Hubei, Anhui, Henan, and Sichuan.

29. Due to Confucian influence in Korea, Japan, and Vietnam, indigenous shamanistic forces were relegated to the lowest social strata. This is reflected in the fact that the shaman's role was assumed almost exclusively by women (the *mudang* in Korea and the *miko* in Japan), when previously both kings and queens had fulfilled these functions.

30. Arthur Waley, *The Nine Songs* (London: George Allen & Unwin, 1956), 11.

31. Waley, 12.

32. Similarly, in Japan there is a Shintō tradition of "single-time concubines" (*hitotoki jorō*) who serve as "temporary consorts" for visiting *kami*. See Waley, 14.

33. See Mircea Eliade, *Shamanism: Archaic Techniques of Ecstasy*, trans. Willard R. Trask (Princeton: Princeton University Press, 1964).

34. Waley, 53. By an interesting accident of history these clearly un-Confucian verses were safeguarded by Confucian scholars, not out of recognition for their literary merit, and certainly not through any respect for the tradition they depict. Instead it was Qu Yuan's reputation as a loyal minister, willing to accept suicide before dishonor, that won him the respect of later Confucians as a fitting role model.

35. "The River God," trans. Waley, 47.

36. For example, a reference to this romantic interlude is found in a fifteenth-century Korean story, "Student Yi Peers Over the Wall," by Kim Si-sup (1435–1493). The title character refers to the incident in a poem sent to a young lady, comparing himself to the King and the young lady to the enticing goddess. It serves as an invitation to sexual intercourse, which is promptly accepted!

37. Michel Beurdeley traces the phrase to the poet Song You (Sung Yu), who reports the amorous interlude in his preface to *Gao Tang Fu/Kao T'ang Fu*, ca. 300 C.E.

38. Lenore Mayhew and William McNaughton, trans., *A Gold Orchid: The Love Poems of Tzu Yeh* (Rutland, Vermont: Charles E. Tuttle Company, 1972), 26.

39. At least three arrangements of the hexagrams were made in different versions of the text, each assigned to a different royal line. Since the Zhou rulers were the ultimate winners in the historical contest, it is natural that their "house" version came to be viewed as orthodox.

40. *The I Ching Book of Changes*, trans. Richard Wilhelm, trans., Cary F. Baynes into English (Princeton, New Jersey: Princeton University Press, 1950), 709.

41. *The Taoist I Ching*, trans. Thomas Cleary (Boston: Shambhala, 1986), 228.

42. Based on my own translations of the primal *Yi Jing* text, images and lines.

43. These are described in the *Book of Rituals* (*Yi Li/I Li*).

44. See Wu, "The Marriage Ceremony and an Unresolved Anomaly," 419–27.

45. Wu, 424–27.

46. Protections for "first wives" were built into the legal code, with fascinating results in Confucian societies. For example, in the records of Korea's Yi Dynasty we find royal ministers urging the king to punish men who have failed to respect the priority of the wife over a concubine, using the authority of Confucian philosophy reflected in the Ming code. See, "On Differentiating Between Main Wife and Concubine" (*T'aejong sillok* 25:13a–b) and "On Treating the Main Wife (*Sejong sillok* 30:20a–b) in Peter H. Lee, ed., *Sourcebook of Korean Civilization*, vol. I (New York: Columbia University Press, 1993), 559–61.

47. Du Fang Qin, "The Rise and Fall of the Zhou Rites: A Rational Foundation for the Gender Relationship Model," chapter 4 of *The Chalice and the Blade in Chinese Culture*, 178–80.

48. Some early works were sheltered in Japan, as included in the *Ishimpō*.

49. Similarly, Socrates credits the priestess Diotima from Mantinea for teaching him about Eros; see Plato's *Symposium*. An account of Diotima's philosophy is found in Mary Ellen Waithe's "Diotima of Mantinea," in *A History of Women Philosophers*, volume I: *Ancient Women Philosopher 600 B.C.–500 A.D.* (Dordrecht: Martinus Nijhoff, 1987), 83–116.

50. The most successful practitioner of these arts was Peng-zi (P'eng-tsu), who lived more than eight hundred years, allegedly due to his nineteen wives and nine hundred concubines.

51. This assumption accounts for a considerably indulgent view of lesbianism in Chinese culture, if discreetly practiced. See Sandra A. Wawrytko, "Homosexuality` and Chinese and Japanese Religions," in *Homosexuality and World Religions* (Valley Forge, Pennsylvania: Trinity Press International, 1993), 203.

52. A Tang text, "Poetical Essay on the Supreme Joy" (*Da-lo-fu/Ta-lo-fu/*), is typical of this often spurious view: "Although these nuns do not dare speak of it, in their hearts they are ready to surrender. Their lovers are noblemen or famous scholars who forsook the world and entered the priesthood, or tall foreign monks. . . . When they are with these lovers the nuns forget the Law of the Buddha and play absent-mindedly with their rosaries." Quoted by Van Gulik, 207. The attitude toward such activities bears an aura of indulgence rather than moral outrage, reflecting the view of celibacy as unnatural. See also Van Gulik, 50.

53. Lin Yutang, *The Importance of Living*, 170–77.

54. Quoted by Van Gulik, *Sexual Life in Ancient China: A Preliminary Survey of Chinese Sex and Society From ca. 1500 B.C. Till 1644 A.D.* (Leiden: E. J. Brill, 1974), 269.

55. Xi-men (Hsi-men), the hero of the erotic novel *The Golden Lotus*, serves as a warning to men who neglect the necessary restrictions on their pleasures. He dies at

the age of thirty-three from the after-affects of sexual overindulgence, brought on by the overdose of an aphrodisiac. This text is discussed later in this chapter.

56. See Van Gulik, 154–56.

57. Van Gulik, 45.

58. See especially *Analects*, 10, which covers such points as the dress and eating habits of Confucius, and his behavior under various conditions.

59. See James Legge, trans., Prolegomena to *The Works of Mencius* (New York: Dover Publications, Inc., 1970), 17–18. Legge observes that the mother of Mencius "was a woman of very superior character, and that her son's subsequent distinction was in a great degree owing to her influence and training" (18).

60. Charles Wei-hsun Fu and Sandra A. Wawrytko, trans. (forthcoming).

61. Li Zehou, *The Path of Beauty—A Study of Chinese Aesthetics* (Beijing: Morning Glory Publications, 1988), 95, 101.

62. Whincup, trans., 18.

63. See Wile, 19.

64. Van Gulik, 12–13.

65. A corresponding fear of women's power existed in early Japan, particularly in the Heian period, seemingly related to women's key roles in Shintō. The unconscious and often fatal force was usually unleashed in fits of sexual jealousy. Several such incidents are reported as routine occurrences in Murasaki's *Tale of Genji*.

66. Van Gulik, 13.

67. The fox was credited with special power in the Zhou period, related to its underground lair (the abode of *yin*). Van Gulik traces the fox as femme fatale motif to the Tang Dynasty; see p. 210. This parallels beliefs about the succubus deemed responsible for erotic dreams and detrimental ejaculations during sleep, condemned by the Christian Church as a waste of the procreative power bestowed by God.

68. Wile, 29. In fairness to true Daoist adepts of the philosophical versus the religious persuasion, it is believed that texts exist maintaining the original tradition. However, due to the increasing resistance to that message in official circles, it took an esoteric turn, and was (is) imparted only to verified initiates.

69. Wile, 45.

70. The phrase first appeared in a Han dynasty history, in reference to a consort of Emperor Xiao-wu (Hsiao-wu); see Anne E. McLaren, *The Chinese Femme Fatale: Stories from the Ming Period* (Canberra, Australia: Wild Peony, 1994), 1, n. 1.

71. Wu, 23.

72. Van Gulik observes: "The Lady Pan would deserve to be called China's first feminist, were it not that she wrote the *Nü-chieh*" (97).

73. Ban Zhao/Pan Chao, *Women's Precepts*, II; quoted by Van Gulik, 99.

74. See Van Gulik, 202–07.

75. Hu Shih, "Women's Place in History," in Li Yu-ning, ed., *Chinese Women Through Chinese Eyes* (Armonk, New York: East Gate Books, 1992), 7.

76. "Song of Unending Sorrow," trans. Witter Bynner, in *Anthology of Chinese Literature*, 266.

77. "Song of Unending Sorrow," Bynner, 269.

78. Lee Yu-Hwa, 69.

79. "Ts'ui Ying-ying," trans. Arthur Waley, in *Anthology of Chinese Literature*, 292. In Chinese the story also is referred to as *"Hui-chen chi"* (*Hui-zhen ji*).

80. An interesting discussion of the debates aroused by this work over the centuries can be found in Lee Yu-Hwa, "Expository Notes on "Hui-chen chi," *Fantasy and Realism in Chinese Fiction: T'ang Love Themes in Contrast* (San Francisco: Chinese Materials Center Publications, 1984).

81. For a discussion of such women through the centuries, and a selection of their Daoist texts, see Thomas Cleary, trans., *Immortal Sisters: Secrets of Taoist Women* (Boston: Shambhala, 1989). Doubtlessly due to their being free of male domination and control, both Buddhist nuns and Daoist women practitioners fell under suspicion for corrupting married women; see Van Gulik, 254.

82. See Jeanne Larsen, trans., introduction to *Brocade River Poems: Selected Works of the Tang Courtesan Xue Tao* (Princeton, New Jersey: Princeton University Press, 1987), xvi–xvii.

83. Some speculate that the intended audience for these poems was Yuan Zhen. See Larsen's commentary, 97–100.

84. See Wile, 24.

85. See Lee Yu-Hwa, 13–19.

86. *Xuanhe shu pu* (*Hsüan he shu p'u*), as quoted by Larsen, xxv.

87. Lin Yutang, "Feminist Thought in Ancient China," in *Chinese Women Through Chinese Eyes* (Armonk, New York: East Gate Book, 1992), 36.

88. See Christine Helliwell, "Women in Asia: Anthropology and the Study of Women," in Grant Evans, ed., *Asia's Cultural Mosaic: An Anthropological Introduction* (New York: Prentice Hall, 1993), 279–80.

89. Van Gulik, 219.

90. Van Gulik, 224.

91. For example, in "Happy and Tipsy" ("To the tune 'A Dream Song'") we read: We got lost in the sunset,/Happy with wine,/And could not find our way back/After our pleasure was fulfilled. Included in *The Orchid Boat: Women Poets of China*, trans. and ed. Kenneth Rexroth and Ling Chung (New York: McGraw-Hill Book Company, 1972), 40.

92. In one such poem, "To the tune 'I Paint My Lips Red'," the poet describes post-coital behavior in graphic terms. See Rexroth and Ling Chung, 43. Hu Shih depicts Li Qingzhao as "one of the most striking personalities among the Chinese women of historical fame. She was always frank and never hesitated to write of her real life with all its love, joy, and sorrows." "Women's Place in History," in Li Yu-ning, ed., *Chinese Women Through Chinese Eyes* (Armonk, New York: East Gate Book, 1992), 8.

93. Lin Yutang, *The Importance of Living*, 183.

94. Van Gulik, 317. See also *Dreams of Spring: Erotic Art in China* (Amsterdam: Pepin Press, 1997), 26.

95. Clement Egerton, *The Golden Lotus: A Translation from the Chinese original, of the novel Chin P'ing Mei*, vol. I (London: Routledge & Kegan Paul, Ltd., 1957), 1.

96. See McLaren: "The Calamitous Golden Eel," "Lovers Murdered at a Rendez-vous," and "A Squabble Over a Single Cooper Cash Leads to Strange Calamities."

97. Quoted by Michel Beurdeley in Beurdeley, et al., *Chinese Erotic Art*, trans. Diana Imber (Hong Kong: Chartwell, Inc., 1969), 4.

98. One notable exception to this fawning on Neo-Confucian strictures involves opposition to the practice of footbinding in the Qing. Emperor Kangxi outlawed the practice in 1662 (a ban that could not be upheld), as did Dowager Empress Ci Xi in 1902. Various individual and groups campaigned sporadically against it. See Robin Morgan, ed. *Sisterhood is Global: The International Women's Movement Anthology* (Garden City, New York: Anchor Books, 1984), 146–47.

99. One of only three Chinese feminists recognized by Lin Yutang, along with scholar Yu Zhengxie (Yü Cheng-hsieh; 1775–1804) and rebel/poet Yuan Mei (Yüan Mei; 1716–1799). As Lin notes, each took great pains to disassociate primal Confucianism from Chinese culture's crimes against women; see "Feminist Thought in Ancient China," 38.

100. This appears as chapter 13 of the English translation, but constitutes chapters 32 through 38 in the Chinese original.

101. Li Ju-chen, *Flowers in the Mirror*, trans. Lin Tai-yi (Berkeley: University of California Press, 1965), 107.

102. The practice also is condemned in another chapter; see Lin Yutang, "Feminist Thought in Ancient China," 53.

103. Chapter 61 in the Chinese original. See Lin Yutang, "Feminist Thought in Ancient China," 56.

104. Letter to Yang Li-hu, quoted by Lin Yutang, 46.

105. Irving Yucheng Lo, "Daughters of the Muses of China," in *Views from Jade Terrace: Chinese Women Artists 1300–1912* (New York: Rizzoli, 1988), 46–47.

References

Birch, Cyril, comp., ed. 1965. *Anthology of Chinese Literature: From Early Times to the Fourteenth Century*. New York: Grove Press.

Beurdeley, Michel, Kristofer Schipper, Chang Fu-ji, and Jacques Pimpaneau. 1969. *Chinese Erotic Art*, Diana Imber trans. Hong Kong: Chartwell, Inc.

Chang, Jolan. 1977. *The Tao of Love and Sex: The Ancient Chinese Way to Ecstasy*. New York: E. P. Dutton.

Chang, K. C., ed. 1986. *Studies of Shang Archaelogy: Selected Papers from the International Conference on Shang Civilization*. New Haven: Yale University Press.

Cleary, Thomas, trans., ed. 1989. *Immortal Sisters: Secrets of Taoist Women*. Boston: Shambhala.

De Mente, Boye Lafayette. 1995. *NTC's Dictionary of China's Cultural Code Words.* Lincolnwood, IL: NTC Publishing Group.

Douglas, Nik, and Penny Slinger. 1981. *The Pillow Book: The Erotic Sentiment & the Paintings of India, Nepal, China & Japan.* New York: Destiny Books,

Dreams of Spring: Erotic Art in China. 1997. Amsterdam: Pepin Press.

Egerton, Clement. 1957. *The Golden Lotus: A Translation from the Chinese original, of the novel Chin P'ing Mei.* 4 volumes. London: Routledge & Kegan Paul, Ltd.

Eliade, Mircea. 1964. *Shamanism: Archaic Techniques of Ecstasy.* Trans. Willard R. Trask. Princeton: Princeton University Press.

Erkes, Eduard. 1935. "Der Primat des Weibes im alten China." *Sinica*, IV, 166–76.

Evans, Tom and Mary Evans. 1975. *Shunga: The Art of Love in Japan.* New York: Paddington Press, Ltd.

Fazzioli, Edoardo. 1986. *Chinese Calligraphy: From Pictograph to Ideogram: The History of 214 Essential Chinese/Japanese Characters.* New York: Abbeville Press.

Helliwell, Christine. 1993. "Women in Asia: Anthropology and the Study of Women." In Grant Evans, ed., *Asia's Cultural Mosaic: An Anthropological Introduction.* New York: Prentice Hall.

Henshall, Kenneth G. 1988. *A Guide to Remembering Japanese Characters.* Tokyo: Charles E. Tuttle Company.

Indianapolis Museum of Art. 1988. *Views from Jade Terace: Chinese Women Artists 1300–1912.* New York: Rizzoli.

Karlgren, Bernhard. 1923/1974. *Analytic Dictionary of Chinese and Sino-Japanese.* New York: Dover,.

——. 1930. "Symbols in Ancient China." *Bulletin of the Museum of Far Eastern Antiquities.*

Lee, Peter H., ed. 1993. *Sourcebook of Korean Civilization*, vol. I. New York: Columbia University Press.

Lee, Yu-Hwa. 1984. *Fantasy and Realism in Chinese Fiction: T'ang Love Themes in Contrast.* San Francisco: Chinese Materials Center Publications.

Legge, James, trans. 1970. *The Works of Mencius.* New York: Dover Publications, Inc.

Loewe, Michael and Edward L. Shaughnessy, eds. 1999. *The Cambridge History of Ancient China: From the Origins of Civilization to 221 B.C.* Cambridge: Cambridge University Press.

Li Ju-chen. *Flowers in the Mirror.* 1965. Ed., trans. Lin Tai-Yi. Berkeley: University of California Press.

Li Yu. *The Carnal Prayer Mat.* 1990. Trans. Patrick Hanan. Honolulu: University of Hawai'i Press.

Li Yü. *Jou Pu Tuan (The Prayer Mat of Flesh).* 1963. Trans. into German Franz Kuhn. Trans. into English Richard Martin. New York: Grove Press, Inc.

Li Yu-ning, ed. 1992. *Chinese Women Through Chinese Eyes.* Armonk, New York: East Gate Books.

Li Zehou. 1988. *The Path of Beauty—A Study of Chinese Aesthetics.* Beijing: Morning Glory Publications.

Lin Yutang, *The Importance of Living*. New York: John Day, 1937.

——, "Feminist Thought in Ancient China." September, 1935. *T'ien Hsia Monthly*.

Lindqvist, Cecilia. 1989, 1991. *China: Empire of Living Symbols*. Trans. Joan Tate. New York: Merloyd Lawrence.

Mayhew, Lenore, and William McNaughton, trans. 1972. *A Gold Orchid, The Love Poems of Tzu Yeh*. Rutland, Vermont: Charles E. Tuttle Company.

McLaren, Anne E. 1994. *The Chinese Femme Fatale: Stories from the Ming Period*. Canberra, Australia: Wild Peony.

Morgan, Robin, ed. 1984. *Sisterhood is Global: The International Women's Movement Anthology*. Garden City, New York: Anchor Books.

Munsterberg, Hugo. 1986. *Symbolism in Ancient Chinese Art*. New York: Hacker Books.

Neumann, Erich. 1963. *The Great Mother: An Analysis of the Archetype*. Bollingen Series XLVII. Trans. Ralph Manheim. Princeton, New Jersey: Princeton University Press.

Raphals, Lisa. 1998. *Sharing the Light: Representations of Women and Virtue in Early China*. Albany, New York: State University of New York Press.

Rawson, Philip, and Laszlo Legeza. 1973. *TAO: The Chinese Philosophy of Time and Change*. Singapore: Thames and Hudson.

Rexroth, Kenneth, and Ling Chung, trans., eds. 1972. *The Orchid Boat: Women Poets of China*. New York: McGraw-Hill Book Company.

Van Gulik, R. H. 1974. *Sexual Life in Ancient China: A Preliminary Survey of Chinese Sex and Society From ca. 1500 B.C. Till 1644 A.D.* Leiden: E. J. Brill.

Waithe, Mary Ellen. 1987. "Diotima of Mantinea." In *A History of Women Philosophers*, volume I: *Ancient Women Philosophers 600 B.C.—500 A.D.* Dordrecht: Martinus Nijhoff.

Waley, Arthur. 1956. *The Nine Songs*. London: George Allen & Unwin.

Wawrytko, Sandra A. 1993. "Homosexuality and Chinese and Japanese Religions." In *Homosexuality and World Religions*. Valley Forge, Pennsylvania: Trinity Press International. 199–230.

Whincup, Greg. trans.1987. *The Heart of Chinese Poetry*. New York: Doubleday.

Wile, Douglas. 1992. *Art of the Bedchamber: The Chinese Sexual Yoga Classics, including Women's Solo Meditation Texts*. Albany: State University of New York Press.

Wu, K. C. 1982. *The Chinese Heritage*. New York: Crown Publishers, Inc.

Wu, Qingyun. 1995. *Female Rule in Chinese and English Literary Utopias*. Syracuse, New York: Syracuse University Press,

Golden Spindles and Axes: Elite Women in the Achaemenid and Han Empires

Michael Nylan

Though historians continue to debate the reliability of the main literary sources for the great Achaemenid empire (559–331 B.C.E.), there is growing consensus about the portrayal of non-Greek (mostly Persian) aristocratic women found in those sources:[1] The women are depicted as smart, powerful agents in the political arena, aggressive defenders of their perceived family interests who were by no means confined to the harem—a portrait confirmed by our few archaeological sources for the period. Accordingly, these Achaemenid elite women, viewed by some of the ancient Greeks as threats to organized male communities,[2] are frequently celebrated as appropriate role models for strong women today.

The situation with early China is reversed, of course. Historians seldom question the reliability of our main literary sources for the Han empire (206 B.C.E.–220 C.E.)—despite passages of dubious historicity—and yet, in utter disregard of the extant sources, there persists a curious consensus about the lives of early Chinese women (borrowed, perhaps, from students of late imperial China): to wit, that Han elite women were generally untutored, weak, or vicious, alternately the victims or makers of unhappy fates. Few students of China attempt more than a dismissal of Han elite women as unhappy products of a benighted, "feudal" past.[3]

Any general consideration of elite women in antiquity is bound to essentialize complex experiences shaped by social class, occupation, age, region, era, individual personality, and family situation. In addition, our sources for the period are so wildly inadequate that it is hard to separate the typical from the unusual. Women, after all, are seldom the protagonists of early accounts, and even where they assume center stage, they make their appearances only to reveal what elite men thought women of their period were like. As a result, modern historians—even in the age of scientific archaeology—know far too little of what the women of antiquity were really like. Thus, astute readers may reasonably object that this paper cannot possibly capture the texture of real life passed in real time and space.[4] Let me assure you, it will not try to. This paper

takes two related subjects (early historians' perceptions of women and modern historians' perceptions of classical perceptions) as its main subject, believing that perceptions of reality in themselves constitute a powerful aspect of reality affecting the behavior and condition of individual women. The juxtaposition of stories told about elite women in two great empires, Achaemenid Persia and in Han China, should help to illustrate the kinds of cultural baggage that we Chinese historians bring to our reading of texts, for the historian is never merely a fact-gatherer; she is always an interpreter.

This particular attempt at interpretation begins with two famous narratives drawn from Herodotus and Ctesias, supplemented by supporting narratives: the first concerns Atossa, daughter of Cyrus and wife to Darius; the second, Artemisia, queen of Halicarnassus. Some have portrayed Atossa as the "bad queen," and Artemisia as the "good," but as I hope to show you, the early Greek historians offer a more complicated picture.[5] In the first narrative, Queen Atossa, daughter of Cyrus, the former king, and wife to Darius, the successful usurper, develops a disfiguring abscess on her breast. At first shame induces Atossa to conceal the problem, but as the infection spreads rapidly, Atossa comes to have reason to fear for her very life. At that point, she calls in the court physician, the Greek Democedes, who is famed for his healing arts. Democedes agrees to cure Atossa on one condition: Atossa must swear to repay him by acceding to any request that Democedes will make, barring a request for sexual favors. Atossa readily accepts the doctor's terms and so Democedes affects a speedy cure. Immediately afterwards, Democedes demands that Atossa persuade Darius to go to war with Greece. As Democedes figures it, he has been kept under virtual house arrest at the Persian court, forbidden to return home lest Darius be deprived of his best court physician. Democedes thinks that if he can get the Persian king to start a war with Greece, Darius will be forced to employ Democedes as scout in Greece. Then, with a combination of luck and ingenuity, Democedes will be able to effect his escape and make his way home.

The scene straightway switches to the bedroom of Darius and Atossa, where Atossa makes the following speech:

> My lord, with the immense resources at your command, the fact that you are embarking on no further conquests to increase the power of Persia must mean that you lack all ambition. Surely a young man like you . . . should be seen engaged in some active enterprise, to show the Persians that they have a man to rule over them. Indeed, there are two reasons to end this inactivity of yours: First, the Persians will know their leader to be a man, and second, making war will . . . leave them no leisure to plot against you. Now is the time to act, while you are still young.

Atossa's speech is well calculated to rouse Darius to action. Ostensibly chiding him, it is sure to flatter him to the core. At the same time, the speech cautions

the crafty usurper that there are always many others equally devious working behind the scenes to usurp Darius's newly-gotten throne. Darius playfully protests that he already has in mind a plan to conquer all of Europe: he will start by attacking the Scythians to the north. "Forget the Scythians for now," Atossa says. "What I want you to do is invade Greece. I have heard talk of the women there, and I should like to have Spartan girls, and girls from Argos and Attica and Corinth to wait upon me." Darius readily agrees, for one place is as good as another to embark upon world domination. As expected, he then sends Democedes back to Greece as scout for his invading army. Once there, Democedes makes good his escape—at least for awhile.[6]

What are we to make of Atossa, often viewed as the archetypal "bad queen"? I suggest that Atossa is powerful, to be sure, but that she can hardly be accused of being an "evil genius" behind the throne.[7] The deed of which she commonly stands accused (casually starting a war) must be read in quite another light: Atossa keeps the promise exacted from her and by doing so, she upholds Persian morality, which strictly enjoined promise-keeping, especially in members of the royal family.[8] At worst, Atossa can be blamed, in the words of one historian, of the "creative manipulation of the constraints of the situation"[9]—of superb strategizing. Obviously, she is sharp-brained and able-tongued, but it is really Darius's ambitions and Democedes's resentment—not Atossa's desire for exotic serving girls (who can always, in any case, be purchased on the open market)— that hurls Persia into war against Greece, just as later, it is Mardonius's ambitions that will keep Persia in the war.

On considered reflection, it is the men who start the war and in so doing act most irrationally, for what can Persia with its fabulous wealth have thought to gain from "robbing Greece of its poverty"?[10] And why would a Greek be willing to risk the ruination of his beloved home, so long as he can make his way home? In any case, the Atossa story must strike the cool reader as improbable fiction, a romance rather than a careful marshalling of evidence. Herodotus himself remarks repeatedly of such accounts that he "merely records the current story, without guaranteeing the truth of it" and, even more clearly, "My business is to record what people say, but I am by no means bound to believe it—and that may be taken to apply to this book as a whole."[11] This is what people claim to have happened, not necessarily what happened.

As the war proceeds, the Greek world divides itself into Persian allies and Persian foes. The most memorable of the Persian allies is Artemisia, queen of Halicarnassus: Artemisia came to power at the death of her husband, when she took over the tyranny. During the war, she commands her city's fleet "in spite of the fact that she has a grown-up son, when consequently there was no necessity for her to do so."[12] (Note the assumption that it would not have been surprising for her to lead a fleet if her son were not grown-up.) She leads her own five ships of war, ships that were the most famous in the fleet "after Sidon"; she also commands male troops from four other regions. In battle, as Herodotus

remarks, she displays a memorable "spirit of adventure and manly courage (*andreia*)."[13] But her greatest contribution to the war effort is the advice she tenders Darius's successor, Xerxes, on a range of military and political matters. As Herodotus tells it, "Not one of the confederate commanders gave Xerxes sounder advice than she did." Artemisia is, in truth, the only advisor to Xerxes brave enough to cut through the cant to tell it like it is. In one war council she advises Xerxes, for example,

> Spare your ships and do not fight at sea, for the Greeks are as far superior to your men in naval matters as men are to women. In any case, what pressing need have you to risk further actions at sea? Have you not taken Athens, the main objective of the war? Is not the rest of Greece in your power? . . . The Greeks will not be able to hold out against you for long. . . . If, on the other hand, you rush into a naval action, my fear is that the defeat of your fleet may involve the army, too.[14]

Xerxes, much as he admires Artemisia's logic, fails to heed her advice. Of course, the Persians before long suffer disastrous defeat at the naval battle of Salamis. Xerxes, badly shaken, cannot decide whether he should continue to engage the Greeks or retreat to safety. The different Persian commanders, blinded by their own ambitions, urge Xerxes to continue fighting. Only Artemisia, absolutely loyal to the Persian king's best interests, sizes the situation up with brutal clarity:

> You yourself should quit this country and leave Mardonius [cousin to the king] behind with a force. . . . If his design prospers and success attends his arms, it will be *your* work, master, for your slaves will have performed it. And even if things go wrong with him, it will be no great matter, so long as you yourself are safe and no danger threatens anything in connection with your house. While you and yours survive, the Greeks will have to run many a painful race for their lives and land, but who cares if Mardonius comes to grief? He is only your slave, and the Greeks will have but a poor triumph if they kill him.[15]

Artemisia has cautioned her ruler twice, knowing that Persian ambitions have overreached themselves. When her king continues to ignore her advice, she is content to leave him to his own devices. Therefore, at the first suitable occasion (Xerxes's request to have her escort his bastards to Ephesus), Artemisia leaves the war arena, never to return. In a curious sense, this "marvel" of a woman, who has exhibited extraordinary valour throughout the long years of the war, leaves no trace behind. Her remarkable departure from the scene cannot help but lead the reader to a related observation: that no deed of Artemisia's in any way alters the negative stereotypes of women held by Athenians and Persians alike. When Artemisia appears in the *Histories*, we are told that the Athenians particularly resented it that a women should take up arms against them.[16] Twice the Persians taunt their enemies by calling them women.[17] And

near the end of war, we learn that "to call a man 'worse than a woman' is the greatest insult one can offer a Persian, since fearlessness is considered their greatest good."[18]

Let me summarize what we know so far. (1) The main sources for the Achaemenid empire may well not be all that reliable. (2) Nonetheless, if we trust those sources at all, the elite women of the Achaemenid empire must be viewed as resourceful agents, often reflecting the best of their culture's values. At the very least, the woman appear in their role as counsellors to kings to be every bit as powerful—and as sensible to power's use—as their male counterparts; indeed, there is a kind of male/female symmetry in the *Histories*, coupling Atossa and Mardonius, Artemisia and Themistocles.[19] Clearly, Herodotus accepts the notion that women are capable of advising kings and commanding warriors. If we were in any doubt about this, corroboration could be found in many other early passages: literary references to the Scythian women who run their own society for twenty-eight years while the men are off doing battle; to the Sauromataean Amazons, who manage complex inter-cultural negotiations with considerable success; and to the Issedones, a tribe to the northeast of Scythia, where men and women share equal authority and a "sound sense of justice."[20] (3) The foregoing analysis, based entirely on early literary sources, tallies with recent archaeological evidence, which bears mute testimony to Persian elite women as estate owners, leaders of immense labor forces, and major economic agents, who were by no means condemned to live out their days within enclosed harem precincts.[21] In a sense, the Achaemenid royal women are inheritors of a grand tradition of women commanders embodied in two Babylonian queens who used "every possible [licit] measure to increase [their own] security."[22] (4) Still, whether their influence was formal or informal, reserved for public council or private bedroom, Achaemenid royal women as a generic category remain objects of scorn; either they are protrayed as weak characters lacking in bravery or they serve to focus male unease. (For evidence of the male unease, I refer the reader to Astyages's dreams of his daughter's conquest over Asia, also to the women phantoms that appear in battle warning strangers to depart.)[23] (5) And the few royal women (Pheretima of Egypt; Queens Atossa and Amestris of Persia) who cannot be made to fit within prevailing stereotypes were later "assimilated with violent and vengeful queens of Attic tragedy."[24]

I have raced through this material because several nuanced studies describe the royal women of the Achaemenid empire. The situation for Han China is hardly comparable. Typically, extant studies devoted to Han women trot out two tired clichés: first, that Han women, according to the ritual prescriptions, were bound by *san-kang* (three ties) to obey their fathers until marriage, their husbands while the husbands live, and their sons when widowed; and second, that women as *yin* to male *yang* must have been weak (and so untutored in a text-centered civilization), docile, and submissive.[25] Taking these limited

prescriptions for women—prescriptions that were themselves the subject to debate—as accurate and complete *descriptions* of women, it seems that few historians have bothered to carefully assess the literary material included in the official histories.[26] For the historical record for Han times, meager though it is, stands in complete contradiction to the ideal woman of ritual canons (as does the spotty archaeological record).[27] If the extant historical records, which Sinologists so rarely mistrust, have any accuracy at all (and there is good reason, as with the Achaemenid sources, to suspect that they liberally mix fiction with fact),[28] then Han elite women tended to be strong-willed, well educated, and physically courageous. More importantly, they were specifically lauded for these qualities by the official histories composed by elite men. That women—especially elite women—must be strong, educated, and brave only makes sense when we consider that many of our main sources for the period[29] begin with the startling premise—startling, at least for later imperial China—that the relation of man to wife (conceived as mutual, even "equal" helpmeets) is more important (because it is even more basic?) than that of ruler-minister or father-son. This is not to deny that there were contemporary debates over the "proper place" of women in elite society, as the Han sources can attest; it is rather to suggest that in such debates the elites—including many committed Confucians—confirmed the value of women.[30] Why, then, do most contemporary historians prefer to bow to relatively modern prejudices—about China as "Orient," about early China, and about women's nature—by repeating *ad nauseam* tales of the supposedly "violent and vengeful" or licentious queens (notably, Dowager Empress Lü and Chao Fei-yen). In failing to provide the proper context for those tales, the historians may have helped to perpetuate the notion—pleasing to some—that women are entities in which both nature and nurture have failed, but they do not seem to have appreciably advanced our understanding of Han views of elite women.

If we are to prove that strong-willed behavior in defiance of males could be considered appropriate for females, we need only to look at the case of Lady Pan, companion to Ch'eng ti, who refused to ride in a carriage with him one day when he was out relaxing in the back courtyard. Lady Pan's refusal was principled (and, for our purposes, an admirable "proof" of the capacity of visual and literary culture to reinforce societal norms). Lady Pan admonished the emperor in these words, they say:

> I have seen the old paintings. The worthy sage-rulers all have famous ministers at their sides, while those to the end of the dynastic cycle have women [by their sides]. Now you want me to ride in the same carriage [with you]. Will it then be possible [for you] to not be like them [the debauched kings of former times]?[31]

After such a pointed rebuke, the emperor did not continue to insist upon the pleasures of Lady Pan's companionship. And some time later, in 13 B.C.E.,

the emperor ceased altogether to "favor" Lady Pan with his presence. (One wonders if her stern moralizing had irritated the libertine.) In any case, with the loss of imperial favour, Lady Pan and her ally, Empress Hsü, became easy targets for their enemies at court, chiefly Chao Fei-yen, a back-palace beauty determined to supplant Empress Hsü on the throne. Chao Fei-yen formally accused Lady Pan and Empress Hsü of using black magic to curse the Han emperor. Empress Hsü was promptly dethroned, and then it was Lady Pan's turn to face the court interrogators. Imagine the scene: The court interrogators have come equipped for the session with instruments of torture. With the same tart tongue, Lady Pan stands up to her examiners. When asked if she has prayed to evil spirits to harm the emperor, she replies with more than a hint of disdain in her voice:

> [The *Analects* of Confucius tell us that] "Life and death are fated; wealth and honour lies in Heaven." If I was not particularly blessed when I did good, what could I hope for from doing ill? Moreover, if it is the case that ghosts and spirits have conscious understanding, they would never accept insubordinate complaints [from disloyal petitioners]. And if the spirits have no powers of comprehension, of what possible use would any such 'prayers' be? Therefore, [it should be obvious, even to you, that] I did not do the deed.[32]

It must have taken a woman of considerable physical and moral centeredness to refuse the emperor's apparently innocent suggestion, and then to rebuke the court interrogators. It is all the more interesting, then, that this same Lady Pan is the author of a little treatise of three *p'ien* on the virtues of "modest and retiring womanhood." Chastising the emperor in practice versus yielding to her lord in theory is simple enough to explain in terms of "Confucian" morality: All humans, men as well as women, were ideally to defer to the wishes of their superiors, until such time as the superiors abused the powers associated with their rank. At that time, subordinates were to protest, mildly if possible, strongly if need be, lest their superiors destroy themselves and others through their mistakes.[33] We are liable to put the pieces of the puzzle together wrongly if we focus entirely on Lady Pan's little treatise, for Lady Pan is also the author of a famous *fu* raging against her ill-treatment.[34] That she upheld the virtues of uncomplaining womanhood in one kind of literary effort while penning a clear rebuke in another is hardly to be wondered at: so did her male counterparts trained in the Classics (Chia Yi, Yang Hsiung, and others). It is perhaps only twentieth-century Americans who are so naive as to expect that heartfelt expressions of innermost emotional truths will appear in every scrap of polished writing.

In recounting their stories, the Han official histories supply a wealth of anecdotes where pampered palace women raised lethal weapons, not just weaving spindles, to preserve their way of life. Physical courage is one attribute of

the ideal classical woman. Perhaps the most remarkable account is that of Lady Feng, who bore a son to Yüan ti. On one occasion, Lady Feng, in company with all the other members of the palace, was watching a tiger fight, when one tiger clawed its way out of the pit and into the spectators' stands. All those in attendance upon the emperor, including Lady Fu (then the emperor's favorite companion), fled in terror, except for Lady Feng. Lady Feng threw herself straight into the path of the tiger, so as to protect the emperor. Somehow she survived. When the emperor questioned her about her action, she explained quietly that it was her duty to protect him. But her bravery (which put the emperor's favorite to shame) incited the enmity of forces within the palace that eventually proved to be her undoing. Despite a later court verdict convicting Lady Feng of treason, literature and paintings alike, dwelling on her bravery, continued to uphold Lady Feng as a model for all elite women.[35]

Turning to education, everyone knows that Pan Chao, niece to Lady Pan and tutor to Dowager Empress Teng, was an accomplished astronomer, mathematician, historian, and classical scholar; also, a tireless advocate of women's education.[36] But numerous other examples exist for elite women's education in early China: The *Han shu* says of Empress Hsü (consort to Ch'eng ti), "she was quick and smart; she was good at history and at writing." The *Hou Han shu* tells us that Ming ti regularly consulted his Empress Ma about the complex charges and counter-charges arising in connection with the treason trial of King Ying of Ch'u in 69 C.E., knowing that she alone with her level head and fine classical training "would be able to figure out the truth" of the matter. "Night and day, she and the emperor would discuss government affairs." And then there was Empress Teng, consort to Ho ti. So intent upon her classical studies was she that after her appointment as empress, the nature of palace tribute abruptly changed: "Whereas in past times, the commanderies had always at harvest time sent in precious jewels for the empress, after Empress Teng's accession, they only sent in paper and ink [in tribute to her vast erudition]." Empress Teng preferred the most difficult texts, and so superior was her classical learning that she, in company with a hand picked group of more than fifty men (including some court academicians) supervised the proper collation of books in the Tung-kuan imperial library. Stories told of elite women outside the palace circles only reiterate this picture of exemplary women as educated advisors to educated men. As masters of *wen* ("pattern"), such women claimed their places at the very apex of high culture; their literary and scholastic encounters with cultivated men transcended the confines of the inner apartments.[37] One story depicts a saucy girl engaging in disputation with her future husband on her betrothal night; a second, a wife's noteworthy skill in drawing up formal administrative documents on behalf of her husband–official.[38]

The histories inform us that what was expected of royal women was "ritual and mutual support," not weakness in mind, body, or spirit.[39] One biography describes an ideal candidate for the rank of empress as smart, perspicacious,

careful, uninclined to arrogance, and ready to confess her faults.[40] Royal women are applauded for their powers of reasoning and self-possession,[41] qualities needed in the political, moral, and religious realms. There was also considerable tolerance for elite women of talent uninterested in "women's work." Take the case of Empress Teng Sui, part of whose biography reads:

> When the [future] empress was 6 years old, [her grandfather] Teng Yü doted on her, so he took it upon himself to cut her hair. Now, as he was aged and his eyesight was blurred, Teng Yü once happened to hurt her with the scissors, but she bore the pain without saying anything [because she didn't want to hurt her grandfather's feelings]. . . . At the age of seven, she could handle history texts; at thirteen, the *Odes* and the *Analects*. Whenever her elder brothers read the classics and commentaries, she would immediately express her ideas and pose difficult questions. So great was her commitment to books that she did not inquire of housekeeping matters. Her mother regularly berated her for not doing "women's work" (i.e., sewing) . . . and only concentrating on her studies. "Do you intend to be selected as court Academician?" her mother would ask [sarcastically]. [After that, Teng Sui] by day attended to domestic matters and only chanted her books at night.[42]

In 92 C.E., Teng Sui was on the point of entering the palace when her father died. She went into such deep mourning that many of her own relatives didn't know her when it was over. During this period of seclusion, she had a curious dream wherein she touched the sky and, finding it milky, proceeded to ingest it. A dream interpreter said that only sage–kings like Yao and T'ang had dreamt of taking in the empyrean heights. In 95 C.E., she did, in fact, enter the palace, where her beauty "set her completely apart from ordinary women."[43] Within six years, at the age of 22 *sui* (21 in our reckoning), Teng Sui had risen to the rank of empress, though her own elevation required the dramatic deposal of the previous empress.

Lest someone object that Teng Sui was a "marvel" unparalleled in early Chinese history, we have other cases where the demands of "women's work" by no means precluded an avid interest in what we regard as paradigmatic "men's work" (i.e., classical learning and political life). Take the case of Liang Na, consort to Shun ti, for example. Na excelled at "women's work" (sewing, embroidery) when she was little, but she also liked to read history. At the age of 9 *sui*, she could recite the *Analects* and commentaries to the *Odes*, then explain their main philosophical concepts. Liang Na always insisted that the portraits of exemplary women be placed around her, so that she would remember to emulate them. Her father, the high official Liang Shang, thought it odd that none of his many male relatives "could match this little girl." And while political life is considered, especially by modern historians, as the male prerogative par excellence, several biographies demonstrate the considerable

skill that many empresses brought to the political arena.[44] Indeed, Empress Dowager Teng was so adept at wielding power from behind the throne that she remained "attending court" (i.e., acting as regent) long after the emperor, An ti, was legally old enough to assume power for himself; An ti took over from her only at her death, when he was already 27 *sui*.

The official records about *lieh nu chuan* (exemplary women) in the dynastic histories—all of whom, so far as we can tell, were members of the gentry— yield much the same picture of elite women:[45] that they were resourceful, deter- mined, loyal, and willing to sacrifice for their families.[46] Frequently, the women as daughters, wives, or mothers had to strengthen the resolve of their menfolk to do good, reminding them of basic moral values.[47] In the stories of exem- plary females, at least, it is the men who often play the villains, when they are not inept, immoral, or immature.[48] And when the men are absent for any rea- son (as they frequently are), it is the women who must run the household, keep the accounts, offer ancestral sacrifices, and manage the family property.[49] And as with exemplary male heads of households, the exemplary women's physical courage—the outward visible sign of their single-minded determina- tion—repeatedly and reliably appears in times of crisis (death, rape or attempted rape, famine), after which it is consistently rewarded by society, not denounced as unfeminine. Some of the Han stories, it is true, fit well enough with our preconceptions of the soft Asian woman, as when the woman Ch'eng Wen- chü reforms her hateful stepsons entirely through her persistent, but quiet devotion to their wellbeing.[50] But many stubbornly refuse to conform to our own stereotypes: There is the bloody revenge exacted by Hsü Sheng's wife and Ch'ung Yü's mother and the self-sacrifice of Filial Daughter Shu Hsien- hsiung, who abandons her two (orphaned?) children to seek her father's drowned corpse in the netherworld. I am forced to conclude, then, that exem- plary elite women in Han (whether in palace or gentry settings) were known for their strong wills, for their educational attainments, and for their physical courage.

It seems that Han official views of elite women were generally more favor- able than those of later times, but in this comparatively new field of women's studies such a sweeping generalization cannot really be confirmed. For the moment, let me merely note two pieces of evidence that support my supposi- tion. First, consider the contrasting accounts of Lady Ts'ai Wen-chi in Han and in late imperial China. The Han accounts praise Lady Wen-chi, portraying her as a loving wife and mother, a brilliant classicist, a talented musician, and a skilled rhetorician capable of standing up to General Ts'ao Ts'ao, then the strong- man of China—in short, an exemplary woman, though she had been thrice married (without ever once contemplating suicide). Later accounts, however, focus on Lady Wen-chi's victimization, rather than her survival skills; they dwell neither on her guts nor her smarts and her multiple marriages are an obvious embarrassment.[51] Moreover, when later independent-minded scholars

such as Chang Hsüeh-ch'eng (1738–1801 C.E.) reviewed the extant records on women in elite China, they themselves were struck with the enormous gap between the customs and values of late imperial China and those of antiquity.

Lest I be accused of misrepresenting my sources in a naive attempt to exalt women's lot in Han and denounce it in later imperial China, I had better return to the notorious cases of "violent and vengeful" Han palace women, suggesting a context for them as I did with Atossa. I will take the worst reported case of violence that I can find, that of Empress Lü (who was empress, dowager empress, and then ruler in her own right). Empress Lü and her natal family members contributed greatly to the war efforts of the founder of the Han dynasty, Kao tsu, the High Ancestor. Had it not been for them, the histories suggest, Kao tsu might well have lost the struggle for unification. Soon after Kao tsu's accession, Empress Lü, now in middle age, heard that her husband was on the point of demoting her son from the rank of heir apparent, and replacing him with the son of her fair rival in love, the young Lady Ch'i.[52] Lady Ch'i and her son did nothing to assuage Empress Lü's fears at this time; instead, they flamed them by taunting her with signs of Kao tsu's affection for them. However, fate intervenes: Quite unexpectedly, Kao tsu dies before appointing the new heir. The new Dowager Empress moves swiftly to have Lady Ch'i's hands and feet cut off, her eyes gouged out, and her ears burnt off. Next she gives Lady Ch'i medicine to make her mute. Finally, she has Lady Ch'i placed in a pigsty, where she is treated like a "human pig." It is said that when Emperor Hui, Dowager Empress Lü's son, was confronted with his mother's cruelty towards Lady Ch'i, he found it so repugnant that he never again could properly attend to affairs of state. At least four other murders and one deposal of a child emperor are attributed to Dowager Empress Lü. Supposedly, Dowager Empress Lü spared only those women and children of Kao tsu whom Kao tsu himself had neglected.[53] Such statements, no doubt, reflect the juridical indictments drawn up against every member of Dowager Empress Lü's clan after her death. The Lü clan as a result of those indictments was exterminated in due time.

The tales told about Dowager Empress Lü bear looking into. I will not try to defend her innocence, though the reports of her cruelty may well be exaggerated. Assuming for the moment that the reports are true, I prefer to establish a context for violent acts by elite women in the Han palaces, whether they took the form of preemptive strikes or revenge after the fact. Let me begin with the simple observation that the dynastic histories record no acts of random violence in the back palaces. Though violence was deliberate and vengeance could be swift, I suggest that such violence was virtually brought on by the very same set of canonical texts that enjoined women to be docile and submissive to their lords' every wish. For the Confucian Classics contained the formula, "The mother is to be honored on account of her son," an innocuous enough sounding phrase that, if acted upon, insured the reigning queen's automatic

deposal following the selection of a new heir. As a result of that one formula, any woman currently in power in the palace would have experienced any incremental diminution in imperial favour (either through a failure to produce a son and heir or through the rise of a brand-new favorite) as a triple threat: she herself would lose power, as would her son and natal relatives. The stakes could not be higher, in other words, and the so-called "Confucian" Classics offered astonishingly little guidance to someone facing this dilemma. In fact, the Classics cite two sets of contradictory prescriptions: They say that the heir should be the eldest son of the emperor, that he should be the eldest son of the highest-ranking lady in the court, and that he should be the first son born after the emperor's accession. Then, too, they include anecdotes suggesting that an exemplary married woman's first loyalty should be to her natal house, while advising the woman to make her first priority loyalty to the clan into which she had married.[54] (Even with the latter prescription, it was unclear whether the moral woman should look after her husband's or her son's interests first.) Given this clash of canonical prescriptions (a reminder of the cacophony of competing values in Han society at large), even tradition-minded women with sufficient resources could wrest remarkable autonomy from their confused situations, justifying public and private acts of violence as needed "protection" for their kith and kin. Add to this the three particulars that (a) Lady Ch'i and her son had violated all standards of decency when they had publicly humiliated Empress Lü and her weak-willed son, scoffing at their own powerlessness; (b) Empress Lü greatly feared retaliation against her relatives, as well she should have; and (c) that the "Confucian" Classics and societal mores alike approved revenge,[55] and we have all the makings of an explosive situation. Empress Lü acts swiftly upon Kao tsu's death to wreak her vengeance upon Lady Ch'i, not only to humiliate her ex-rival in love, but also to advertise her intention to ruthlessly suppress anyone, no matter how powerful, who dares to threaten the position of herself, her son, or her natal family. The advertisement works. As long as she lives, all are safe. Even after her death, some ministers and members of the Liu royal clan hesitate to move against her. And it is nearly a century before members of the Han ruling house dared to refuse to include offerings to her spirit in the regular sacrifices conducted at Kao tsu's ancestral shrine.[56]

 Once again, as with the case of Persia, we would do wrong to apply anachronistic or inapplicable standards (for example, "turn the other cheek") to situations where no such standards were expected. Once again, as with the case of Persia, when we examine the cases of royal women in Han, we find a symmetry between male and female powerholders, with members of each group acting strategically to further its own perceived interests. Although questions of morality versus immorality are scarcely irrelevant, the Han historians seem more willing than we to tie individual misbehavior by palace women to inherent flaws in the Han power structure, since they show that when palace women

acted ruthlessly, they did so either because they had no strong male relatives to protect them or because they were loyal to the longer-lasting ties they had forged with natal relatives or sons, at the expense of their husbands.

As projects sponsored by the royal house, the dynastic histories naturally favored the rights of royal husbands over sons or natal families, but they do not pretend that similar tensions did not exist outside the heady atmosphere of the palace. There is the case of Chou Yu's wife, for example, who was educated and well-behaved. Unfortunately, her husband was a reprobate. So when her father-in-law told her to remonstrate with the n'er-do-well husband, Chou Yu's wife replied, quite sensibly, that she felt damned if she did and damned if she didn't. For if her husband appeared to listen to her, when he had cheerfully ignored his own father, her own position in the household would be endangered. At the same time, she knew that her husband's continuing debauchery threatened the stability of the entire family into which she had married. Eventually, caught between conflicting duties, Chou Yu's wife committed suicide. "Nobody blamed her," we are told. Far from it, she became an officially designated exemplary women. If we can apply arguments drawn from the Persian histories to the case of early China, we discover Han elite women not so much ignoring the ritual prescriptions as regarding them as one possible factor to be considered in complex calculations about suitable action.[57] The Han historians, for their part, express far greater interest in recording strategies for effective action as they correlate with specific social roles (few of which were gendered by convention) than in acceding to our modern preoccupation with male/female polarities.[58]

Having broached this tricky issue of our sources for early China, I would like to say that while the Chinese dynastic histories may be our best sources for elite women, that simply means that they are very nearly our only sources. Judging from their contents, the Han biographies for our two groups of elite women (the palace women and the gentry women) must have been based largely on two kinds of literary sources, each inherently biased: (1) the legal plaints for various trials involving court women accused of murder or peculation or black magic; and (2) the eulogies commissioned or prepared by regional and national elites for their women, which often became the basis for stele inscriptions and public memorials. (Note that in early China, in contrast to Pericles's Athens, it was not incumbent on the "good woman" and her family to keep her name off everybody's lips; rather it was incumbent upon them instead to publicize her virtues. Surely that is significant.)[59] Aside from these two sources, the lives of elite woman (especially those in the palace) was probably a virtual blank to court historians, except in cases when the dowager empresses acted as regents. That the official historians have constructed plausible historical romances from available evidence becomes entirely clear when we examine the official dynastic histories closely, for the histories not only record secret conversations and secret deeds in full. They also employ women to act

as deae ex machina to move the plot along, to catalyze powerful opposing factions at court,[60] and to heighten the impact of the dramatic narrative, removing the stories from anecdotal status to universal tales of power's use and abuse. That the official records did not always present truthful records of events—that the dynastic histories themselves readily admit, as when, for example, Ts'ao Ts'ao has false accusations about Empress Fu (consort to Hsien ti) entered into the official accounts.[61]

If the individual biographies of elite women have been molded by the larger historiographical aims of the dynastic historians (including the absolute necessity to impose a dynastic cycle on the material), I suggest that they are nonetheless good guides to the general views of elite Han males towards women, *when used with even elementary caution*. The problem is, they are not often used with such caution. As we have seen, modern readers, looking at passages on female virtue in isolation, have generally failed to notice that canonical prescriptions for the ideal female would have powerful males cultivate the exact same virtues of docility and submission as females.[62] Also, later readers, untutored in the full range of Han rhetorical styles, all too often mistake polite formulae in conventional discourse for literal truth.[63]

Still, when we avoid the most obvious mistakes in reading about elite women, we allow our classical Chinese texts to talk with almost stunning clarity of the power for good and evil that women bring to politics, as well as to the domestic scene. The *Han shu* describes the good influence of mothers and wives of founders of the empire, no less than the evil influence of vixens like Hsi Shih and Pao Ssu. The *Hou Han shu* is still more precise in extolling good women, insisting that three types of women share star billing in the moral-political arena with the "noble *shih* who improves local mores" (i.e., the best kind of public servant): (1) the worthy consort who aids in state administration; (2) the wise wife who improves the family fortunes; and (3) the chaste or principled wife—the adjective can mean either—who remains loyal to her family members in crisis.[64] Virtue for women, the history continues, does not "necessarily rest in one principle [such as chastity] alone"; talent, resourcefulness, adaptability, and determination are required for the truly noble conduct meriting commemoration, just as in the case of males. The dynastic histories, in other words, exhibit no gendered impulse "to talk better about women (for ill)" by making "them into a *genos*," a separate race or tribe outside of normal humanity.[65] Certainly, this is not because the official accounts gloss over Han debates concerning the degree of freedom and relative worth to be accorded wives. They detail, for instance, the rising rhetorical tide against the remarriage of widows. But they also reveal the yawning gap between rhetoric and life, for the very "Confucianized" elites we would expect to favor widow chastity (as they had no pressing financial need to remarry daughters) were not at all averse to roundly rejecting trumped-up calls for "traditional family values."[66]

I would also complement the Han dynastic histories for the acute insight which they display with respect to negative (male) stereotypes about women. The sources explicitly state four reasons why Han elite men sometimes viewed Han elite women with suspicion: (1) The case of a loving husband and wife who cannot bear a child brings uncomfortably to home the inexplicable power of fate.[67] (2) Palace women in particular are prime symbols of senseless random change, since a single chance encounter could make or break the fortunes of entire families; "that is why they are feared."[68] (3) Romance is apt to undermine the strict hierarchies enjoined by patrilineal structures: "One glance can overturn a city; two glances, a state."[69] And (4) Women, like barbarians at the gate (with whom they are often coupled in the popular imagination), are often virtual "strangers" to their husband's families; naturally enough, in moments of crisis, they may refuse to put the fortunes of their husband's family before those of their natal family.[70]

I hope I have demonstrated to the skeptics that the extant "histories" for the Achaemenid and Han empires are somewhat more than romantic fictions that can tell us nothing about the true condition of elite women in antiquity.[71] I hope also to have quietly scored a second, more subtle point, for it is not the skeptics I fear most, but the ahistorical historians: those who presume linear models of cultural continuity between ancient and modern times, based on highly ideological meta-narratives about the contemporary "survival" of ancient Chinese practices in Chinese society today.[72] To my mind, every act of cultural replication over time requires incredible maneuvers, often to reposition older cultural elements for new ends. It is that process to which we should direct our attention, rather than taking cultural replication as self-evident and unproblematic. As an avid student of comparative history, let me quote one scholar of ancient Persia on this issue:

> The judgment of modern scholars resembles very much that of ancient historiographers, except that, as time passes, the scale of prejudice widens until the contrast between Greek and Persian cultures is seen as that between the (androcentric) Western World and the (gynocentric) Orient.[73]

In the case of China, the foregoing statement would have to be slightly modified: Our stereotypes of ancient China do not come so much from the ancient historiographers as from relatively recent sources, the Neo-Confucians and the May Fourth reformers, both of whom (for different reasons) preferred to assume the existence of rigid gender roles among cultured elites in antiquity, as well as the continuity of ultra-stable traditional Chinese culture. From their misapprehensions, we derive a backward Orient singularly oppressive towards women, contrasted with our forward-looking West promoting notions of progress, equality, and modernity. But once we begin to examine these invidious

assumptions of the field, it is easy to see that much work remains to be done if we are ever to restore Han elite women to their rightful place in history, let alone address the much larger question of whether androcentrism in the classical world was, as one historian of Greece put it, "both an unquestioned truth and a universal fib."[74]

Notes

1. For Ctesias, see Felix Jacoby, 1922; M.F. Braun, 1938; Truesdell Brown, 1973, 77–86; Heleen Sancisi-Weerdenburg, 1987; K. Karttunen, 1997; and Joan Bigwood, 1978. For the rhetorical purposes of the Greek sources on Persia, consult P. Briant, 1989; Marie Brosius, 1996; R.B. Stevenson, 1987; and Mary Boatwright, 1991, especially p. 258.

2. Gould, 1980, 57; Nicole Loraux, 1978. For the strict division of labor by sex advocated in classical Athens, see Xenophon's *Oeconomicus*, a treatise on household management, VII.17ff.

3. Note that I use "feudal" here to refer to the pre-capitalist stage of historical development.

4. Consider one assessment made of Han: "Every hundred *li* there were different habits; every thousand *li* there were different customs. Households had different governments; people wore distinguishing clothes." See Pan Ku, *Han shu* (Beijing: Chunghua, 1970), hereafter HS, 72:3063.

5. Three queens (Atossa, Amestris, and Parysatis) are described as powerful (mostly evil) influences on the Persian kings. Women tend to be mentioned in memorable narratives for one of three reasons: (1) because their tales are particularly exciting; (2) because their tales can be made to support larger authorial agendas; and (3) because their portraits can be used to illustrate the boundary line between acceptable and unacceptable behavior, as women in most societies are required to act as cultural conservators.

6. *Herodotus* III.133ff.

7. References to Atossa's power are repeated in *Herodotus* VII.1–3; for the fictitious character of Atossa's story, see Heleen Sancisi-Weerdenburg, 1983.

8. On the Persian king's birthday, he is required to fulfill any request that is made of him. See *Herodotus* I.137 for evidence of the Persian notion of justice; see Josef Wiesehöfer, 1996, p. 82, on the king as "no friend to the man who is a lie-follower."

9. Carolyn DeWald, 1981, p. 108.

10. *Herodotus* IX.81. Much the same point is made in Aeschylus, lines 232–33.

11. Ibid. IV.195; VII.152. Cf. Thucydides's statement in section 22 of *The Peloponnesian War*: "So my method has been, while keeping as closely as possible to the general sense of the words that were actually used, to make the speakers say what, in my opinion, was called for by each situation."

12. *Herodotus* VII.99. Of this, Herodotus writes, "It seems to me a marvel that she—a woman—should have taken part in the campaign against Greece."

13. The Persian king Xerxes pays her the supreme compliment, when he remarks of her courage, "My men have turned into women, my women into men." Artemisia says of herself that her "courage and achievements in the battles at Euboea were unsurpassed." See *Herodotus* VIII.68a, 88.

14. *Herodotus* VIII.68.

15. Ibid. VIII.102.

16. Ibid. VIII.93.

17. Ibid. IX.20; VIII.68a.

18. Ibid. IX.107.

19. See Carolyn Dewald, 1981; Rosaria Munson, 1988; Carolyn Brosius, 1997. Note that Pheretima of Egypt is the one woman openly charged with 'excessive' behavior, in *Herodotus* IV.205.

20. Herodotus IV.1, 27, 110–17.

21. Our main archaeological sources for the early Achaeminid period come from excavations at Persepolis, which have yielded both Elamite tablets and Aramaic inscriptions. Among the tablets are the so-called Fortification texts, many thousands of more or less complete administrative texts written between 509–494 B.C.E. These show women working in a wide range of occupations, some of which were highly paid. See also Josef Wiesehöfer, 1996, pp. 85–88; Carolyn Brosius, 1997, p. 127. R.T. Hallock, 1969, is the classic study of the Fortification tablets. For elite women in Roman Asia Minor evading relegation to the private sphere, see Mary Boatwright, 1991.

22. For Semiramis and Nitocris, see *Herodotus* I.184. The phrase is said of Nitocris, but Herodotus demonstrates the same impulse in Semiramis as well.

23. *Herodotus* I.109; VIII.84.

24. Carolyn DeWald, 1981, p. 92.

25. The *san-kang* may first have referred to a woman's financial dependence upon the *chia*. See A.R. O'Hara, 1955, p. 279. In Han, remarriage for women took place at all socioeconomic levels, as Ch'ü Tung-tsu, 1972, noted; there was even a case where a remarried woman became empress (p. 43). When Pan Chao urges chaste widowhood on her daughters, she knows that her prescription goes against contemporary mores, as HHS 114: 2792 shows. (Pan Chao's own sister-in-law Ts'ao Feng-sheng wrote a treatise refuting her.) It is not coincidental that the Pans were a military family, who emphasized absolute loyalty. In several recorded cases in Han (e.g., that of Sheng Tao), widowers also refused to remarry after their wives' deaths.

26. Pu Wei-chung, 1995, chap. 3, shows that the *san-kang* were promoted especially, if not exclusively, by followers of the Ku-liang tradition associated with the *Ch'un Ch'iu*.

27. Alison Black, 1986, shows that the cosmological conception of woman is more complicated also than is usually thought. (I am indebted to Henry Rosemont for this reference.)

28. Many of the *lieh-nü* traditions would clearly have been based on the biographies (near hagiographies) compiled by family members for eulogistic purposes (and sometimes as introductions to collected works).

29. Unfortunately, the *Shih chi* mentions women—even elite women—only in passing, with the exception of Dowager Empress Lü, who is accorded a "Basic Annals" chapter in her own right. There are the *wai-ch'i* (maternal relatives) traditions recorded in the *Han shu* and *Hou Han shu*; also, the *lieh nü* (traditions of exemplary females) recorded in the *Hou Han shu*.

30. For disagreements, see FSTY 3:22; for critiques of the Confucians for exalting the wife too much, see *Mo tzu*, chap. 39 (trans. in Watson, *Mo tzu: Basic Writings*, pp. 125–26). Note that I carefully distinguish "Confucians" (self-identified followers of Confucius) from classicists (Ju).

31. HS 97B:3983–84. Women are powerful agents for good or for ill, as shown in HS 97B:3997 and the opening remarks to HS 97A.

32. HS 97B:2984–85.

33. Aside from the ritual texts, a number of Han texts explicitly enjoin the male to be modest and yet ready to remonstrate. See, for example, Yang Hsiung's *T'ai hsüan ching* and Liu Hsiang's *Shuo yüan*. The potential abuses associated with strict hierarchy, according to Han Confucians, were to be mitigated by equally strict observance of reciprocal obligations between members of the hierarchy.

34. For the *fu*, see *Han shu* 97B:3985–87. For example, unsophisticated readers have seen Pan Chao's citation of Ode 189/7 as "proof" that Han conventions viewed women as decidedly inferior. But Kidder Smith, 1989, p. 442, astutely notes that "the *Shi* [*Odes*] texts rarely seem to have carried their original context with them when pressed into rhetorical usage."

35. For literature, see HS 97B:4005. For painting, see the famous *Admonitions* Scroll (British Museum; Palace Museum), good plates for which appear in *Three Thousand*, pp. 50–53.

36. Pan Chao is the aristocratic author of *Admonitions for Women*. The best account of her life and works remains that of Nancy Lee Swann, 1932.

37. A.R. O'Hara, 1955, p. 272, says, "These cases are of of sufficient number and variety to indicate that husbands frequently consulted their wives in both domestic matters and those of the state." For another example, see HHS 84: 2801.

38. HHS 84:2796. For a wife influencing her husband's career choices, see HHS 83:2766; HHS 84:2783. Huang-fu Kuei's second wife, famed for her literary abilities, composed administrative briefs (HHS 84: 2798). See Holmgren, 1982, for the elite education of women.

39. HS 97B:3999.

40. HHS 10B:439.

41. Ibid.

42. HHS 79B:418.

43. HHS 10A:419.

44. HHS 10B:438. Even Richard W. Guisso, 1981, p. 56, writes, "As much as

anything else, the *Tso* makes clear that women in pre-Confucian China were relatively active in such spheres as warfare and state ceremonial. . . . In sexual and social intercourse, they were relatively free and even influential in politics." If the *Tso* (composed 4th c. B.C.E.) portrays women this way, it should perhaps not surprise us that Han writers do, too, a few centuries later, although we must always be on the lookout for the telescoping of history. Susan Mann, 1997, pp. 82–95, suggests that some Chinese scholars in late imperial China noted the strength and scope of women's writings in the classical period.

45. All the women in these stories seem to be members of the elite. In many cases, we can trace their family backgrounds, as they are members of prominent local and national elites. We must assume that the biographies are based on eulogies prepared upon the death (if not before) by the women's natal and married families.

46. Pao Hsüan's wife was determined, loyal, and ready to sacrifice. See HHS 84:2781–82.

47. For examples, see HHS 94:2792, 84:2783, and 84:2792–93.

48. See, e.g., HHS 84:2794 and HHS 84:2798.

49. On the subject of autonomy, let us not forget that extant literary sources, confirmed in a few cases by archaeological evidence, shows that court women had titles, emoluments, and property in their own right, not only as appendages to the male members of their family. See HS 97A:3935.

50. HHS 84:2793–94.

51. Ibid., 84:2800–2. For later accounts, see Robert Rorex, 1974.

52. HS 97A:3937ff. We are told that Kao tsu after his victory seldom visited Empress Lü, preferring instead to stay with Lady Ch'i.

53. Cf. the case of Empress Ch'en, consort to Wu ti, who also killed every child of her rival (HS 97A:3948).

54. See the *Tso chuan*, Duke Huan 15, where Yung Chiu's wife must choose between killing her father and her husband; she kills the husband, as "all men are potential husbands, but one has only one father." Obviously, such canonical stories worked against other canonical injunctions that the wife should always obey her husband. Two of the most famous stories that bear upon divided loyalties are HS 97B:2959; HHS 10B:450. In the chapters reviewed, roughly the same number of elite women expressed loyalty to their husbands' clans as to their natal families. Finally, note the parallel between Han and Achaemenid debates regarding the selection of an heir. See *Herodotus* VII.1.

55. Anne Cheng, National Center for Scientific Research, Paris, has written an excellent paper on the topic of revenge in the Confucian Classics, which has been published in a memorial volume for Léon Vandermeersch: *En suivant la Voie Royale, Mélanges offerts en hommage à Léon Vandermeersch*, ed. Jacques Gernet and Marc Kalinowski (Paris: École française d'Extrême-Orient, 1997), 85–96.

56. Empress Lü died in August of 180 B.C.E. For a vivid account of divided loyalties among her officials, see FSTY 9:68–69. The decisive demotion of Empress Lü came in the winter of 56 C.E. (HHS 1B:83).

57. The ritual prescriptions, of course, contained a wide variety of advice (much of it conflicting) for females. The ritual prescriptions were often at odds with local and family custom, which had its own force. In many cases, there is also a real question in my mind as to how faithfully the ritual canons reflected "traditional" views.

58. On the (mistaken?) preoccupation with sexuality as the most important defining aspect of identity, see Michel Foucault, 1985–98. In a generally uncritical article Richard Guisso, 1981, admits, "the ["Confucian"] Classics have little to say of women as persons, but deal almost entirely in idealized life-cycle roles" (p. 47). For misplaced gender polarities see Lucy Nixon, 1994, especially p. 13; K.E. Brashier, 1996.

59. See Pericles's funeral oration in Thucydides, section 46: "The greatest glory of a woman is to be least talked about by men, whether in praise or in blame." Cf. for a later period Plutarch's *Moralia* 138C, which says that the "speech [of a virtuous woman] ought not to be for the public." So far, no royal inscriptions in Persia mention mortal women, even where we might expect them to do so on the basis of Greek reports. Women are similarly absent from the palace reliefs at Persepolis, though the reliefs depict many groups in the empire, including high officials and barbarian peoples. Contrast the China side, where Ch'eng Wen-chü's stepsons ask the magistrate to publicize the good stepmother's merit; also, the numerous accounts attesting to palace murals of women.

60. Although Han court women followed the emperor on hunts and outings just as Persian elite women did, the official histories supply few details. A princess senior to Wu ti is said to have been powerful enough to more or less force him to choose Empress Ch'en as consort (HS 97A:2949); cf. the powerful alliance between another Senior Princess (elder sister of Chao ti) and the evil minister Shang-kuan Chieh (HS 97A:3958). See Bret Hinsch, 1994, chap. 5, "Government," for the power of imperial sisters.

61. The following story is told of the last Han emperor, Hsien ti, and his Empress Fu Shou, who by 196 C.E. were virtual prisoners at Hsü, in the camp of Ts'ao Ts'ao. See HHS 10B:452–54.

62. The *Li chi* describes as ideal persons who are "mild and gentle, sincere and good . . . pure and still, refined and subtle . . . courteous and modest, grave and respectful." See Legge's translation, 2:256. Both men and women are to bow to the wishes of the single head of household, the temporary embodiment in the family of the community of living and dead, unless there is clear and present danger to the family from the head's activities. Both are to regulate their every movement by tinkling jade girdle ornaments, being mindful of the virtues of balance, gravity, and reverence.

63. Han rhetorical style requires the author of a memorial to begin with self-abasement, protestations of his or her own lack of worth. Three brilliant examples of it occur in Pan Chao's *Admonitions*, in a memorial sent by Empress Hsü (consort to Ch'eng ti) in protest against those who blamed all of the court's current ills (including the emperor's continued lack of an heir) on her undue influence and ostentatious ways, and in the testamentary edict of Empress Teng (d. 112 C.E.), which bemoaned

her signal lack of virtue (HHS 84:2786; HS 97B:3974; and HHS 10A:429). The same rhetorical style is employed by men for similar occasions.

64. HHS 84:2781. The passage cited does not explicitly provide the context "who remains loyal to her family in crisis"; I have supplied that context based on the contents of the chapter. The framing devices for chapters in the HHS date to the time of Fan Yeh (398–445 C.E.), but they (a) are probably based on Han materials and (b) in no way contradict earlier materials.

65. Cf. for early China, A.R. O'Hara, 1955, which translates Liu Hsiang's writings on seven categories of women, only one of which is "the pernicious and depraved." Contrast the case of certain Greek writers, especially Hesiod, as recounted in Nicole Loraux, 1978; rpt. in English, p. 107.

66. Han elites seem to have rejected the proposition that widows must not remarry. Three possible reasons occur to me: (1) If so-called "chastity of widows" were to be enforced, the Han *paterfamilias* would have lost the ability to replace the (possibly) weakened relations with the dead man's family with a more advantageous marriage alliance contracted through the widowed daughter. (2) Judging from extant texts, Han elites would have felt it inhumane to condemn a relatively young woman to a life without heterosexual sex. (3) There were undoubtedly many different competing beliefs held by Han elites ("non-synchronicity" or "non-contemporaneities," to borrow the language of Ernest Bloch's *The Utopian Function of Art and Literature*). Historical change is not a monolithic and standardizing event that happens at a single time to all members of society. There were at least three related issues debated at this time: (1) the degree of affection to be displayed for women in public (as in HHS 10A:399), (2) the proper way to finance the emperor's back palace establishment, and (3) the general character of yin, wherein certain factions (such as those led by Liu Hsiang and Ku Yung) wish to attribute more blame to palace women than seems merited (e.g., HS 97B:2977).

67. HS 97A:3933.

68. HS 97B:4011. Ch'ü T'ung-tsu, 1972, p. 56, lists a number of amazing reversals of fortune.

69. A proverb saying, applied to Lady Li, Li Yen-nien's little sister, who was consort to Wu ti (HS 97A:3951).

70. For woman's loyalty to uterine, natal, and husband's families, see Marjorie Wolf, 1972, ch. 2.

71. Historians of a critical bent may dismiss several accounts in the dynastic histories, but one cannot rule out the possibility that the real strength of those accounts lies in their symbolic suggestiveness.

72. See C.N. Seremetakis, 1993.

73. Maria Brosius, p. 3. The adjectives in parentheses are my words, not those of Brosius.

74. John Winkler, 1990, p. 5.

References

Abbreviations:

> FSTY: Ying Shao, *Feng su t'ung yi*
> HHS: Fan Yeh, *Hou Han shu*
> HS: Pan Ku, *Han shu*

Aeschylus. 1991. *The Persians*. Trans. Seth G. Benardete. In *Aeschylus II. The Complete Greek Tragedies* series, ed. David Grene and Richmond Lattimore. Chicago: University of Chicago Press.

Bigwood, Joan M. 1978. "Ctesias as Historian of the Persian Wars." *Phoenix* 32: 19–41.

Black, Alison Harley. 1986. "Gender and Cosmology in Chinese Correlative Thinking." In *Gender and Religion: On the Complexity of Symbols*, ed. Caroline W. Bynum, Steven Harrell, and Paula Richman. Boston: Beacon Press, pp. 165–95.

Boatwright, Mary Taliaferro. 1991. "Plancia Magna of Perge: Women's Roles and Status in Roman Asia Minor." In *Women's History and Ancient History*, ed. Sarah B. Pomeroy. Chapel Hill: University of North Carolina.

Brashier, K.E. 1996. "Han Thanatology and the Division of Souls." *Early China* 21: 125–58.

Braun, M. 1938. *History and Romance in Greco-Oriental Literature*. Oxford: Oxford University Press.

Briant, P. 1989. "Histoire et idéologie: Les grecs et la 'décadence perse.'" In *Mélanges Pierre Levêque, ii, Anthropologie et société*, ed. Marie-Madeleine Mactoux and Evelyne Geny. Paris: Belles lettres, pp. 33–47.

Brosius, Maria. 1996. *Women in Ancient Persia: 559–331 B.C.* Oxford: Clarendon Press, 1996.

Brown, Truesdell S. 1973. *The Greek Historians*. Lexington, MA: D.C. Heath & Co.

Ch'ü Tung-tsu. 1972. *Han Social Structure*. Seattle: University of Washington.

Dewald, Carolyn. 1981. "Women and Culture in Herodotus' *Histories*." In *Reflections on Women in Antiquity*, ed. Helene P. Foley. New York: Gordon and Breach, pp. 91–126.

Fan Yeh. 1965. *Hou Han shu*. Beijing: Chung-hua. 12 vols. Abbreviated HHS in text.

Foucault, Michel. 1985–86. *The History of Sexuality*. Vols. 2 and 3, trans. R. Hurley. New York: Pantheon.

George, Pericles. 1994. *Barbarian Asia and the Greek Experience: From the Archaic Period to the Age of Xenophon*. Baltimore: Johns Hopkins University.

Gould, John. 1980. "Law, Custom, and Myth: Aspects of the Social Position of Women in Classical Athens." *Journal of Hellenic Studies* 100: 39–59.

Guisso, Richard W. 1981. "Thunder over the Lake: The Five Classics and the Perception of Woman in Early China." In *Women in China: Current Directions in Historical Scholarship*, ed. Guisso and Stanley Johannesen. Youngstown: Philo Press, pp. 47–62.

Hallock, R.T. 1969. *Persepolis Fortification Tablets*. Chicago: University of Chicago Press.

Halperin, David M., John J. Winkler, and Froma I. Zeitlin, eds. 1989. *Before Sexuality: The Constructions of Erotic Experience in the Ancient Greek World*. Princeton, NJ: Princeton University Press.

Herodotus. 1974. *The Histories*. Trans. Aburey de Sélincourt. London: Penguin, 1954; rev. 1974.

Hinsch, Bret Hunt. 1994. "Women in Early Imperial China." Ann Arbor: University Microfilms.

Holmgren, Janet. 1982. "Myth, Fantasy or Scholarship: Images of the Status of Women in Traditional China." *Australian Journal of Chinese Affairs* 6: 147–170.

Jacoby, Felix. 1922. "Ktesias." In *Realencyclopädie der classicschen Altertumswissenschaft*, ed. A. Pauly and G. Wissowa. Stuttgart, 1894–, 11:2032–73.

Karttunen, Klaus. 1997. "Ctesias in Transmission and Tradition." *Topoi* 7: 635–47.

Loraux, Nicole. 1978. "Sur le race des femmes et quelques-unes de ses tribus." *Arethusa* 11:43–88; rpt. in English translation in *The Children of Athena*; Princeton, Princeton University Press, 1993.

Mann, Susan. 1996. *Precious Records: Women in China's Long Eighteenth Century*. Stanford: Stanford University Press.

Mo Tzu. 1963. *Mo Tzu: Basic Writings*. Trans. Burton Watson. New York: Columbia University Press.

Munson, Rosaria Vignolo. 1988. "Artemisia in Herodotus." *Classical Antiquity* 7,1: 91–106.

Nixon, Lucia. 1994. "Gender Bias in Archaeology." In *Women in Ancient Societies*, ed. Léonie J. Archer, Susan Fischler, and Maria Wyke. London: MacMillan, pp. 24–52.

O'Hara, Albert Richard. 1955. *The Position of Women in Early China*. Hong Kong: Orient Publishing rpt. of 1945 limited edition.

Pan Ku. 1970. *Han shu*. Beijing: Chung-hua. 8 vols. Abbreviated HS in text.

Pu Wei-chung. 1995. *Ch'un Ch'iu san chuan tsung ho yen chiu*. Taipei: Wen-chin.

Rorex, Robert A., and Wen Fong. 1974. *Eighteen Songs on a Nomad Flute*. New York, Metropolitan Museum.

Sancisi-Weerdenburg, Heleen. 1983. "Exit Atossa: Images of Women in Greek Historiography on Persia." In *Images of Women in Antiquity*, ed. Averil Cameron and Amelie Kuhut. Detroit: Wayne State, pp. 20–33.

———. 1987. "Decadence in the Empire or Decadence in the Sources? From Source to Synthesis: Ctesias." In *Achaemenid History I: Sources, Structures and Synthesis*, ed. Sancisi-Weerdenburg. Leiden: Nederlands Instituut voor het Nabije Oosten.

Seremetakis, C. Nadia. 1993. "Gender, Culture, and History: On the Anthropologies of Ancient and Modern Greece." In *Ritual, Power and the Body: Historical Perspectives on the Representation of Greek Women*. New York: Pella Publishing, pp. 11–34.

Smith, Kidder, Jr. 1989. "*Zhou yi* Interpretation from Accounts in the *Zuozhuan*." *Harvard Journal of Asiatic Studies* 49: 421–63.

Stevenson, R.B. 1987. "Lies and Invention in Deinon's *Persica*." In *Acaemenid History II; The Greek Sources*, ed. Heleen Sancisi-Weerdenburg and Amélie Kuhrt. Leiden: Nederlands Instituut voor het Nabije Oosten.

Swann, Nancy Lee. 1932. *Pan Chao: Foremost Woman Scholar of China*. New York, Russell & Russell.

Thucydides. 1954. *History of the Peloponnesian War*. Trans. Rex Warner. London, Penguin.

Tso chuan: Selections from China's Oldest Narrative History. Trans. Burton Watson. New York: Columbia University Press, 1989.

Wiesehöfer, Josef. 1996. *Ancient Persia From 550 BC to 650 AD*. Trans. Azizeh Azdo. London: I.B. Tauris.

Winkler, John J. 1990. *The Constraints of Desire: The Anthropology of Sex and Gender in Ancient Greece*. New York: Routledge.

Wolf, Margery. 1972. *Women and the Family in Rural Taiwan*. Stanford: Stanford University Press.

Wu Pei-yi. 1995. "Childhood Remembered: Parents and Children in China, 800–1700." In *Chinese Views of Childhood*, ed. Anne Behnke Kinney. Honolulu: University of Hawaii Press, pp. 129–56.

Yang Xin, Richard M. Barnhart, *et al.*, eds. 1997. *Three Thousand Years of Chinese Painting*. New Haven: Yale University.

Ying Shao. 1946. *Feng su t'ung yi*. Indexed in *Feng su t'ung yi fu t'ung chien*, Peiping: Centre franco-chinois d'études sinologiques. Rpt. Taipei: Ch'eng Wen, 1968. Abbreviated FSTY in text.

Gendered Virtue Reconsidered: Notes from the Warring States and Han

Lisa Raphals

> *We cannot reasonably expect, that a piece of woolen cloth will be wrought to perfection in a nation which is ignorant of astronomy, or where ethics are neglected.*

David Hume, "Of Refinement in the Arts"

Claims that virtue is gendered come in many forms. A particular version of such claims for both Chinese and Western philosophy is the idea that men and women differ in their capacity for moral reasoning.[1] Claims of this kind are legion. Jean-Jacques Rousseau's *Émile* sets out one education for its eponymous hero and another for his sister Sophie.[2] Sigmund Freud might have drawn on the *Li ji* 禮記 claim that fathers judge children by merit and mothers by affection when he stated that for women the level of what is ethically normal is different than for men; women's superegos are less inexorable, impersonal, and independent of their emotional origins than men's.[3] Some contemporary feminists give the issue a new twist, and ask whether gender predisposes women toward certain virtues, and men toward certain vices. Other feminist voices have opposed the notion, starting with Mary Wollstonecraft's *Vindication of the Rights of Women*.[4]

One recurring problem in so-called "Classical Confucian" accounts of virtue is whether "everyone" has the potential to cultivate, let alone attain, it. This "self-cultivation" may be defined in strong form as acquiring virtuous or charismatic power 德, or becoming a sage 聖人, or a "gentleman" 君子. It may be expressed more modestly as the desire for benevolence 仁. A key element of the Mencian theory of human nature was that everyone had such potential, expressed as the "four sprouts" 四端 of virtue. Yet this potential was a necessary, but not sufficient condition for virtue.[5]

I want to specify the question in the following terms: Can this "everyone" be a woman? Consider the statement by Mencius 孟子: "People having these four sprouts is just like their having four limbs 人之有是四端也, 猶其有四體也 (2A6).

If we take the first word in its usual meaning of "person," "human," or "people," Mencius seems to be making it clear that everybody possesses these

sprouts, in other words, the potential for self-cultivation. Roger Ames suggests a very different possibility: that the usual polarity between female and male (*nan-nü* 男 女) refers to sex, but that: "*nan* is not used to classify characters that identify specifically 'male' gender traits. Rather the contrast is between 'female' (*nü* 女) and 'person' (*ren* 人), defining human traits."[6]

If true (and he does not elaborate), it provides a rationale for interpretations of the language of Mencius 2A6 and other philosophical texts that simply exclude women from self-cultivation. A related but distinct question I do not explore here is whether the readers, writers, and audience of Chinese philosophical works were assumed to be men.

Is such an interpretation plausible? What follows is not a philological investigation of the polarities of *nan-nü* and *ren-nü*. Rather, I adduce evidence for early Chinese beliefs about gender, self-cultivation, and sagacity from three strata of Warring States and Han thought. Let me begin with a note of caution toward two fairly widespread approaches to the problem of gender and China. One is a set of "feminist" attacks on "Confucian" "patriarchy" based on a kinship model that posits family interactions as the only basis for the construction of gender, without reference to social structures outside of kinship.[7] The other is an exclusive reliance on the philosophical interpretation of a small set of canonical "Confucian" texts, with the tacit premise that the statements in these texts transparently and authoritatively reflected Warring States and Han attitudes ("Confucian" and otherwise) and social practices.

I begin with views ascribable to Confucius in the *Analects* and elsewhere, insofar as these define at least some versions of a Confucian project. Next I touch on a range of evidence from Warring States and Han narratives about sagacious women. Whilst the stories are compiled in what is traditionally viewed as a late Han text, the *Collected Life Stories of Women* 列 女 傳 of Liu Xiang 劉 向, many of these narratives first appear in early Warring States texts such as the *Zuo Annals* 左 傳 and *Discourses of the States* 國 語. The heroines of several stories also appear in an influential Han dynasty classification of individuals of intellectual and moral worth (and otherwise) in the *Han History* 漢 書, the "Table of Ancient and Modern Persons" 古 今 人 表. It includes women in its named designations "Benevolent Persons" 仁 人 and "Wise Persons" 智 人.[8]

In the remainder of the paper I reconsider this Chinese evidence on belief in gendered virtue in the light of contemporary feminist claims for a distinct female ethic. I conclude with a discussion of implications for Confucianism and claims that Confucianism is "feminist," or "more" or "differently" benign or feminist than Western philosophy.

1. Gender, Sagacity and Self-Cultivation

Did late Warring States and Han reflective thinkers believe that men and women had different attitudes toward, or capacities for, moral reasoning and its atten-

dant intellectual abilities? In a recent volume I argued that Warring States and Han narratives represented women as possessing the same capacities for wisdom, practical intelligence and moral reasoning as men.[9] Capacity, however, does not imply opportunity or motive. We must also consider the opportunities and contexts in which women might actually *practice* self-cultivation by functioning as active agents in social and political life. To put the question differently, did women's lives put them in the path of what Bernard Williams, Martha Nussbaum, and others have referred to as "moral luck"?[10]

Confucius

What did "becoming a sage" and "self-cultivation" mean to the first "Confucian" thinkers of Warring States China? By all accounts, the latter was difficult, the former almost impossible, for *anyone*. According to the *Analects* 論語, Confucius associated sagehood with "perfect virtue" (6.28), and refused to claim the title for himself (7.33). He referred to four kinds of people: those born with wisdom, those who acquire it by study, those who learn despite limitations, and those who have ability but do not learn (16.9). Finally, he held that only those of the highest wisdom or the lowest stupidity could not be changed (17.3).

Neither these statements nor the *Analects* overall clarify whether such statements about *ren* applied to all people or to men only. Two passages do mention Confucius's possible opinions of the capacities of women. *Analects* 8.20 contains a statement that Shun 舜 governed the empire with five capable officials and King Wu 武王 with ten. Confucius comments:

> Talent is difficult [to find], is it not! It flourished through the period of Tang and Yu [Yao and Shun]. There was a woman amongst them, so the men (*ren*) were only nine.
>
> 才難，不其然乎？唐虞之際，於斯為盛。有婦人焉，九人而已。

This passage uses *ren* to refer specifically to *men*, in the Master's dictum. It also indicates Confucius's recognition, with no disapproval expressed, that one of King Wu's ten ministers who ordered the state of Zhou was a woman.[11] Huang Kan's 皇侃 (488–545 C.E.) commentary emphasizes the importance of this statement in clarifying Confucius's view that the success of the Zhou depended on the talents of both men and women:

> When he [Confucius] states clearly that there was a woman, he makes it clear that the flourishing of the Zhou dynasty was not due to the talents of men, it also relied on the abilities of women to help in the transformation of government.[12]
>
> 又明言有婦人者，明周代盛，匪唯丈夫之才，抑婦人之能匡弼於政化也。

The second passage is *Analects* 17.25, which is widely cited as evidence that Confucius believed that women presented *some* kind of difficulty when it came to education and/or self-cultivation.

> Girls/women and servants are difficult to manage/nurture.
> Approach them, and they are insubordinate; stay distant and they are malcontent.
> 唯女子與小人，為難養也，近之則不孫，遠之則怨。

The second part is unproblematic: proximity makes them insubordinate and distance makes them malcontent. The commentaries are brief and focus on explaining the behavior described in the latter part of the passage.[13] There are two distinct tendencies in the interpretive translation of the first part. The prevalent one is that women and servants are difficult to manage or behave to appropriately. A second approach takes *nan yang* 難養 more literally as "difficult to nurture," with the implication of that women or girls are difficult to instruct.[14] There is an important difference. An instructor or nurturer acts on behalf of the recipient of the care; this need not be true of a handler or manager. Another possibility is that the passage refers to *girls* 女子 as distinct from women 婦人.[15] Read thus, Confucius does suggest that the education (and self-cultivation) of girls presents particular difficulties, of which many can be imagined. It does not state that it is impossible or undesirable. But Confucius does not elaborate. Both passages may be later interpolations, and not reflect the views of Confucius at all.[16] The views of the historical Confucius on this point are unclear, and cannot be pressed into evidence.

The "Table of Ancients and Moderns"

In contrast to the brief and cryptic discussions of women in the *Analects* and other Warring States "Confucian" philosophical literature, historical narratives from the Warring States and Han portray women as political and intellectual agents within their own society. Initially compiled by men, but later used by both male and female authors of instruction texts, these stories depict female intellectual and moral influence as central to the success or failure of states and dynasties. They conspicuously show sagacious women who make use of the same intellectual and moral skills attributed to male sage–kings and their ministers. They thereby present an alternative to the prevailing "outer and inner court" picture of history which, in stressing the proper powers of appointed officials, portrays female influence, necessarily indirect, in a social system in which women could not hold office, as inevitably destructive. They also show women possessing a wide variety of expertise and social mobility.[17]

Later Han dynasty assessments of sagacity and potential also include women, as evidenced by the *Han History*'s "Table of Ancients and Modern Persons."[18] Its four named categories, "Sage Persons," "Benevolent Persons," "Wise Persons" and "Stupid (or "morally retarded") Persons" 愚人, are the

first three and the last in a hierarchy of nine tiers. The intervening ranks are unnamed. Self-cultivation would seem to comprehend innate ability, moral discrimination (intellectual virtue), the ability to learn, and the ability to put learning into practice. I focus on the categories of "Benevolent" and "Wise" and on the unnamed fourth category. Only the ninth category is explicitly pejorative, yet to identify the fifth through eighth categories with "self-cultivation" verges on damnation by faint praise.

The table lists fourteen persons in the first category of "Sage Persons." All are men. The first eight date from legendary antiquity: the Three Sages (Fu Xi 伏羲, Shen Nong 神農, and Huang Di 黃帝) and Five Emperors (Shao Hao 少昊, Zhuan Xu 顓頊, Di Ku 帝嚳, Yao 堯, and Shun 舜). Five more are the dynastic founders of the Xia, Shang, and Zhou dynasties: Yu 禹, Tang 湯, Kings Wen 文王 and Wu 武王, and the Duke of Zhou 周公 (Western Zhou). The last is Confucius.[19] The absence from this category of prominent individuals usually considered sagacious has been widely noted. Many of the names associated with the "Masters" category of the *Han shu* bibliography appear only in the unnamed fourth category. Liang Yusheng's 梁玉繩 Qing dynasty study of the Table, the *Renbiao kao* 人表考, includes discussions from the commentaries on this issue. The Wei 魏 commentator Zhang Yan 張晏 takes up two such individuals he considers particularly sagacious. Both are omitted from the "Sage Persons" and classed in the fourth category. The first is Laozi, who, "is not among the sages, but is considered a great sage nonetheless" 不在聖要為大聖. The second is a woman, the Mother of Wenbo, who, though classed in the fourth category, was discerning in ritual and canon, acted according to the precepts of the sages, and whose words served as models for later generations.[20]

Female Relatives of the Fourteen Sages

Many of the men and women classified as "Benevolent Persons" are the teachers, female relatives, and (non-ruling) male progeny of the fourteen men listed as sages of the first category of the table. Of the women, almost all are the mothers and consorts of the fourteen sages: Nü Wa 女媧, sister of Fu Xi,[21] the wife of Shen Nong,[22] the four consorts of Huang Di,[23] the wives of his descendants of with Lie Zu 嫘祖,[24] the four consorts of Di Ku,[25] the wives of Yao, Shun, Hou Ji 后稷, and Yu,[26] You Shen 有莘, wife of King Tang,[27] and the "Three mothers of the Zhou," the wives of the founders of the Zhou dynasty.[28] Twelve of the fourteen sages have a mother, wife, or sister listed in this category; the only exceptions are Shao Hao and Confucius himself! Of the two benevolent women who are not relatives of the fourteen sages, Ji Ren 姞人, the wife of Hou Ji, is still closely connected to them. Three women in "Wise Persons" are also relatives of the fourteen sages: Ji Shou 擊手, the younger sister of Shun, and Yi Jiang 邑姜 and Tai Ji 大姬, the consorts of King Wu.[29]

These women have male counterparts in the table. Several of the men in the "Benevolent Persons" category also have close connections with the

Fourteen Sages, as teachers or as sons who did not inherit the throne. Examples include: Huang Di's teachers,[30] Zhuan Xu's son and three teachers,[31] Di Ku's father and teachers,[32] a minister, son and grandson of King Tang,[33] as well as the minister and teacher of the Shang king Wu Ding 武丁.[34] The category ends with three figures closely connected to Confucius: his grandson Zisi, Mencius, and Xunzi.[35]

As Derk Bodde has pointed out in his study of the table, the vast majority of the exemplary individuals of the first four categories of the table lived before the Warring States, most before Confucius.[36] Most women (and men) in the first two categories are figures of legend. After Confucius, the population of all of the first four categories drops off considerably. The fourth category names 310 men, including Laozi, Mo Di, Shang Yang, Han Fei, Gaozi, and Yin Wenzi.[37] It also names six women, none of whom are related to the Fourteen Sages. These are quasi-historical figures who appear in such sources as the *Zuo zhuan*, *Guo yu* and *Lienü zhuan*.

It has been argued that when women were included as exemplars of virtue, their sole function was the domestic one of instructing sons and aiding husbands.[38] It also has been argued that they represent "types" and not individuals, with the implication that they cannot be taken seriously as exemplars of self-cultivation or moral reasoning.[39] Given their overwhelming connection to the fourteen sages of the table, the thirty-five women listed in this table would seem to fit that characterization. The table, however, differs from other accounts of Warring States and Han texts in that it gives no account of any of the individuals listed in it, male or female. It is normative, not descriptive, and does not privilege either gender (beyond naming many more men than women).

Nonetheless, it is worth asking whether the women in the table had some special opportunities for "moral luck" that allowed them to excel in ways unavailable to the generality of women. The very lack of description makes the point impossible to address on the evidence of the table itself. However, several of the women named in the table also appear in other Warring States and Han sources, notably (but not exclusively) the *Lienü zhuan*.[40] *Lienü zhuan* accounts of these women come from the first three chapters: the majority from "Maternal Rectitude" 母儀 (Chapter 1).[41] These stories focus on a particular aspect of motherhood: the importance of teaching and intellectual skills. The virtuous mothers they describe were the original teachers of the legendary founders of civilization. They raised and instructed Yao and Shun's most important ministers (Jiang Yuan and Jian Di), the founders of the Zhou dynasty (Tai Ren and Tai Si), and the successful sons of dynastic founders, who maintained the thrones their fathers had created (Nü Qiao).

The *Lienü zhuan* stories, unlike other versions of these legends, focus on the actual abilities of women.[42] One example will illustrate the point. Most accounts of Jian Di (LNZ 1.3) focus on the life and abilities of her son Xie, including his miraculous birth from the egg of a black swallow and his pro-

mulgation of rules for ordering human society at the request of Emperor Shun.[43] The *Lienü zhuan* life story of Jian Di emphasizes her understanding of human relationships and astronomy, and specifically describes her as the source of his knowledge and the cause of his advancement.

This emphasis on the intellectual skills and moral judgment of women is not unique to the *Lienü zhuan*. The *Shi ji* collective biographies of the wives of emperors portrays these women, not only as agents of political virtue, but as responsible for the rise to power of their respective states: the Xia came to power because of the Tu Shan girl, the Shang because of You Shen, and the Zhou because of Jiang Yuan and Tai Ren.[44]

The Intellectual Virtues of Quasi-Historical Women

Despite a consistent emphasis on teaching, the accounts of the female relatives of the Fourteen Sages give little detail about their virtues, beyond the facts of their marriages and sons. The twelve women who are not directly connected to the Fourteen Sages present a different situation, which warrants a more detailed examination of why they were considered so virtuous. Only one woman appears in the "Benevolent Persons" category, but their numbers increase to four in "Wise Persons" and six in the unnamed fourth category. Most of these virtuous women also appear in the *Lienü zhuan*, consistently the chapters that contain what I elsewhere have called intellectual virtue stories.[45]

The only woman in the "Benevolent Persons" category who is not directly connected to the Fourteen Sages is the "Mother of Xiang" 向母, who follows her son Jin Shuxiang 晉叔向 in the table; she also appears in the "Benevolent and Wise" 仁智 chapter of the *Lienü zhuan* as "The Mother of Sun Shu'ao" 孫叔敖母.[46] She interprets the portent when her son sights and kills a two-headed snake, and correctly predicts the course of his political career. The *Lienü zhuan* eulogy describes her "deep knowledge of the way of heaven," that is, her accurate prognostication.[47] A minister would use this expertise on behalf of his ruler and the state; she uses it on behalf of her family. The expertise is completely independent of her role as wife or mother.

The "Two Yao" 二姚 were the wives of Shao Kang (who appears before them), but the *Zuo zhuan* account of their marriage gives no details as to their particular wisdom.[48] We have a fuller account of the third woman in the "Wise Persons" category, the wife of Zhao Shuai 衰姜, whom she follows in the table. She appears twice in the *Zuo zhuan* and also in the "Sage Intelligence" 賢明 chapter of the *Lienü zhuan*, as the wife of Zhao Shuai of Jin 晉趙衰妻.[49] The *Lienü zhuan* story is virtually identical to the *Zuo zhuan* accounts.[50] In both, she impartially admonishes her husband to welcome a previous wife from the Di tribe and advances the Di wife's talented son above her own. While the context of her admonition is marriage, the impartiality and recognition of merit that define her virtuous conduct are the hallmarks of a virtuous official. Indeed,

her husband's wisdom consistes in following her advice. The fourth woman in "Wise Persons" is the "Mother of Tui" 推母. She is not in the *Lienü zhuan*, but her story and that of her son Jie Zitui 介子推 appear in the *Zuo zhuan* and elsewhere. He is a loyal retainer who cuts off part of his own thigh to feed the marquis of Jin and asks for no recompense. His mother urges him to let his case be known. He, instead, opts to withdraw from the world, whereupon she too withdrew and hid herself from the world with him. The marquis later seeks him in vain and endows a sacrifice for him as the mark of distinction of a good man.[51]

The first of the women in the fourth category of the table is the mother of Duke Kang of Mi 密母. She uses moral arguments about the violation of principle to predict the downfall of her state. Her story appears in both the *Guo yu* and in the "Benevolent and Wise" chapter of the *Lienü zhuan*.[52] She tries to persuade her son to give up three concubines to King Gong of Zhou, whom he is worthy to possess. His refusal to give them up ultimately results in the destruction of Mi. She is described as able to recognize the rise and decline of things.

"The wife of Duke Mu of Qin" 秦穆夫人 used a combination of courage and wits to resolve a conflict of loyalties between the interests of her natal state of Jin and her husband's state of Qin.[53] Her half-brother Hui had fled to Qin after an ambitious concubine turned his father Duke Xian of Jin against the designated heir Shen Sheng.[54] After the death of Duke Xian, Hui returned to Jin with the help of Duke Mu. Thereafter he neglected the alliance with Qin, disobeyed orders from Duke Mu, and even denied Qin grain during a famine. Finally, Duke Mu invaded Jin and took him prisoner. On their return, she intervened on his behalf by threatening to kill herself and her children, including the heir apparent. Thereupon Duke Mu pardoned Hui and the alliance was restored. The *Zuo zhuan* version elaborates and justifies Duke Mu's reasons for the antagonism.[55]

The "Wife of the Jiang" 夫人姜氏 uses outright deception and ruses to attain her (highly laudatory) goals. In the *Zuo zhuan* and *Guo yu* accounts of the wanderings of Chong Er, she uses an outright plot to spirit her husband Chong Er back to Jin with his followers when he refuses to return. Her ends justify her means; he regains his rightful position. Reflecting this, her life story in the "Sage Intelligence" chapter of the *Lienü zhuan* is titled "Jiang of Qi, wife of Duke Wen of Jin" 晉文齊姜.[56]

The wife of Qi Liangzhi of Qi 齊杞梁殖妻 is the one widow suicide in the first four categories of the table.[57] According to the *Lienü zhuan*, after her husband's death in battle, she was left without relations (father, husband, or son). She refused condolences from her husband's victorious opponent, mourned her husband's corpse by the city wall, with such sincerity that the wall itself crumbled. Thereafter she drowned herself, since she wished to avoid remarriage and had no relations in any generation on whom to depend or

toward whom to manifest propriety.[58] Unlike the other quasi-historical women in the table who appear in the *Lienü zhuan*, hers is not among the intellectual virtue stories, and the virtues ascribed to her do not involve intellectual discernment, moral reasoning or statecraft. Instead, she appears in the "Chaste and Obedient" 貞順 chapter as "The Wife of Qi Liang of Qi" 齊杞梁妻.

The *Analects* is relatively silent on the subject of women, but in other texts, Confucius comments on the behavior, ethics and knowledge of several. One for whom he seems to have had a particularly high regard is "the woman of the Ji" 季氏之婦, who appears in the table as "The Mother of Gongfu Wenbo" 公夫文伯母 and in the "Maternal Rectitude" chapter of the *Lienü zhuan* as "Jing Jiang of the Ji of Lu" 魯季敬姜.[59] Confucius praises her for understanding the rites and the distinctions between men and women and between superior and inferior. Nor was he alone in this opinion. Zhang Yan singles her out, along with Laozi, as extraordinary individuals who are not classed as "Sage Persons" in the table.[60] She was the wife of one official, the mother of another, and the grand-aunt of yet another.[61] Despite an apparent paradigm for female virtue in which women avoid even commenting on politics, Jing Jiang admonished both her son and nephew on important matters, and even negotiated some tricky ritual situations herself. Her arguments stress the "separate spheres" of men and women, but her obvious erudition and savoir-faire raises question about the extent to which the education was in fact available to at least some women.

She appears with considerable frequently in Warring States and Han texts. The *Guo yu* contains eight separate stories about her; her life story is the longest and most complex in the *Lienü zhuan*; and she also appears in the *Han Shi waizhuan*, *Zhanguo ce* and *Li ji*.[62] These accounts agree that she was widowed young, and raised her son and instructed him, his concubines, and her paternal grand-nephew. Her discourses include examples of illustrious men of the past, analogical discourses on weaving, admonitions on propriety in the treatment of a guest, admonitions to Wenbo's concubines after his death, and discourses on correct conduct (both ritual and quotidian), especially her understanding of the separation of men and women. All these narratives take the form of admonitions: to her son, to his concubines, and to Ji Kangzi.

The elder sister of the assassin Nie Zheng 聶政姊 (d. 397) appears in Han sources: the *Shi ji*, the Supplementary Life Stories of the *Lienü zhuan*, and the *Zhanguo ce*.[63] After the death of his aged mother, the assassin Nie Zheng belatedly sought employment with Yan Sui, who recognized his abilities, and determined to be of use to "one who knew him." Yan's commission left Nie Zheng in a fatal situation in which he was forced to commit suicide. He mutilated his own body to spare his elder sister Nie Ying 聶嫈 from retributive punishment. She chose to identify him and kill herself, thereby completing his honor by public recognition. This story is the locus classicus for the use of the term *lienü* 烈女 for "virtuous woman." In the *Zhanguo ce* version, Nie Zheng

is the central character, but the details of the story coincide with those of the
Lienü zhuan and *Shi ji* versions.

In conclusion, these narratives and the evidence of *Han shu* 20 suggest
that Han thinkers considered both women and men capable of self-cultivation
and even sagacity. Accounts of the women who are not relatives of the Four-
teen Sages are especially noteworthy because they cannot be dismissed as
"merely" being mothers or wives of sages. They act independently in ways
that have direct consequences for their states.[64] The *Gujin renbiao* does not
give explanations for any of its entries, but the inclusion of these women in the
table lends authority both to their individual reputations for virtue and self-
cultivation, and, implicitly, to the notion that women could and did exercise
the same kinds of moral and intellectual judgments as men. Only one of the
women in the first four categories of the table corresponds to the gender-spe-
cialized accounts of "women's virtue" 女德 that came to characterize later di-
dactic literature for or about women, such as the *Gui fan* 閨範 of Lü Kun 呂坤
(1536–1618) and Ming editions of the *Lienü zhuan* that emphasized chastity,
widow suicide, self-sacrifice, etc.[65]

The Female Ethic Debate

This evidence bears on the contemporary debate about whether women think
differently from men, and whether there is, as some feminist philosophers
claim, a distinct "female ethic." Such claims must be put in the context of two
crucial developments in feminist scholarship. The first is a shift from the study
of women to the study of gender.[66] This new perspective led to a range of
studies of the social construction of gender, including its definition by polarity
and difference. An interesting example is the role of binary dichotomies in the
cultural construction of gender. Jean Grimshaw calls for a critique of the polar-
ization of masculine and feminine qualities and how they are interpreted or
clustered.[67] Alison Black argues that the polarities of Chinese cosmology cor-
relate to, but are not centered on, gender, although gender shapes and is shaped
by cosmological thinking.[68] Other studies suggest that whatever qualities are
ascribed to masculinity (being warlike, bookish, competitive, cooperative, indi-
vidualist, role-oriented), femininity tends to be associated with their opposites.[69]

The second is the growth of feminist philosophy, especially the develop-
ment of feminist epistemology and ethics. Feminist epistemology per se began
with a challenge articulated by Sandra Harding and Merrill Hintikka to "root
out sexist distortions and perversions in epistemology, metaphysics, method-
ology and the philosophy of science—in the 'hard core' of abstract reasoning
thought most immune to infiltration by social values."[70] In the past fifteen
years, it has moved beyond an initial strategy of "document and deplore" to
more nuanced studies of the epistemic biases of traditional western philoso-
phy.[71] It should not be assumed that all feminist philosophy is unfriendly to

either "male" philosophy or philosophers. For example, Moira Gatens argues against feminist philosophy that sees philosophy as inherently antithetical to feminist aims. Femininst philosophers of this persuasion reject "male" theory in favor of "female" *praxis*. Gatens prefers to identify the "oppresiveness" of much traditional Western philosophy with particular (male) philosophers, rather than with philosophy itself.[72] Along similar lines, Annette Baier recommends David Hume as the "reflective woman's epistemologist."[73]

The distinctive development in feminist ethics has been a set of claims for a distinct female ethic. Such claims arose out of the research of Anglo-American object-relations theorists. Nancy Chodorow argued that each generation reproduces a "universal" gender system of masculine and feminine personalities and roles, not because of essential physical or biological difference, but because of different childhood experiences of social environment by young boys and girls.[74] Carol Gilligan's studies on moral judgment suggest that moral reasoning is gendered. Gilligan used case studies to argue that men abstract ethical problems according to rules and principles (a tendency Freud associates with the mature superego), whilst women contextualize them in concrete situations (In Freud's terms, women's superegos are less inexorable than men's).[75] Along similar lines, Nel Noddings has argued that morality based on rules and principles misses what is distinctive about female moral reasoning. She argues for a "feminist care ethics" in which the highest morality is based on a caring relation that Noddings describes as "better than, superior to, other forms of relatedness."[76] Another approach to the idea of the female ethic centers on core social practices particular to women—especially mothering—as sources for ethical models for both genders.[77]

Many late nineteenth-century feminists also believed that female virtues might transform society, and that the "domestic" virtues that made women morally superior to men might be extended into society at large through works of charity, philanthropy, etc.[78] Twentieth-century feminists such as Mary Daly have linked much of the warfare and destruction of this century to claims for an essentially destructive "male nature."[79]

Critiques of the Female Ethic

The notion of a "female ethic" is open to critique on several levels. One is the claim that it is grounded in essentialism, whether by attributing a universal, trans-historical essence or "nature" to women, or by assigning women to universal social categories, functions or activities, here defined by psychological characteristics. The notion is also based on an implicit claim that men and women differ in intellectual capacities and moral reasoning.

Some feminist philosophers have criticized it along these lines.[80] Grimshaw questions the viability of a female ethic, both because it does not correspond to actual gender in all cases, and because it might reinforce the very stereotypes

it seeks to overcome. She points out that claims for a female ethic go farther than merely asserting difference and providing a method for describing it; they also suggest that "female ethic" is better than "male philosophy."[81]

A distinct critique of the female ethic emerges from its origins in eighteenth-century Western philosophy, in a context very different from that of its contemporary feminist advocates. In the West, the idea that women should be educated and held to different standards of morality than men dates from eighteenth-century ideas of a "female ethic," "feminine" nature and specifically female virtue, especially in the *Émile* of Jean-Jacques Rousseau, first published in 1762 as *Émile: ou de l'éducation*.[82] As Rousseau puts it (presumably to a male audience): "You are always saying, 'Women have such and such faults, from which we are free'. You are misled by your vanity; what would be faults in you are virtues in them; and things would go worse if they were without these so-called faults."[83]

According to Rousseau, women should be obedient, dutiful, modest, chaste, and above all, responsible to the demands of husband and children. Rousseau not only thought that women should be subordinate to men, but that their virtues were in some sense subordinate as well. The idealized "feminine" virtues of sympathy, compassion, modesty, and charm were inferior inverses of the virtues men should cultivate: the capacities for rationality, acting on universal principles, and exercising impersonal judgment. A woman who aspires toward the moral virtues appropriate to men will merely become an inferior woman, and lose the appropriate bases of female virtue. Rousseau's articulation of a separate virtue for women coincided with important changes in the social situation of women, including the idealization of marriage and family life, and increasing economic dependence on men and marriage by women.[84]

These ideas found immediate attack in Mary Wollstonecraft's *Vindication of the Rights of Women*. Its immediate context was *Émile* and Rousseau's view that women possess different natures from men, and must be educated to different principles of virtue. Whilst its target was eighteenth-century views of femininity and female consciousness, it still has much to say to contemporary tensions in feminist philosophy. Grimshaw emphasizes the importance of its focus on two related aspects of eighteenth-century thought about women:

> . . . the idea that virtue is *gendered*, that it is *different* for women and for men [emphasis in original], and that it is female 'sensibilities', women's particular psychological characteristics, which fit women for a specifically female type of virtue (but also disqualify them from that type of thought appropriate to the male, and render them weaker and potentially easily corruptible).[85]

The attack on Rousseau's idea of gendered virtue was central to the *Vindication*.

. . . the most perfect education, in my opinion, is such an exercise of the under-
standing as is best calculated to strengthen the body and form the heart. Or, in
other words, to enable the individual to attain such habits of virtue as will render
it independent. In fact, it is a farce to call any being virtuous whose virtues do not
result from the exercise of its own reason. This was Rousseau's opinion respecting
men. I extend it to women and confidently assert that they have been drawn out
of their sphere by false refinement, and not by an endeavor to acquire masculine
qualities.[86]

Wollstonecraft's argument was twofold. One was that men and women
had the same moral and intellectual capacity for virtue. The other is that both
should receive the same education in substance.

But I still insist, that not only the virtue, but the *knowledge* of the two sexes should
be the same in nature, if not in degree, and that women, considered not only as
moral but rational creatures, ought to endeavor to acquire human virtues (or per-
fections) by the *same* means as men, instead of being educated like a fanciful kind
of *half* being—one of Rousseau's wild chimeras [emphasis in original].[87]

Contemporary readers may be wary of an Enlightenment viewpoint that
privileges reason and rationality above every other faculty.[88] Latter-day feminists
have attacked the *Vindication* for its glorification of reason—a "male virtue"—
and critical attitude toward sensuality and "feminine" sensibility. It is important
to distinguish these two critiques. The former does not require any notion of
gendered virtue. The terms of the latter come straight out of twentieth-century
appropriations of the female ethic. Wollstonecraft's attack on the consequences
of gendered virtue in denying full humanity to women is as trenchant today as
it was in 1793.

Confucianism and Gendered Virtue

In the introduction to this volume, Chenyang Li points out that Chinese history
presents abundant instances of the repression of women in *Confucian* China:
"A philosophic-religious tradition cannot have a future if it is hostile to half of
the human population. Most curiously, however, leading contemporary Con-
fucian scholars have been practically silent on this matter."[89]

In 1985, Tu Wei-ming made the curious statement that a woman might
practice self-cultivation "despite her structural limitation," but did not pursue
the question.[90] In a 1994 publication, Margery Wolf recounts a long discus-
sion with Tu at a conference in which:

I could not make him appreciate how remote the whole Neo-Confucian project is
for the rural people I have worked with or how crippling the so-called "structural

limitations" under which he believes women must labor are. What I would consider structural difference—certainly not limitation—is a matter of different anatomical features, but Professor Tu was thinking of the cultural baggage that is usually associated with those anatomical features.[91]

Both Tu and Wolf seem to assume some kind of fundamental difference in thinking and reasoning between men and women, whether its "structures" are anatomical differences of sex, cultural constructions of gender, or the burden of the past on the present.

David Hall and Roger Ames give a different picture of the "cultural baggage" in their account of Chinese and Western cultural definitions of the truly human person. In the West, they argue, the achievement of humanity was construed as the realization of "masculine" gender traits. They contrast a narrow "masculine" Western "humanity" available to both sexes and a broader androgynous Chinese "humanity" available to men only. Chinese sexism "denies to the female the possibility of becoming a human being," but its androgyny "might be more humane than is the Western model" in which "to be human you must be male."[92] On the other hand, a Western woman might attain some equality by assuming men's gender traits, but the Chinese gender system presents no such option because of inevitable hierarchy. In their attempt to "separate the baby from the bathwater" they note a reductionistic pattern of equating traditional Chinese culture with Confucianism, condemning Confucianism for its unrelenting patriarchy, and thereby ignoring the distinctiveness and accomplishments of both.[93]

Wollstonecraft's *Vindication* and the arguments of contemporary feminist philosophers who oppose appeals to a "female ethic" make two powerful claims. One is that gendered virtue ethics are vicious; the other is that gendered virtue theories are not inherent in or necessary to Western philosophy. The problem with "Western philosophy" is the gendering of virtue by particular Western philosophers. Can we say the same of Confucianism?

One aspect of this question is whether we can pinpoint a Confucian ideology that does not rely on gendered virtue ethics. In the first part of this paper I presented evidence from the *Analects* through the "Table of Ancient and Modern Persons" in the *Han History* to the effect that in Warring States and Han narratives, women were represented as possessing the same virtues valued in men: moral integrity, intellectual judgment, the ability to admonish a superior, courage, and chastity, in the sense of single-minded loyalty. These representations of virtuous women probably were composed and redacted by men, yet their narratives consistently emphasize a view that virtue was not gendered. Their relatively gender-neutral epistemology and ethics is clear testimony that gendered virtue ethics are not inherent in Chinese culture.

This testimony cannot, however, be extended to "Confucianism," however defined. The two individuals most closely associated with the compilation and

selection of these individuals, Liu Xiang (for the *Lienü zhuan*) and Ban Zhao (for the *Gujin renbiao*), can be described unproblematically as Confucians. Nonetheless, it is a mistake to describe the *stories* as "Confucian." Most of these Warring States and Han narratives predate the establishment of Confucianism, either as hegemonic ideology or as prevailing social practice.[94] Specifically Confucian ideologies and social practices from the Later Han through Song and Ming-Qing Neo-Confucianism overwhelmed the earlier pattern of an ungendered approach to wisdom and the capacity for moral judgment. During the period of specifically Confucian intellectual hegemony in China, these stories were de-emphasized, substantially reinterpreted, and largely replaced by accounts of female chastity and widow suicide, the "cultural baggage" to which Margery Wolf refers.[95]

By way of example, in his account of "Women's Place in Chinese History," Hu Shi 胡適 (1891–1962) tries to counteract what he describes as "a general impression that the Chinese woman has always occupied a very low place in Chinese society."[96] He begins with the legends of the didactic queens of legendary times, but quickly turns to the specifically political achievements of women: the forty-year reign of the queen-regent of Qi (also known for her breaking of a "Gordian knot" of jade rings), the continued consolidation of the Han under Empress Lü 呂后 (d. 180 B.C.E.), the lowborn wife of the Han founder, and the patronage of Taoism by Empress Dou 竇后 (d. 135 B.C.E.). His greatest praise goes to Ti Ying 緹縈, the daughter of the Han physician Chunyu Yi 淳于意, for bringing about the abolition of corporal tortures during the Han (c. 167 B.C.E.).[97] All these events occurred well before the extremely gendered Confucian ideologies of the Song, Ming, and Qing.[98] It is no coincidence that almost all his examples come from a period in Chinese history that preceded the entrenchment of a gendered virtue ethic.

It remains to ask whether a gendered virtue ethic is inherently necessary to Confucianism. Given a broad history of emphasis on gender roles and distinctions, it is disconcerting that recent philosophical studies of greater or lesser Confucian affiliation have attempted to advance the discourse by using female ethic arguments to claim that Chinese constructions of gender are in some ways more fluid than their Western counterparts.[99]

These claims that Confucianism is in some sense "feminist" are largely based on appeals to the gendered virtue arguments of twentieth-century feminist philosophers, the very arguments that another strain of feminist philosophy since Wollstonecraft have strenuously opposed, for good reasons. Jean Grimshaw's critique of the idea of a female ethic ends with the observation that "If ethical concerns and priorities arise from different forms of social life, then those which have emerged from a social system in which women have so often been subordinate to men must be suspect."[100]

The target of her remark is the history of gendered virtue ethics in Europe, including its links with changes in eighteenth-century society that worked

against the independence of women, including near-total economic depen-
dence on marriage and the idealization of marriage and family life. In China,
changes in women's economic status and increased value of women's labor
went hand in hand with the theories of gendered virtue that became especially
prominent from the Song dynasty on.[101] A generation of feminist Chinese social
history has begun to document how late imperial Chinese women functioned
as active agents in their own society.[102] Yet they did so at a cost. Even where
women enjoyed a measure of intellectual and artistic autonomy, both they and
their productions were relegated to an inferior and circumscribed sphere of
women's culture, and excluded from the "masculine" realms of statecraft, politics
and philosophy.[103]

Arguments that try to align Confucianism with a "female ethic" may seem
friendly to feminism. Their actual effect is to perpetuate a gendered virtue
ethic. The history of "gendered virtue" theories, both in traditional China and
in Europe, is vicious. Hu Shi, Lu Xun and others have described the ill effects
of Confucian gendered virtue theories on Chinese women, ranging from their
relegation to an inferior moral and intellectual status to the promotion of chas-
tity cults and widow suicide.[104]

Nowadays, condemnation of "Confucian" patriarchy is a *sine qua non* for
any attempt to reformulate Confucian values for the contemporary world. I
have argued here that an ethic of gendered virtue is equally problematic in
both Europe and China, yet appeals to it continue to be made in the interest of
reform.

Notes

1. The capacity for moral reasoning is only one of any number of possible artic-
ulations of the idea that virtue is gendered. Other important variants of the question
not addressed here include notions of gendered virtue in the contexts of education,
sexual morality, and employment, to name just a few. How children of both sexes
should be raised and taught gender identity, including norms of behavior and moral-
ity? Should there be separate desiderata for men and women in the areas of chastity,
marriage, or divorce? Are certain kinds of employment morally inappropriate for one
sex and not the other (for example the armed military, the priesthood, leadership or
rulership of a state, etc.)?

2. Rousseau, 1762 (1966).

3. Freud, 1925:342, quoted in Grimshaw 1986:187.

4. Wollstonecraft, 1792 (1975).

5. A particularly interesting one is Nivison, 1996.

6. Hall and Ames, 1998:294, n. 18. Their view also implies that Chinese uses
different polarities to make what we would call the distinction between sex (*nan-nü*)
and gender (*ren-nü*).

7. Cf. Connell 1994 and Mann, forthcoming.

8. Bodde, 1939 (1981):148–70. He translates *"Gujin renbiao"* as "Table of Ancient and Modern Men," with no hint of the several dozen women in its preeminent categories of virtue.

9. Cf. Raphals, 1998.

10. Cf. Williams, 1991 and 1995 and Nussbaum, 1986.

11. The commentaries disagree about whether she was King Wu's grandmother (King Wen's mother) Tai Ren 大任, his mother Tai Si 大姒 (King Wen's wife) or his own first wife Yi Jiang 邑姜 (*Lunyu jishi*, vol. 2, 16:480–84). Chen Shishi 陳師誓 explains that Tai Si and Yi Jiang "from the time they entered office used the passage from the inner [quarters]" 自在官壼之內, (p. 481), and thus kept themselves separate from the other officials.

12. *Lunyu jishi*, vol. 2, 16:483.

13. *Lunyu jishi*, vol. 3, 35:1078.

14. Examples of the first interpretation include James Legge's (1861:194) "girls and servants are the most difficult to behave to," S. Couvreur's "difficile à traiter" (1910:272), Arthur Waley's "difficult to deal with" (1938:216), D.C. Lau's "it is the women and the small men that are difficult to deal with," (1984:148) and Brooks and Brooks's "Women and little people are hard to handle" (1998:166). An example of the second approach is Roger Ames's "It is only women and morally retarded men that are difficult to raise and provide for" (Hall and Ames 1998:88). As Paul Goldin (2000) has pointed out, being "difficult to nurture" is a more serious charge than merely being difficult to manage, because it implies incapacity or ineptitude for participation in moral discourse or benefitting from moral instruction.

15. Cf. Couvreur's Latin rendering of *puellae* also follows this view, though his "femmes de second rang" in the French half of his bilingual translation contradicts it (1910:272). Some commentaries do at least suggest that the passage refers to both girls and women. One quotes the *Zuo zhuan* (Xi 24): "virtue in a girl is to be without preeminent talent; women's resentments are without end" 女德無極。婦怨無終. Another refers to "the mind-set of women and girls" 婦女之志. *Lunyu jishi*, vol. 3, 35:1078.

16. Cf. Brooks and Brooks 1998:177 and 240.

17. Cf. Raphals 1998 passim.

18. *Han shu* 20. It presents a ninefold classification of 1,955 individuals from legendary times to the Qin dynasty. It was begun by Ban Gu 班固 (32–92 C.E.) and completed by his sister Ban Zhao 班昭 (d. circa 125 C.E.). Its four named categories probably are based on the fourfold categorization of Confucius discussed above.

19. *Han shu* 20:863–924.

20. Liang 1:14.

21. *Han shu* 20:864, Liang 2:35. The accounts of these women vary among sources, and warrant a separate study.

22. "The woman of Shao Dian" 少典, also the mother of Huang Di. *Han shu* 20:866.

23. Fang Lei 方雷 (mother of Xuan Xiao 玄囂, grandmother of Qiao Ji 僑極, and great grandmother of Di Ku), Lie Zu (mother of Chang Yi 昌意 and grandmother of Zhuan Xu), Tong Yu 彤魚 (mother of Yi Gu 夷鼓) and Mou Mu 暮母 (mother of Cang Lin 倉林). *Han shu* 20:867, Liang 2:44–44.

24. Chang Pu 昌僕 (wife of Chang Yi and mother of Zhuan Xu), Nü Lu 女綠 (wife of Zhuan Xu and mother of Lao Chong 老童), and Jiao Ji 嬌極 (wife of Lao Chong and mother of Wu Hui 吳回, Chong 童 and Li 黎). This series ends with Nü Kui 女潰, wife of Wu Hui's son Ling Zhong 陵終. *Han shu* 20:869–70, Liang 2:48–50.

25. Jiang Yuan 姜原 (mother of Hou Ji), Jian Di 簡狄 (mother of Xie 契), Chen Feng 陳豐 (mother of Yao) and Ju Zi 娵訾 (mother of Zhi 摯). *Han shu* 20:872–73, Liang 2:53–55.

26. Nü Huang 女皇 was the wife of Yao. Their daughters E Huang 娥皇 and Nü Ying 女英 were the wives of Shun. Ji Ren was the wife of Hou Ji. Nü Qiao 女趫, (also known as the Tu Shan girl) was the wife of Yu. *Han shu* 20:875, 878, 879 and 880, Liang 2:59, 64–66 and 66–69.

27. *Han shu* 20:884, Liang 2:69.

28. Jiang Nü 姜女 (wife of Tai Wang 大王, grandmother of King Wen), Tai Ren (wife of Wang Ji 王季, mother of King Wen), and Tai Si (wife of King Wen, mother of King Wu and the Duke of Zhou). *Han shu* 20:888, 889, and 891, Liang 2:74. They are "The Three Mothers of the Zhou" 周室三母 in the *Lienü zhuan* (LNZ 1.6).

29. *Han shu* 20: 878 and 92–3, Liang 2:106 and 107–8.

30. Feng Ju 封鉅, Tai Tian 大填, and Tai Shanji 大山稽. *Han shu* 20:864–68.

31. *Han shu* 20: 871–2.

32. Cf. Qiao Ji 僑極 and Chi Songzi 赤松子, the legendary rainmaster of Shen Nong. *Han shu* 20:872–4.

33. Jiu Dan 咎單, Tai Ding 大丁, and Tai Jia 太甲. *Han shu* 20:884–5.

34. *Han shu* 20:888.

35. *Han shu* 20:924. This category also includes Bo Yi 伯夷 and Shu Qi 叔齊 (*Han shu* 20:890) and Guan Zhong 管仲 (*Han shu* 20:907).

36. Bodde, 153. His table separates each historical period. I have consolidated them to illustrate the differences between the legendary past, and the early and late Zhou.

37. *Han shu* 20:924.

38. Cf. Goldin 2000.

39. Guisso 1981.

40. For discussion of other Warring States accounts see Raphals 1998, chapter 4.

41. They are: (1) The Two Consorts of You Yu [Shun] 有虞二妃, (2) Jiang Yuan, Mother of Qi [Hou Ji] 棄母姜原, (3) Jian Di, Mother of Xie 契母簡狄, (4) The Tu Shan Girl, Mother of Qi 啓母塗山, (5) You Shen, Consort of Tang 湯妃有㜪 and (6) The Three Mothers of the Zhou 周室三母. For discussion see Raphals 1998, chapter 2.

42. Cf. Raphals 1998, chapter 4.

43. The *Shi jing* odes *Xuan niao* 玄鳥 (Mao 303) and *Chang fei* 長廢 (Mao 304) describe Xie's miraculous birth, almost without reference to Jian Di, as do the versions of the story in the *Shu jing* (tr. Legge 44) and *Shi ji* (3:91).

44. *Shi ji* 49:1967.

45. For discussion of this concept see Raphals 1998, chapter 1.

46. *Han shu* 20:923, Liang 2:84; *Lienü zhuan* story 3.5.

47. *Shen zhi tian dao* 深知天道, *Lienü zhuan* 3:3b.

48. *Han shu* 20: 882, Liang 4:99. According to the *Zuo zhuan* (Ai 1), Shao Kang's 少康 mother, the queen of Xia, barely escaped the sack of Xia 夏 and fled to her native state of Reng 仍. Shao Kang found refuge in You where he worked as a cook. King Si of You recognized his virtue and gave him his two daughters in marriage and the city of Lun.

49. *Han shu* 20:913, Liang 3:122; *Zuo zhuan* (Xi 23 and 24); *Lienü zhuan*, story 2.8.

50. The first (Xi 23) recounts Chong Er's flight from Jin to the Di with Zhao Shuai, their marriages to Ji Wei and Shu Wei, and the birth of Zhao Shuai's son Dun by Shu Wei (Xi 23). In the second (Xi 24), Chong Er gives Zhao Shuai his own daughter Ji as his second wife after their return to Jin, and she upbraids him at length for his treatment of Shu Wei and Dun. She perceives Dun's abilities and urges that he be declared heir, and his mother promoted accordingly.

51. *Han shu* 20: 913, Liang 4:123; *Zuo zhuan* (Xi 24). He also appears in later accounts in the *Lü Shi chunqiu* (*Jie li*) and *Liexian zhuan*, which describes how, as a recluse, he was visited each morning by yellow birds that would appear at his door.

52. *Han shu* 20:897, Liang 4:160. The *Lienü zhuan* life story is titled "The Mother of Duke Kang of Mi" 密康公母 (story 3.1).

53. *Han shu* 20:911, Liang 4:166. The *Lienü zhuan* lists her slightly differently as the "Secondary Wife of Duke Mu of Qin" 秦穆公姬 (story 2.4).

54. Cf. *Lienü zhuan*, story 7.7.

55. Zuo, Xi 15.4, pp. 358–9, cf. Legge 168.

56. *Han shu* 20:913, Liang 4:168, *Zuo zhuan* (Xi 23.4–6, pp. 402–11 cf. Legge 186–7), *Guo yu* (10.2 [Jin 4], pp. 340–42), *Lienü zhuan* story 2.3.

57. *Han shu* 20:922.

58. *Lienü zhuan* story 4.8.

59. *Guo yu* 5.10–17 (Lu 2), p. 208; Liang 4:196–7, *Lienü zhuan*, story 1.9. The *Lienü zhuan* account contains five distinct narrative elements, in some cases of several parts each. For a detailed study of the nature of this reputation see Raphals, forthcoming.

60. Liang 1:14.

61. She was the wife of Gongfu Mubo 公夫穆伯, the mother of Gongfu Wenbo, and the paternal grandaunt of Ji Kangzi 季康子.

62. *Guo yu* 5.10–17 (Lu 2), pp. 202–12; *Li ji* 3, 924b–25b; *Han Shi waizhuan*, stories 1.1 and 1.19; *Zhanguo ce* 20 (Zhao 3), pp. 692–9.

63. *Han shu* 20:924, *Lienü zhuan* story 8.3, *Shi ji* 86:2522–25, *Zhanguo ce* 27 (Han 2) pp. 993–1000.

64. I pursue this argument at length in Raphals, 1998.

65. Cf. *Gujin Lienü zhuan* and *Huitu Lienü zhuan*. See Raphals 1998, chapters 5, 9, and 10.

66. Cf. Rosaldo and Lamphere, 1974; Ortner, 1974; Ortner and Whitehead, 1981; Illich, 1982; Scott, 1988; Moore, 1994; and Hevia, 1995.

67. Grimshaw, 1986:47–8.

68. Black, 1989, especially 166f and, 178–84.

69. Griffiths and Whitford, 1998:6

70. Harding and Hintikka, 1983:ix. Cf. Haraway, 1989; Flax, 1989; Parsons, 1990; Code, 1991; Duran, 1991; Alcoff and Potter, 1993; Anthony and Witt, 1993.

71. Anthony and Witt, 1993:1.

72. Gatens, 1994.

73. Baier, 1993. She notes that many of the themes emphasized by feminists appear in his writings, including skepticism (p. 37) and the attempt to shift the source of epistemic authority away from deductive reason (p. 39).

74. Chodorow, 1974:43–44 and 169. For discussion see Gilligan 1982:6–11, Scott 1988:38. For an application of Chodorow's observations to Chinese village life see Wolf, 1994.

75. Gilligan, 1982.

76. Noddings, 1984:83, cf. Li 1994:79–81 and 87 and Grimshaw 1992:226–28.

77. Cf. Whitbeck, 1983 and Ruddick, 1989.

78. Cf. Grimshaw, 1992:223.

79. Cf. Daly, 1979.

80. For discussion of the developmental models of moral reasoning in the works of Jean Piaget, Erik Erikson, and Lawrence Kohlberg, and their critique by Carol Gilligan see Grimshaw, 1986:190. For other critiques of Gilligan see Scott, 1988:40–41 and Grimshaw, 1986:224 and 1992:225–32. For discussion of Grimshaw's position, see Hall and Ames, 1998:174–78.

81. Grimshaw, 1986:194. For a balanced and useful discussion of Grimshaw's summary of and reservations about claims for a female ethic see Hall and Ames, 1998:3–85.

82. Cf. Rorty, 1994:46–51.

83. Rousseau, 1762 (1966):326–27.

84. Cf. Grimshaw, 1992:221–2.

85. Grimshaw, 1990:14.

86. Wollstonecraft, 1792 (1994):86–87.

87. Wollstonecraft, 1792 (1994):106.

88. These readings stand in interesting contrast to its original reception: outraged rejection for its advocacy of libertinism and amorality. Cf. Grimshaw, 1990.

89. Li, introduction

90. Tu, 1985:144.

91. Wolf, 1994:253–54.

92. Hall and Ames, 1998:81–82. As Nancy Chodorow puts it in a psychoanalytic account of the development of perceptions of gender difference, men have defined maleness as human, and defined women as not-men (1994:47).

93. Hall and Ames, 1998:99–100.

94. Cf. Raphals, 1998, chapter 4.

95. Cf. Raphals, 1998, chapters 5 and 8–10.

96. Hu Shi, 1931 in Li Yu-Ning 1992:3. See also Lin Yutang, 1935 in the same volume.

97. Hu Shi, 1931 in Li Yu-Ning, 1992:6–7. Chunyu Yi was born in 216 B.C.E., and is known to have practiced medicine during the early Han. This incident is dated to 167 B.C.E., during the reign of Han Wen Di (r. 180–157 B.C.E.), named here as King Xiao Wen 孝文.

98. See Raphals, 1998, chapters 5–10. For a useful discussion of *yin-yang* and *nei-wai* polarities as "unequal encompassment," see Zito, 1997:211–15.

99. In addition to the Hall and Ames study discussed above, Henry Rosemont has argued that, although completely male-dominated, Confucian ethics (and Chinese ethics) *seem* to correspond more closely to the female ethic advocated by Gilligan than to the hegemonic "male philosophy" of the West (Rosemont, 1996). Chenyang Li tries to bring together the concept of *ren* in Confucian ethics and the concept of care in feminist ethics (Li, 1994).

100. Grimshaw, 1992:235.

101. Cf. Ebrey, 1993:261–71.

102. Cf. (among many others) Widmer, 1989; Ebrey, 1993; Ko, 1994; Bray, 1997; Mann, 1997; and Widmer and Sun Chang, 1997; and Mann, forthcoming.

103. Cf. Widmer, 1989 and Widmer and Sun Chang, 1997.

104. Cf. Lu Xun 1918:117 and 119, tr. Yang 1973: 138 and 140–41.

Bibliography

Alcoff, Linda, and Elizabeth Potter, 1993. *Feminist Epistemologies*. New York: Routledge.

Anthony, Louise, and Charlotte Witt, eds. 1993. *A Mind of One's Own: Feminist Essays on Reason and Objectivity*. Boulder, San Francisco, and Oxford: Westview Press.

Baier, Annette C. 1993. "Hume: The Reflective Woman's Epistemologist?" In *A Mind of One's Own: Feminist Essays on Reason and Objectivity*. Ed. Louise Anthony and Charlotte Witt. Boulder, San Francisco, and Oxford: Westview Press.

Black, Alison Harley. 1989. "Gender and Cosmology in Chinese Correlative Thinking." *Gender and Religion: On the Complexity of Symbols*. Ed. C.W. Bynum, S. Harrell, and P. Richman, Boston: Beacon Press.

Bodde, Derk. 1981. "Types of Chinese Categorical Thinking." In *Essays on Chinese Civilization by Derk Bodde*. Edited and introduced by Charles Le Blanc and Dorothy Borei. Princeton, NJ: Princeton University Press.

Bray, Francesca. 1997. *Technology and Gender: Fabrics of Power in Late Imperial China*. Berkeley: University of California Press.

Brooks, E. Bruce Brooks and A. Taeko. 1998. *The Original Analects: Sayings of Confucius and His Successors*. New York: Columbia University Press.

Cheng Shude 程樹德 (1877–1934), ed. *Lunyu jishi* 論語集釋 [Collected Commentaries to the Lunyu]. Guoli huabei bianyiguan, 1943.

Chodorow, Nancy. 1974. *The Reproduction of Mothering: Psychoanalysis and the Sociology of Gender* Berkeley: University of California Press.

———. 1994. "Gender, Relation and Difference in Psychoanalytic Perspective." In *The Polity Reader in Gender Studies*. Cambridge: Polity Press.

Code, Lorraine. 1991. *What Can She Know? Feminist Theory and the Construction of Knowledge*. Ithaca, NY: Cornell University Press.

Connell, R.W. 1994. "Gender Regimes and Gender Order." In *The Polity Reader in Gender Studies*. Cambridge: Polity Press.

Couvreur, S.J., trans. 1910. *Les Quatres Livres*. Ho Kien Fou: Imprimiere de la Mission Catholique.

Daly, Mary. 1979. *Gyn/Ecology: The Metaethics of Radical Feminism*. London: The Women's Press.

Duran, Jane. 1991. *Toward a Feminist Epistemology*. Lanham, MD: Rowman & Littlefield.

Ebrey, Patricia Buckley. 1993. *The Inner Quarters: Marriage and the Lives of Chinese Women in the Sung Period*. Berkeley: University of California Press.

Flax, Jane. 1989. *Thinking Fragments: Psychoanalysis, Feminism and Postmodernism in the Contemporary West*. Berkeley: University of California Press.

Gatens, Moira. 1994. "The Dangers of a Woman-Centered Philosophy." In *The Polity Reader in Gender Studies*. Cambridge: Polity Press.

Gilligan, Carol. 1982. *In a Different Voice: Psychological Theory and Women's Development*. Cambridge, MA: Harvard University Press.

Goldin, Paul. 2000. "The View of Women in Early Confucianism." Chapter 2 in present volume.

Griffiths, Morwenna, and Margaret Whitford. 1988. *Feminist Perspectives in Philosophy*. Bloomington: Indiana University Press.

Grimshaw, Jean. 1986. *Feminist Philosophers*. Brighton, England: Wheatsheaf Books.

———. 1990. "Mary Wollstonecraft and the Tensions in Feminist Philosophy." In *Socialism, Feminism and Philosophy: A Radical Philosophy Reader*. Ed. Sean Sayers and Peter Osborne. London and New York: Routledge.

———. 1992. "The Ideal of a Female Ethic." *Philosophy East & West* 14.2:221–38.

Guisso, Richard W.L. 1981. "Thunder Over the Lake: The Five Classics and the Perception of Woman in Early China." In *Women in China: Current Directions in Historical Scholarship*, ed. Richard W. Guisso and Stanley Johannesen. Youngstown NY: Philo Press.

Guo yu 國語 [Discourses of the States]. Shanghai: Guji chubanshe, 1988.

Hall, David L., and Ames, Roger T. 1998. *Thinking From the Han: Self, Truth, and Transcendence in China and the West.* Albany: SUNY Press.

Han shu 漢書. Beijing: Zhonghua shuju, 1962.

Han Ying 韓嬰 (1st century B.C.E.). *Han Shi wai zhuan* 韓氏外傳. [Exoteric commentary to Master Han's version of the Odes]. Sibu congkan.

Haraway, Donna. 1989. *Primate Visions: Gender, Race and Nature in the World of Modern Science.* New York: Routledge.

Harding, Sandra, and Hintikka, Merrill, eds. 1983. *Discovering Reality: Feminist Perspectives on Epistemology, Methodology, and the Philosophy of Science.* Dordrecht: Reidel.

Hevia, James. 1995. "Gender and China Studies." *Journal of the Economic and Social History of the Orient* (JESHO) 38.2: 224–231.

Huitu lienü zhuan 繪圖列女傳. [Illustrated Life Stories of Women]. Zhibuzu zhai edition, 16 juan, 1779. Rpt. Taibei: Zhengzhong shuju, 1971.

Hu Shi. 1931. "Women's Place in Chinese History." In *Chinese Women Through Chinese Eyes.* Ed. Li Yu-Ning. Armonk, NY and London: East Gate Books, 1992.

Illich, Ivan. 1982. *Gender.* Berkeley: Heyday Books.

Ko, Dorothy. 1994. *Teachers of the Inner Chambers: Women and Culture in Seventeenth-Century China.* Stanford, Calif.: Stanford University Press.

Lau, D. C., trans. 1979. *Confucius: The Analects (Lun yu).* N.p. Reprint, London: Penguin, 1984.

Legge, James, trans. 1861 *The Chinese Classics.* Vol. 1, *The Confucian Analects.* N.p. Reprint, Hong Kong: Hong Kong University, 1960.

——. 1872. *The Chinese Classics V. The Ch'un Ts'ew with the Tso Chuen.* N.p. Reprint Hong Kong: Hong Kong University Press, 1960.

——. 1865. *The Chinese Classics III. The Shoo King or The Book of Historical Documents.* N.p. Reprint Hong Kong: Hong Kong University Press, 1960.

Liang Yusheng 梁玉繩, *Renbiao kao* 人表考, 9 juan. Preface dated 1786. In *Guoxue jiben congshu* 國學基本叢書 (Taiwan, Shangwu, 1968) vol. 352. Also in *Guangya congshu* 廣雅叢書, 1888.

Li, Chenyang. 1994. "The Confucian Concept of Jen and the Feminist Ethics of Care: A Comparative Study." *Hypatia* 9.1: 70–89.

Li ji 禮記 [Book of Rites]. Harvard-Yenching.

Lin, Yutang. 1935. "Feminist Thought in Ancient China." *T'ien Hsia Monthly* 1.2:127–50 (August 1935). Reprint in *Chinese Women Through Chinese Eyes.* Li Yu-Ning, ed. Armonk, NY and London: East Gate Books, 1992.

Liu Xiang 劉向 (attributed). 1983. *Lienü zhuan jiaozhu* 列女傳校注 [Collected Commentaries on the Collected Life Stories of Women]. Ed. Liang Duan 梁端 (c.1793–1825). Taibei: Zhonghua shuju.

——. *Liexian zhuan* 列仙傳 [Collected Life Stories of Immortals]. In *Dao zang*, 138.

——. *Zhanguo ce* 戰國策 [Strategies of the Warring States]. Shanghai: Guji chubanshe, 1985.

Lü Kun 呂坤 (1536–1618). 1618. *Gui fan* 閨範 [Female Exemplars]. Xin'an (Hui-zhou): She Yongning. Facsimile edition in Harvard-Yenching library.

Lu Xun 魯迅. 1918. 我盛節烈觀. [My Views on Chastity]. In *Lu Xun quanji* 魯迅北集 [*Collected Works of Lu Xun*]. Beijing: Renmin wenxue chubanshe, 1981.

Lu Xun 魯迅. 1918. "My Views on Chastity." In *Silent China: Selected Writings of Lu Xun*. Ed. and trans. Gladys Yang. Oxford: Oxford University Press, 1973.

Mann, Susan. 1997. *Precious Records: Women in China's Long Eighteenth Century*. Stanford: Stanford University Press.

——. Forthcoming. "Women, Families, and Gender Relations." In *Cambridge History of China*. Early Ch'ing. vol. 9. Willard J. Peterson, ed. Cambridge UK: Cambridge University Press.

Mao Kun 茅坤 (1512–1601) (attributed to). 1407. *Gujin lienü zhuan* 古今列女傳 [Collected Life Stories of Women Past and Present]. Ed. Xie Jin 解縉. Siku quanshu.

Mengzi yinde 孟子引得 [Concordance to the Mencius]. Harvard-Yenching.

Moore, Henrietta. 1994. "The Cultural Constitution of Gender." In *The Polity Reader in Gender Studies*. Cambridge: Polity Press.

Nivison, David S. 1996. "The Paradox of Virtue." In *The Ways of Confucianism: Investigations in Chinese Philosophy*. La Salle, IL: Open Court Press.

Noddings, Nel. 1984. *Caring: A Feminist Approach to Ethics and Moral Education*. Berkeley: University of California Press.

Nussbaum, Martha C. 1986. *The Fragility of Goodness: Luck and Ethics in Greek Tragedy and Philosophy*. London: Cambridge University Press.

Ortner, Sherry. 1974. "Is Female to Male as Nature is to Culture?" In *Women, Culture and Society*. Ed. M. Rosaldo and L. Lamphere. Stanford: Stanford University Press.

Ortner, Sherry B., and Whitehead, Harriet. 1981. *Sexual Meanings: The Cultural Construction of Gender and Sexuality*. Cambridge: Cambridge University Press.

Parsons, Susan F. 1990. "Feminism and the Logic of Morality." In *Socialism, Feminism and Philosophy: A Radical Philosophy Reader*. Ed. Sean Sayers and Peter Osborne. London and New York: Routledge.

Raphals, Lisa. 1998. *Sharing the Light: Representations of Women and Virtue in Early China*. Albany: SUNY Press.

——. forthcoming. "A Woman Who Understood the Rites." Chapter in *Essays on the Analects of Confucius*. Ed. Bryan W. Van Norden. Oxford: Oxford University Press.

Rorty, Amélie Oksenberg. 1994. "The Coordination of the Self and the Passions." In *Self as Person*.

Rosaldo, Michelle, and L. Lamphere. 1974. *Women, Culture and Society*. Stanford: Stanford University Press.

Rosemont, Henry. 1996. "Classical Confucian and Contemporary Feminist Perspectives on the Self: Some Parallels, and Their Implications." In *Culture and Self: Philosophical and Religious Perspectives East and West*. Ed. Douglas Allen. Boulder, CO: Westview Press.

Rousseau, Jean-Jacques. 1762. *Émile: ou de l' éducation*. Trans. Barbara Foxley, *Émile*, Dent: London and Dutton, New York: Everyman's Library, 1911, reprint 1966.

Ruddick, Sara. 1989. *Maternal Thinking*. Boston: Beacon Press.

Scott, Joan Wallach. 1988. *Gender and the Politics of History*. New York: Columbia University Press.

Shang shu zhengyi 尚書正義 [Rectified Interpretations of the Book of Documents] Sibu beiyao.

Sima Qian 司馬遷, comp. *Shi ji* 史記 [Annals]. Beijing: Zhonghua shuju, 1959.

Tu, Wei-ming. 1985. *Confucian Thought: Selfhood as Creative Transformation*. Albany: State University of New York Press.

Waley, Arthur. 1938. *The Analects of Confucius*. London: Allen and Unwin.

Whitbeck, Caroline. 1983. "A Different Reality: Feminist Ontology." In *Beyond Domination*. Ed. C. Gould. Totowa, NJ: Rowman and Allenheld.

Widmer, Ellen. 1989. "The Epistolary World of Female Talent in Seventeenth-Century China." *Late Imperial China* 10, no. 2 (1989): 1–43.

Widmer, Ellen and Kang-i Sun Chang, ed. 1997. *Writing Women in Late Imperial China*. Stanford: Stanford University Press.

Williams, Bernard. 1981. *Moral Luck: Philosophical Papers, 1973–1980*. New York: Cambridge University Press.

Williams, Bernard. 1985. *Ethics and the Limits of Philosophy*. Cambridge, MA: Harvard University Press. Rpt. 3rd ed. London: Fontana, 1993.

Wolf, Margery. 1994. "Beyond the Patrilineal Self: Constructing Gender in China." In *Self as Person in Asian Theory and Practice*. Ed. Roger T. Ames, Wimal Dissanayake, and Thomas P. Kasulis. Albany: State University of New York Press.

Wollstonecraft, Mary. 1792. *Vindication of the Rights of Women*. In *Mary Wollstonecraft: Political Writings*. Oxford: Oxford University Press, 1994.

Yang Bojun 楊伯峻; ed. 1991. *Chunqiu Zuo zhuan zhu* 春秋左傳注 [Commentary on the Spring and Autumn and Zuo Annal]. Gaoxiong: Fuwen tushu chubanshe, 1991.

Zito, Angela. 1997. *Of Body and Brush: Grand Sacrifice as Text/Performance in Eighteenth-Century China*. Chicago: University of Chicago Press.

Contributors

ROGER AMES is professor of philosophy and Director of the Center for Chinese Studies at the University of Hawaii. He is editor of *Philosophy East and West* and *China Review International*. His recent publications include translations of Chinese classics: *Sun-tzu: The Art of Warfare, Sun Pin: The Art of Warfare*, and *Tracing Dao to its Source* (both with D.C. Lau), and the Confucian *Analects* (with H. Rosemont). He has also authored many interpretative studies of Chinese philosophy and culture: *Thinking Through Confucius, Anticipating China: Thinking Through the Narratives of Chinese and Western Culture*, and *Thinking From the Han: Self, Truth, and Transcendence in Chinese and Western Culture* (all with D.L. Hall).

PATRICIA EBREY is professor of Chinese history at the University of Washington. Her works on Chinese women's history include *The Inner Quarters: Marriage and the Lives of Chinese Women in the Sung Dynasty* (1993) and the co-edited volume *Marriage and Inequality in Chinese Society* (1991). Her primary field of interest is the social and cultural history of the Song dynasty, but her most recent book ranged more broadly—*The Cambridge Illustrated History of China* (1996).

PAUL RAKITA GOLDIN teaches Chinese history and philosophy at the University of Pennsylvania. He is the author of *Rituals of the Way: The Philosophy of Xunzi*, in addition to several scholarly articles. His current research focuses on intellectual conceptions of sex and sexuality in ancient China.

DAVID L. HALL received his Ph.D. from Yale University, and is professor of philosophy at the University of Texas at El Paso. In addition to his collaborative efforts with Roger Ames, he has published several books and essays on the philosophy of culture and American philosophy, and is the author of a philosophical novel entitled *The Arimaspian Eye*. His current projects include collaboration with Roger Ames on a translation and philosophical interpretation of the *Zhongyong*, a book on American philosophy entitled *Peace in Action—America's Broken Promise*, and a collection of fictionalized travel essays, *The Sydney Explorer*.

PHILIP J. IVANHOE is associate professor in the Department of Asian Languages and Cultures as well as the Department of Philosophy at University of Michigan, Ann Arbor. He is the author of *Ethics in the Confucian Tradition: The Thought of Mencius and Wang Yang-ming*, and *Confucian Moral Self Cultivation*. He has edited and contributed to *Chinese Language, Thought and Culture* and co-edited and contributed to *Essays on Skepticism, Relativism and Ethics in the Zhuangzi*, and *Religious and Philosophical Aspects of the Laozi*. His forthcoming publications include *The Sense of Anti-Rationalism: Zhuangzi and Kierkegaard's Religious Thought* (co-authored with Karen L. Carr), *Virtue, Nature and Agency in the Xunzi* (contributor and co-editor with Thornton C. Kline), and *Readings in Classical Chinese Philosophy* (contributor and co-editor with Bryan W. van Norden).

JOEL J. KUPPERMAN is professor of philosophy at the University of Connecticut and has been a visiting fellow at colleges at Cambridge and Oxford. He is the author of *Ethical Knowledge, The Foundations of Morality*, and *Character.* His most recent books are *Value . . . And What Follows* and *Learning From Asian Philosophy*. He has also published articles in journals such as *Philosophy East and West, Mind, and Proceedings of the Aristotelian Society.*

PAULINE C. LEE is a Ph.D. candidate in the Department of Religious Studies at Stanford University. She is specializing in Chinese religious and philosophical thought. She received her B.A. from Stanford in 1991 and her M.T.S. from Harvard Divinity School in 1995. Her primary interests are Chinese feminist ethical and political thought.

CHENYANG LI is associate professor and Chair of the Department of Philosophy at Central Washington University. He is the author of *The Tao Encounters the West: Explorations in Comparative Philosophy*, and numerous articles in such journals as *Hypatia: A Journal of Feminist Philosophy, International Philosophical Quarterly, Philosophia, Philosophy East and West, Journal of Value Inquiry,* and *Review of Metaphysics.* He was the first president of the Association of Chinese Philosophers in America, Inc., 1995–1997.

MICHAEL NYLAN received her Ph.D. from Princeton University and is the Caroline H. Robbins Professor of History at Bryn Mawr College. Her research focuses on the Warring States and Han periods (fifth century B.C.E. to third century C.E.). She has published three books on classical philosophy, and a fourth, on the Five "Confucian" Classics, is forthcoming. Her essays range more widely, reflecting her interest in archaeology, religion, socioeconomic phenomena, and the history of modern sinology.

LISA RAPHALS is associate professor in the Department of Comparative Literature and Foreign Languages at the University of California, Riverside. She is

the author of *Knowing Words: Wisdom and Cunning in the Classical Traditions of China and Greece*, a comparative study of some aspects of Chinese and Greek ethics and epistemology, and of *Sharing the Light: Representations of Women and Virtue in Early China*. Her other areas of interest and publication include Daoist thought and the history of science.

INGRID SHAFER, a native of Innsbruck, Austria, is professor of Philosophy and Religion and Mary Jo Ragan Professor of Interdisciplinary Studies at the University of Science and Arts of Oklahoma, where she has taught since 1968. She has published three books (with two more in press) and over fifty articles, book chapters, and poems. She is creator/editor of nine comprehensive websites designed to foster dialogue among diverse groups and combat intolerance of any kind.

SANDRA A. WAWRYTKO received her Ph.D. in Philosophy from Washington University in St. Louis, and is professor of Asian Studies, Philosophy and Religious Studies at San Diego State University. She has authored several books, including *CRYSTAL: Spectrums of Chinese Culture Through Poetry*, *The Buddhist Religion,* and *Chinese Philosophy in Cultural Context*, and has edited more than ten volumes. Serving as Executive Director of the International Society for Philosophy and Psychotherapy since its inception in 1985, she has organized its seven biennial conferences. Previously she was Secretary General of the World Congress of Logotherapy. Currently she edits the Asian Thought and Culture series published by Peter Lang and is President of the Charles Wei-hsun Fu Foundation.

Index